PHOTOREALISM SINCE 1980

PHOTOREALISM

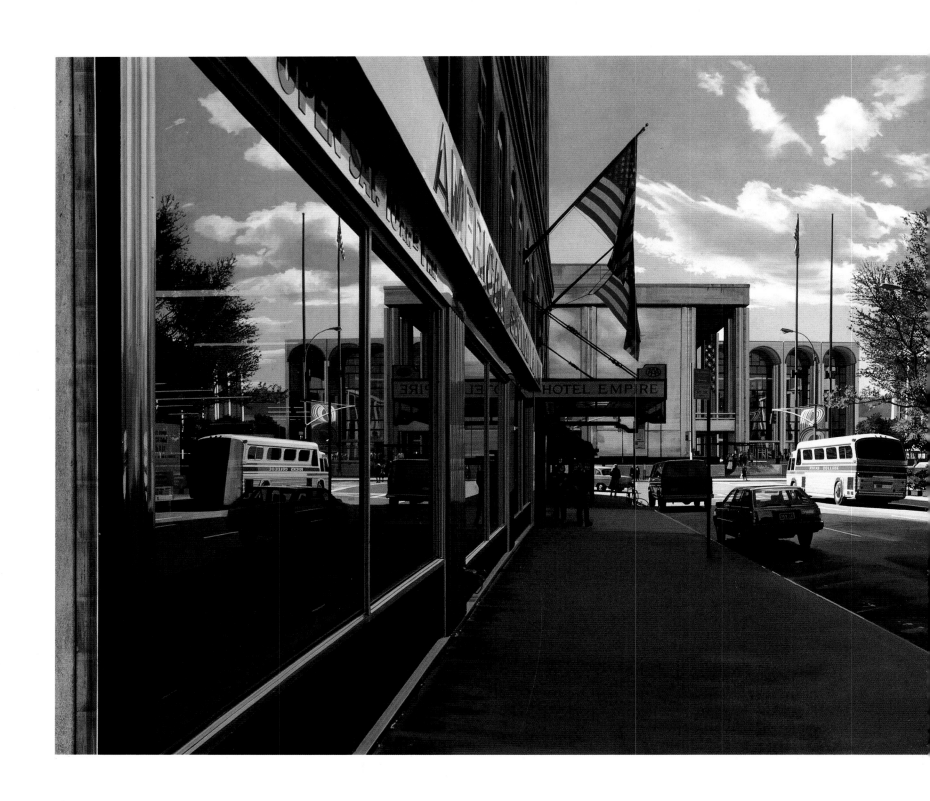

SINCE 1980

Louis K. Meisel

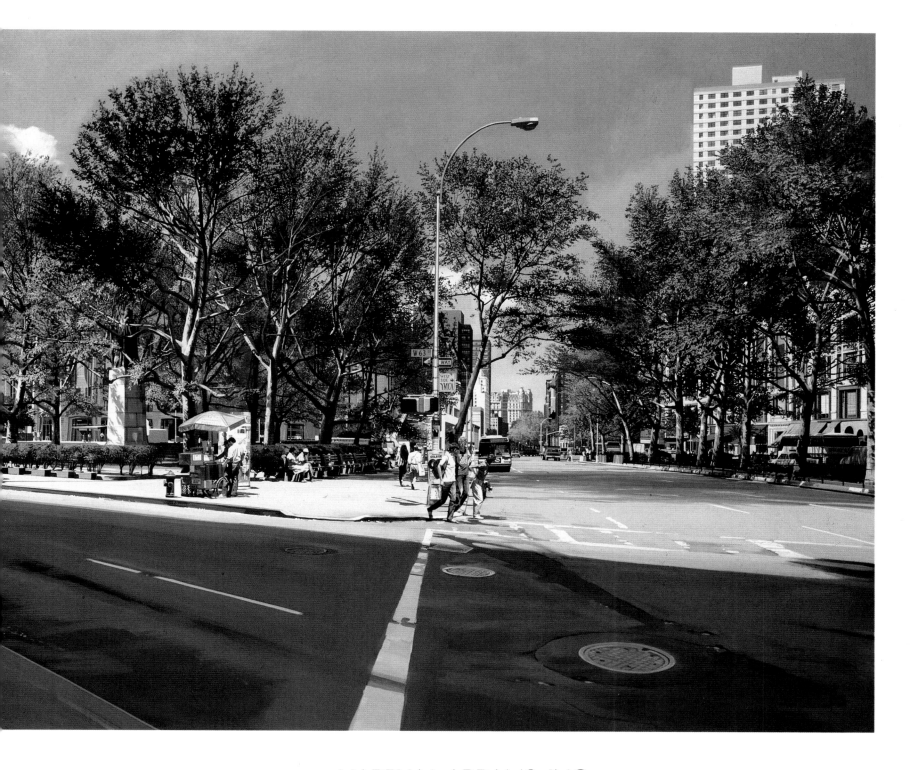

HARRY N. ABRAMS, INC.,
PUBLISHERS

To Susan, the Mother of Photorealism, for all she has
been to me for twenty-nine years

To Charlie Bell, for twenty-four years of friendship,
loyalty, and artistry during a relationship every artist
and dealer should enjoy

To Ari, who will work on volume three with me in the
new millennium

Editor: Margaret Donovan
Assistant Editor: María Teresa Vicens
Designer: Dirk Luykx
Research and documentation: Aaron J. Miller, Diane Sena

Frontispiece: Richard Estes. *Hotel Empire*. 1987 (47). Oil on canvas, 37$^1/_2$ x 87".
Collection Louis K. and Susan Pear Meisel, New York

Library of Congress Cataloging-in-Publication Data
Photorealism since 1980 / [selected by] Louis K. Meisel.
 p. cm.
 Includes bibliographical references and index.
 ISBN 0–8109–3720–4
 1. Photo-realism—United States. 2. Art, Modern—20th century—
United States. I. Meisel, Louis K.
N6512.5.P45P56 1993
759.13′09′048—dc20 92–21997
 CIP

CONTENTS

PREFACE

Isn't it unfortunate that some patterns of behavior, clearly within human control, keep repeating themselves as though they weren't? For example, an art movement achieves popular acclaim, then demand for the art soars, and finally imitators dilute and degrade the movement. As time passes, it becomes difficult to prove that works of art fully representative of the movement are actually what they seem to be. These works gradually lose market value, but more important, they become devalued for study purposes and fail to get the wide exposure and appreciation they deserve. This sad scenario has repeated itself again and again during the course of recorded art history. Consider one twentieth-century example. Alexander Calder made approximately eighteen thousand sculptures in his career, but only about three thousand are provable through documentation and provenance. It is very difficult to sell the others for even a fraction of their true value, and there are, indeed, numerous fakes on the market. Since no one actually knows what is real and what isn't, much of the work may not be studied, bought, or preserved.

The prime purpose of this volume is to prevent what happened to Calder, and to others, from happening to the Photorealists. The movement is now achieving more and more popular acclaim, and demand for the art is soaring. Is Photorealism therefore destined to be diluted and degraded by imitators? With the aim of documenting as many works by the Photorealists as possible, we have illustrated in these pages virtually every painting done by them from 1980 through 1990. This book stands as a companion volume to *Photo-Realism*, published by Harry N. Abrams, Inc., in 1980, which documents the Photorealists from 1967, when the movement emerged, through 1979. Thus, ninety-nine percent of the existing Photorealist works are now documented in two accessible volumes.

This documentation will help deter imitation, forgery, and counterfeiting. If a prospective buyer of a Photorealist painting cannot find it either illustrated or listed in these two volumes, its authenticity should be suspect. If that buyer does find it, he or she can compare what is here to the work being considered. In most cases, the buyer will also find some information concerning provenance in these two volumes. And, more generally, the buyer will benefit from the fact that the art and the artist are placed in historical perspective, so that some sense is conveyed both of the forces that shaped the art and of the relationship of a specific work of art to an entire career.

The spotlight of documentation will also deter theft. A well-known, well-documented painting is less desirable to steal, harder to fence, and easier to recover. As a result, it should also be easier to insure and safeguard.

Contemporaneous documentation of virtually the entire work of an art movement has obvious additional benefits in terms of study and research. Fifty years from now, scholars and collectors will have more to rely on than a single chapter in an art history survey showing three or four works by each of three or four artists who had been chosen by the author, years after the fact, as representative of a movement. When we look at a book on the Art Deco period written today, we see the Ruhlmanns, Laliques, Chérets, and Brandts that the author has decided we should see. Not only are we forced to rely on someone else's judgment, we must rely on a judgment that most probably has been distorted by the passage of time. The author did not live through the era that produced the art, did not know the artists, and may lack an instinctive sense of the forces that made the art movement representative of its era.

In compiling the present volume and its predecessor, I have drawn on my close involvement, from the very beginning, with Photorealism as a movement and with all its artists. In these two volumes, future students of Photorealism will find the entire careers of all the participants fully illustrated, chronologically, with substantial biographies and bibliographies. All this should serve to protect the hard-won respect and value that Photorealist works have earned over the years.

A comprehensive documentation of Photorealism like the present one is feasible because there are fewer than twenty painters to be fully documented as Photorealists, and their total output has been relatively small—less than three thousand works. The first *Photo-Realism* introduced the thirteen artists central to the movement, while also defining and describing the movement as a whole. In addition, the earlier volume considered fifteen others who were, for one reason or another, included with the primary group of Photorealists in shows, articles, and books.

The original thirteen central figures in Photorealism are all still actively creating significant art (though some of them have moved away from a strict Photorealist mode), and their work in the eighties is fully documented in the present volume. In addition, there are four artists who were not accorded a primary place in the earlier volume, either because they became Photorealists a bit late or had not yet created a significant enough body of work. Today, these four—John Baeder, John Kacere, Jack Mendenhall, and David Parrish—are considered full participants in the further development of the style.

There appeared in the late seventies only a single painter who seems to be a second-generation Photorealist worthy of inclusion in this volume. He is Davis Cone, who has produced a body of work in the eighties on a level commensurate with the ideals and standards of Photorealism.

Whether first or second generation, the Photorealists are quintessentially American, probably because the movement came into being while New York and America still had a seemingly iron grip on contemporary art. It is therefore not surprising that the only classic non-American Photorealist, Englishman John Salt, lived in New York throughout his formative years; his decidedly American imagery is very consistent with that of the other Photorealists.

There is, however, one other non-American who has produced a body of work that is relevant to the movement and as fine and powerful as that of any artist alive today. Franz Gertsch, who lives in Switzerland, does not now, nor did he ever, consider himself a Photorealist, but the history of the movement would be incomplete without in some way making note of his imagery. I have included Gertsch in this volume as the nineteenth and final artist I will ever call one of the Photorealists.

Finally, at the end of this book, I have included a few artists in answer to a question I constantly hear, "Who are the next group of Photorealists to look for?" Some may consider these to be third generation, but my own inclination is to simply state that these and future artists may make paintings in the style and technique of the Photorealists, but they are not *the* Photorealists, just as, for instance, the abstract painters of today are not the Abstract Expressionists, and no Pop artists appeared after the sixties. These few artists, however, are the best and most original in their imagery of those who will ideally mature and develop in the nineties. They are Randy Dudley, Stephen Fox, Robert Gniewek, Gus Heinze, Don Jacot, and Reynard Milici.

The nineteen artists who first developed the Photorealist style—or whose contributions are the most significant and ongoing—are each represented herein by a full chapter. These chapters consist of a short commentary followed by the most complete documentation and illustration possible of the artist's work in the eighties (I have included 1990 as the final year of that decade). The small number of works not illustrated are listed at the end of each chapter.

For most of the artists whose work was marked with a chronological number in *Photo-Realism* (abbreviated herein, in plate references, as *P-R*), the number appears in parentheses in the caption, following the date of the work. For the following artists, not given chronological numbers in the first volume, we are instituting the system now, beginning with 1980: John Baeder, Richard Estes, John Kacere, Jack Mendenhall, and David Parrish. For Davis Cone, the numbering also starts with 1980. There is only a sampling of Franz Gertsch's work, for which the dates provide the chronology. The section on the six newer artists working today in the Photorealist style contain illustrations that are meant to serve as an introduction to each artist's work.

All the biographical, exhibition, and bibliographical information has been placed at the back of the book. To make research as useful as possible, this material has been heavily edited to select the most significant listings. If an exhibition, article, catalogue, or book included four or more of the artists, and is helpful for research purposes, it will be found in the general listings; the individual listings contain information that is primarily exclusive to each artist.

PHOTOREALISM: AN UNFLINCHING LOOK AT THE EIGHTIES

Four decades ago, no one could have predicted the rise of a movement like Photorealism. In the fifties, realist artists were outcasts; by the sixties, an intense argument had begun to rage over the use of the camera and photographs to make art. Not until 1970 did the term *Photorealism* begin to appear in print. Now, a scant twenty years later, Photorealism has joined Post-Impressionism, Dadaism, Surrealism, Abstract Expressionism, Pop Art, and Minimalism as a major art movement of the twentieth century.

Unlike many fads that have come and gone in the past twenty-five years—Pattern and Decoration, Op Art, Kinetic Art, Graffiti, New Expressionism, Neo-Geo, to name a few—Photorealism was a logical outgrowth of developments in art history, and in turn it has gone on to influence other movements. To appreciate Photorealism's dramatic effect on the art of the eighties, consider that most of what was "hot" in that decade concerned itself with recognizable images, not with abstract compositions, expressions, or impressions. To be sure, Pop Art was the first to bring imagery back to painting, on the heels of Jasper Johns and Robert Rauschenberg, but Pop was followed by Op-Kinetic-Minimal and other nonobjective forms.

However, a parallel development to Pop could be seen in the work of a group of artists called the New Realists, among whom were Richard Artschwager, Jack Beal, Alex Katz, Malcolm Morley, and Philip Pearlstein. In the late sixties, these realists were joined by Robert Bechtle, Chuck Close, Richard Estes, and Audrey Flack, the originators and leaders of Photorealism. And in the seventies, Photorealism became the culmination of all the realist impulses in the art that had come before. The success of Photorealist artists, and their popularization through hundreds of international exhibitions, legitimized the camera, the photograph, and the realist image for all artists afterward.

While the Photorealists are painters and will continue as such, their influence has been felt by artists in other genres. In the early eighties, for instance, Chuck Close made a series of giant Polaroid photographs of himself and friends (mostly faces, but also some extraordinary nudes, fourteen to twenty feet long). These works—and the overall acceptance of photography as a fine art—have obviously led artists like Cindy Sherman and Barbara Kruger to feel that the photo could stand as the final work of art. The message they had to convey was in the image, the scale, and the context; it did not have to be painted.

Despite Photorealism's pervasive influence, wide exposure, and enormous public acceptance, it has met with a dearth of critical understanding and support. Ironically, the public understood and embraced what confused and confounded the professionals. As we will see, the critics seemed to resent that museums and collectors worldwide responded with enthusiasm to Photorealism, that a fledgling art movement could take on a life of its own without their imprimatur, and that their power to influence art audiences, collectors, and museums might be questioned.

While the day-to-day critics in the press and art magazines failed to reflect Photorealism's acceptance with the public, the art historians—who wait for time to tell and then record the results—have begun to include the movement in the updates of their books, though some of their accounts are more accurate than others. Books devoted entirely to Photorealism have also appeared; in addition to the unprecedented documentation in my own two volumes, notable works have been written by John Arthur, Linda Chase, Christine Lindey, and Edward Lucie-Smith. In addition, at the time of this writing, about half the artists included here are the subjects of monographs.

Each of the chroniclers of Photorealism has brought his or her unique viewpoint to the subject. In choosing a few to include in this volume, I have selected excerpts from what I consider the most important art history texts. While the following quotations are only small parts of their respective texts, they seem, in the aggregate, to support my contention that Photorealism is beginning to be acknowledged by art historians as a significant development, equal to Abstract Expressionism or Pop Art. They even suggest that Photorealism may ultimately join the other two as the most important American art movements of the post–World War II period (after which the art world became international).

Another reason for the extensive quotation from art historians here is that I generally respect their judgment. And, for the most part, their incisive comments are crucial in placing Photorealism in its proper historical perspective.

Barbara Rose, in her book with Jules D. Prown, treats Photorealism as a major style of the seventies, with an important role in opening new possibilities. She writes:

Because it so flagrantly embraced traditional academic modes of illusionism, rehabilitating the entire panoply of trompe-l'oeil devices against which modernism originally rebelled, Photo Realism attracted immediate attention when it first began to be widely exhibited around 1970, about the time that photography itself was beginning to gain recognition as a fine art in America. We must remember, however, that trompe-l'oeil painting has been popular in the past in America. The recent rediscovery of the trompe-l'oeil still lifes painted by Peto, Harnett and Haberle in the late nineteenth century, as well as the photography craze, also helped stimulate the emergence of Photo Realism as a major style of the seventies. In any case the popularity of Photo Realism, coupled with the renaissance of photography itself, has revived the possibility of representational art as a serious threat to the hegemony of abstraction in American art. . . .

. . . Photo Realism, a leading seventies' style of trompe-l'oeil illusionism that vies with photography itself in duplicating and documenting the external world. The heir apparent of Pop art, Photo Realism (or Hyper-Realism or Super-Realism as it is sometimes called) bears the same relationship to photography that Pop art did to graphic design, advertising and printmaking. Pop artists flattened and stylized the images derived from mass media, forcing them to conform with the pictorial principles of modernism, but the Photo Realists . . . feel no such necessity.[1]

Frederick Hartt also discusses the movement in his scholarly survey of art history:

Its [Photo-Realism's] practitioners, who varied greatly among themselves in subject and in style, agreed on two principles: first, that the picture be painted, unaltered, with an airbrush from a photographic slide projected on the actual canvas; and second, that the subject be as banal as possible. In this latter respect the Photo-Realists clearly derived from the tradition of such American Scene painters as Hopper, a style continued by the Pop movement of the 1960s. In the former they derived from Pop's insistence on mechanical methods, preserving even the inevitable blurry focus of snapshots enlarged to such size. The apparent impersonality of the Photo-Realists is belied by the fact that, after all, they took the photographs from which they worked, so a considerable latitude of choice was available in subject, mood, lighting, composition, and color.[2]

Hartt's "principles" are inaccurate: only about a quarter of the Photorealists have used the airbrush, and almost all of them alter the photo in some way while making the painting. (Some do project a slide, but others grid, and still others simply refer to the photo.) And the banality issue concerns Pop Art more than Photorealism. However, he does make some valuable comments on Photorealism's origins and character.

Anthony Janson's text in the third revised edition of his father's History of Art[3] includes an important discussion of Photorealism and its artists. Notable for its inclusion of female artists for the first time, this edition accords Audrey Flack an essay and a colorplate.

The best account of Photorealism in an art history survey is found in the third edition of H. H. Arnason's History of Modern Art. A major section, titled "The New Illusionism," touches on the critical and popular response to the movement:

Almost simultaneously as Conceptualists were abandoning studios and object-making, in favor of performances, process, Earthworks, and Duchampian wordplay, others rebelled against Minimalist exclusivity by returning to the studio and reembracing the very kind of handwrought trompe-l'oeil or illusionistic painting and sculpture that mainstream modernism had largely rejected as irrelevant to art's higher purposes: self-purifying formalism. To the art-critical community, this constituted a counterrevolutionary development with far more shocking implications than any of the iconoclastic strategies undertaken by the Conceptualists. Thus, the new super- or hyper-Realist art triumphed principally

as a dealer-collector affair, with broad popular appeal, that had to make do, unlike any other significant movement in the postwar period, outside the pale of enlightened critical support. But make do it did—and quite handsomely too—for photographically veristic easel paintings and hallucinatingly lifelike sculptures offered welcome refreshment to a world starved for collectible art, an art whose mimetic character offered the thrill of not only recognition but also verifiable rendering skills the likes of which had not been noted in more than a generation. . . .

At the same time, however, the new representational work was more closely related to high modernism than many realized in the late 1960s and early 1970s, when disbelieving eyes long accustomed to evermore radical abstraction and fantastic neo-Dada invention beheld a kind of one-for-one replication of the visible world so exact that the dealer Sidney Janis dubbed it "Sharp-Focus Realism," while his commercial peer Louis K. Meisel called it "Photorealism," the term that has stuck. First of all, recrudescent illusionism had been sanctioned by that father of minimalizing procedures as well as of Pop's readymades and fantasy, Marcel Duchamp. This came about in 1969 with the posthumous discovery of *Étant Donnés* . . . which revealed the old antiartist to have been secretly occupied during the years 1946–66, at the height of abstraction's hegemony, in creating a voyeuristic, dupe-the-eye tableau, complete with pigskin nude and motorized tinfoil waterfoil. . . .[4]

This introduction is then followed by a discussion, with historical analysis and essays, of the leading Photorealists, including Estes, Close, and Flack.

In his art history text with John Jacobus, Sam Hunter also begins his section on Photorealism with an account of the genesis of the movement. He identifies Photorealism as a reaction against abstract doctrine, and particularly against Minimalism:

At the time that certain artists were concentrating on concepts, technology, and environmental issues as a means of escaping the dry formalism of Minimal aesthetics, others among their contemporaries were turning to an anti-abstract variety of literalism to revive the techniques and factuality of trompe-l'oeil painting, the very kind of hand-rendered illusionistic expression that virtually the whole of modernism had rejected as the most meretricious of all the possibilities available to art. But rather than compete with the camera, which had been so instrumental in liberating painting and sculpture from the need to illustrate life, many of the new realists *exploited* the photographic image, especially the color transparency, as their main point of departure. Thus, instead of setting an easel up in the street, they projected a slide onto the screen and painted what resolved on that focal plane. Because the new pictures truly resembled painted Ektachromes, even to their filmic luminosity, they gave the history of art a new ism: Photorealism.[5]

Next follows an interpretation of the forces that shaped Photorealism:

Photorealism, as practiced on the Western side of the Atlantic, might claim a legitimate and not too distant ancestry in mainstream American Realism, which, after flowering in what seemed one last brilliant autumnal season in the 1930s . . . had actually survived with remarkable vitality. . . . Photorealism, moreover, in its witty and ironic exploration of commonplace subject matter, was clearly an outgrowth of Pop Art, but without that development's fantastic invention and satirical commentary.[6]

Hunter then discusses some of the artists, including Richard Estes and Audrey Flack:

In order to deny the image its importance and to concentrate on abstract elements of the painted surface, Richard Estes (1936–) began to forge novel expressive truths from the photographic evidence, concentrating on glistening vitrines of shopping centers or upon theater marquees with a passion ironically contradicted by the dispassionate manner of his meticulous rendering. . . . However, subtle realignments and slight distortions for the sake of firmer structure reveal Estes to be a master of pictorial composition. . . .

Several Photorealists not only returned to the illusionism of older painting but also revived the genres which had given that art its significance and symbolic content. The airbrush still lifes of Audrey Flack (1931–), for instance, with their proliferation of intimate items fraught with personal or even social and historic associations, present, on a grand scale, a late-20th-century version of the 17th-century *Vanitas* picture. . . .[7]

The discussion of Photorealism concludes with essentially the same idea with which it began: "By 1974 the more conservative and ambivalent mode represented by illusionistic Photorealism had developed into a reaction against Minimalist aesthetics fully as dramatic as Conceptual, Technology, and Environmental Art."[8]

Richard Sarnof, in his chapter on realism in *An American Renaissance,* adds more information concerning Photorealism's origins and antecedents:

In the 1970s, Photo-Realism achieved the status of a movement, with many practitioners as well as a fund of critical literature. The Photo-Realist style involves considerations of both technique and content. . . . Subjects have tended to be drawn from images of popular culture or an obsessive personal mythology—a potpourri of motorcycles, diners, candy bars, automobiles, neon signs, urban vistas vacant of human presence, symbolist *vanitas* still life, among others.

This literal, *trompe l'oeil* painting technique can be understood as an extension of Pop Art, reflecting the latter artists' concern for commercial icons and standardized surfaces as much as it mirrors the photographic reality to which it is more familiarly ascribed. Photo-Realism shows a similar sensitivity to the ubiquitous advertising media of our society, but it lacks the social irony or commentary, or even tragic themes, associated with Pop Art. Instead, images are presented for their inherent sensuous or allusive qualities, in stunning detail but without overt commentary. Although recently criticized as a somewhat empty style, Photo-Realism has facilitated a cross-fertilization between photography and painting. This dialogue plays an important role in today's art, and can be clearly seen in latter-day variations by such contemporary artists as Robert Longo, Jack Goldstein, Troy Brauntuch, and Cindy Sherman. In addition, there are a few Photo-Realist artists who have transcended any consideration of a group style.[9]

Finally, and most recently, Hugh Honour and John Fleming, in their highly acclaimed textbook, *The Visual Arts: A History,* astutely point out a major difference between Photorealism and all the realist painting that has gone before. They state: "The extreme purism and formalism of Minimalist art did not fail to arouse reactions, of which Photo-Realism . . . was the most obvious, though it is often misunderstood. So far from being a revival of academic realism this style is as objective or object-oriented as Minimalism itself."[10] The same discovery had been made years earlier by the academic and traditional realists who had been exiled to teaching and exhibiting regionally in the hinterlands. After a short period of rejoicing at the news of a renewed interest in realist painting, they realized they were not to be part of this new modernist movement, and the bitterness and animosities that followed were sad to behold.

In their chapter on contemporary art, Honour and Fleming also include Photorealism among the seven significant movements of the period: Abstract Expressionism, Pop, Minimalism, Conceptualism, Photorealism, Post Modernism, and Neo Expressionism. (In my opinion, the last two are not legitimate art movements, but are more in the nature of catchall phrases encompassing large numbers of artists with little in common beside working at a particular time and with little else to set them apart as notable for historical purposes.)

I believe the preceding comments by distinguished art historians are worthy of note—for the fact of their existence as well as for their content. I do not, on the other hand, put much credence in the writings of the journalists who review art for the newspapers and magazines. Their work is almost invariably inaccurate and insensitive. With poor understanding of their subject matter and a self-conscious approach to their craft, they are generally either too flattering and pandering (to the point of embarrassment) or vehemently negative and aggressive. Much of the time, their articles are incoherent or boring, or both.

But this has not always been the case. When I first began reading art reviews, as I was learning about the art world in the mid-fifties and early sixties, I found through personal experience that the critics of the day were accomplished writers and poets. They were friends of the artists and musicians and participated with them in the New York art scene. These critics spent time in the studios while the art was being made and countless hours in bars and coffee houses discussing the concerns confronting all the arts in that fertile and exciting time. When they were asked to review shows or concerts (for $10 or so an article), these writers not only were able to do so with intimate knowledge and understanding but also could many times point out artistic problems and even suggest solutions. Usually, the artists were truly grateful. And the reading public, which was quite small but intensely interested, gained real understanding and insight.

The relationship between artist and critic in those early days reminds me of the time, a few years ago, when a restaurant critic at the *New York Times* gave only three stars to a restaurant widely considered to be of four-star caliber. The critic singled out three dishes that he felt could be improved with modification. That Sunday (his day off), the restaurant's chef prepared those three dishes the way the critic suggested. His comment later that week was: "He's right on two of them, but my way is better on the third."

Essentially the same serious and generous give-and-take used to happen in the art world, but in the past twenty years it has become so rare as to be nearly nonexistent. Going into the nineties, it

seems that most "critics" have their own personal agendas and concerns. They care intensely about being "politically correct" and about their egos, friendships, enmities, debts, goals, and power. They do not care as much about the art and artists. If they do not know the work of an artist they are asked to review, their tight deadlines and low pay prevent them from doing the research or spending the time necessary for a really good job.

Research and time are particularly necessary to report effectively on Photorealism, for there is far more to understand than immediately meets the eye. Given the demands of their art, Photorealists spend most of their time in their studios, alone and working. They generally do not involve themselves with partying, politicking, and bar-sitting, and therefore they do not spoon-feed the critics with information. One result is that I have rarely seen a review of any of their work worth remembering.

Despite my dismal view of the current generation of art critics, there are some exceptions. Two of the most notable are Hilton Kramer, formerly of the *New York Times* and now writing—more aggressively—for the *Observer,* and Robert Hughes of *Time* magazine. Both have strongly felt ideas and positions and are logical, proficient, aggressive, and unafraid in communicating their insights. Neither, by the way, is a fan of Photorealism.

There have been a few amusing reviews that contain positive comments about Photorealism while at the same time tending to temper these with less flattering remarks—primarily, I suppose, to offset anticipated ridicule or other backlash from colleagues.

Just three examples will suffice here. John Russell, reviewing one of the most popular, well attended exhibitions at the Guggenheim Museum, begins by saying, "Looking at photorealist paintings is like eating horseflesh. If you can stand it, the case against it seems like dated prejudice. If you can't stand it, nothing on earth will make you change your mind." Later in the review, he accurately states, "No photorealist looks like any other photorealist. Individual personality wins out, just as it does in every other kind of painting." And he concludes with insights of a decidedly laudatory cast: "First, there is in certain photorealist paintings an emotional charge as frantic as anything in German Expressionism. Second, the idiom has possibilities that go way beyond its initial glassy illusionism. In Richard Estes's "Chase Manhattan Bank, 1981," the play back and forth between the interior of the building and the Dubuffet sculpture outside is neat enough for Canaletto."[11]

Adam Gopnick's review of a recent Chuck Close show contains a sentence beginning with this ironic phrase: "Though Photo-Realism never had much of an art-world following—it was too easy to get, and was got too quickly by the wrong people." But the sentence concludes with this: "it was in fact the first movement in American art that now seems vividly (rather than doggedly) postmodern."[12] It is interesting to note that the idea of Photorealism as a postmodern movement was first developed and expanded upon in 1976 by Linda Chase, an early commentator on Photorealism, in her article "Photo-Realism: Post Modernist Illusionism."[13]

And finally Vivien Raynor tries very hard not to appear to be reversing herself with a confusing bit of give-and-take in a review of a Whitney Museum show, but some interesting points still get through. She says:

> [Photorealism] came out of Pop yet had the affectlessness of Minimalism and, at the same time, capitalized on the public's fondness for exact replication. No small achievement this. But it took the critic Thomas Albright to nail the movement by quoting Roland Barthes's 1958 definition of the New Objectivity in French literature: "No alibis, no depth, keeping to the surface of things, examining without emphasis, favoring no one quality."
>
> The trend prospered until the mid-1970's, when New Image Painting, a less conservative figural style, took over. To assume that Photo-Realism had no place to go, however, is to underestimate the revisionism-minded art establishment.[14]

What of the other critics? Rather than quoting much of the nonsense they have written in order to make points by rebuttal, I recommend you read Kramer for that. I will cite only one case. In 1976, Peter Schjeldahl came to my gallery during an Audrey Flack exhibition, and I, somewhat boldly, asked him how he got his job as a critic at the *New York Times.* He replied that, as a poet, he had applied to the *Times* for a job, period. They asked if he felt he could write about art. He said yes and was hired. I then asked about his background and credentials in art. He replied, "Art 101," a statement I had every reason to believe was the truth.

In the late seventies, Schjeldahl confined himself basically to reporting. In more recent times, however, his deficiencies have become more obvious as he has sought to offer his "expert" opinions on the art scene. Although much of what he has written demands rebuttal, one of his recently published pieces is a special case in point.

The article is about a Richard Estes exhibition. For the past decade, Estes has been largely

ignored by the critics, even though he has had several one-man exhibitions at major museums and galleries. Paradoxically, Schjeldahl chose the most minor showing of Estes's work ever as the occasion for a full-page article on the artist: an art seller with many Estes prints to sell exhibited a grand total of two of the artist's paintings to bolster the credibility and sales of the prints.

Schjeldahl's article, written in 1991, begins by quoting the Random House Dictionary's definition of Photorealism. He clearly was not aware of the literature concerning the style, since he continues by describing the one-sentence definition as "a fuller account . . . than will be found in most contemporary art history and criticism."[15] As we have seen, any student of Art 101 today would find that most contemporary art history texts define and discuss the movement at length.

Schjeldahl does not offer any insights into Estes's work, but instead uses the occasion to illustrate his personal antagonism toward the Photorealist movement, its artists, and its champions. He criticizes Photorealism as "besotted with diners, motorcycles, gum machines, and other cornball Americana,"[16] as though renderings of the commonplace cannot be beautiful, cannot help us understand the spirit of an era, and cannot possess aesthetic or compositional drama. Schjeldahl goes on to write that "pretty much everything a Photorealist painting has to give is received at first glance." Yet his subsequent attempt to discuss Estes's work demonstrates, by its very inadequacies, just how much there is to analyze, see, and learn from such painting.

In one particularly revealing passage, Schjeldahl remarks: "Vermeer, Canaletto [see previous comment by Russell], and Edward Hopper get mentioned by his [Estes's] critical apologists—notably including the dealer Louis K. Meisel, marketer extraordinary of Photorealism. (Photorealism was impressive in the '70s for selling big amid an art-market bust, and Meisel had much to do with it.)"[17] These comments on how well Photorealism has "sold" (or rather, been collected) reflect jealousies that exist throughout the critical establishment and in much of the art world in general. Despite such envy, the fact remains that the public has always demanded quality, and always will. And, sadly, our judgment of quality can no longer (as in the fifties and sixties) be guided by a handful of influential art critics.

Today's critics do not set the standards. The museums don't either—they just try to choose and preserve the best. It is the audience for the arts, and particularly the buyers, who set the standards by voting with their time and money. And they usually turn out to be right in the long run. Despite various pressures, people always seem to be able to discern quality on their own, without much need for critics and advisors. Left to themselves, they will always find quality, and it will always be the same. While fashions and fads, politics, race, religion, and money may from time to time skew the truth, quality will always eventually rise to be cherished and preserved as the rest fades into oblivion.

Commenting on this phenomenon, in a more general discussion of the contemporary rejection of traditional standards of beauty and worth, critic James F. Cooper sarcastically speaks of the "cultural police."[18] And, to be sure, concerted efforts to dictate aesthetic values have been made in the past decade, and they continue to be made. The cultural police would have us believe that to have quality, a work of art must be "politically correct."

It is, of course, a natural response when contemplating varieties of art, literature, or music (or of anything, for that matter) to contrast and compare and then to determine a preference. Choices must always be made, but it doesn't matter in the least whether the artist, writer, or musician is black, white, red, or yellow, male or female, old or young. Even if all those facts are unknown, quality will still prevail, and the consequences of that fact have to be faced.

During the summer of 1990, the art critic Michael Brenson wrote an article in the *New York Times* entitled "Is Quality an Idea Whose Time Has Gone?"[19] This article centered on the current debate surrounding the word *quality* in the art world. To some, it seemed to represent a set of standards which, although developed over thousands of years, are in fact racist, sexist, Eurocentric, white, heterosexual, and male-oriented. And, as such, these standards are judged to be inherently harmful. If taken to its logical conclusion, such a "politically correct" approach would suggest that, if standards prove too difficult or exclusionary to permit success to all who compete in today's art world, we should seriously consider eliminating them—and we should begin by shunning the use of the word *quality* altogether. That way, everyone can play.

However, such arguments cannot help but work overwhelmingly to the detriment of art. One observer recently wrote:

From Washington's Hirshhorn Museum (*Awards in the Visual Arts*), to Cincinnati's Contemporary Art Center (*Mapplethorpe: The Perfect Moment*), to New York's Whitney Museum *Biennial,* the apparent objective was to undermine artistic excellence—now regarded as a symbol of the economic, racial and cultural oppression of minorities by white heterosexual males. These new philistines are pleasant,

urbane politically correct intellectuals who barely control their intolerance for the pluralist freedom and multiculturalism they profess to champion.[20]

If quality and artistic excellence are there, it does not matter if the artist is a white, heterosexual male or a black, lesbian female. (Of the five leading Photorealists, in fact, one is not male and two are not heterosexual, but they all have quality, skill, discipline, craftsmanship, and ideas.) Nor should such categories matter one whit if the quality and artistic excellence are not there.

In fact, in the eighties, the entire concept of craftsmanship, discipline, and education in art was subverted in favor of the lowest common denominator. But as James Cooper has noted: "Advocates of political correctness fail to understand . . . [that] politically-correct art must first be artistically correct."[21] Without craft, an enduring expression of ideas and political agenda is not possible in art. An actor must have the innate talent plus the training and experience to know how to convincingly communicate emotions. A writer must hone his or her craft to develop the ability to link imagination to words. These pursuits are not democratically open to anyone who decides he or she is or wants to be an actor or writer.

The same is true of painting, and Photorealism in particular is hard to do. It requires many skills, much knowledge, extreme discipline, and overwhelming dedication. It is one of the few remaining ways of painting that demands high-level craftsmanship. All the Photorealists are college-educated and most have advanced degrees. The youngest was thirty at the time the movement was accepted, the oldest was about forty-six. (Such relative maturity is characteristic of almost all the artists of previously successful movements.)

Perhaps the real issue is that very few people can achieve quality, and so it has become fashionable to eliminate it as a requirement. Consider one extreme example. When women were excluded from being New York City fire fighters because they couldn't carry a 150-pound weight down a three-story ladder, the solution was to lower the standard for women to 100 pounds. No one seemed to consider the very real, serious consequences such a decision would have in an actual fire.

The concept of making it easy to participate extended to virtually every discipline in the eighties, the decade of mediocrity. There were the "geniuses" in the financial world, the "superstars" in real estate, the new crop of TV evangelists, and so on. And it was easy for them to be "geniuses." Almost everyone seemed to win, proving that it was easy. There was so much money around that it was easy to be "right" without having education, training, or discipline in any field. From 1983 through 1988 or thereabouts, almost anyone could jump on the bandwagon and be a winner . . . for a while.

But the foundations were not there, the premises were false, the logic was severely flawed, and the reality was only an illusion. It ended. Several young, flamboyant real estate "geniuses" whose ventures were not based on sound traditional principles lost their investments. The stock market—and eventually the law—corrected the greedy Wall Street geniuses who thought it was easy.

There were many in the art world who took the same approach. As a dealer and gallery owner in New York, I was a firsthand witness to this phenomenon. Youngsters barely out of their teens and barely out of school thought they were artists ready for professional careers and wanted me to provide the platform. They felt—because they were taught so by the misguided art schools—that it was passé and unnecessary for artists to know about materials and their use, to know how to draw, paint, or craft. They felt there were no requirements for success in the art world other than a desire to express themselves. I told them the proper place for that was an analyst's couch, not a canvas.

But they were right, or so it seemed, if only for a while. There were many ersatz dealers who were happy to further the careers of these ersatz artists. And it was easy, because just as thousands flocked to become real estate magnates and stock market experts, thousands considered themselves astute art collectors. Hundreds of new art galleries opened (mostly in the East Village), thousands of new artists appeared, dozens of new publications began publishing, and art advisors taught classes at "avant-garde" schools on how to be collectors—spelled i-n-v-e-s-t-o-r-s.

The critics loved it. This explosion of artistic activity confused and confounded the public, and the critics could then attempt to display their intellect and power by explaining what others were "missing."

The dealers loved it. There was now a hundred times more "art" to sell, and it was being sold at ridiculously inflated prices.

The new generation of museum curators loved it, because most of them were products of the same background and education as the artists. The art schools, which had made art education a joke, turned out unqualified artists, curators, and critics with degrees but not much else. These curators simply picked up on the flood of trendy artists in the eighties and hauled their work into the muse-

ums for trendy shows; they had little choice because they knew nothing else. They, like the writers, were dealing with their own little egos, power, and alliances—as well as with museum boards loaded with the new "art collectors," with agendas of their own.

The "collectors" loved it. The process went like this. Ten or twenty of the so-called insiders "discovered" a new artist and bought his or her works for about $1,000 apiece. The "critics" then wrote about the artist. The "secondary collectors" next bought the works for $5,000 to $10,000 apiece. Then, the museums, in their rush to keep up with fads and fashions, began the retrospectives of two- and three-year careers, and the "critics" made lots of noise. The "nouveau" art collectors got dragged in at $20,000 to $100,000 and up, just as the original handful of insider collectors started to sell out. Sounds just like the stock market.

Now that the dust has settled and the illusions have dissipated, most of the galleries have closed, most of the artists have faded into oblivion, most of the publications are no more than vague memories. The East Village is gone. Perhaps one or two percent of the galleries and artists have moved to SoHo and still exist on some minor level. It was fashionable for six months or a year or two to rush to buy works by artists like Jean-Michel Basquiat or Keith Haring (two of the dozen or so names we can still remember out of the hundreds of "art luminaries" discovered by the art critics of the eighties). However, by the beginning of the new century (only a decade away), if any of the works by these artists have found their way into museum collections—and there will be very few indeed—they are sure to confuse discriminating viewers.

The novelist Ayn Rand could have predicted this phenomenon. A vehement enemy of communism, socialism, and conformity of any kind, she advocated instead an individualism driven by the capitalist motives of reward, profit, personal achievement, and success. What Rand advocated was available to very few, but she was convinced that those few would be the true leaders of the future.

In Rand's novel *The Fountainhead,* an architecture critic named Ellsworth Toohey is giving advice to Peter Keating, a mediocre but very successful architect. He is explaining how critics can turn mediocre architects (or artists) into famous and respected ones:

> Want to know how it's done? . . . Kill man's sense of values. Kill his capacity to recognize greatness or to achieve it. Great men can't be ruled. We don't want any great men. Don't deny the conception of greatness. Destroy it from within. The great is the rare, the difficult, the exceptional. Set up standards of achievement open to all, to the least, to the most inept—and you stop the impetus to effort in all men, great or small. You stop all incentive to improvement, to excellence, to perfection. Laugh at Roark [in the novel, the greatest architect of his time] and hold Peter Keating as a great architect. You've destroyed architecture. . . . Don't set out to raze all shrines—you'll frighten men. Enshrine mediocrity—and the shrines are razed.[22]

Now, half a century after Rand's words were first published, they continue to prove prophetic. As she would have predicted, communism is dead. And, as she would also have predicted, critics still hope to enshrine mediocrity. The champions of political correctness argue for eliminating quality as a standard in evaluating the arts and, ultimately, for lowering standards in the arts so anyone can participate.

Rand's critic spoke in favor of killing man's capacity to recognize greatness or to achieve it. Latter-day art critics have taken that advice to heart. They have written commentaries on Photorealism that denigrate and belittle the discipline, skills, and knowledge of the artists. Or, using Toohey's strategy, they have undermined Photorealism by ignoring it. They have not attempted seriously to "raze the shrines" of Photorealism because, in my opinion, they are heartily threatened by these artists. Originally thinking that the movement was reactionary, or possibly in the same category of realism as Andrew Wyeth's work, they never realized that Photorealism represented important ideas to be examined and discussed. The few who attempted thoughtless, knee-jerk attacks were met with the scorn of the reading public, and one or two even lost jobs. Most—afraid of peer reaction if they supported Photorealism and apprehensive about attacking it overtly—simply did not review Photorealist artists.

One critic writing for a major city magazine mentioned at a symposium that she did not like Photorealism and therefore would not write about it. While it is fine for most of us to have our personal likes and dislikes, it seems odd for a critic to be so driven by them—not to review a book because one does not like mysteries, or a restaurant because one does not like Mexican food, or a movie because one does not like science fiction. It is obviously a critic's job to review all endeavors in his or her field so that interested readers may receive an objective idea as to whether or not their time and money ought to be spent reading, eating, watching, or looking at and buying.

More than twenty years after its beginnings, Photorealism has withstood the test of time. The several books on the movement as a whole plus the numerous monographs on individual artists are carefully written and researched, in vivid contrast to the volumes rushed into production to commercialize on the momentary frenzy associated with many artists of the last decade.

All the leading Photorealists are still actively producing art. Almost all are still making paintings that can be called Photorealist; the rest are doing realist work. Most are making advances in technique, ideas, and images. The movement as a whole is entirely intact and still vital. The artists have learned from each other and taught one another, directly and indirectly. There is a kinship among the group and, though they do not see each other often, there is an underlying unity and friendship. While there has been competition, there has never been animosity or disharmony.

There were never more than two dozen Photorealists. There are nineteen today. The quality of their work is indisputable. The ability to draw, the craft, the discipline, the knowledge, the understanding of materials and tools, are all there.

Quality equals rarity. Quality is not common. Quality is hard to attain and harder to find. Few achieve it, and very few achieve it in art. When, years from now, all of the current verbiage and diatribes are forgotten, objects of quality will survive, unfettered by contemporary baggage. And Photorealist works will be among them.

NOTES
1. Barbara Rose and Jules D. Prown, *American Painting* (New York: Skira/Rizzoli, 1977), pp. 237–39.
2. Frederick Hartt, *Art: A History of Painting, Sculpture, Architecture,* 3rd ed. (New York: Harry N. Abrams, Inc., 1989), pp. 948–49.
3. H. W. Janson, *History of Art,* 3rd ed., revised and expanded by Anthony F. Janson (New York: Harry N. Abrams, Inc., 1986), pp. 723–24.
4. H. H. Arnason, *History of Modern Art,* 3rd ed., revised and updated by Daniel Wheeler (New York: Harry N. Abrams, Inc., 1986), p. 589.
5. Sam Hunter and John Jacobus, *Modern Art,* 2nd ed. (New York: Harry N. Abrams, Inc., 1977), p. 372.
6. Ibid., pp. 372–73.
7. Ibid., pp. 373, 374.
8. Ibid., p. 374.
9. Richard Sarnof, "Return to Realism," in Sam Hunter, ed., *An American Renaissance: Painting and Sculpture since 1940* (New York: Abbeville Press, 1986), pp. 132–33.
10. Hugh Honour and John Fleming, *The Visual Arts: A History,* 3rd ed. (New York: Harry N. Abrams, Inc., 1991), p. 709.
11. John Russell, "Seven Photorealists," *New York Times,* October 9, 1981.
12. Adam Gopnick, "Close-Up," *The New Yorker,* February 24, 1992, p. 76.
13. Linda Chase, "Photo-Realism: Post Modernist Illusionism," *Art International,* vol. XX, no. 3–4 (Mar.–Apr. 1976), pp. 14–27.
14. Vivien Raynor, *New York Times,* January 5, 1992.
15. Peter Schjeldahl, "Order Aura," *Village Voice,* May 28, 1991, p. 95.
16. Ibid.
17. Ibid.
18. James F. Cooper, "The Inquisition of Political Correctness," *American Arts Quarterly,* Summer 1991, p. 4.
19. Michael Brenson, "Is Quality an Idea Whose Time Has Gone?" *New York Times,* July 22, 1990.
20. Cooper, p. 3.
21. Ibid., p. 4
22. Ayn Rand, *The Fountainhead* (New York: New American Library, 1943), p. 690.

JOHN BAEDER

Since the mid-seventies, John Baeder has been known exclusively for his paintings of American diners, dating for the most part from the thirties to the fifties. Arriving somewhat late on the Photorealist scene, Baeder staked out a territory from which he has never strayed; in fact, it seems as though his primary artistic intention is to document as thoroughly as possible the Great American Diner.

Baeder's technical proficiency as a painter is not as finely developed as that of the other Photorealists, and his compositions are less than adventurous—even quite conservative. It is basically the nostalgic interest of his subject matter that holds the viewer's attention.

During the eighties, Baeder painted 94 diner images. Of these, 38 paintings and 30 watercolors are illustrated herein. The watercolors have been assigned a separate chronology from the oils; they are identified with chronological numbers preceded by the letter *W*.

1. *Blue Beacon.* 1980 (3).
Oil on canvas, 42 x 66".
Collection Alice
Zimmerman, Tennessee

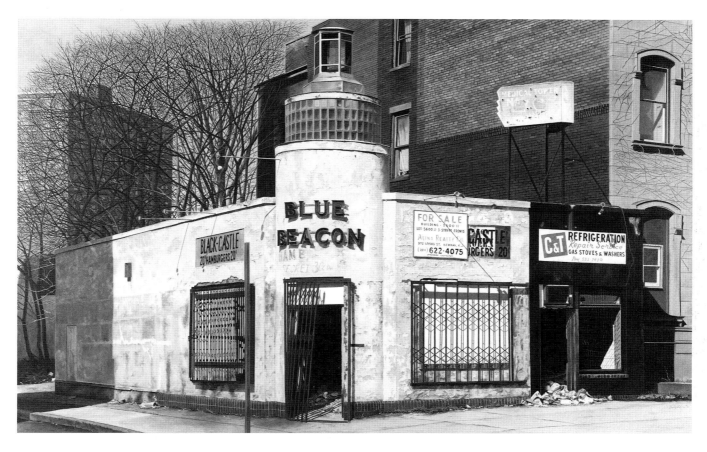

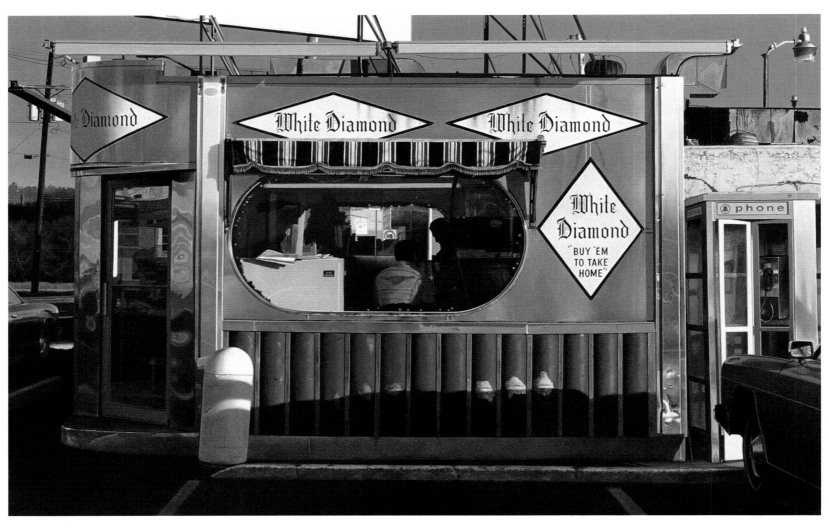

2. *White Diamond.* 1982 (10). Oil on canvas, 42 x 65¼". Private collection, Massachusetts

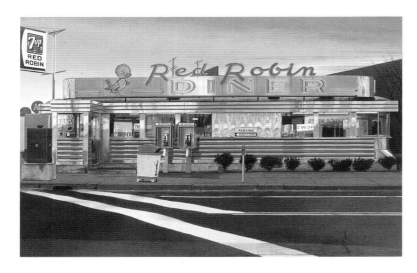

3. *Red Robin Diner.* 1982 (11). Oil on canvas, 30 x 48".
Private collection, Washington, D.C.

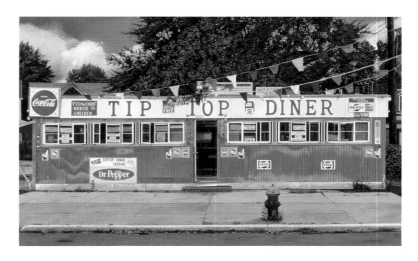

4. *Tip Top Diner.* 1982 (12). Oil on canvas, 30 x 48".
Collection Gibbs family, Massachusetts

18

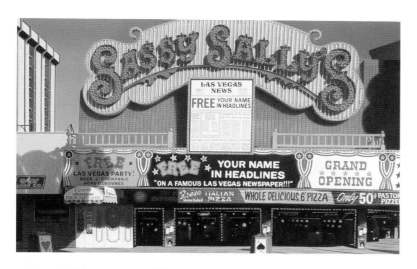

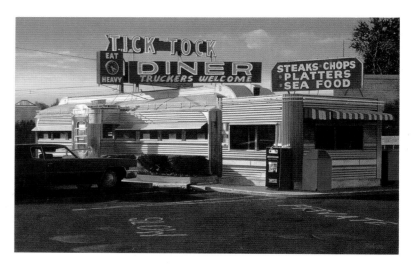

5. *Sassy Sally's.* 1983 (13). Oil on canvas, 30 x 48".
Private collection, Maryland

6. *Tick Tock Diner.* 1983 (14). Oil on canvas, 27 x 40".
Collection Vernon Powell, Jr., Virginia

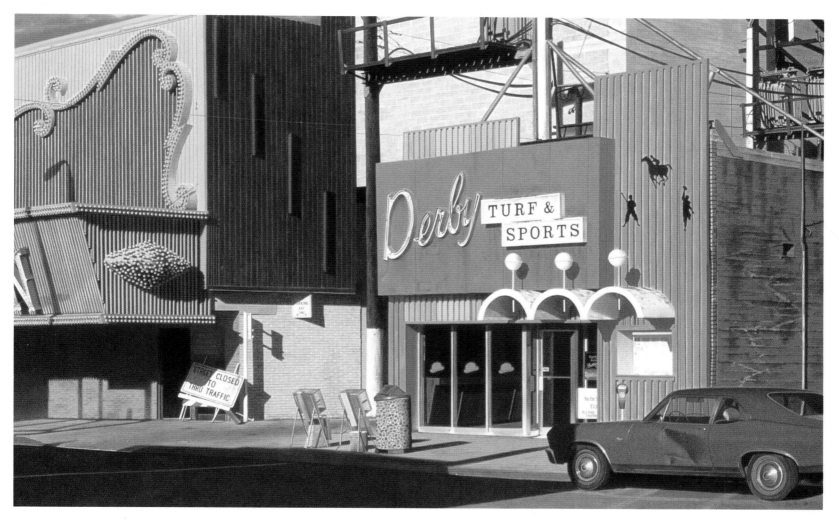

7. *Derby.* 1983 (15). Oil on canvas, 42 x 66". Private collection, Maryland

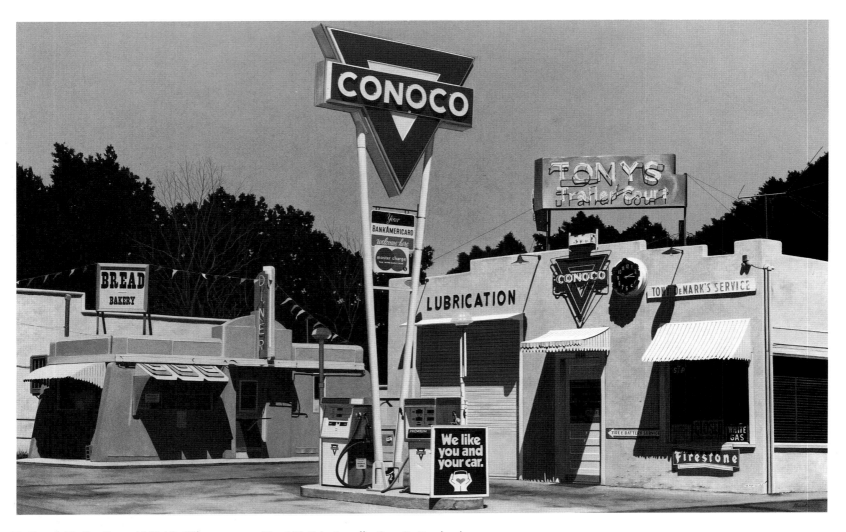

8. *Tony's Trailer Court.* 1980 (4). Oil on canvas, 42 x 66". Private collection, Switzerland

9. *Al's Soul Food.* 1980 (5). Oil on canvas, 30 x 48".
Collection Jesse Nevada Karp, New York

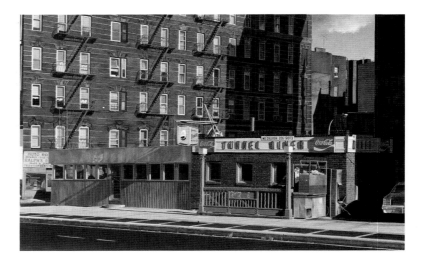

10. *Tunnel Diner.* 1981 (6). Oil on canvas, 31 x 48".
Collection Robert B. and Cecilia Mendez Hodes, New York

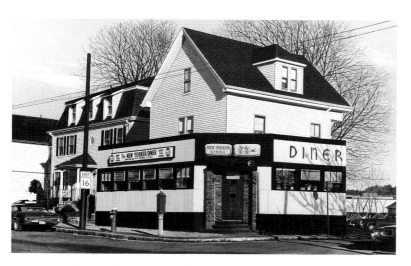

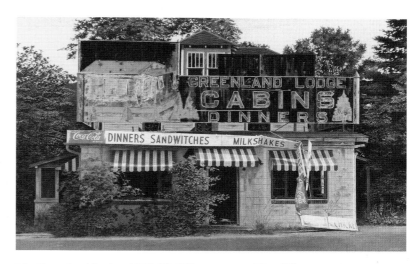

11. *New Yorker Diner.* 1981 (7). Oil on canvas, 28 x 44".
Private collection, New York

12. *Greenland Lodge.* 1981 (8). Oil on canvas, 29 x 47".
Private collection, Tennessee

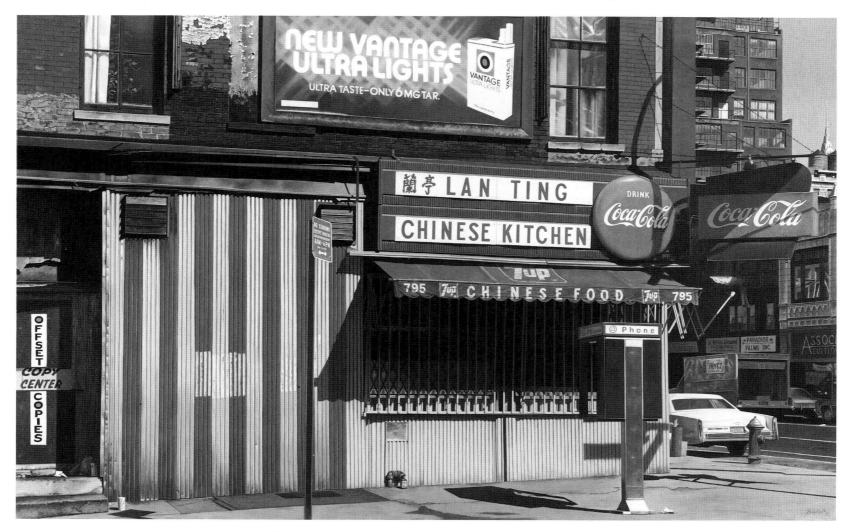

13. *Lan Ting.* 1982 (9). Oil on canvas, 42 x 66". Collection the artist

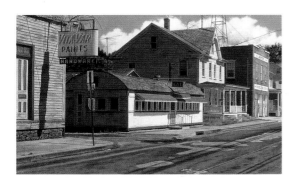

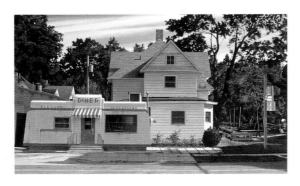

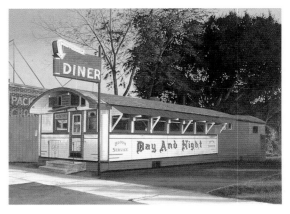

14. *Diner (Belvidere, N.J.).* 1983 (16).
Oil on canvas, 30 x 48".
Collection Edward Minskoff, New York

15. *Diner (Angola, Ind.).* 1983 (17).
Oil on canvas, 30 x 48".
Collection Donna and Neil Weisman, New Jersey

16. *Day and Night Diner.* 1984 (18).
Oil on canvas, 30 x 40".
Collection Paula and Leonard Weingarten, New York

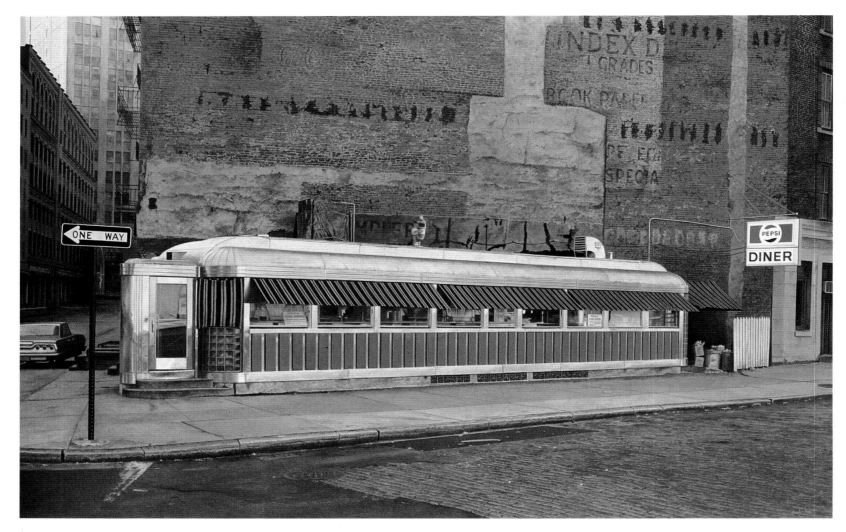

17. *Square Diner.* 1984 (19). Oil on canvas, 42 x 66". Private collection, Maryland

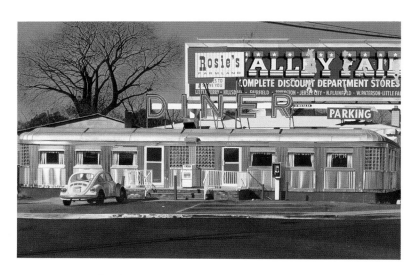

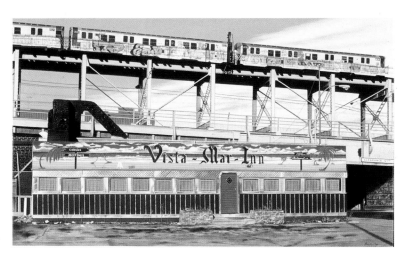

18. *Rosie's Farmland Diner.* 1979 (1). Oil on canvas, 42 x 66".
Collection Alex Weber, New York

19. *Vista-Mar-Inn.* 1980 (2). Oil on canvas, 30 x 48".
Collection Joyce Bogart, California

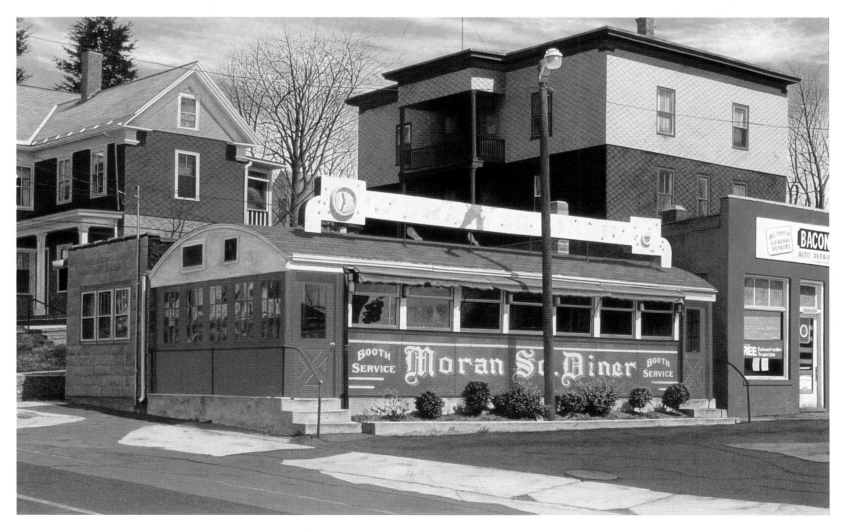

20. *Moran Square Diner.* 1986 (26). Oil on canvas, 42 x 66". Private collection, Switzerland

21. *Willie's—Route 22.* 1984 (20). Oil on canvas, 38 x 48".
Private collection, Connecticut

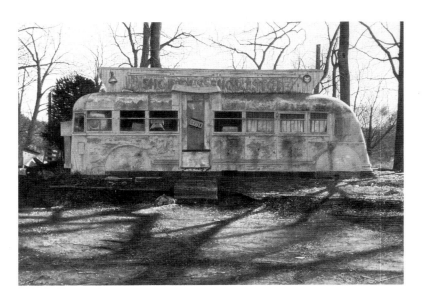

22. *Shorty's Shortstop.* 1984 (21). Oil on canvas, 38 x 48".
Collection Michael Rakosi, New York

23. *North End Diner.* 1985 (22). Oil on canvas, 30 x 48".
Collection Richard Brown Baker, New York

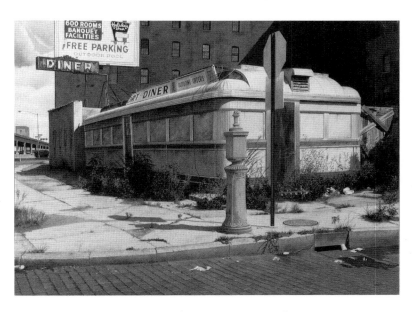

24. *Seaport Diner.* 1985 (23). Oil on canvas, 36 x 48".
Collection Hope and Howard Stringer, Tennessee

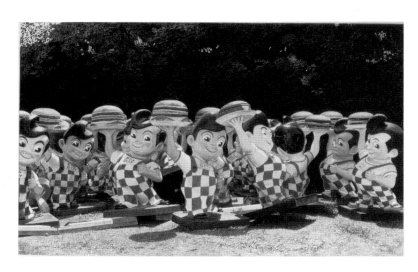

25. *Big Boy Bop.* 1985 (24). Oil on canvas, 30 x 48".
Private collection, Tennessee

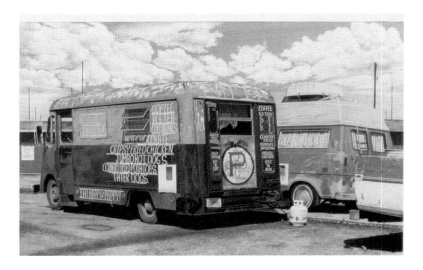

26. *Pappy's Place.* 1985 (25). Oil on canvas, 30 x 48".
Private collection, Switzerland

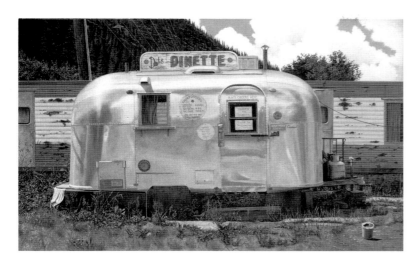

27. *Dot's Dinette.* 1986 (27). Oil on canvas, 30 x 48".
Collection Wade F. B. Thompson, New York

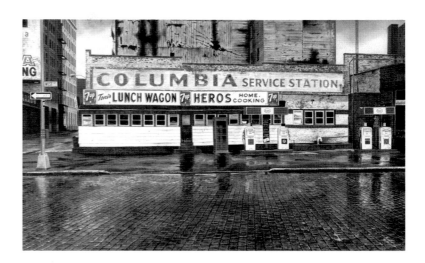

28. *Toni's Lunch Wagon.* 1986 (28). Oil on canvas, 30 x 48".
Collection Maria Celis Wirth, New York

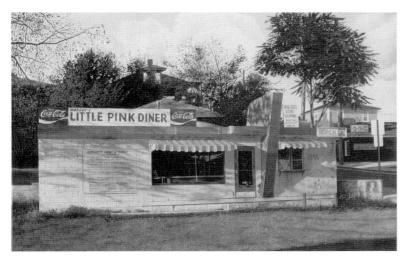

29. *Margot's Little Pink Diner.* 1987 (29). Oil on canvas, 34 x 52".
Private collection, Switzerland

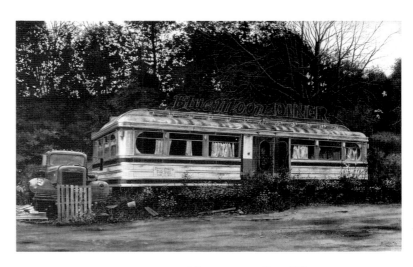

30. *Blue Moon Diner.* 1987 (30). Oil on canvas, 30 x 48".
Private collection, Switzerland

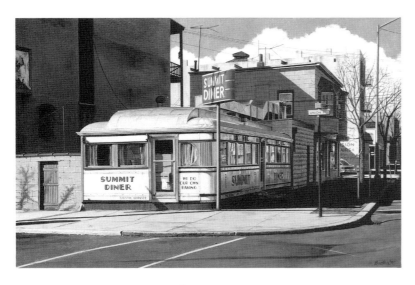

31. *Summit Diner.* 1987 (31). Oil on canvas, 24 x 36".
Private collection, California

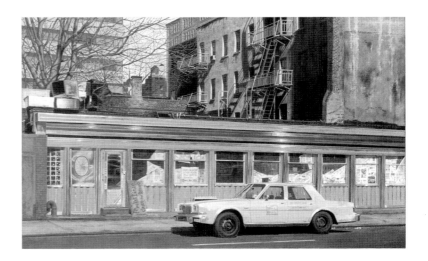

32. *Market Diner.* 1987 (32). Oil on canvas, 30 x 48".
Private collection, Switzerland

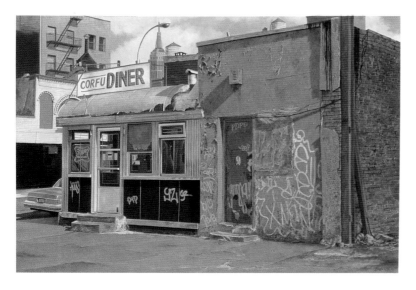

33. *Corfu Diner.* 1988 (35). Oil on canvas, 21 x 30".
Private collection, Switzerland

34. *Palace Diner.* 1988 (36). Oil on canvas, 30 x 48".
Collection Mrs. Robert Saligman, Pennsylvania

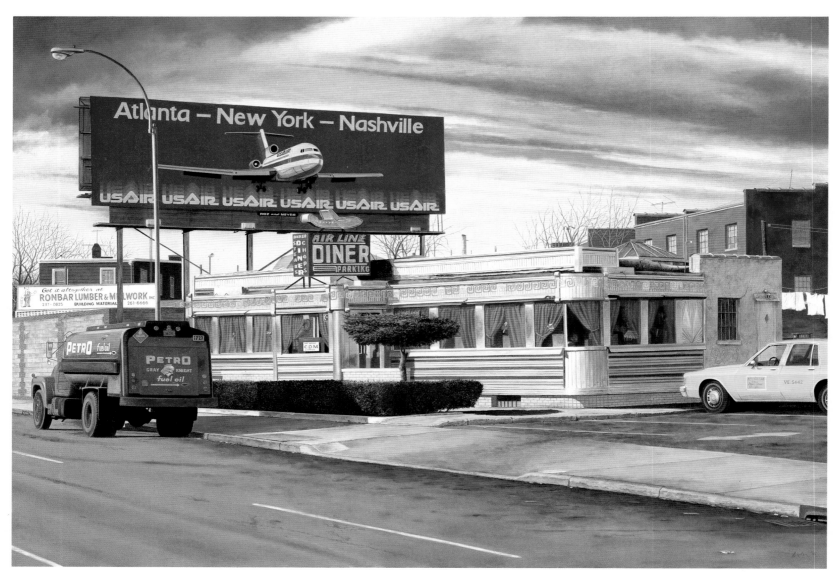

35. *Airline Diner.* 1988 (34). Oil on canvas, 40 x 66". Collection Barbara and Ronald D. Balser, Georgia

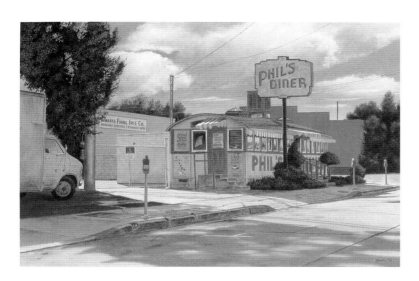

36. *Phil's Diner.* 1988 (38). Oil on canvas, 24 x 36".
Private collection, California

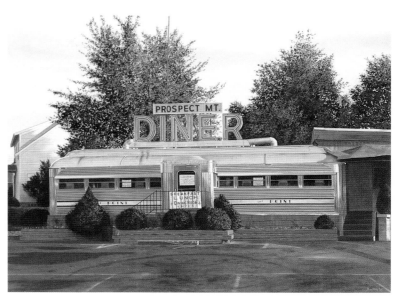

37. *Prospect Mt. Diner.* 1989 (39). Oil on canvas, 36 x 48".
Collection Mathew and Eileen Brady, New York

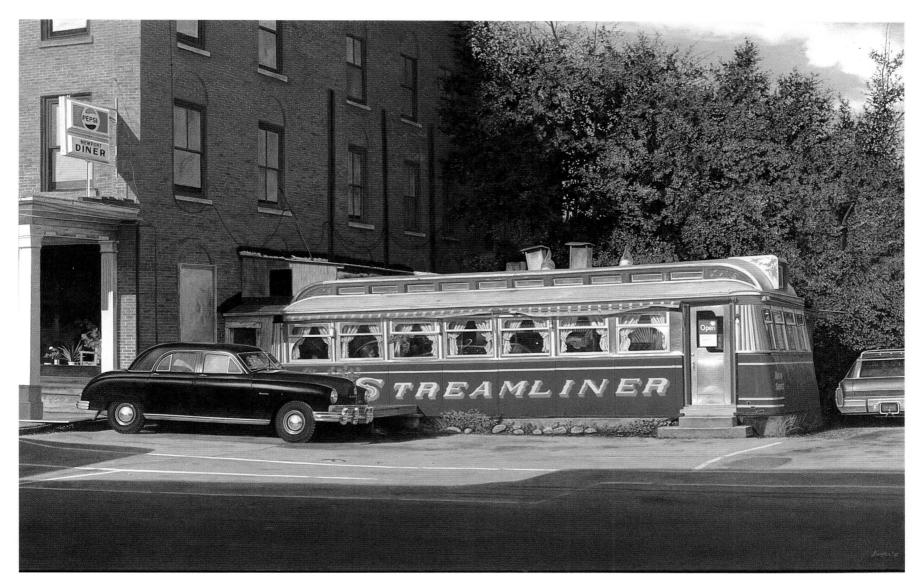

38. *Newport Diner.* 1988 (37). Oil on canvas, 42 x 66". Collection Judy and Noah Liff, Tennessee

39. *Deluca's Dining Car.* 1980 (W2).
Watercolor on paper, 18½ x 25½".
Collection Bruce and Barbara Berger, New York

40. *International Hoagie House.* 1980 (W3).
Watercolor on paper, 17 x 25¼".
Private collection, New Jersey

41. *Toni's Lunch Wagon.* 1980 (W4).
Watercolor on paper, 18 x 25½".
Private collection, New York

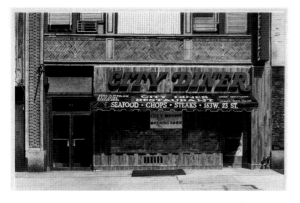

42. *City Diner.* 1982 (W13).
Watercolor on paper, 16½ x 24".
Private collection, Tennessee

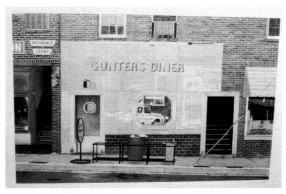

43. *Gunter's Diner.* 1982 (W14).
Watercolor on paper, 18 x 26¼".
Collection Glenn C. Janss, Idaho

44. *Viv's Diner.* 1982 (W15).
Watercolor on paper, 23 x 29".
Collection William Perry, New York

45. *Wally's Diner.* 1982 (W16).
Watercolor on paper, 17¼ x 23¾".
Private collection, France

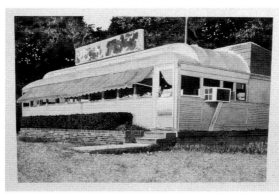

46. *Mike's Diner.* 1982 (W17).
Watercolor on paper, 17 x 24½".
Collection the artist

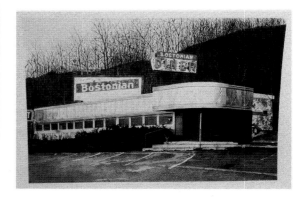

47. *Bostonian Diner.* 1982 (W20).
Watercolor on paper, 16½ x 24".
Private collection, Massachusetts

48–50. *Untitled.* 1982 (W23). Triptych, watercolor on paper, each panel 13 x 19". Robertson, Colman and Stephens, California

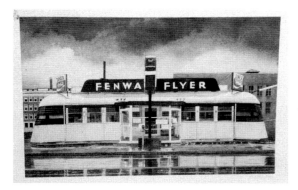 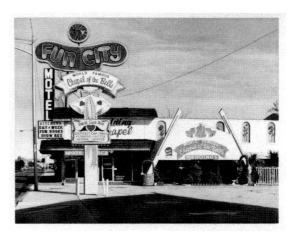

51. *Fenway Flyer.* 1982 (W21).
Watercolor on paper, 13 x 19¾".
Private collection, Massachusetts

52. *Orange Diner with Graffiti.* 1982 (W24).
Watercolor on paper, 16 x 23½".
Private collection, Maryland

53. *Chapel of the Bells.* 1983 (W25).
Watercolor on paper, 17 x 21".
Private collection, Maryland

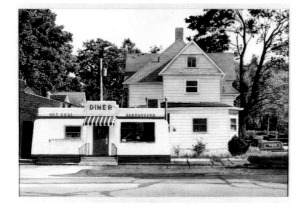 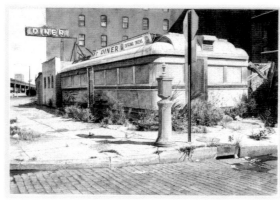 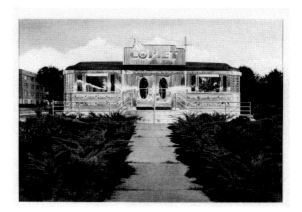

54. *Diner (Angola, Ind.).* 1983 (W26).
Watercolor on paper, 17 x 23½".
Collection Marcia Rodrigues, California

55. *Seaport Diner.* 1984 (W29).
Watercolor on paper, 17¾ x 24½".
Collection Stephens Inc., Arkansas

56. *Comet Diner.* 1984 (W30).
Watercolor on paper, 17 x 23".
Collection Malcolm Holzman, New York

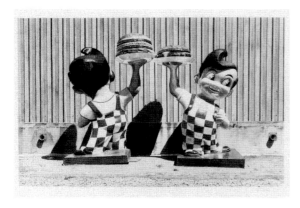 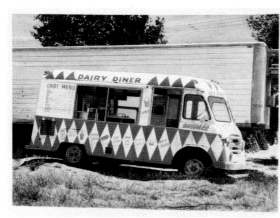 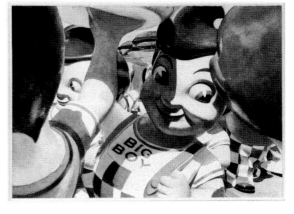

57. *Big Boy.* 1984 (W31).
Watercolor on paper, 13¼ x 20".
Collection Malcolm Holzman, New York

58. *Dairy Diner.* 1986 (W33).
Watercolor on paper, 18½ x 24½".
Collection Sidney and George Perutz, Texas

59. *Seven Big Boys.* 1986 (W34).
Watercolor on paper, 9½ x 13".
Collection Mr. and Mrs. Charles B. Moss, Jr., Colorado

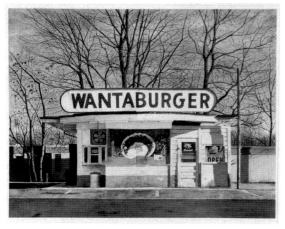 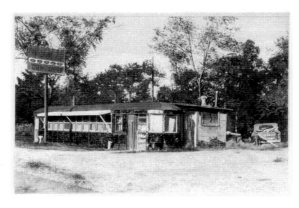 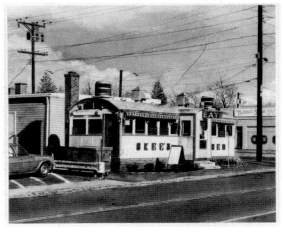

60. *Wantaburger.* 1986 (W35).
Watercolor on paper, 18½ x 22¾".
Collection the artist

61. *Mers' Diner.* 1987 (W36).
Watercolor on paper, 17½ x 26".
Collection the artist

62. *Skee's Diner.* 1987 (W37).
Watercolor on paper, 18 x 21½".
Collection Howard and Judy Tullman, Illinois

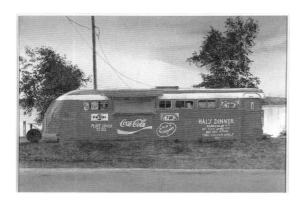

63. *Hal's Dinner.* 1988 (W42).
Watercolor on paper, 15¼ x 21¼".
Collection the artist

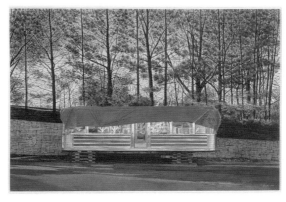

64. *Mountain View Diner, circa 1955, Awaiting New Home.* 1989 (W44). Watercolor on paper, 17¾ x 25½". Collection the artist

65. *Corner Lunch.* 1989 (W45).
Watercolor on paper, 14¼ x 22".
Collection the artist

66. *Bendix Diner.* 1989 (W43).
Watercolor on paper, 12½ x 18½".
Collection Louis K. and Susan Pear Meisel, New York

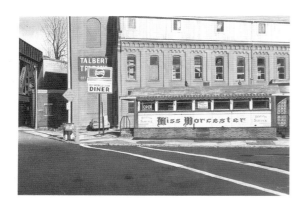

67. *Miss Worcester Diner.* 1989 (W46).
Watercolor on paper, 30½ x 38".
Collection Philippe Santini, France

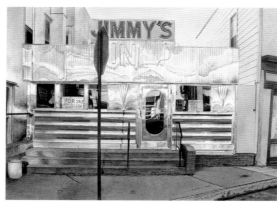

68. *Jimmy's.* 1989 (W47).
Watercolor on paper, 19½ x 26½".
Private collection, California

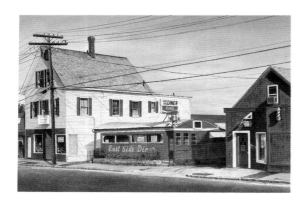

69. *East Side Diner.* 1990 (W48).
Watercolor on paper, 18 x 27".
Collection the artist

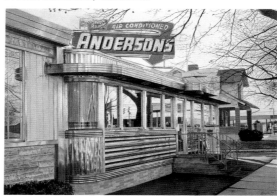

70. *Anderson's Diner.* 1990 (W49).
Watercolor on paper, 17½ x 26".
Private collection, France

NOT ILLUSTRATED

Oils

Main Street, Crane, Texas, 1973. 1987 (33).
Oil on canvas, 43 x 67".
Collection Martin Z. Margulies, Florida

Miss Worcester Diner. 1989 (40).
Oil on canvas, 46 x 66".
Collection Ruth and Harold Roitenberg, Minnesota

Wilson's Diner. 1989 (41). Oil on canvas, 46 x 66".
Private collection, Switzerland

Bell's Pond Diner. 1990 (42). Oil on canvas, 30½ x 36¼".
Private collection, France

Tumble Inn Diner. 1990 (43). Oil on canvas, 30 x 48".
Collection Allan Silber, Canada

White Way Diner. 1990 (44). Oil on canvas, 42 x 66".
Collection the artist

John's Diner. 1990 (45). Oil on canvas, 24 x 36".
Collection the artist

Watercolors

Routes 1 and 9. 1980 (W1).
Watercolor on paper, 14¼ x 21".
Museum of Art, Rhode Island School of Design,
Providence. Purchased with the Aid of Funds
from the National Endowment for the Arts

Cottage. 1980 (W5). Watercolor on paper,
16¼ x 24½". Private collection, Missouri

"OK" Lunch. 1980 (W6). Watercolor on paper,
17½ x 24". Dunkin' Donuts, Massachusetts

Diner (Belvidere, N.J.). 1980 (W7).
Watercolor on paper, 16¾ x 25¼".
Private collection

Diner (Meriden, Conn.). 1980 (W8).
Watercolor on paper, 16¾ x 25¼".
Private collection

Bell's Pond Diner. 1981 (W9).
Watercolor on paper, 15 x 23".
Technimetrics, New York

Deco Diner Door. 1981 (W10).
Watercolor on paper, 29¼ x 23½".
Private collection, Tennessee

Diner Corner Window. 1981 (W11).
Watercolor on paper, 29¾ x 25".
Collection the artist

T-Diner. 1982 (W12).
Watercolor on paper, 17½ x 25¾".
Collection Richard and Gloria Manney, New York

Red Robin Diner. 1982 (W18).
Watercolor on paper, 16 x 26".
Private collection, Massachusetts

Miss Worcester. 1982 (W19).
Watercolor on paper, 16 x 23¼".
Private collection, Massachusetts

Art's Diner. 1982 (W22).
Watercolor on paper, 15 x 22½".
Private collection, Florida

Casino of Fun. 1984 (W27).
Watercolor on paper, 17 x 23½".
Private collection, Maryland

Epicure Diner. 1984 (W28). Watercolor on
paper, 17¼ x 24". Collection the artist

Sandwich Cafe. 1985 (W32). Watercolor on
paper, 16½ x 24¼". Collection the artist

Post Office Diner. 1987 (W38).
Watercolor on paper, 16 x 23¾".
Private collection, California

You Ring, We Bring. 1988 (W39).
Watercolor on paper, 17 x 23".
Private collection, California

Los Cuñados. 1988 (W40).
Watercolor on paper, 18 x 28".
Collection the artist

Mount Prospect. 1988 (W41).
Watercolor on paper, 16½ x 25½".
Private collection, California

ROBERT BECHTLE

Until the eighties, Robert Bechtle, one of the earliest Photorealists, painted primarily snapshot-like images of ordinary people and their ordinary cars on ordinary sun-washed California streets. The images generally appeared centered in the composition and placed in the middle ground rather than in the distance or the foreground. Then, in the earlier part of the decade, Bechtle began to focus on indoor images, primarily of his studio. The interiors and the figures within them are usually dark and monochromatic, while the prominently placed windows are brightly sunlit yet also lacking in strong color.

Toward the end of the eighties, Bechtle began to concentrate on long-distance views down suburban streets. Although these in a way bring to mind his first style of painting, they incorporate distance, vanishing points, and horizons instead of the flatly presented houses and automobiles of the earlier work. (The only early work that relates at all to these new street scenes is *Burbank Street* of 1967; *P-R* pl. 60.) The development of Bechtle's original style over twenty years is intriguing to witness, and the results are quite strong as images. *Vicente Avenue Intersection* (pl. 95) is the best of these new works; it incorporates the added dimension of the San Francisco hills and offers something of a challenge in its visual ambiguity.

Bechtle has produced a total of 130 Photorealist works in his career. *Photo-Realism* illustrated 94 of these and listed 1 (a watercolor of a painting). We have recently discovered 3 other works (2 oils and 1 watercolor) from the seventies, and they are illustrated herein. Of the works done in the eighties, all 14 oils are illustrated, as are 14 of the 18 watercolors (the other 4 are listed). Of the total works, therefore, 125 are illustrated in the two volumes and the remaining 5 are documented.

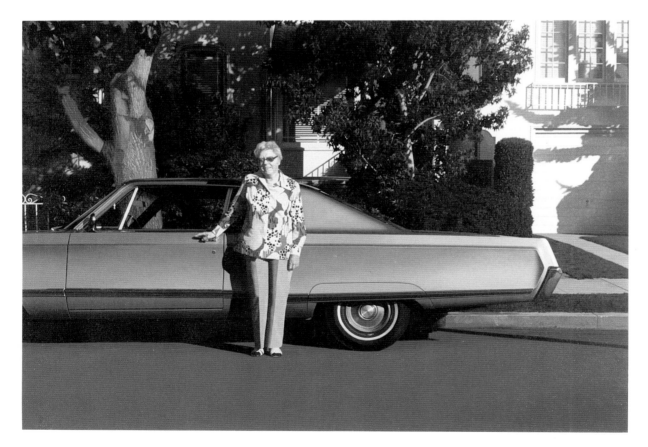

71. *Alameda Chrysler*. 1981 (98).
Oil on canvas, 49 x 70".
Private collection, New York

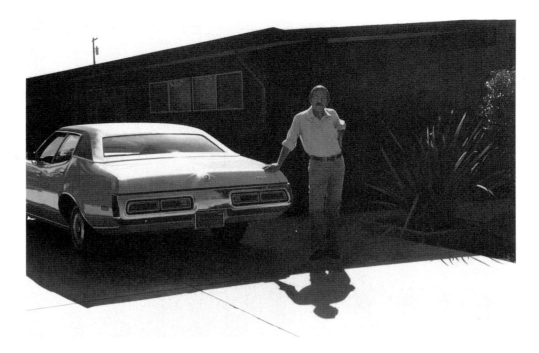

72. *Sacramento Montego.* 1980 (97). Oil on canvas, 40 x 57¾".
Collection Richard Brown Baker, New York

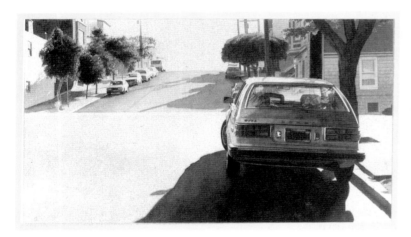

73. *Potrero Honda.* 1984 (107). Watercolor on paper, 11 x 19".
Private collection, Maryland

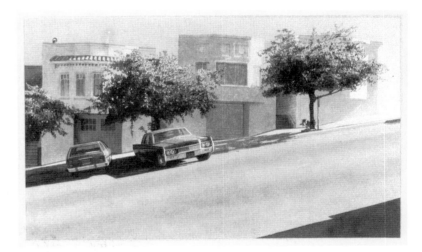

74. *Potrero Houses.* 1984 (108). Watercolor on paper, 12½ x 20¼".
Private collection, California

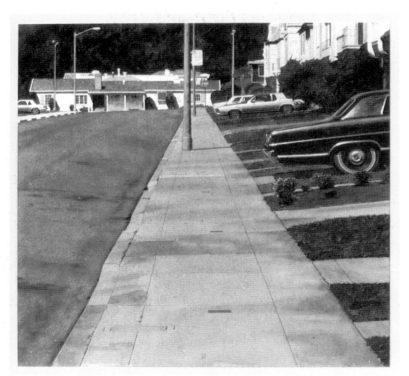

75. *White Ranch House.* 1985 (112).
Watercolor on paper, 18 x 19".
Collection Howard and
Judy Tullman, Illinois

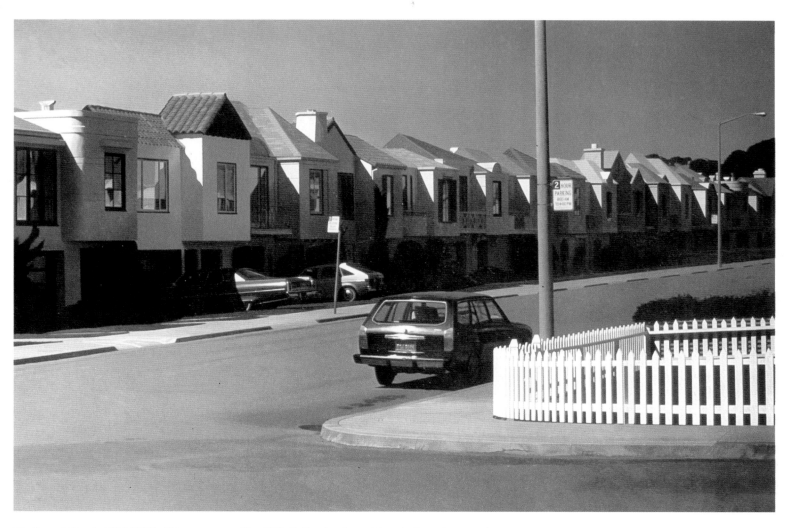

76. *Sunset Street.* 1984 (110). Oil on canvas, 48 x 70". Collection Jesse Nevada Karp, New York

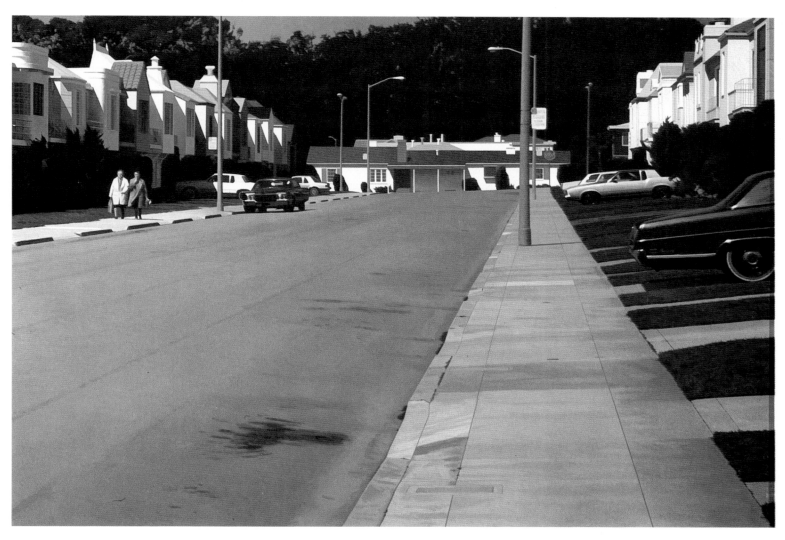

77. *Sunset Strollers.* 1985 (111). Oil on canvas, 48 x 69". Private collection, Germany

78. *Santa Barbara Patio.* 1983 (105).
Oil on canvas, 48 x 60".
Private collection, France

79. *Portrait of Richard McLean.* 1983 (104). Watercolor on paper,
14¼ x 17½". Collection Sidney and George Perutz, Texas

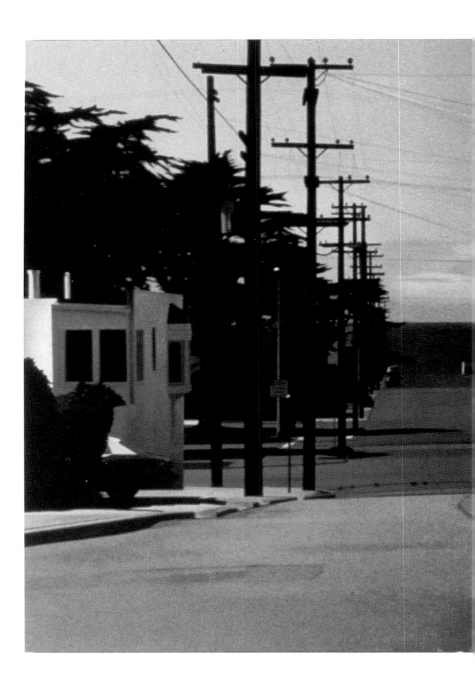

80. *Wellfleet Telephone.* 1983 (106). Watercolor on paper, 13¾ x 18".
Private collection, California

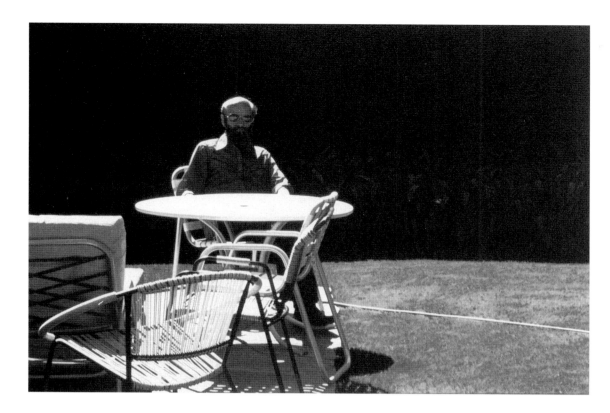

81. *Santa Barbara Chairs.* 1983 (103). Oil on canvas, 48½ x 69¾". Collection Richard Brown Baker, New York

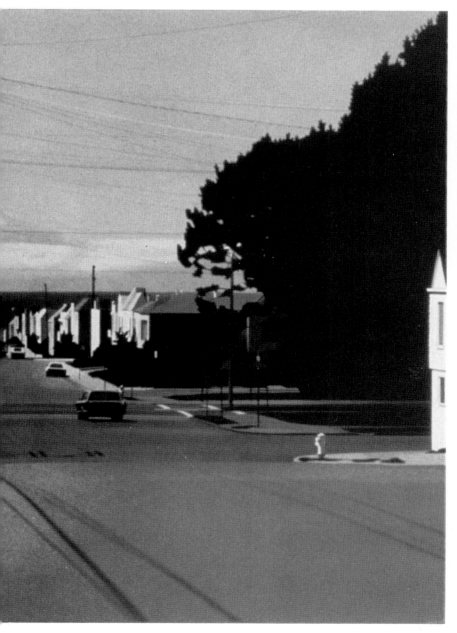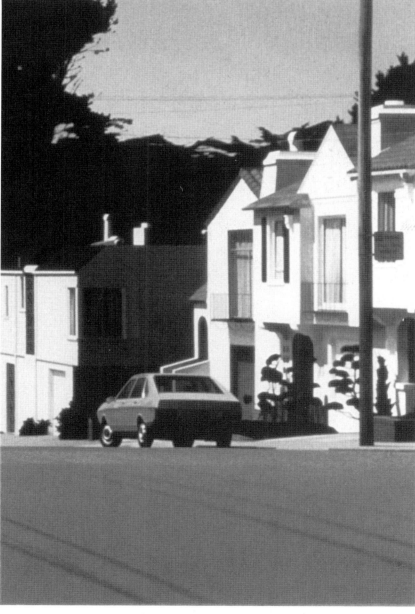

82. *Sunset Intersection.* 1984 (109). Triptych, oil on canvas, each panel 56 x 40".
Hunter Museum of Art, Chattanooga, Tennessee. Museum Purchase with Funds
Provided by the Benwood Foundation and the 1984 Collectors' Group

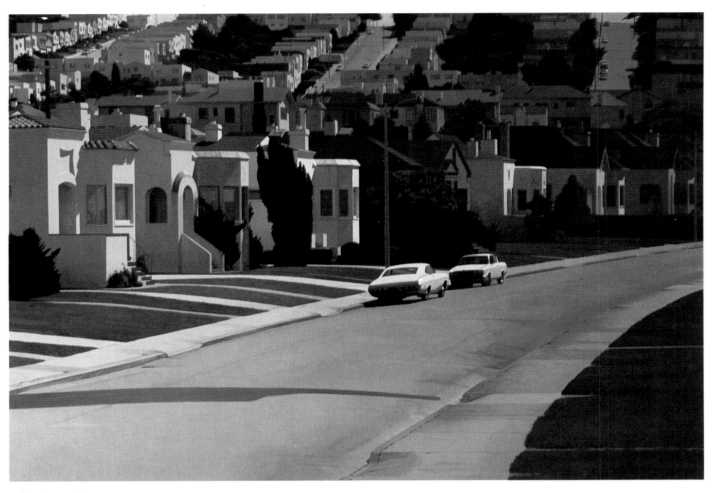

83. *Inglesipe Street.* 1986 (116). Oil on canvas, 48 x 69". Collection Mrs. Robert Saligman, Pennsylvania

84. *Ocean Avenue.* 1987 (121). Oil on canvas, 40 x 50½". Pacific Telesis Group, California

85. *Oakland Intersection.* 1988 (123). Watercolor on paper, 22 x 30".
Private collection, California

86. *Oakland Intersection—West and 40th.* 1989 (125).
Watercolor on paper, 22³/₄ x 30¹/₄". Collection the artist

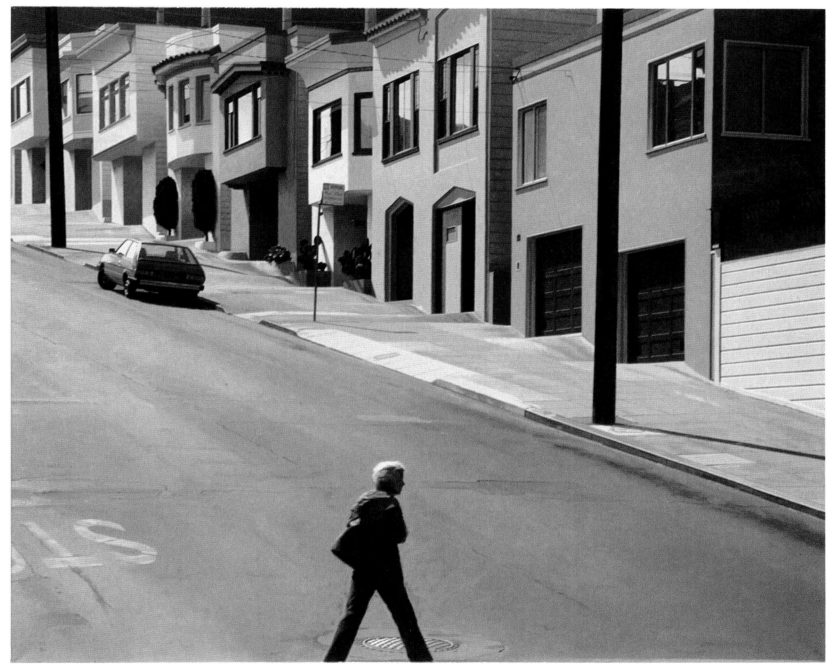

87. *Potrero Stroller—Crossing Arkansas Street.* 1988 (122). Oil on linen, 40 x 48". Private collection, Switzerland

88. *Athens Balcony.* 1985 (114).
Watercolor on paper, 7 x 11".
Private collection, California

89. *Potrero Sun.* 1985 (113).
Watercolor on paper, 18 x 21".
Private collection, California

90. *Broome Street Zenith.* 1986 (117).
Watercolor on paper, 13 x 19¹/₂".
Private collection, Tennessee

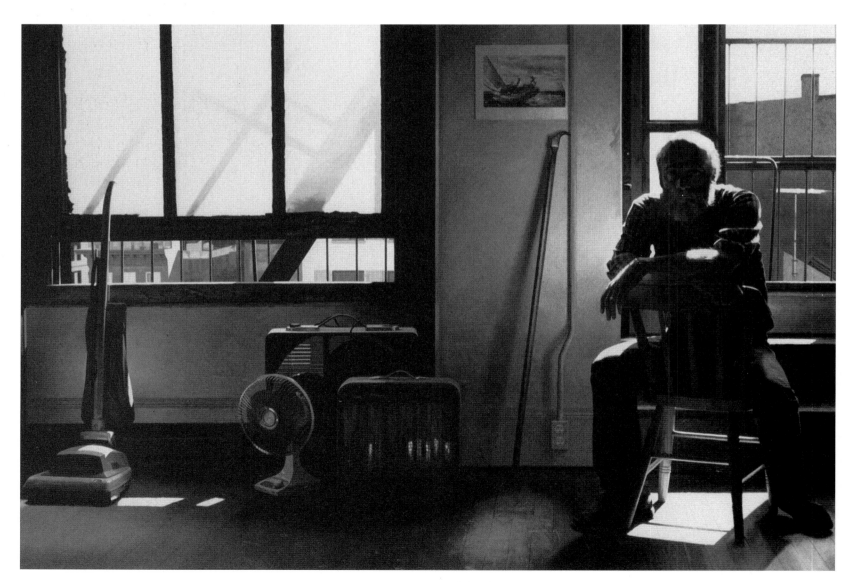

91. *Broome Street Hoover.* 1986 (115). Oil on canvas, 48¹/₂ x 69".
Private collection, Massachusetts

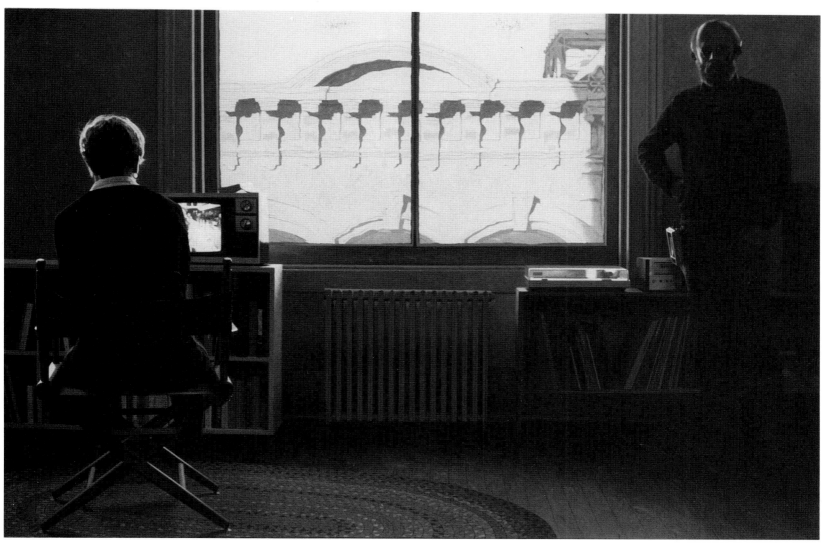

92. *Broome Street Zenith.* 1987 (118). Oil on canvas, 48 x 69". Collection Judy and Noah Liff, Tennessee

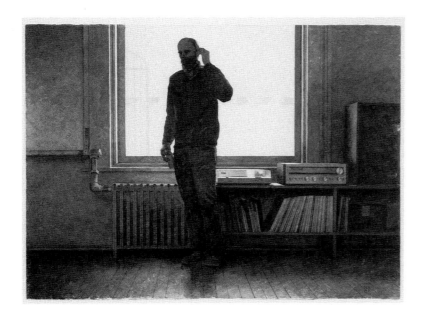

93. *Broome Street Walkman.* 1987 (119). Watercolor on paper, 22½ x 30". Collection Jason Schoen, Louisiana

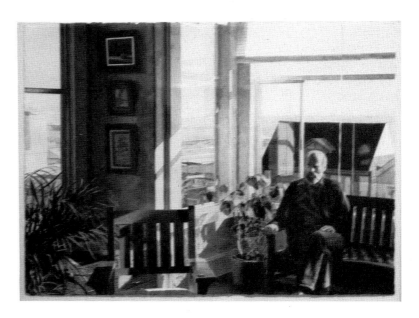

94. *Potrero View.* 1987 (120). Watercolor on paper, 22¾ x 30". The Metropolitan Museum of Art, New York

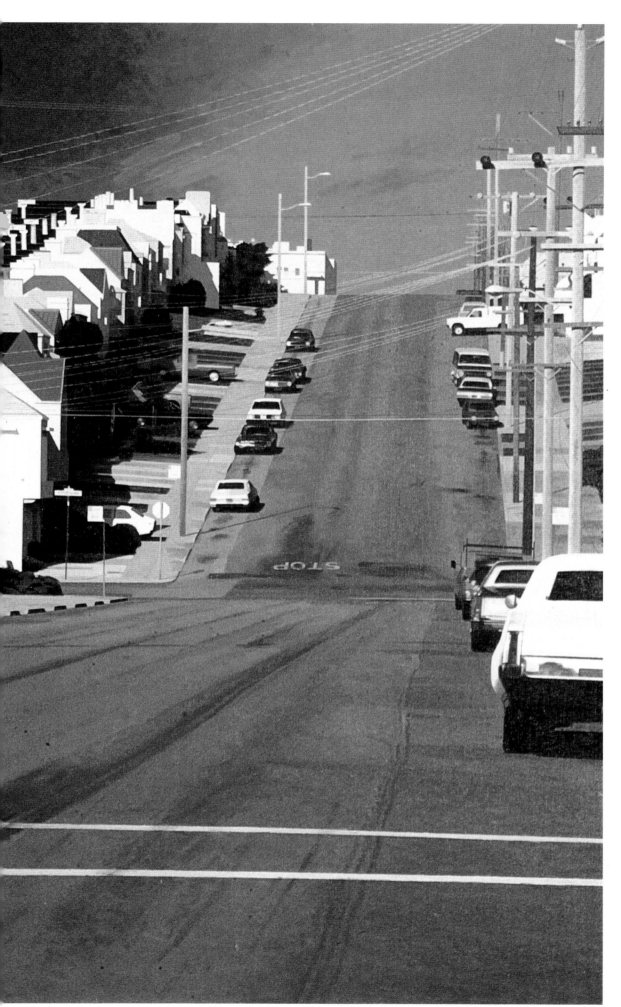

95. *Vicente Avenue Intersection.* 1989 (124).
Oil on linen, 48 x 69".
Louis K. Meisel Gallery, New York

NOT ILLUSTRATED

Sunset Painter. 1981 (99).
Watercolor on paper, 10½ x 15¼".
Hunter Museum of Art, Chattanooga,
Tennessee. Museum Purchase with Funds
Provided by the Benwood Foundation and
the 1982 Collectors' Group

San Francisco Nova. 1981 (100).
Watercolor on paper, 10½ x 15".
Private collection, New York

22nd Avenue. 1982 (101).
Watercolor on paper, 10 x 14".
Collection Malcolm Holzman, New York

Santa Barbara Patio. 1982 (102).
Watercolor on paper, 24 x 31".
Collection Robert Harshorn Shimshak, California

96. *Oakland Intersection—59th and Standard.* 1990 (126).
Oil on canvas, 40 x 58". Collection the artist

97. *Sunset Wagon.* 1990 (127). Watercolor on paper, 12 x 16".
PieperPower Companies, Inc., Wisconsin

98. *20th Street VW.* 1990 (128). Watercolor on paper, 10½ x 16".
Collection the artist

99. *San Francisco Nova.* 1979 (95). Oil on canvas, 49 x 69".
Collection City and County of San Francisco, California

100. *'68 Cadillac.* 1970 (28a). Oil on canvas, 22 x 24".
Collection Louis K. and Susan Pear Meisel, New York

101. *Miles City Bar-Be-Que.* 1978 (92b). Watercolor on paper, 10 x 15".
Collection Robert Harshorn Shimshak, California

CHARLES BELL

In the formative years of Photorealism, Charles Bell's most popular images were toys and gumball machines. While he continued to explore these subjects in the eighties, the later toy paintings are decidedly different from the earlier ones. More surreal in character—due in part to the influence of Salvador Dali during their brief friendship—Bell's toy paintings became mysterious narratives rather than straightforward still lifes.

The paintings in the Marbles series originated in the eighties. This motif proved to be for Bell what the square was for Josef Albers. Bell's use of this theme in an elegant series of experimentations with color, texture, transparency, translucency, and focus will continue and evolve in the nineties.

However, it is Bell's Pinball Machine series that seems to have superseded all the others. Actually begun in the seventies but fully developed only in the late eighties, this series has radically expanded the artist's use of high technology. He has had to push his photography to much higher levels of sophistication (involving detail, focus, and lighting effects) and has employed computers to help create the photographs and images from which to paint. Although Bell has become far more technologically sophisticated throughout his career, the photography and computers he employs remain only tools of his art. They help to make, but do not actually create, the art itself.

Bell has become the preeminent Photorealist still-life painter and, in fact, one of the leading contemporary masters of this genre in the entire art world.

Bell was extremely productive for a Photorealist in the eighties. He had created 45 works by 1980—all but 1 illustrated in *Photo-Realism*—and since then he has added 100 more. All of those are illustrated herein, for a total of 145.

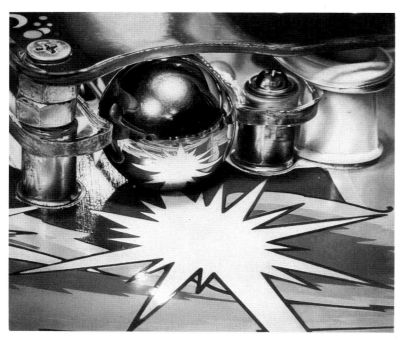

102. *Captive Messenger No. 2*. 1980 (45). Oil on canvas, 34 x 40".
Private collection

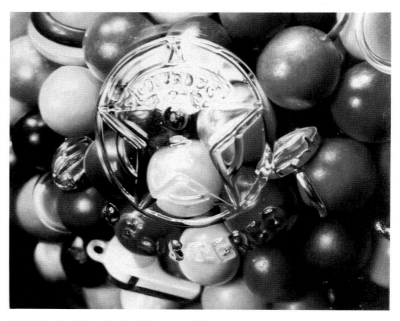

103. *Gumball Section A*. 1980 (46). Oil on canvas, 32 x 40".
Private collection, New Jersey

43

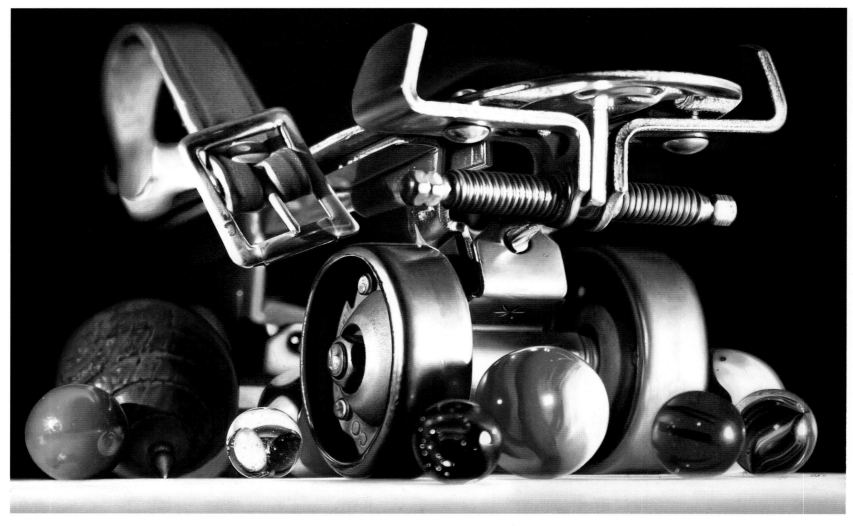

104. *"Chicago" Pat. No. 1,910,193.* 1980 (47). Oil on canvas, 52 x 84". Collection Jack and Harriet Stievelman, New York

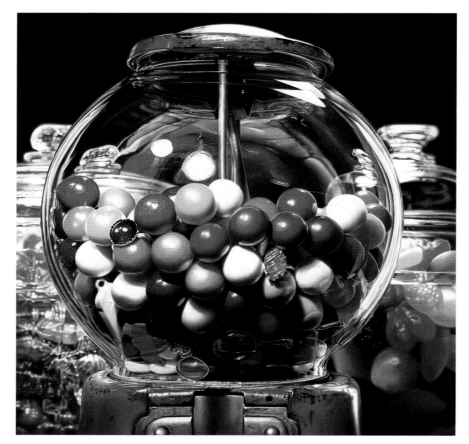

105. *Gumball XIV.* 1980 (48).
Oil on canvas, 66 x 66".
Private collection, Ontario

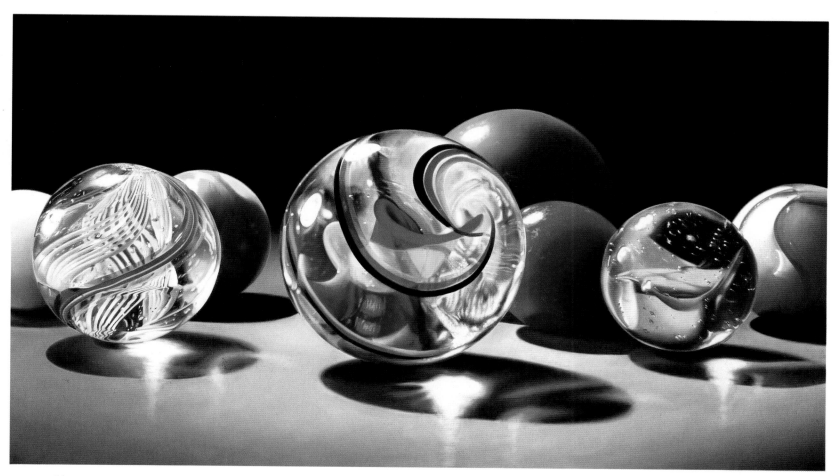

106. *Marbles I.* 1980 (49). Oil on canvas, 48 x 84". Private collection, New York

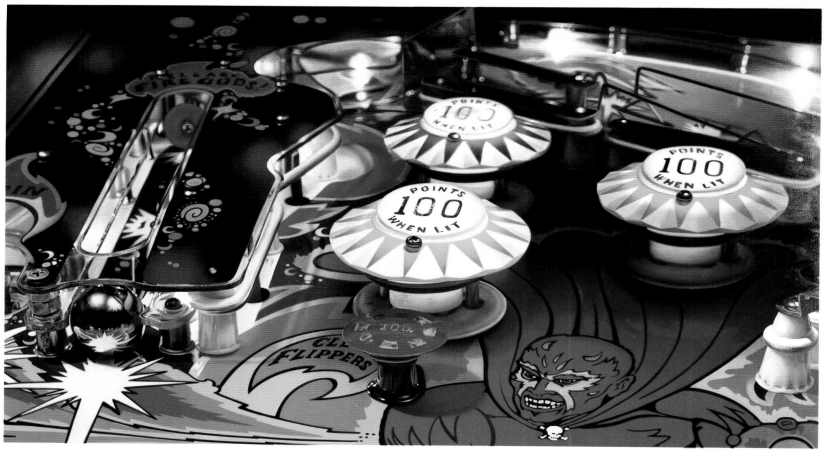

107. *100 Points When Lit.* 1981 (55). Oil on canvas, 60 x 108". Private collection, New York

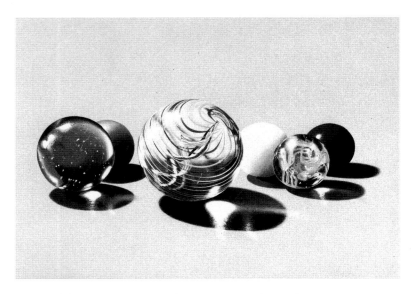

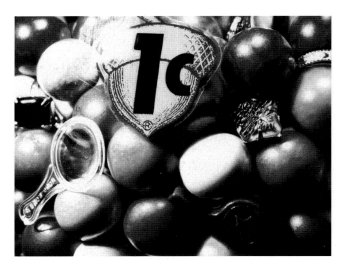

108. *Marbles.* 1980 (50). Gouache on paper, 19½ x 27½".
Collection Mr. and Mrs. W. Jaeger, New York

109. *1 Cent Win the Ring.* 1981 (51). Oil on canvas, 32 x 40".
Private collection, Michigan

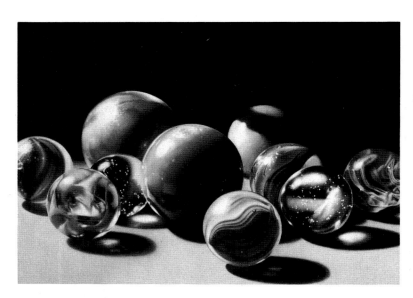

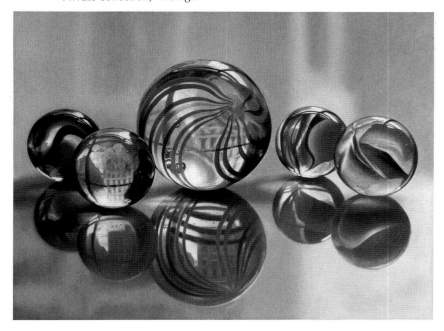

110. *Marbles II.* 1981 (52). Oil on board, 29½ x 39¾".
Collection Mr. and Mrs. W. Jaeger, New York

111. *5 Marbles and 465 West Broadway IV.* 1981 (57). Oil on canvas, 32 x 42".
Private collection, New York

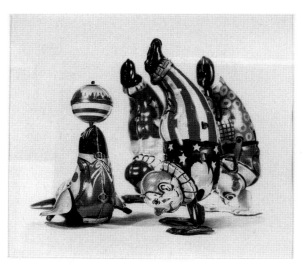

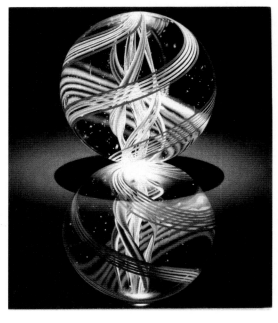

112. *Puss in Boots (Cat Toy).* 1981 (54).
Colored pencil on paper, 30 x 22¼".
Collection Gilbert and Judith Shapiro, New York

113. Study for *Troupe* (Clowns and Seal). 1981 (53).
Colored pencil on paper, 20 x 23".
Collection Louis K. and Susan Pear Meisel, New York

114. *"Solitaire Blue," Marbles VI.* 1982 (59).
Oil on canvas, 42 x 36".
Private collection, New Jersey

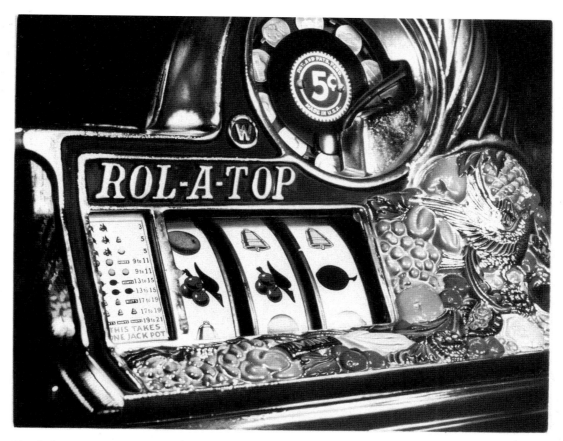

115. *Rol-A-Top.* 1981 (56). Oil on canvas, 32½ x 40". Collection Gloria and Gerald Lushing, California

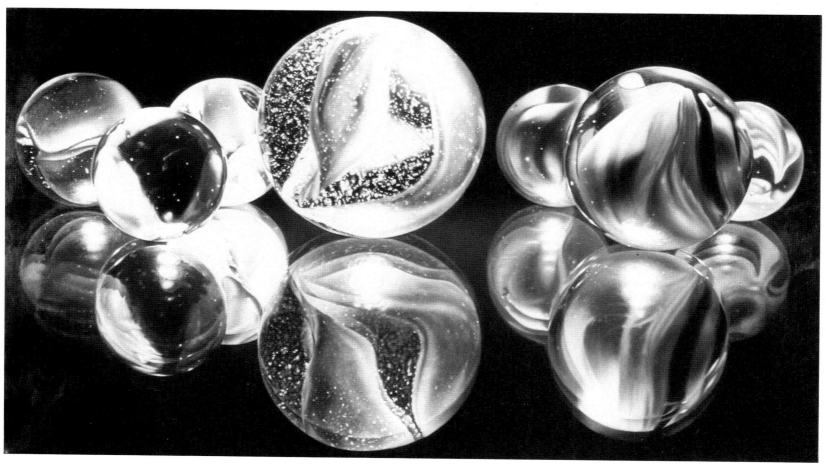

116. *Marbles V.* 1982 (58). Oil on canvas, 48 x 84½". Collection Barbara and Arnold Falberg, New York

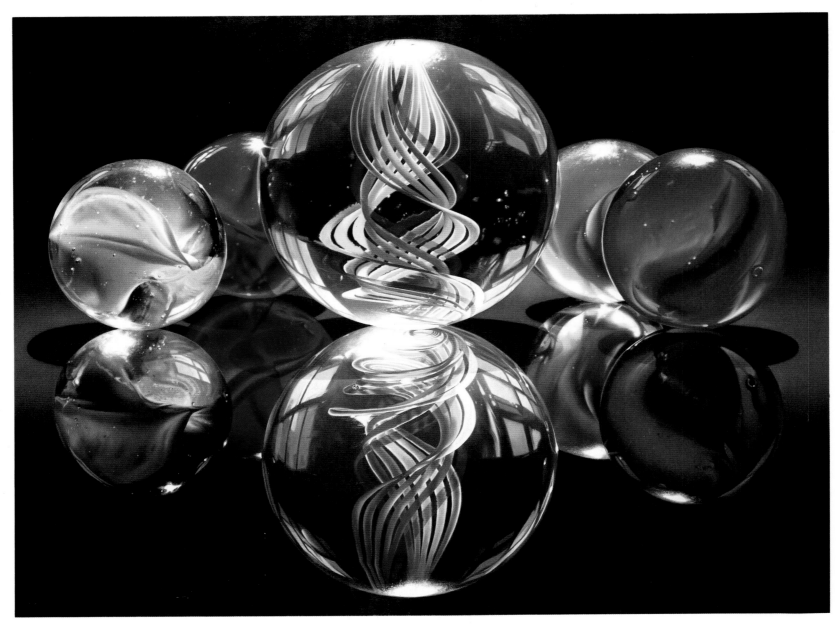

117. *Marbles VII.* 1982 (60). Oil on canvas, 60 x 78¼". Collection Zoe and Joel Dictrow, New York

118. *Marbles.* 1982 (61).
Pastel on black paper, 21 x 29½".
Collection Louis K. and Susan Pear Meisel, New York

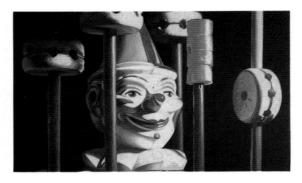

119. *Tinker Toys and Clown.* 1982 (62).
Colored pencil on black paper, 16 x 26".
Private collection, New York

120. *Seaplane.* 1982 (63). Colored pencil on paper, 8½ x 11½". Collection Louis K. and Susan Pear Meisel, New York

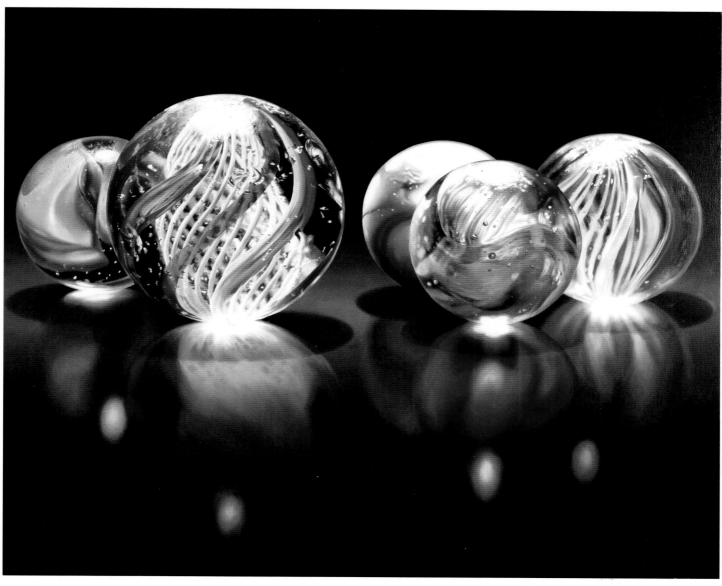

121. *Marbles VIII.* 1982 (64). Oil on canvas, 54½ x 66¼". Collection Jack and Harriet Stievelman, New York

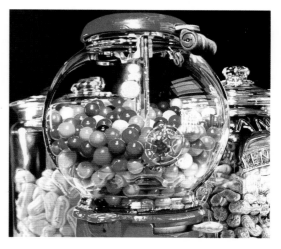

122. *Red Rider.* 1982 (65).
Oil on canvas, 47 x 35". Collection
Dale C. and Alexandra Zetlin Jones, New York

123. *Pace Bantam.* 1982 (66).
Watercolor on paper, 7⅜ x 9⅜".
Collection Bruce Vinokour, California

124. *"Columbus Star," Gumball Watercolor No. 3.*
1982 (67). Watercolor on paper, 10¾ x 12".
PieperPower Companies, Inc., Wisconsin

49

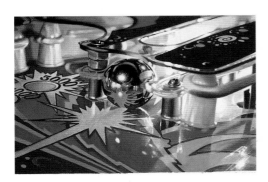

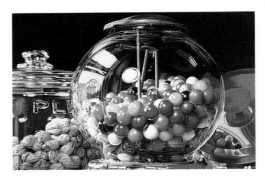

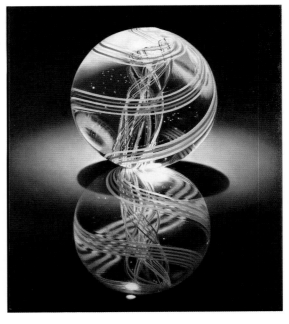

125. *"Captive Messenger," Pinball Watercolor No. 2*. 1982 (68). Watercolor on paper, 4³/₄ x 7". Collection Pierre and Sylvie Mirabaud, Switzerland

126. *Gumball Watercolor No. 4*. 1982 (69). Watercolor on paper, 9¹/₂ x 14¹/₄". Private collection, New York

127. *Solitaire Yellow*. 1982 (70). Oil on canvas, 42 x 36". Private collection, California

128. *The Critics*. 1982 (71). Oil on canvas, 66 x 96¹/₄". Collection Donna and Neil Weisman, New Jersey

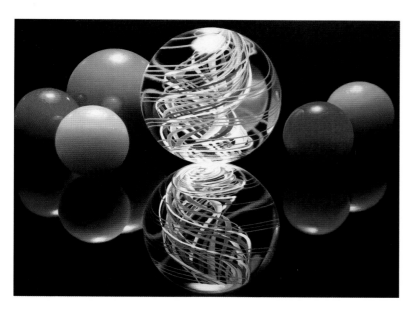

129. *Marbles IX.* 1982 (73). Oil on canvas, 36 x 48".
Private collection, New York

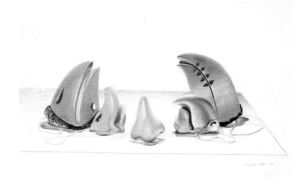

131. *Untitled (Nose Masks).* 1986 (114).
Colored pencil on paper, 11¼ x 14¼".
Private collection, Portugal

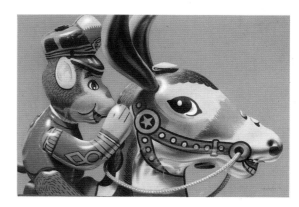

132. *The Secret.* 1983 (78).
Colored pencil on paper, 27¼ x 39¼".
Collection Barry and Susan Paley, New York

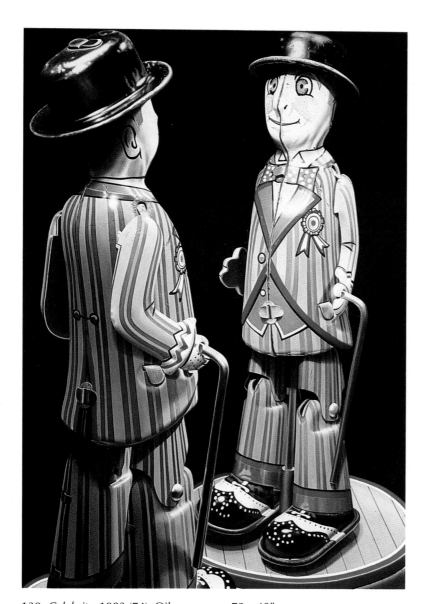

130. *Celebrity.* 1983 (74). Oil on canvas, 72 x 48".
Collection Joan and Barrie Damson, Connecticut

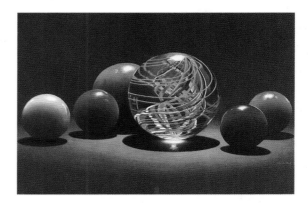

133. *Marbles X.* 1983 (79).
Pastel on paper, 27 x 38".
Collection Mark Schiff, New York

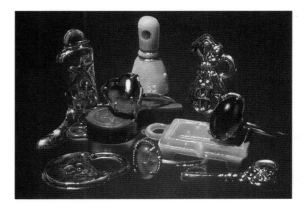

134. *Texas.* 1983 (80).
Colored pencil on black paper, 27½ x 39½".
Private collection, Texas

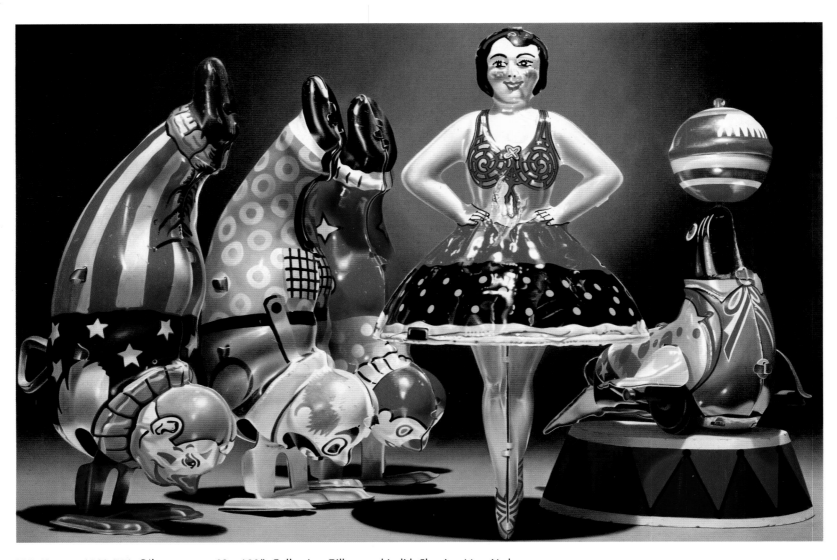

135. *Troupe.* 1983 (77). Oil on canvas, 68 x 102". Collection Gilbert and Judith Shapiro, New York

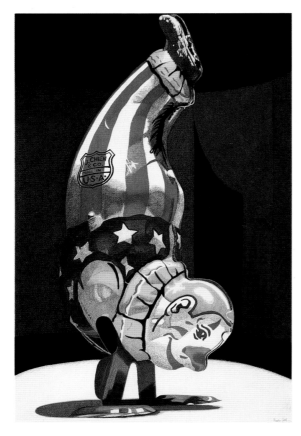

136. Study for *Troupe (Solitary Clown)*. 1983 (76).
Gouache and pastel on paper, 59¹/₂ x 40".
Private collection, France

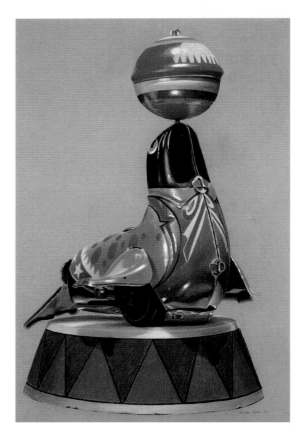

137. *Trained Seal.* 1983 (75).
Colored pencil on paper, 39¹/₄ x 27¹/₂".
Private collection, New York

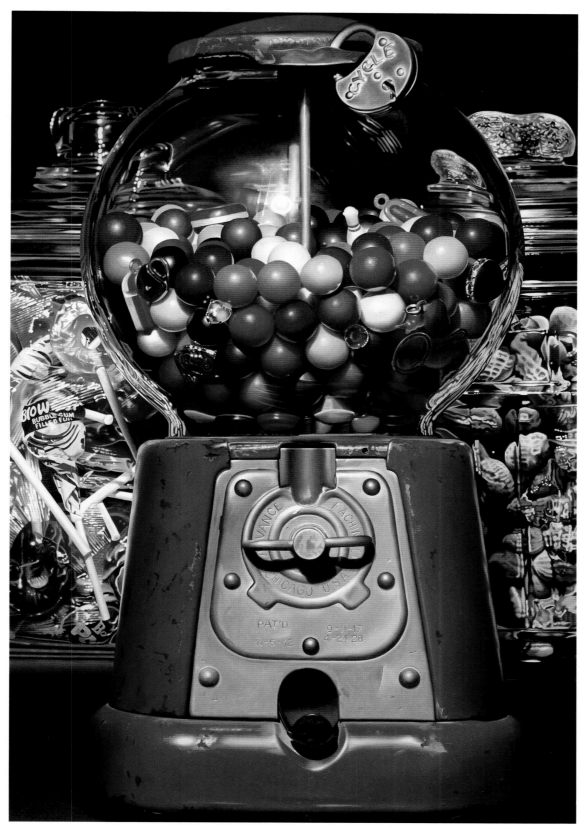

138. *Gumball XV*. 1983 (81). Oil on canvas, 89 x 61". Collection Jack and Harriet Stievelman, New York

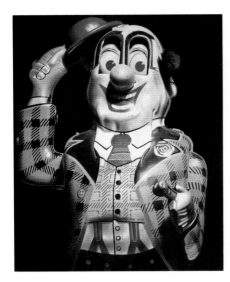

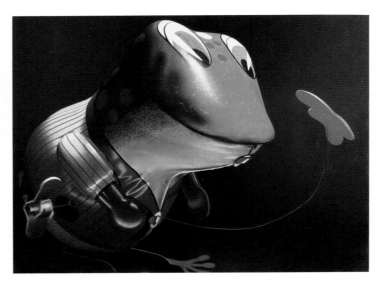

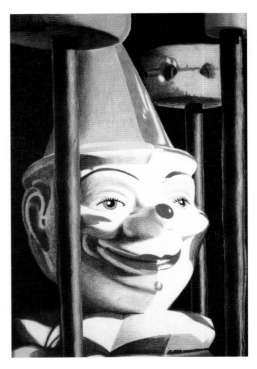

139. *Uncle Harry.* 1983 (82).
Oil on canvas, 28 x 22". Collection
Stan and Beverly Salsberg, Ontario

140. *The Optimist.* 1983 (83).
Oil on canvas, 36 x 48".
Private collection, Illinois

141. *Study (Roly-Poly).* 1983 (87).
Oil pastel on paper, 77 x 52".
Collection Copy Berg and Paul Nash, New York

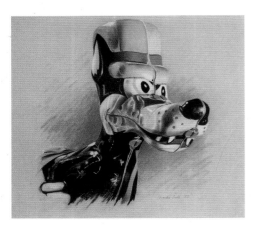

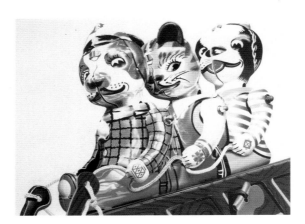

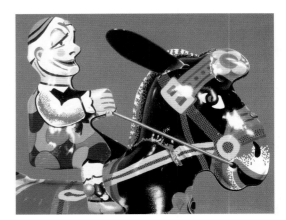

142. *The Big Bad Wolf.* 1983 (84).
Colored pencil on paper, 19¼ x 21".
Private collection, Texas

143. *Snow Scene.* 1983 (85).
Colored pencil on paper, 27 x 37".
Private collection, California

144. *A Study for The Journey.* 1983 (86).
Gouache, pastel, and graphite on paper, 31½ x 39½".
Collection Donna and Neil Weisman, New Jersey

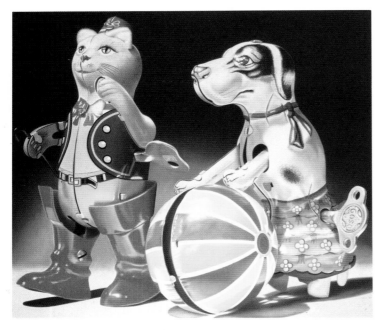

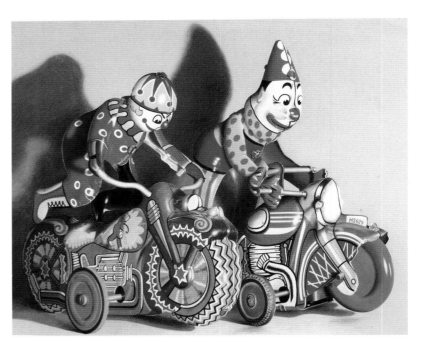

145. *Circus Act.* 1983 (88). Oil on canvas, 58 x 64".
Private collection, New Jersey

146. *Hot Pursuit.* 1984 (90). Pastel and colored pencil on board, 40 x 50".
Louis K. Meisel Gallery, New York

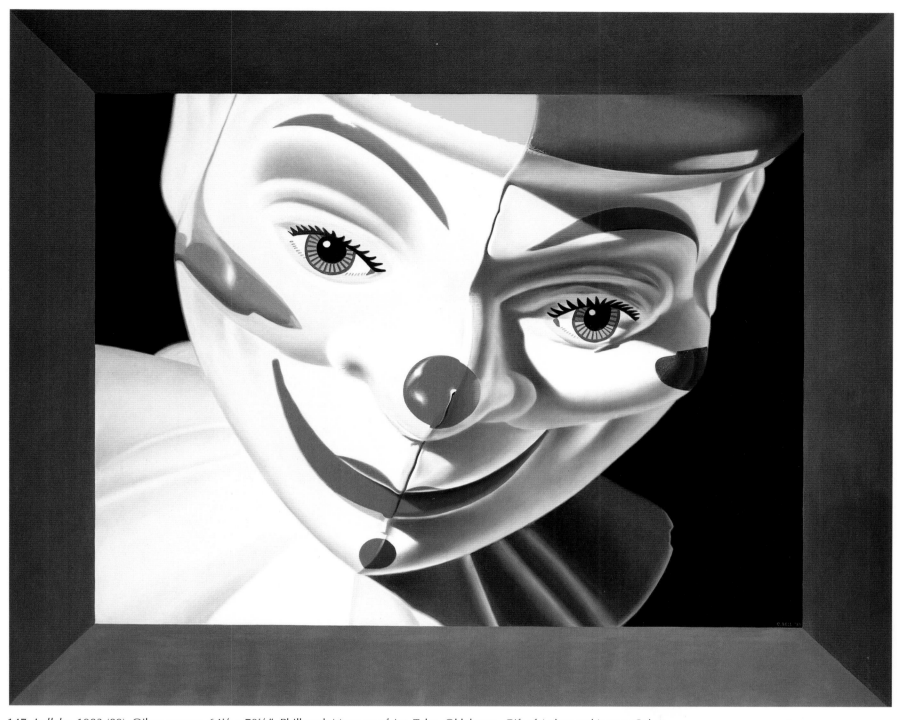

147. *Lullaby.* 1983 (89). Oil on canvas, 64¼ x 78¼". Philbrook Museum of Art, Tulsa, Oklahoma. Gift of Arthur and Jeanne Cohen

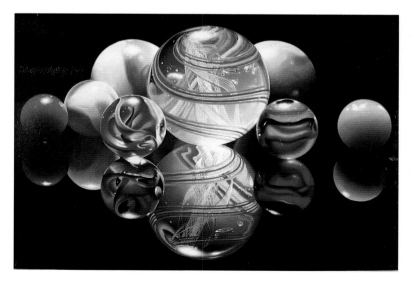

148. *Marbles XIII.* 1984 (93). Oil on canvas, 40 x 60".
Private collection, Pennsylvania

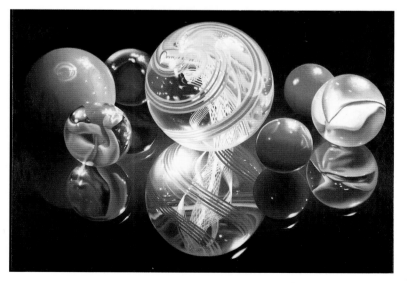

149. *Marbles XI.* 1984 (91). Oil on canvas, 38 x 54".
Private collection, California

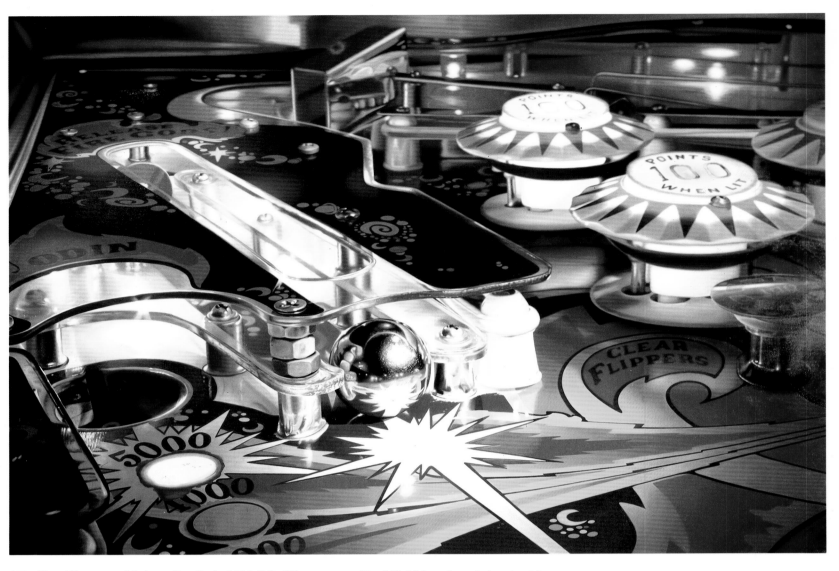

150. *Clear Flippers and Release Fire Gods.* 1984 (96). Oil on canvas, 62 x 90". Virlane Foundation, Louisiana

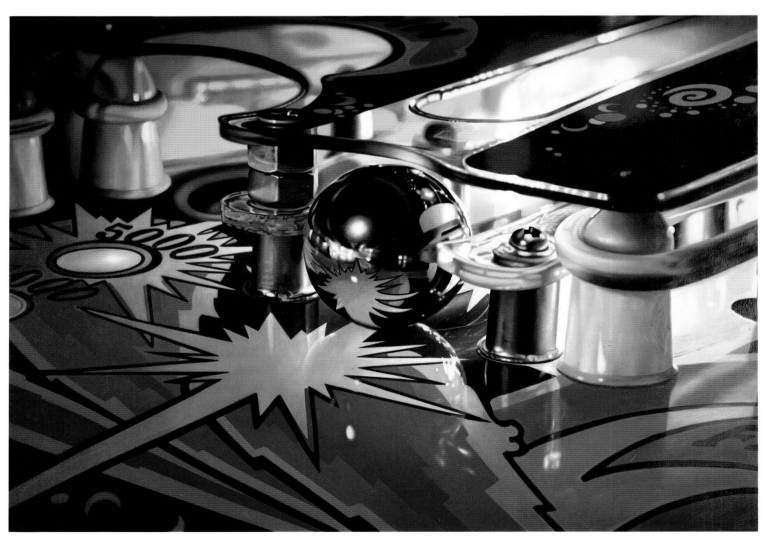

151. *Night Fireball.* 1984 (94). Oil on canvas, 60 x 84". Collection Hope and Howard Stringer, Tennessee

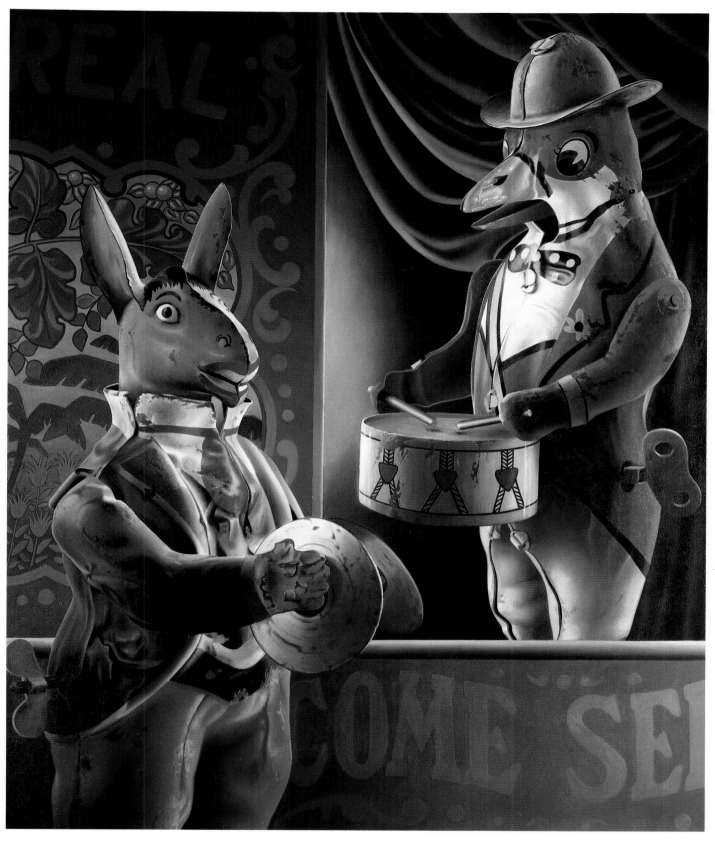

152. *Side Show*. 1984 (95). Oil on canvas, 72 x 60". Phoenix Art Museum, Arizona.
Museum Purchase with Partial Funding by The Contemporary Forum

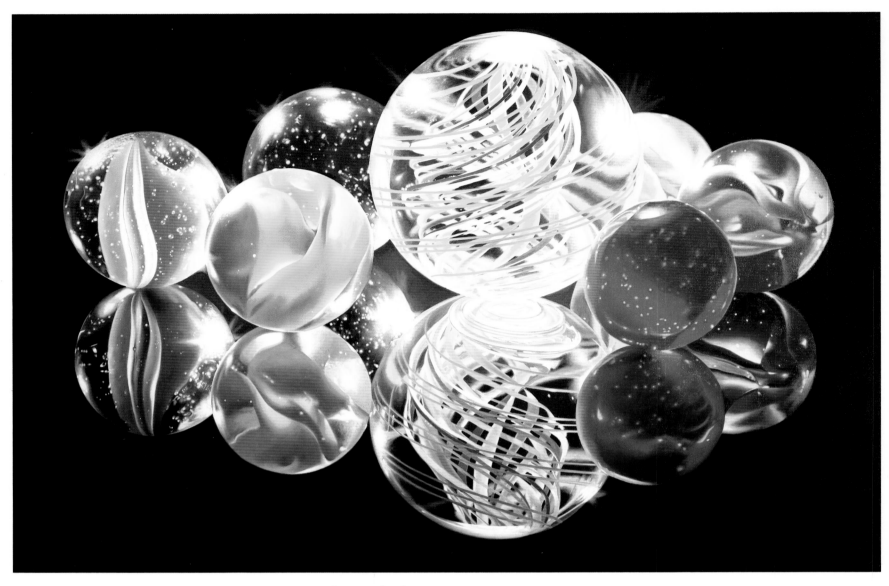

153. *Marbles XII*. 1984 (92). Oil on canvas, 48 x 72". Private collection, Florida

154. *Valentine*. 1984 (97).
Oil on board, c. 10 x 7".
Private collection

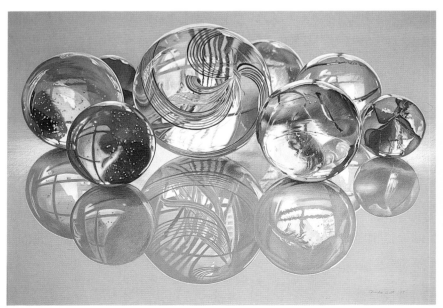

155. *"Glassies," Marbles XIV*. 1985 (98).
Colored pencil on gray paper, 27½ x 39⅜".
Private collection, Texas

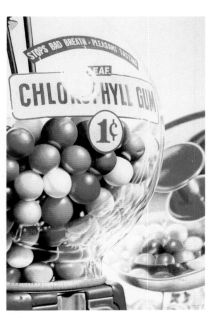

156. *"Pleasant Tasting," Gumball XVI*.
1985 (99). Colored pencil on board,
56½ x 39½". Akron Art Museum, Ohio

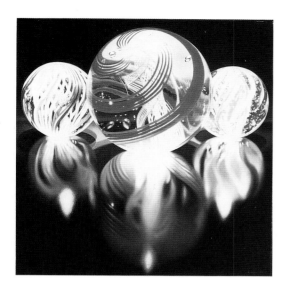

157. *Marbles XV*. 1985 (102).
Oil on canvas, 48 x 46½".
Private collection, New York

158. Study for *Bunny Cycle*. 1985 (103).
Colored pencil on black paper, 40 x 57".
Private collection, Illinois

159. Drawing for *Nature Study*. 1985 (104).
Colored pencil on board, 58 x 40".
Private collection, Michigan

160. *Get Ready, Get Set*. 1985 (107).
Colored pencil on board, 40 x 60".
Private collection, New York

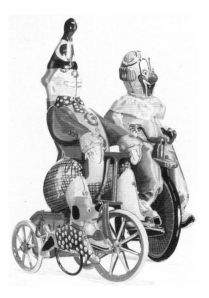

161. *Le Cirque*. 1985 (106).
Colored pencil on board, 60 x 40".
Private collection, Idaho

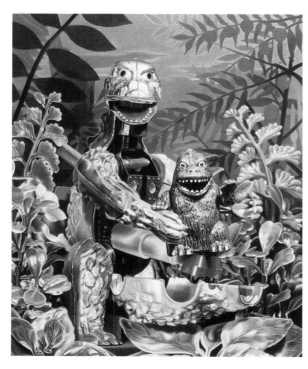

162. *Nature Study*. 1985 (105). Oil on canvas, 72 x 60".
Collection the artist

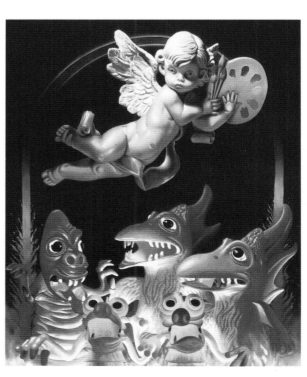

163. *Art Angel*. 1986 (108). Oil on canvas, 72 x 60".
The Estate of Will Ching, New York

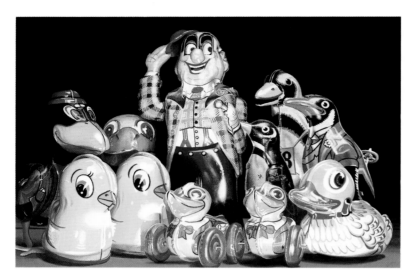

164. *Curtain Call.* 1982 (72). Watercolor on paper, 9¼ x 14".
Collection Glenn C. Janss, Idaho

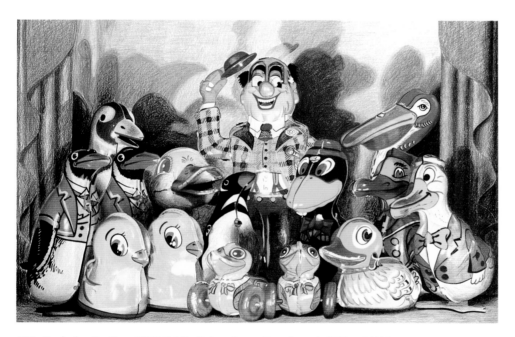

165. Study for *Ta-Daa.* 1985 (100). Colored pencil on board, 39½ x 56½".
Private collection, New York

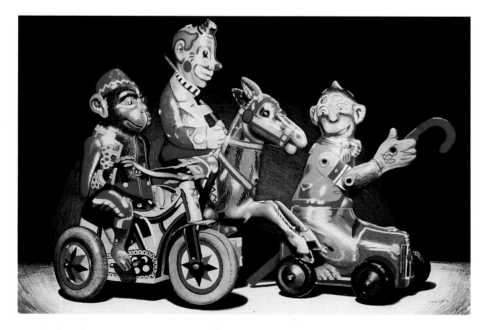

166. *Before the Journey.* 1986 (113). Colored pencil on board, 39 x 58".
Collection Robert and Brenda Pangborn, Michigan

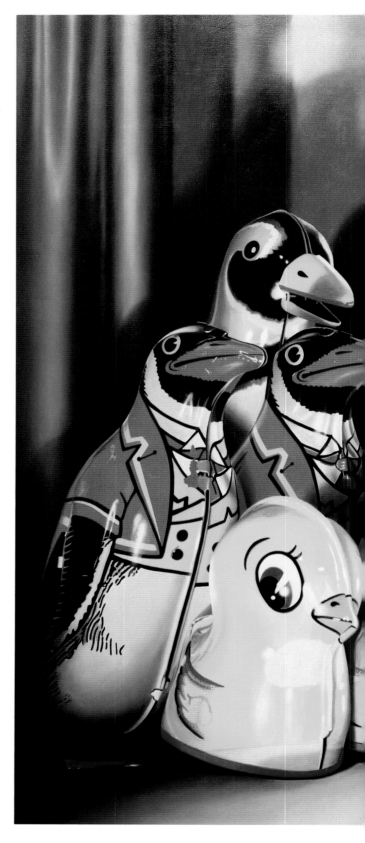

167. *Ta-Daa.* 1985 (101). Oil on canvas, 72 x 108".
Private collection, New York

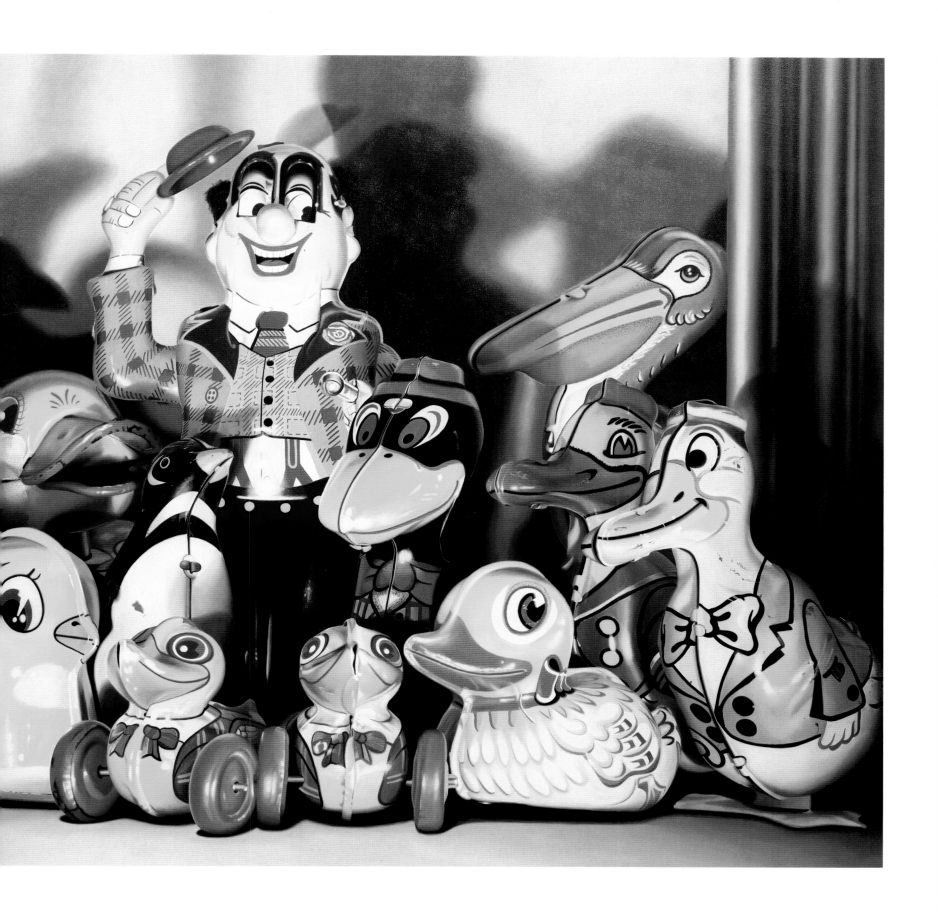

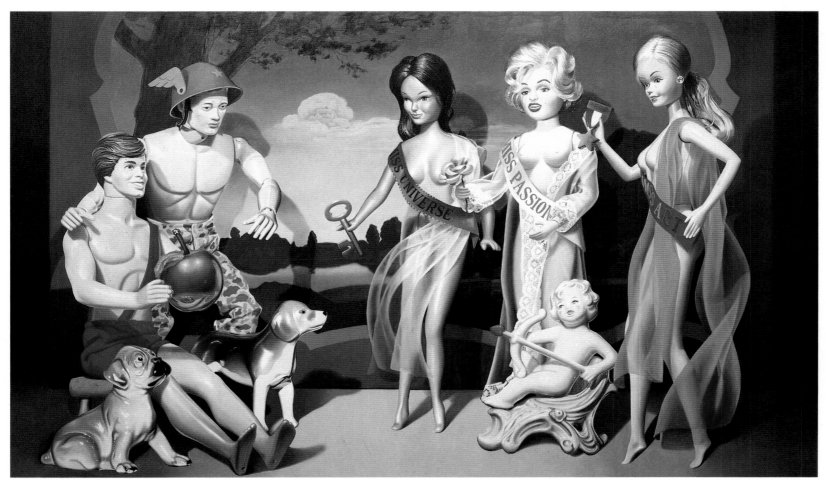

168. *The Judgement of Paris.* 1986 (109). Oil on canvas, 72 x 120". Louis K. Meisel Gallery, New York

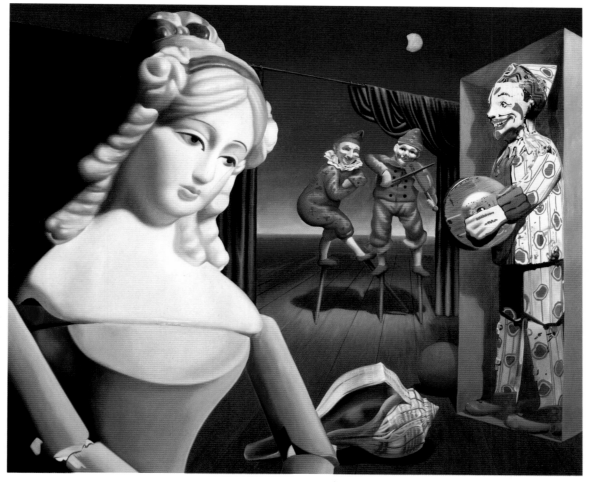

169. *Midsummer's Dream.* 1986 (111). Oil on canvas, 60 x 72". Louis K. Meisel Gallery, New York

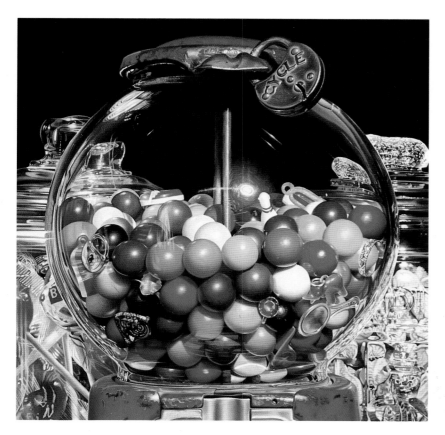

170. *Gumball XVII.* 1986 (110). Oil on canvas, 66 x 66".
Hiroshima City Museum of Contemporary Art, Japan

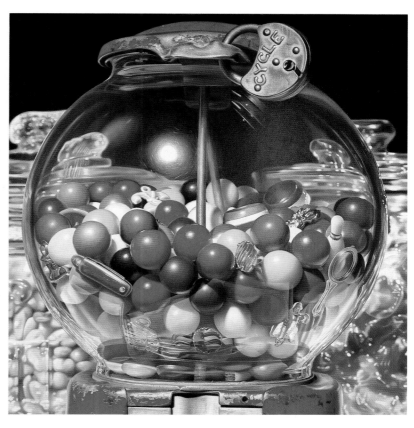

171. *Gumball XVIII.* 1986 (112). Oil on canvas, 66 x 66".
Collection Douglas and Beverly Feurring, Florida

172. *Tiger.* 1986 (115). Colored pencil and gouache on paper, 27½ x 31½".
PieperPower Companies, Inc., Wisconsin

173. *Bridgehampton Bunnies.* 1987 (116). Pastel and colored pencil on
black paper, 26 x 30". Collection Ari Ron Meisel, New York

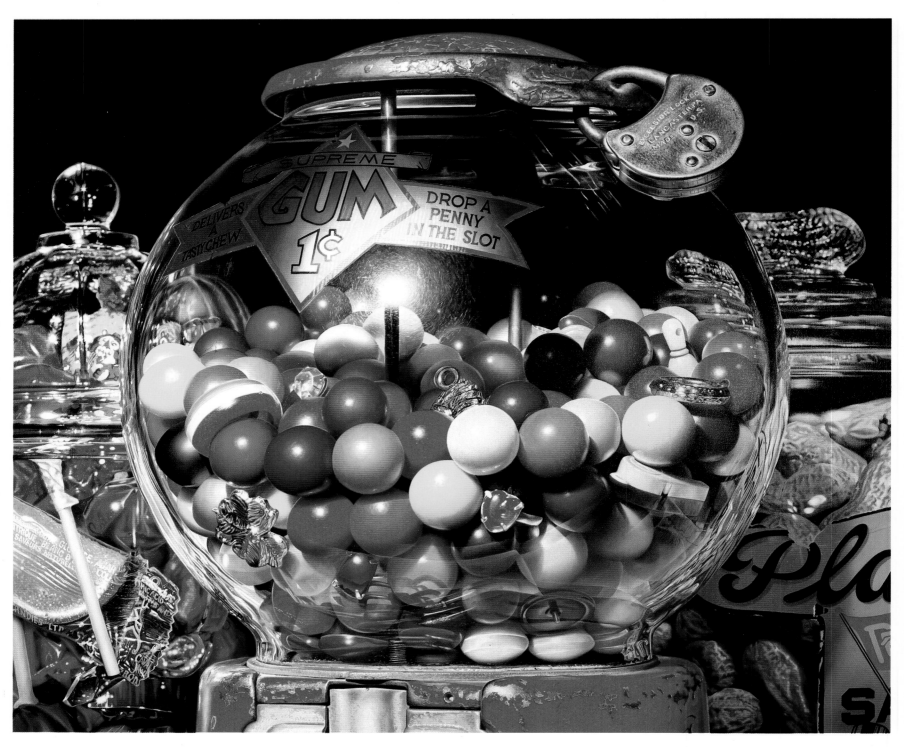

174. *"Drop a Penny in the Slot," Gumball XX.* 1988 (125). Oil on canvas, 72 x 84". Collection Donna and Neil Weisman, New Jersey

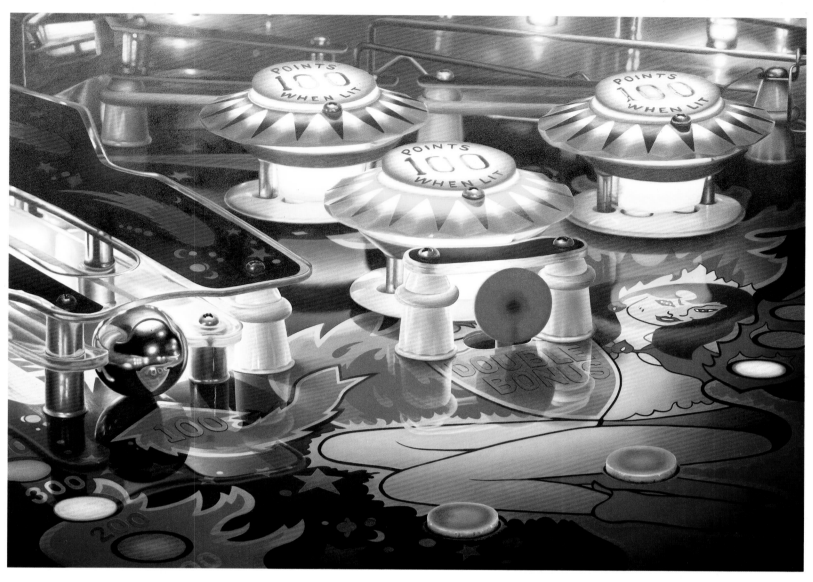

175. *Double Bonus.* 1987 (120). Oil on canvas, 60 x 84". Private collection, France

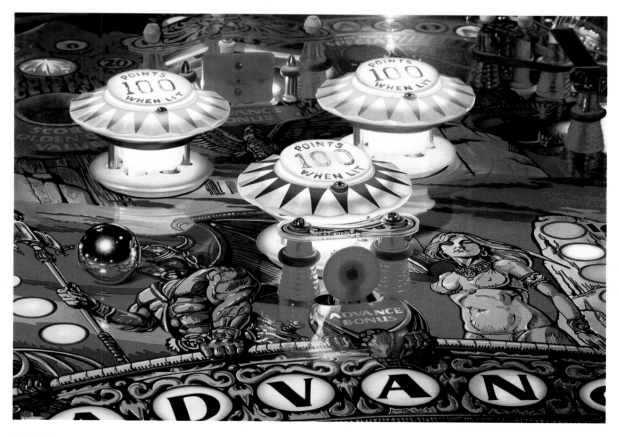

176. *Advance Bonus.* 1987 (118). Oil on canvas, 60 x 84". Private collection, California

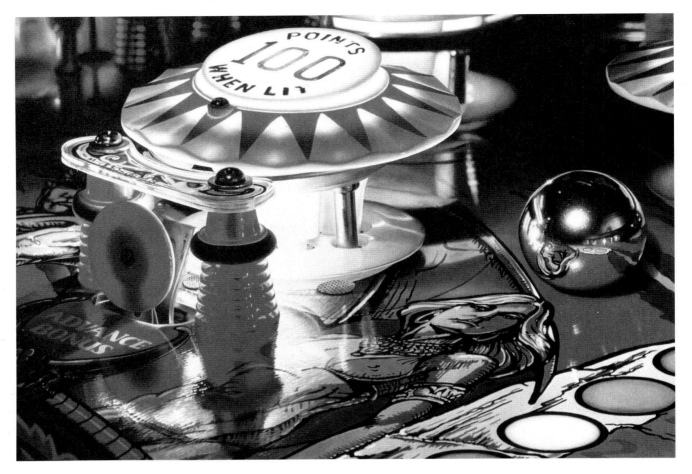

177. *Viking Strikes.* 1987 (121). Oil on canvas, 42 x 60". Collection Dale C. and Alexandra Zetlin Jones, New York

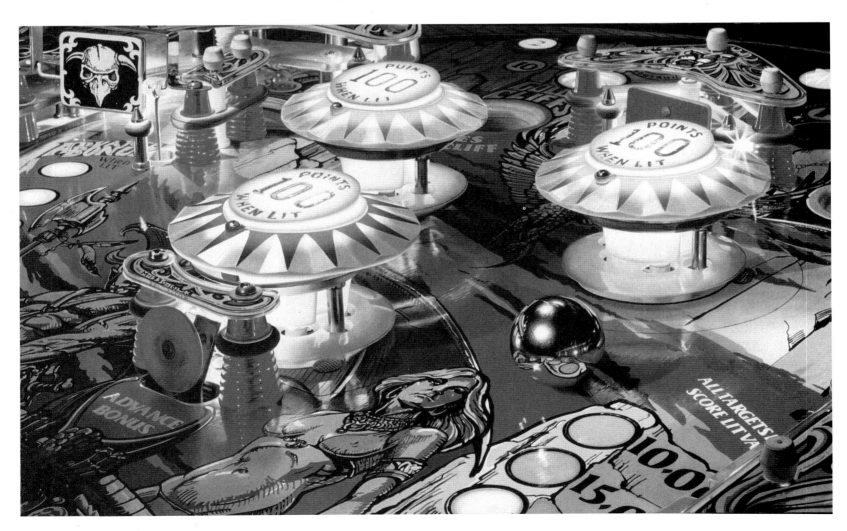

178. *1 to 4 Can Play.* 1988 (124). Oil on canvas, 60 x 96". Private collection, Switzerland

179. *25.* 1987 (119). Conté crayon on paper, 17 x 24".
Private collection, California

180. Study for *Double Bonus.* 1987 (122). Acrylic on Mylar, 11 x 15".
Private collection, Michigan

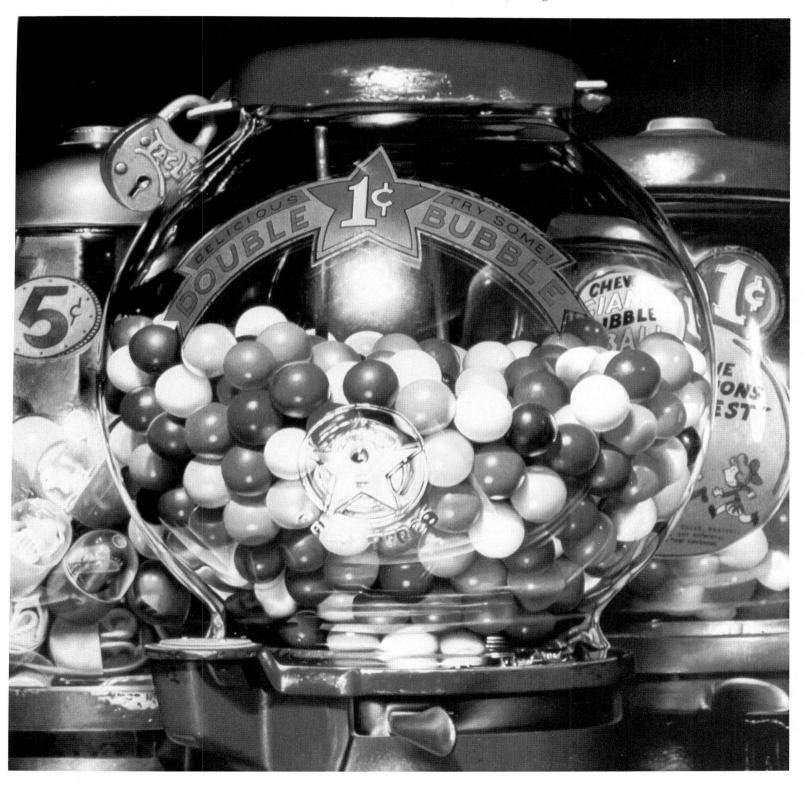

181. *"Double Bubble," Gumball XIX.* 1987 (117). Oil on canvas, 72 x 72". Private collection, Switzerland

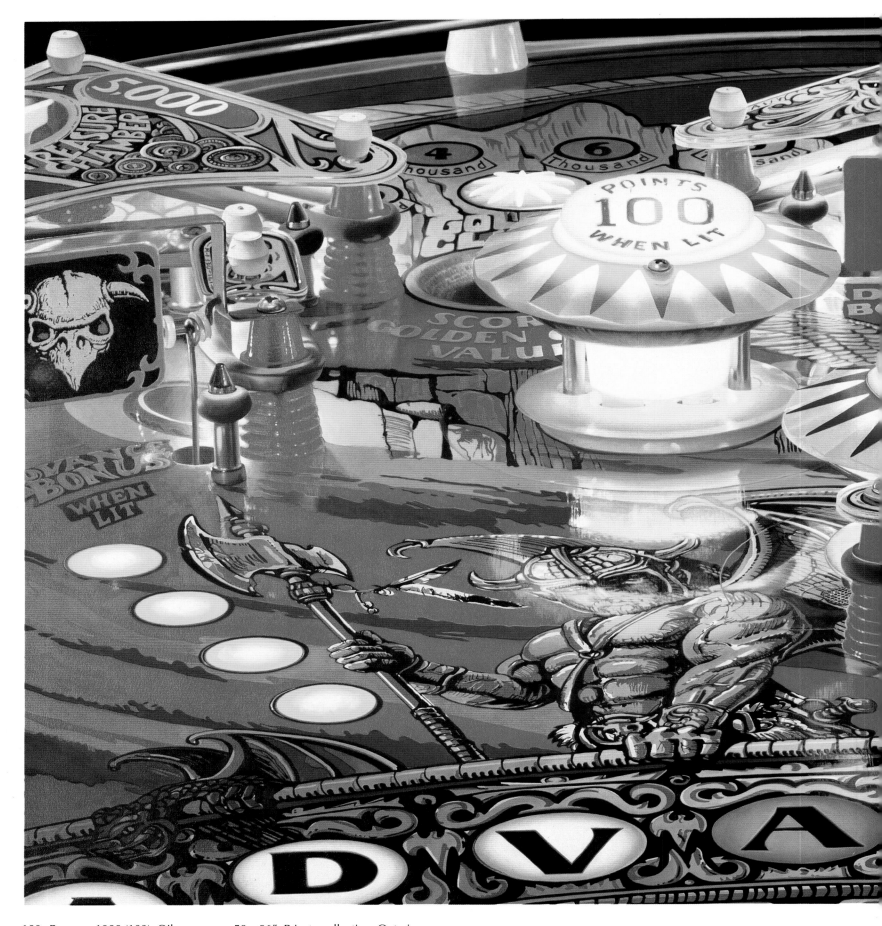

182. *Paragon.* 1988 (123). Oil on canvas, 50 x 96". Private collection, Ontario

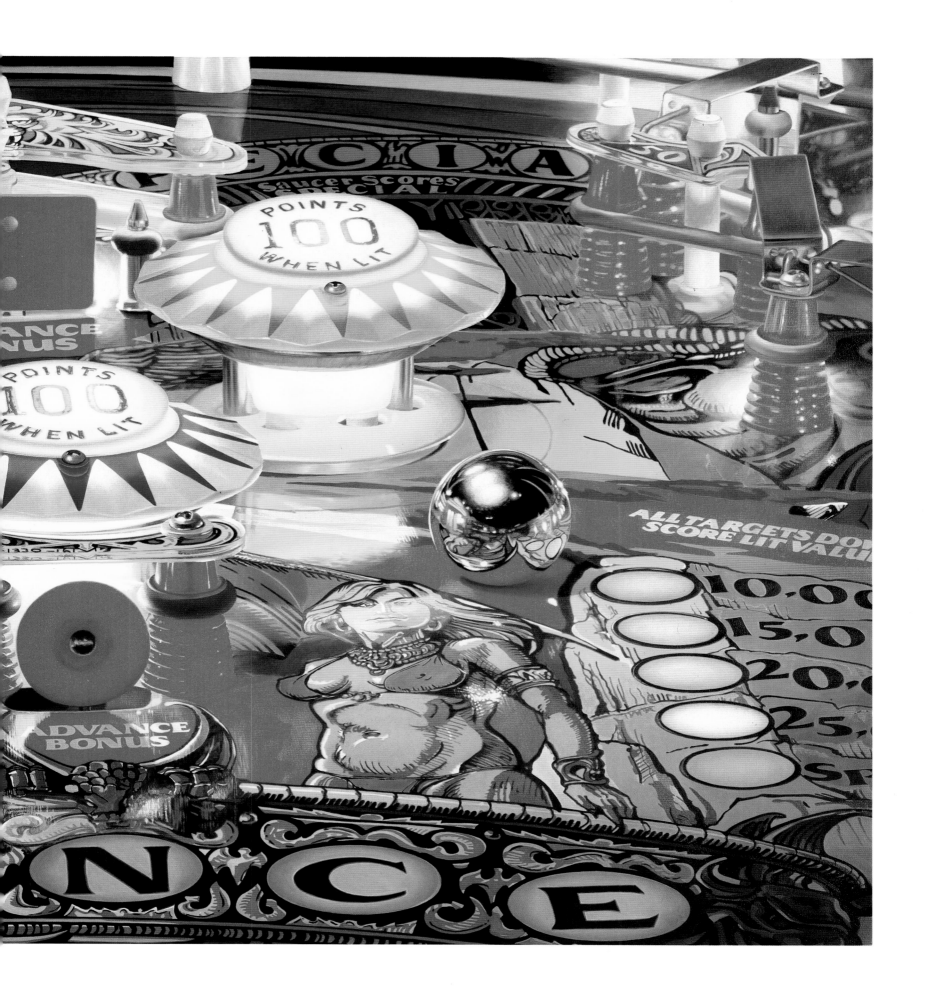

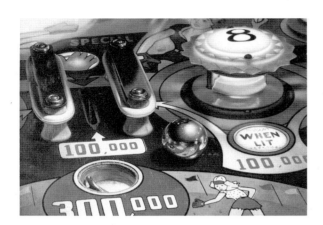

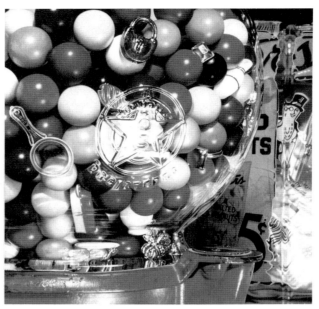

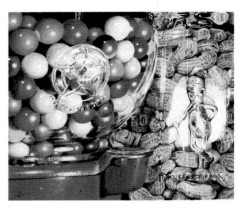

183. *Catcher.* 1988 (126).
Oil on canvas, 40 x 56". Collection David and
Jeanine Smith, California

184. *"1 Cent—5 Cents," Gumball XXI.* 1988 (127).
Oil on canvas, 60 x 60".
Private collection, Pennsylvania

185. *"Andy's Mr. Peanut," Gumball XXII.*
1990 (134). Watercolor, gouache, and pencil
on paper, 7½ x 8¾". Collection Bruce
Vinokour, California

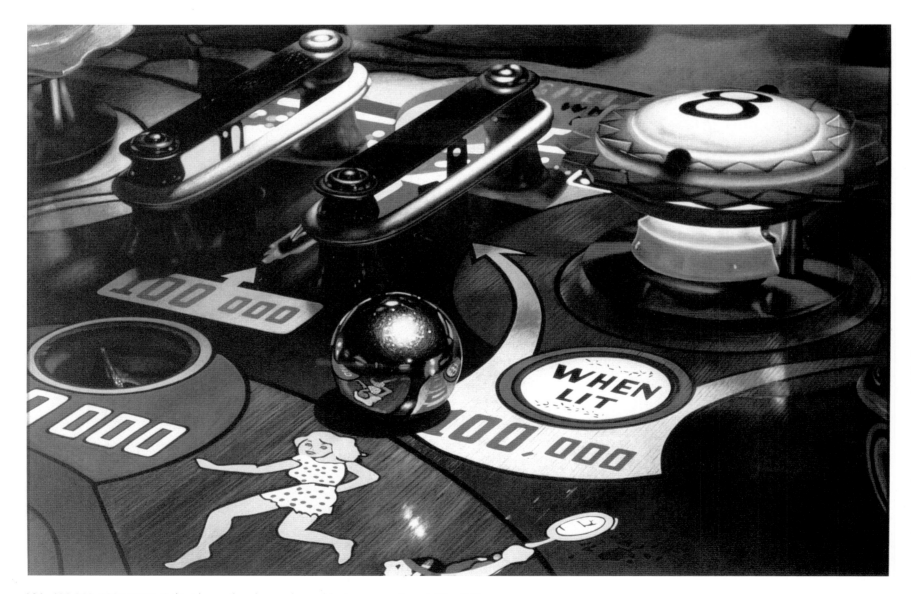

186. *100,000.* 1989 (129). Colored pencil and gouache on black museum board, 36 x 54".
Collection Mr. and Mrs. Roger D. Hecht, Ohio

187. *Miami Beach Watercolor.* 1989 (132).
Watercolor and gouache on board, 4½ x 6".
Collection Donna and Neil Weisman, New Jersey.
There is also 'an acrylic on Mylar maquette (1989;
133) for *Miami Beach*

188. *Miami Beach.* 1989 (131). Oil on canvas, 60 x 84".
Collection Louis K. and Susan Pear Meisel, New York

189. *Bingo!* 1989 (130). Colored pencil and gouache on black museum board, 40 x 60".
Private collection, Pennsylvania

190. *Dragnet.* 1988 (128).
Oil on canvas, 46 x 80".
Private collection, Tennessee

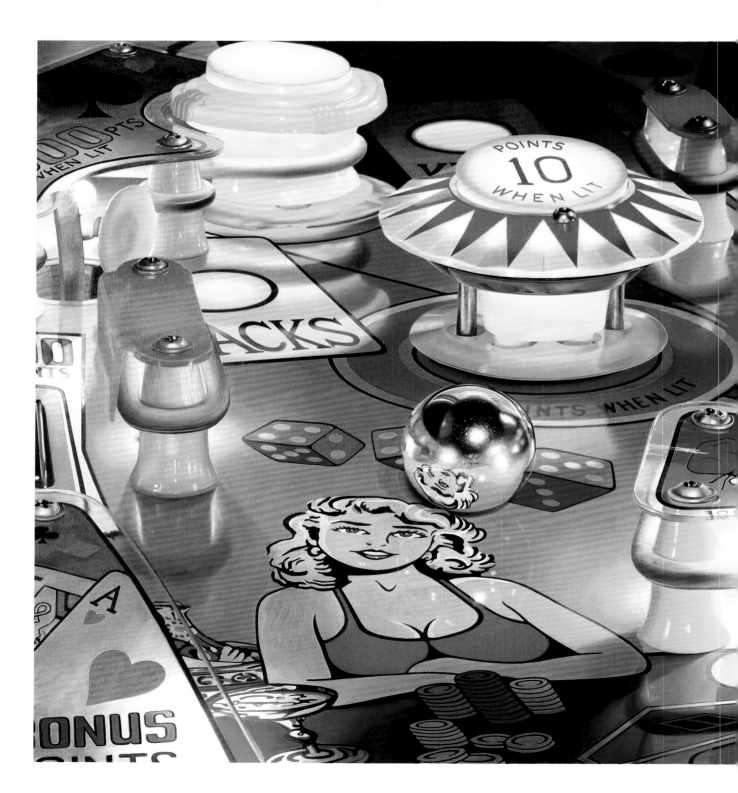

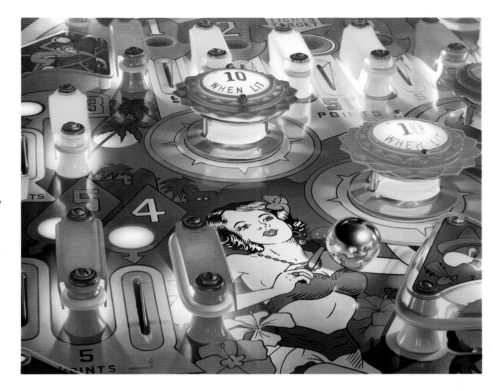

191. *Tropic Nights.* 1991 (144).
Oil on canvas, 67 x 84". Collection
Donna and Neil Weisman, New Jersey

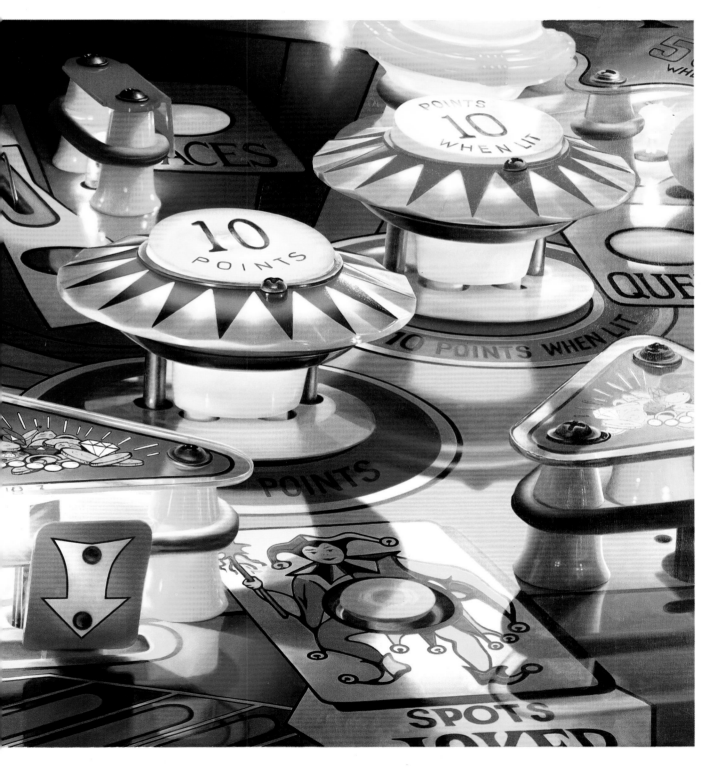

192. *Lucky Lady.* 1990 (135).
Oil on canvas, 50 x 96".
Collection Donna and
Neil Weisman, New Jersey

73

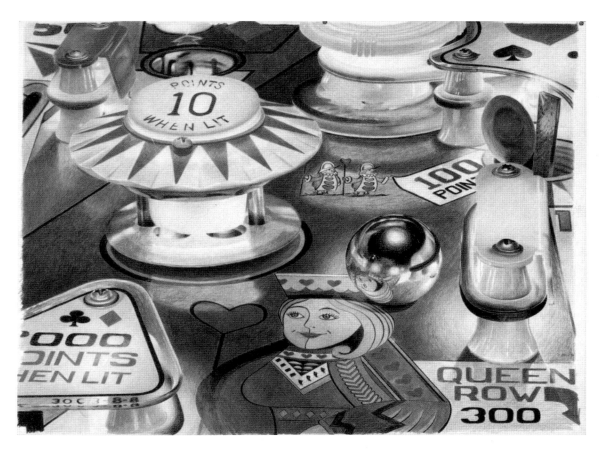

193. *Queen of Hearts.* 1990 (137). Colored pencil on museum board, 38 x 50".
Louis K. Meisel Gallery, New York

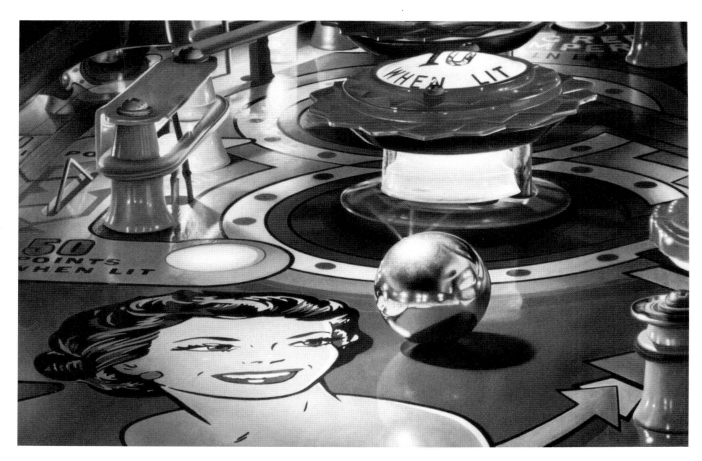

194. *50 Points when Lit.* 1990 (139). Oil on canvas, 36 x 54".
Private collection, Michigan

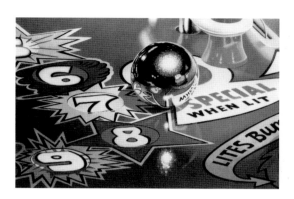

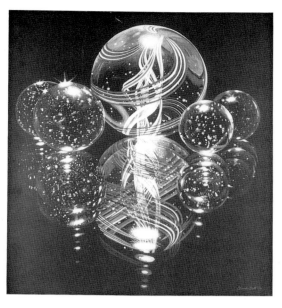

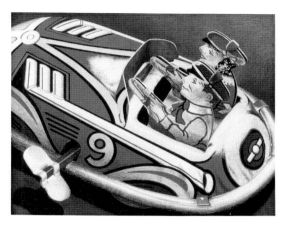

195. *5, 6, 7, 8, 9.* 1990 (141).
Gouache on paper, 11½ x 17¼".
PieperPower Companies, Inc., Wisconsin

196. *Clear Marbles.* 1990 (138).
Gouache and colored pencil on black paper,
21 x 19". Private collection, Switzerland

197. *Dodge 'Em.* 1990 (140).
Gouache and colored pencil on board, 24 x 30".
Private collection, Michigan

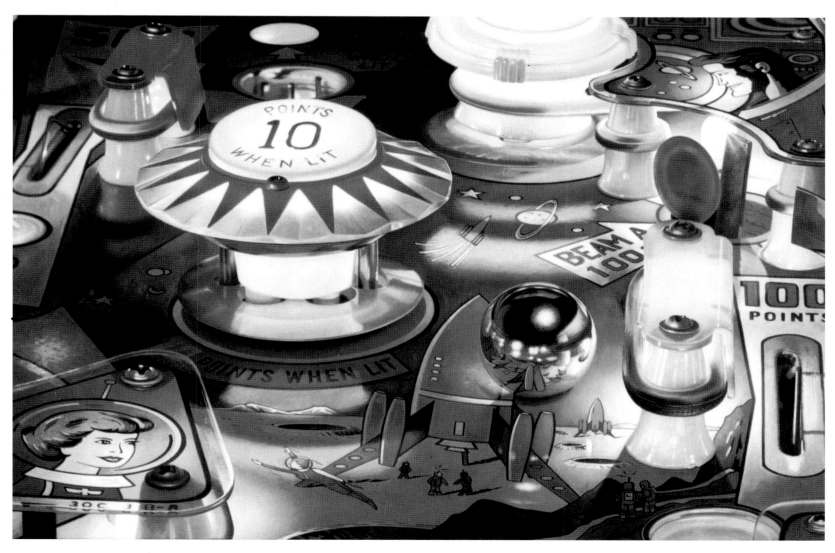

198. *Moon Mission.* 1990 (136). Oil on canvas, 48 x 72".
Private collection, Ontario

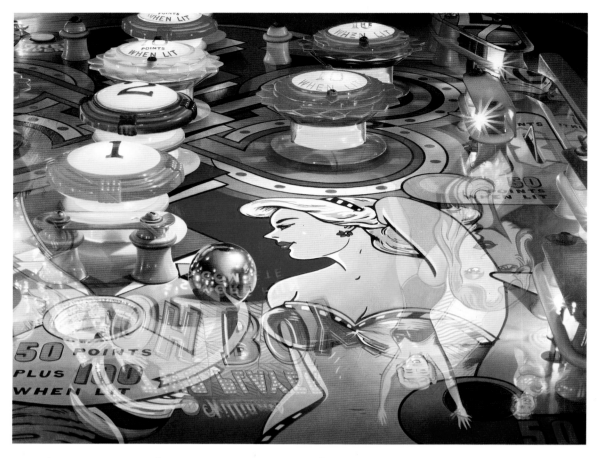

199. *Oh Boy.* 1990 (142). Oil on canvas, 66 x 84". Private collection, Ontario

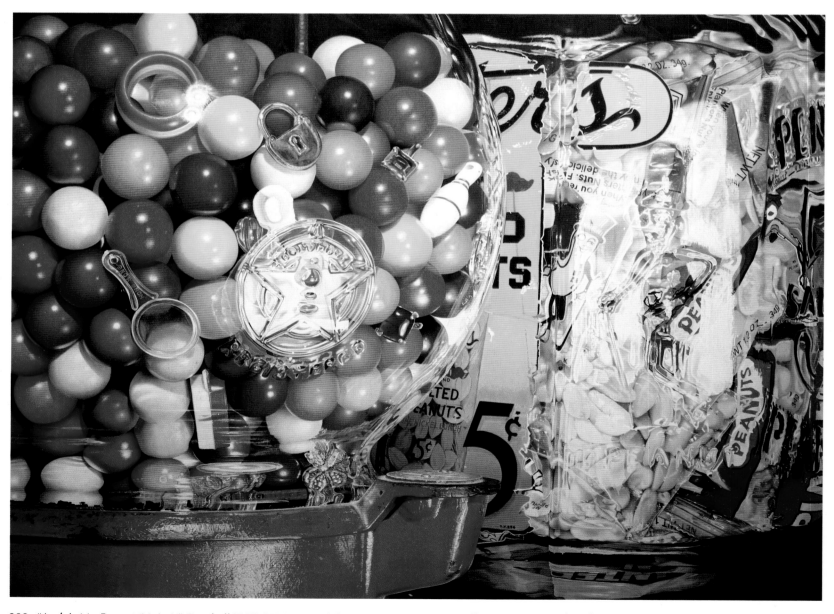

200. *"Andy's Mr. Peanut (Major)," Gumball XXIII.* 1991 (143). Oil on canvas, 90 x 120". Collection Donna and Neil Weisman, New Jersey

TOM BLACKWELL

Tom Blackwell's signature image in the formative years of Photorealism was the motorcycle; for many, his paintings of this subject came to symbolize the movement. At the end of the seventies, however, he began to explore another image: the storefront. Although he had touched on this subject in 1973 with *Main Street (Keene, N.H.)* (*P-R* pl. 188), in 1974 with *Takashimaya* (*P-R* pl. 158), and in 1975 with *GM Showroom* (*P-R* pl. 186), it wasn't until 1979 that he discovered the specific aspect of show windows that was to hold his attention for most of the eighties. In that year, he painted *Bendel's* (*P-R* pl.181), his final work of the decade and the first to contain mannequins.

With *Bendel's*, Blackwell began a series of display windows that contain mannequins but also reflect people on the street. These works have a particular kind of complexity that can arise only with the use of a camera: they are realist but also anti-realist. The mannequins are real but not real people; the real people exist only as reflections.

Although the storefronts occupied Blackwell for most of the decade, he did take several years out in the mid-eighties to experiment with another series of paintings. While not Photorealist (and not illustrated herein), these works feature various photo-derived images. While some of these have been shown, it is likely Blackwell will resolve the problems and ideas introduced in these works only in the nineties.

Blackwell has painted a total of 100 works as a Photorealist. *Photo-Realism* illustrates 48 of these and lists 7. He has completed 45 more works through 1990, all of which are illustrated herein.

201. *Gil's Yamaha.* 1980 (56). Watercolor on paper, 14½ x 18".
Collection Pierre and Sylvie Mirabaud, Switzerland

202. *Cardinal.* 1980 (57). Watercolor on paper, 13 x 20".
Private collection, New York

203. *A Life in Motion I.* 1980 (58). Oil on canvas, 60 x 84". Private collection, Michigan

204. *A Life in Motion II.* 1980 (59). Oil on canvas, 60 x 84". Archer M. Huntington Art Gallery, University of Texas at Austin. Archer M. Huntington Museum Fund, 1982

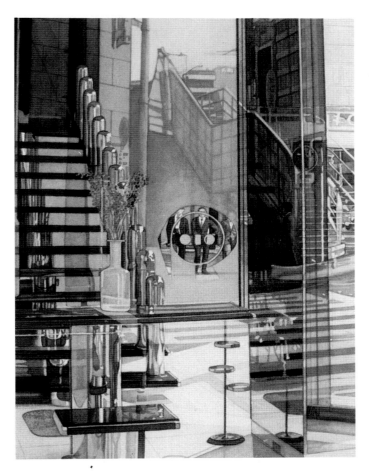

205. *Tokyo Showroom.* 1981 (60). Watercolor on paper, 22 x 14".
Fort Wayne Museum of Art, Indiana. Museum Purchase
with Funds from the National Endowment for the Arts and
the Alliance-Weatherhead Endowment

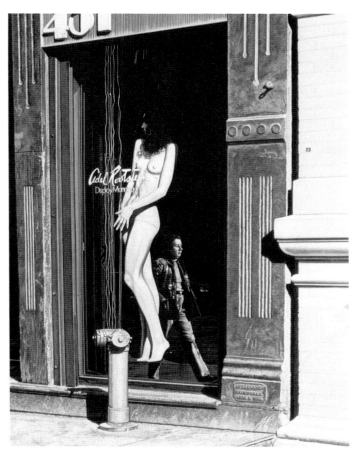

206. *Nude Mannequin.* 1981 (61). Oil on canvas, 48 x 36".
Private collection, Belgium

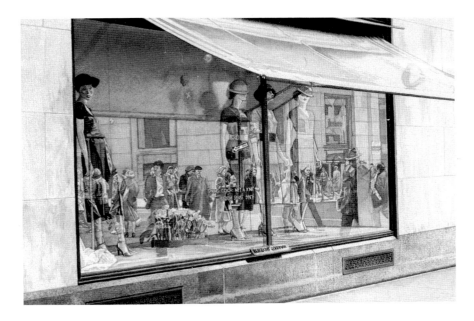

207. *Bergdorf-Tiffany.* 1981 (62). Watercolor on paper, 11 x 15½".
Private collection, New York

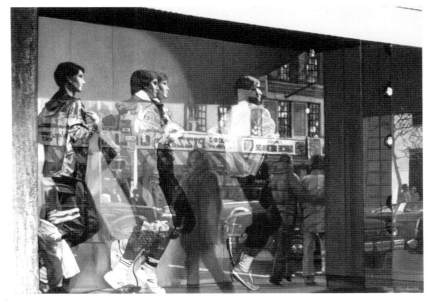

208. *Jogging Mannequins.* 1981 (65). Oil on Masonite, 10¾ x 15".
Private collection, New Jersey

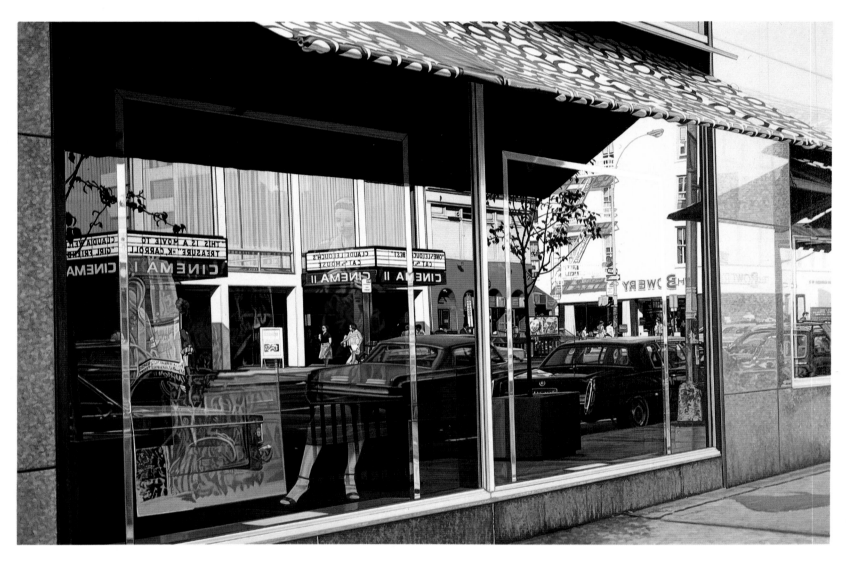

209. *Cinema I and II.* 1981 (63). Oil on canvas, 40 x 60". Private collection, New York

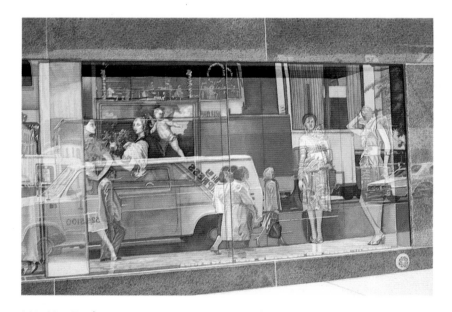

210. *Van Dyck at Bonwit's.* 1981 (64). Watercolor on paper, 22½ x 30".
Collection Glenn C. Janss, Idaho

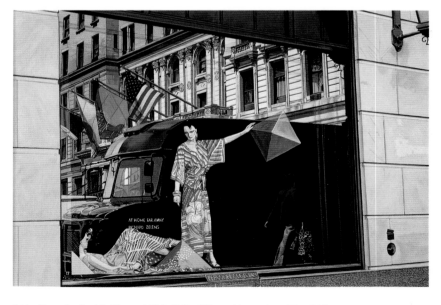

211. *Bergdorf with Flags.* 1982 (66). Oil on Masonite, 17 x 25".
Collection Pierre and Sylvie Mirabaud, Switzerland

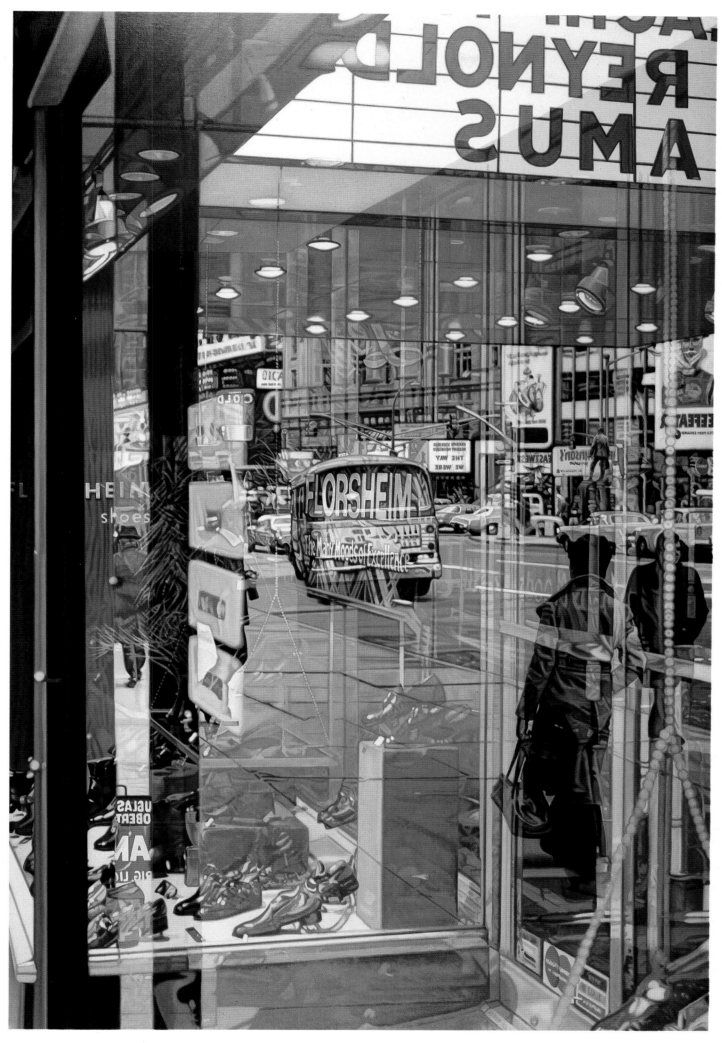

212. *Broadway.* 1982 (67). Oil on canvas, 90 x 60". Collection Muriel and Howard Weingrow, New York

213. *Jogging Mannequins.* 1982 (68). Oil on canvas, 72 x 108". Private collection, Germany

214. *La Shack.* 1982 (69).
Watercolor on paper, 15 x 22".
The Currier Gallery of Art, New Hampshire

215. *Saks.* 1982 (70).
Oil on canvas, 17½ x 25".
Private collection, Germany

216. *Blue Harley.* 1982 (71).
Watercolor on paper, 10¾ x 15¾".
Private collection, Belgium

217. *North Beach Leather.* 1983 (72). Oil on canvas, 42 x 62¼". Private collection, California

218. *Double Rainbow, Tucson.* 1983 (73). Oil on canvas, 42 x 62". The University of Arizona Museum of Art, Tucson

219. *Herald Square.* 1983 (75). Oil on canvas, 60 x 84".
Collection Mr. and Mrs. Bob M. Cohen, California

220. *Bonwit Teller.* 1990 (93). Watercolor on paper, 15 x 23".
PieperPower Companies, Inc., Wisconsin

221. *Piñata.* 1984 (80). Oil on canvas, 50 x 34".
Collection Victor Hofmann, Switzerland

222. *Bendel's II.* 1984 (77). Oil on canvas, 60 x 84". Private collection, New York

223. *North Beach Leather II.* 1984 (78). Oil on canvas, 34 x 50". Collection Zoë and Joel Dictrow, New York

224. *Bergdorf's and the Park.* 1984 (79). Oil on canvas, 33½ x 50". Collection Dale C. and Alexandra Zetlin Jones, New York

225. *Dressing Lights (Bergdorf's).* 1983 (76). Watercolor on paper, 14 x 21".
Collection Barry and Susan Paley, New York

226. *Harlow (Broadway and 46th).* 1983 (74).
Oil on canvas, 14 x 10". Collection
Pierre and Sylvie Mirabaud, Switzerland

227. *Sequined Mannequins.* 1985 (81). Oil on canvas, 60 x 78". Private collection, California

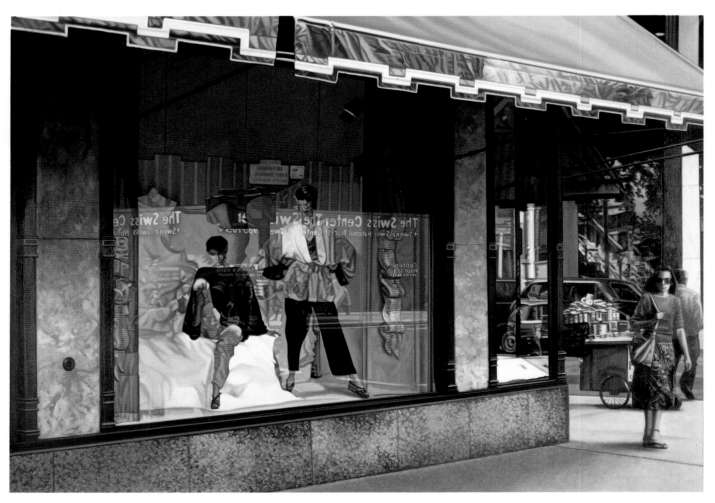

228. *Saks Fifth Avenue.* 1985 (83). Oil on canvas, 60 x 84". Private collection, California

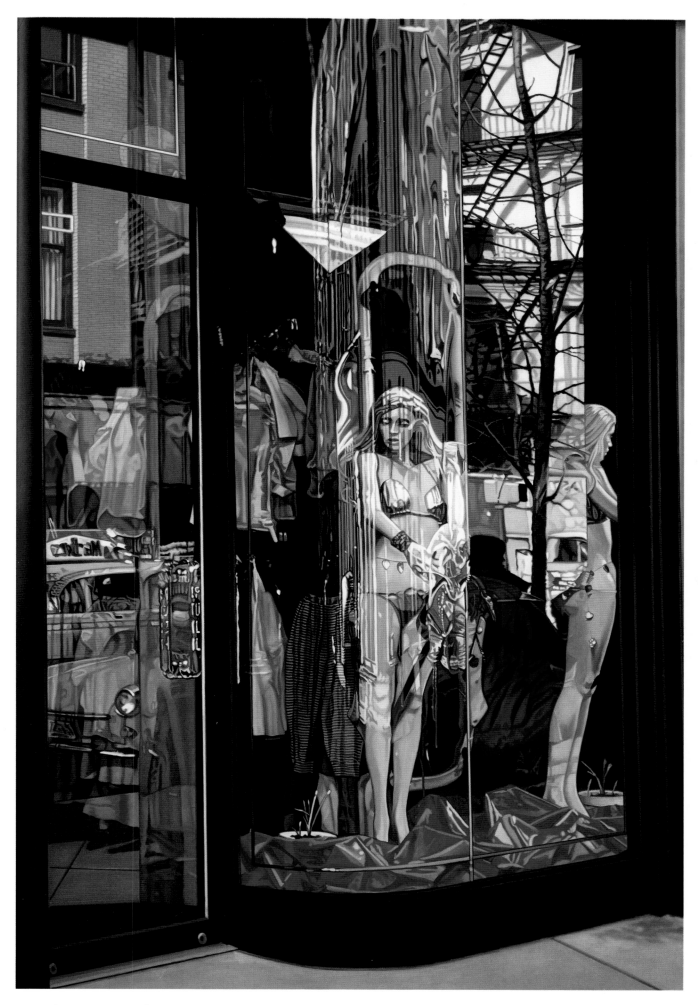

229. *Lulu's.* 1985 (82). Oil on canvas, 72 x 48". Collection Louis K. and Susan Pear Meisel, New York

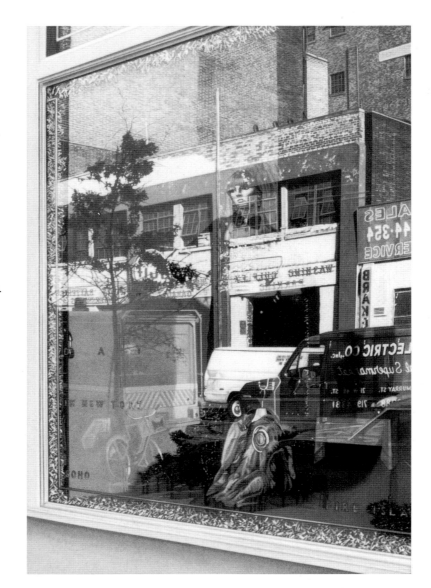

230. *Sunday in New York*. 1987 (84).
Oil on canvas, 40 x 60".
Private collection, California

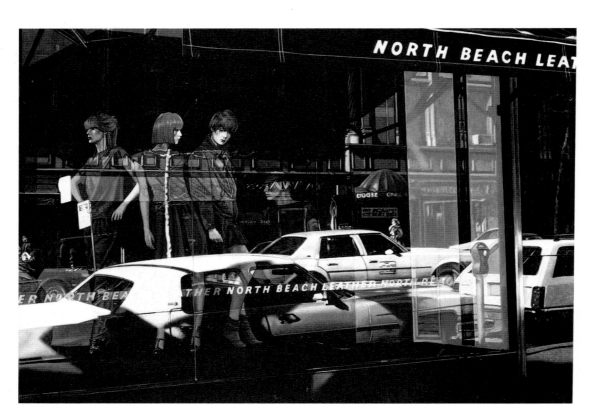

231. *North Beach Leather III*. 1988 (85). Oil on canvas, 22 x 32". Private collection, Switzerland

232. *Modesty under Construction.* 1988 (87). Oil on canvas, 36 x 48".
Private collection, Switzerland

233. *Chanel.* 1989 (89). Oil on canvas, 22 x 30".
Collection Mr. and Mrs. Roger D. Hecht, New York

234. *Ralph Lauren (Fist Full of Dollars).* 1989 (91). Oil on
canvas, 48 x 36". The Rheingold Collection, Massachusetts

235. *'47 Indian.* 1990 (95). Oil on linen, 36 x 24".
Private collection, Ontario

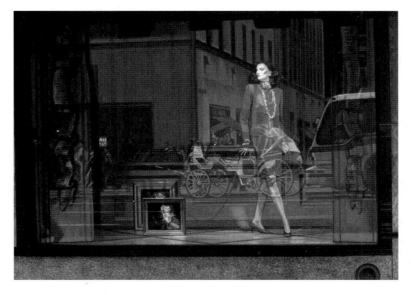

236. *Saks Fifth Avenue.* 1990 (92). Oil on canvas, 24 x 34".
Private collection

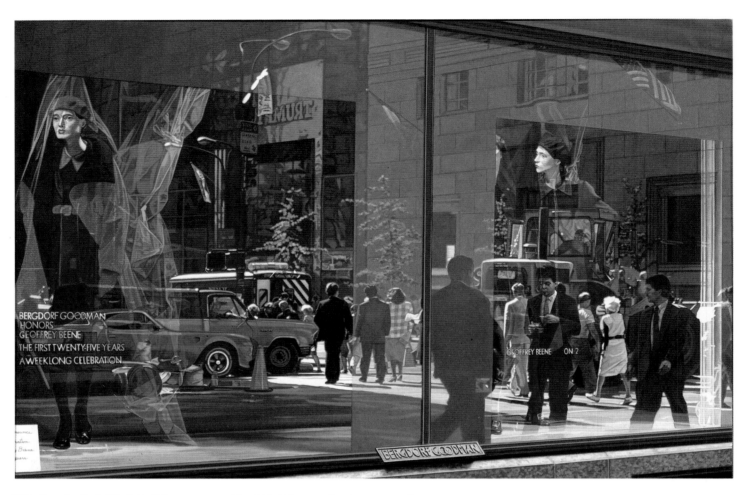

237. *Bergdorf's.* 1989 (88). Oil on canvas, 40 x 60". Private collection, Switzerland

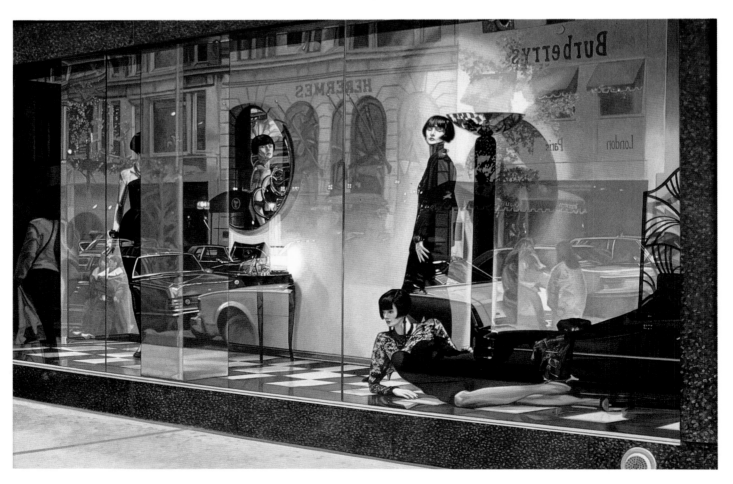

238. *Bonwit Teller.* 1989 (90). Oil on canvas, 40 x 60". Virlane Foundation, Louisiana

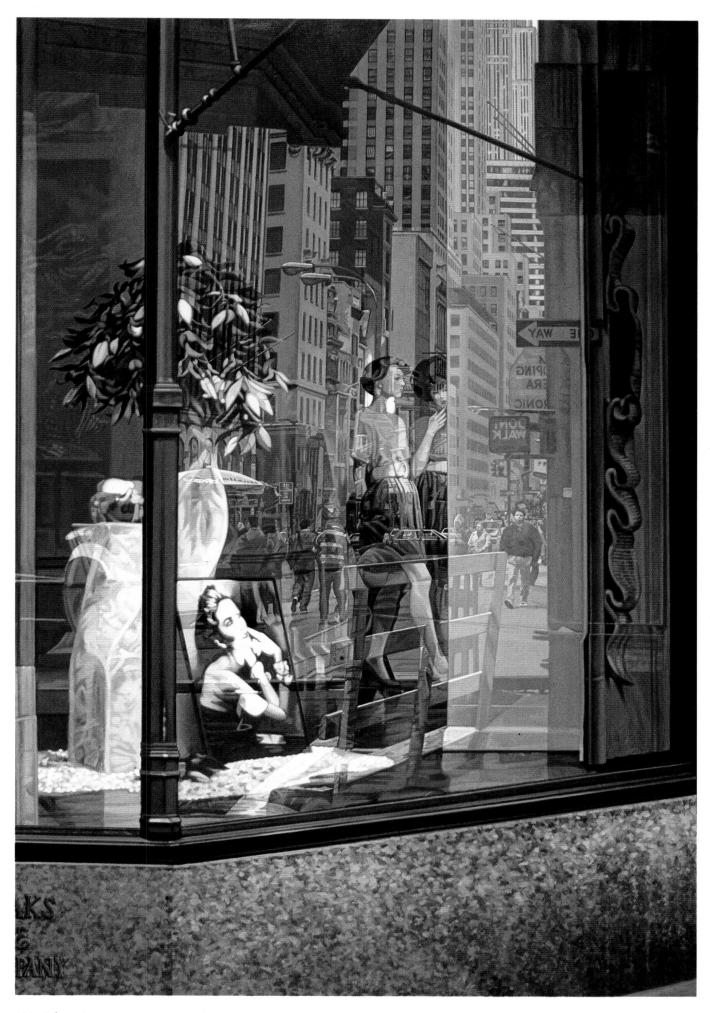

239. *Saks & Company.* 1988 (86). Oil on canvas, 72 x 48". Private collection, Switzerland

240. *Three Graces.* 1990 (94). Oil on linen, 42 x 62". Private collection, Tennessee

241. *Chanel Study.* 1990 (96).
Oil on board, 12 x 9".
Collection the artist

242. *Bloomie's.* 1990 (97).
Oil on board, 12 x 9".
Collection the artist

243. *American Flavor, L.A.* 1990 (98).
Oil on board, 12 x 9".
Collection the artist

244. *B. Altman's.* 1990 (99).
Oil on board, 12 x 9".
Collection the artist

245. *Saks Window with Panels.* 1990 (100). Oil on linen, 29¼ x 39¼".
Destroyed (painted over) in 1992

CHUCK CLOSE

Between 1967 and 1973, Chuck Close painted eight major black-and-white, nine-foot-high portraits and about ten other works that appeared as photographic as anything painted anywhere by anyone during those years. Close's portraits coincided with the emergence of photographic-looking paintings by about six or eight other artists, and along with the others, Close became inexorably associated with the movement called Photorealism. While his early fame was due almost entirely to the exhibition and publication of his first works in all the shows, books, and magazine articles devoted to the Photorealists, it soon became evident that Close's work was about a completely different set of ideas from those held by the rest of the group.

After making the initial decision to adopt the human face as his subject, Close spent a painstaking, disciplined three years producing the first eight major works. He then began to formulate the concepts under which he has worked, and seemingly will continue to work, throughout his art-making career. His subject matter and composition have remained constant from 1967 until the present. The thought process, the invention, in his work has consisted of finding new ways—new methods, techniques, tools, and materials—with which to continue making these same images.

Toward the end of the eighties, Close suffered a severe medical problem that destroyed part of the nervous system in his spine and deprived him of most of his mobility and dexterity. If he were a true Photorealist—and still occupied with the methods of work he was employing in the beginning—his career as a Photorealist painter would have ended. While there was much discussion and concern for him and his art at the time, it was also true that his art had always consisted of finding new ways to make art, and it was hoped that he would continue to do so.

With very little control of his arms and none over his fingers and

hands, Close discovered ways to make new marks on the canvas, and in the winter of 1991, he exhibited the most dynamic and inspiring group of paintings he has done to date. The scale is there, the strength and power have increased, and the impact may not be surpassed by a painter for some time to come.

Close had produced 100 works by the end of 1979, shortly before *Photo-Realism* was published. He has done a slightly greater number, 103, since; all of these are illustrated herein except for 5, which are listed.

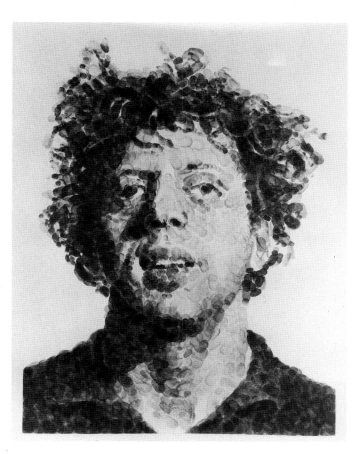

246. *Phil Fingerprint/Random*. 1979 (100).
Stamp-pad ink on paper, 40 x 26". Seattle Art Museum, Washington. Gift of the American Art Foundation

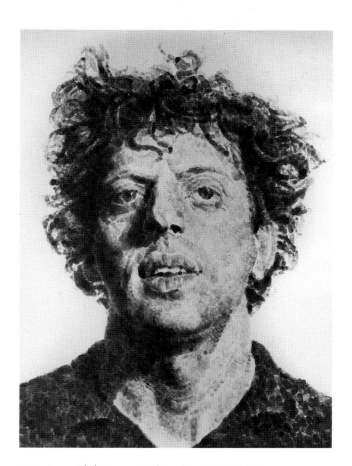

247. *Large Phil Fingerprint/Random*. 1979 (101).
Stamp-pad ink on canvas-backed paper, 58 x 41".
Private collection, California

248. *Keith/Square Fingerprint.* 1979 (102).
Stamp-pad ink on paper, 30 x 22½".
Reynolda House, North Carolina

249. *Keith/Watercolor.* 1979 (103).
Watercolor on paper, 30 x 22½".
Reynolda House, North Carolina

250. *Keith/Round Fingerprint.* 1979 (104).
Stamp-pad ink on paper, 30 x 22½".
Reynolda House, North Carolina

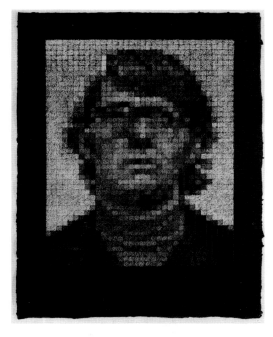

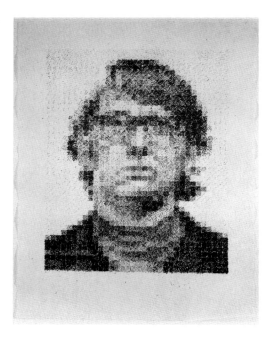

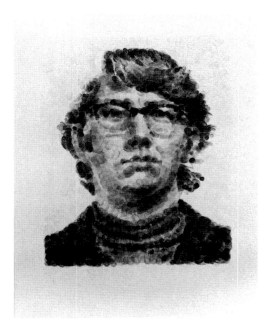

251. *Keith/White Conté Crayon.* 1979 (105).
Conté crayon and black gouache on paper, 30 x 22".
Reynolda House, North Carolina

252. *Keith/Ink Stick.* 1979 (106).
Ink on paper, 30 x 22".
Reynolda House, North Carolina

253. *Keith/Random Fingerprint.* 1979 (107).
Stamp-pad ink on paper, 30 x 22".
Reynolda House, North Carolina

254. *Practice Sheet.* 1979 (108).
Mixed mediums on paper, 30 x 22".
Reynolda House, North Carolina

255. *Stanley.* 1980 (111). Oil on canvas, 55 x 42".
Collection Mr. and Mrs. Charles M. Diker, New York

256. *Phil/Fingerprint.* 1980 (112). Stamp-pad ink on paper, 93 x 69".
Chase Manhattan Bank, New York

257. *Self-Portrait/Charcoal.* 1980 (115). Charcoal on paper, 43 x 30½".
Louis K. Meisel Gallery, New York

258. *Arne.* 1980 (117). Stamp-pad ink on gray paper, 42 x 30½".
The Pace Gallery, New York

259. *Phil (Houndstooth Check)*. 1980 (113). Ink and pencil on paper, 29½ x 22¼". Private collection, Michigan

260. *Georgia*. 1980 (118). Stamp-pad ink on paper, 43 x 30½". Private collection, California

261. *Frank*. 1980 (114). Stamp-pad ink on paper, 42¾ x 30¼". Private collection, Illinois

262. *Keith*. 1980 (119). Stamp-pad ink on paper, 30 x 22½". Galerie Isy Brachot, Belgium

263. *Self-Portrait.* 1980 (120).
Stamp-pad ink on gray paper, 15³/₄ x 11¹/₂".
Private collection, Minnesota

264. *Self-Portrait.* 1980 (121).
Stamp-pad ink on gray paper, 15³/₄ x 11¹/₂".
Private collection, California

265. *Keith.* 1980 (122).
Stamp-pad ink on gray paper, 15³/₄ x 11¹/₂".
Collection Dr. and Mrs. Paul Sternberg, Illinois

266. *Klaus.* 1980 (123).
Stamp-pad ink on gray paper, 15³/₄ x 11¹/₂".
Private collection, New York

267. *Frank.* 1980 (124).
Stamp-pad ink on gray paper, 15³/₄ x 11¹/₂".
Private collection, New York

268. *Self-Portrait.* 1980 (125).
Stamp-pad ink on gray paper, 15³/₄ x 11¹/₂".
Private collection, New York

269. *Phil.* 1980 (126). Stamp-pad ink on
gray paper, 15³/₄ x 11¹/₂". Collection
Louis K. and Susan Pear Meisel, New York

270. *Robert.* 1980 (127).
Stamp-pad ink on gray paper, 15³/₄ x 11¹/₂".
Private collection, New York

271. *Phil with Flowers.* 1980 (128). Stamp-
pad ink on water-marked paper, 11³/₄ x 8¹/₄".
Private collection, Connecticut

272. *Stanley*. 1981 (129). Oil on canvas, 101 x 84". The Solomon R. Guggenheim Museum, New York.
Purchased with Funds Contributed by Mr. and Mrs. Barrie M. Damson

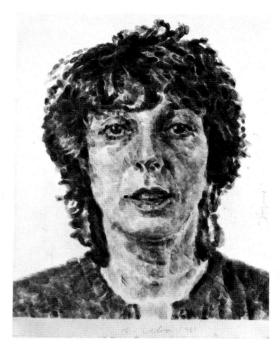

273. *Gwynne/Spray Watercolor.*
1981 (130). Watercolor on paper, 30 x 22½".
PieperPower Companies, Inc., Wisconsin

274. *Gwynne.* 1981 (131).
Stamp-pad ink on paper, 43¼ x 30½".
Collection Glenn C. Janss, Idaho

275. *Gwynne.* 1981 (132). Litho ink on gray paper,
28¾ x 21½". The Carnegie Museum of Art,
Pittsburgh, Pennsylvania. Wilbur Ross, Jr., Fund,
Mary Oliver Robinson Memorial Fund, Patrons Art
Fund, Contemporary American Drawings Fund,
and the National Endowment for the Arts, 1982

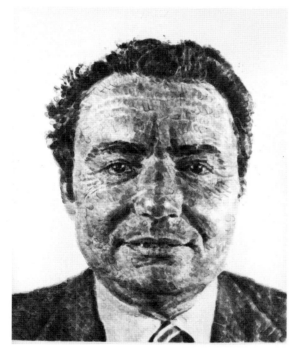

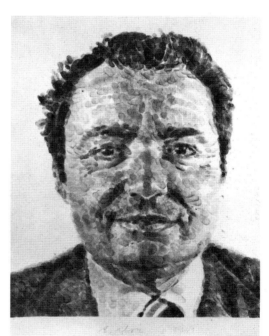

276. *Dick.* 1981 (133).
Litho ink on paper,
43¼ x 30½".
Private collection,
Colorado

277. *Dick.* 1981 (134).
Litho ink on gray paper,
28½" x 21½".
The Pace Gallery,
New York

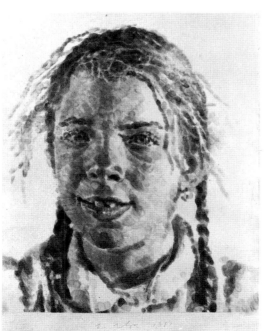

278. *Georgia.* 1981 (135).
Litho ink on gray paper,
28½ x 21½".
Louis K. Meisel Gallery,
New York

279. *Arnold.* 1981 (136).
Litho ink on gray paper,
15¼ x 11¼".
Collection Robert Harshorn
Shimshak, California

280. *Phyllis.* 1981 (137). Litho ink on gray paper, 57½ x 40¼".
Collection Robert M. Kaye, New Jersey

281. *Arne/Second Version.* 1981 (138). Litho ink on gray paper, 43 x 30½".
Art Institute of Chicago

282. *Jud/Profile.* 1981 (139). Litho ink on gray paper, 57½ x 40".
Private collection, Minnesota

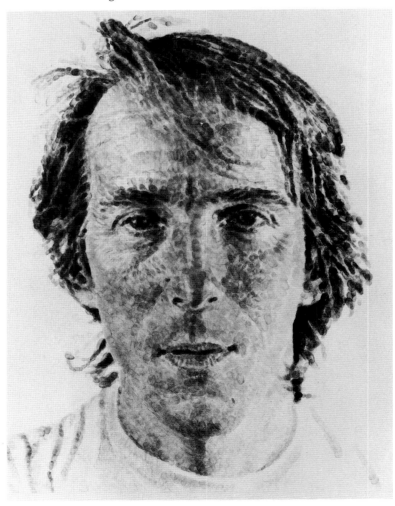

283. *Bevan.* 1981 (140). Litho ink on gray paper, 43 x 30¼".
American Medical Association, Washington, D.C.

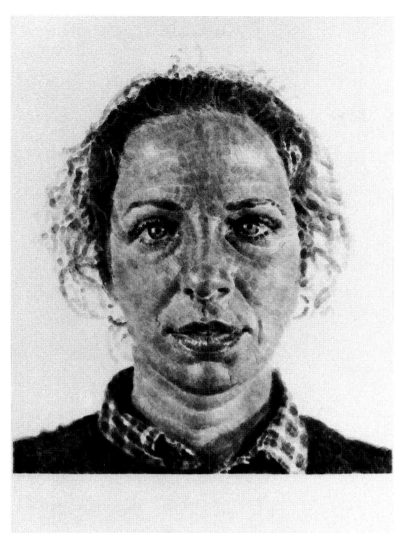

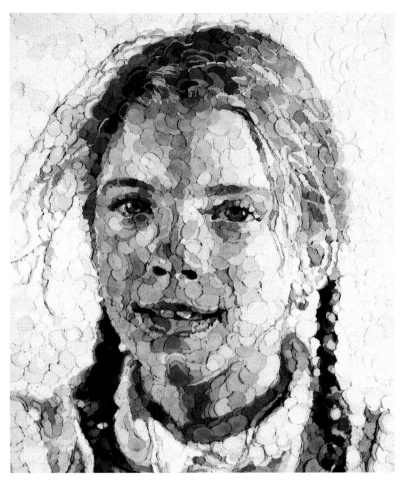

284. *Leslie.* 1981 (141). Litho ink on gray paper, 43 x 30½".
Collection Richard Brown Baker, New York

285. *Georgia/Collage.* 1982 (143). Pulp-paper collage on canvas,
48 x 37½". Collection the artist

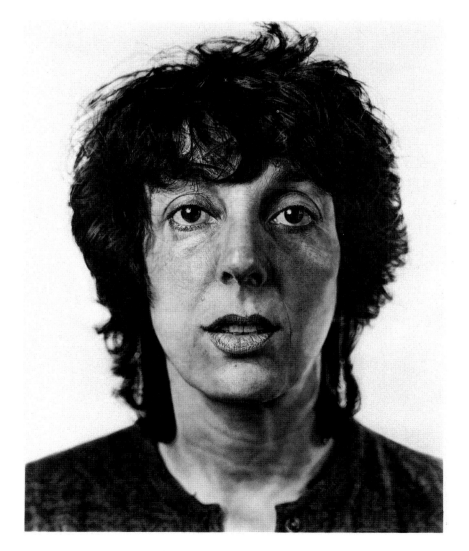

286. *Gwynne/Watercolor.*
1982 (142).
Watercolor on paper
laid down on canvas,
74¼ x 58¼".
Private collection,
Pennsylvania

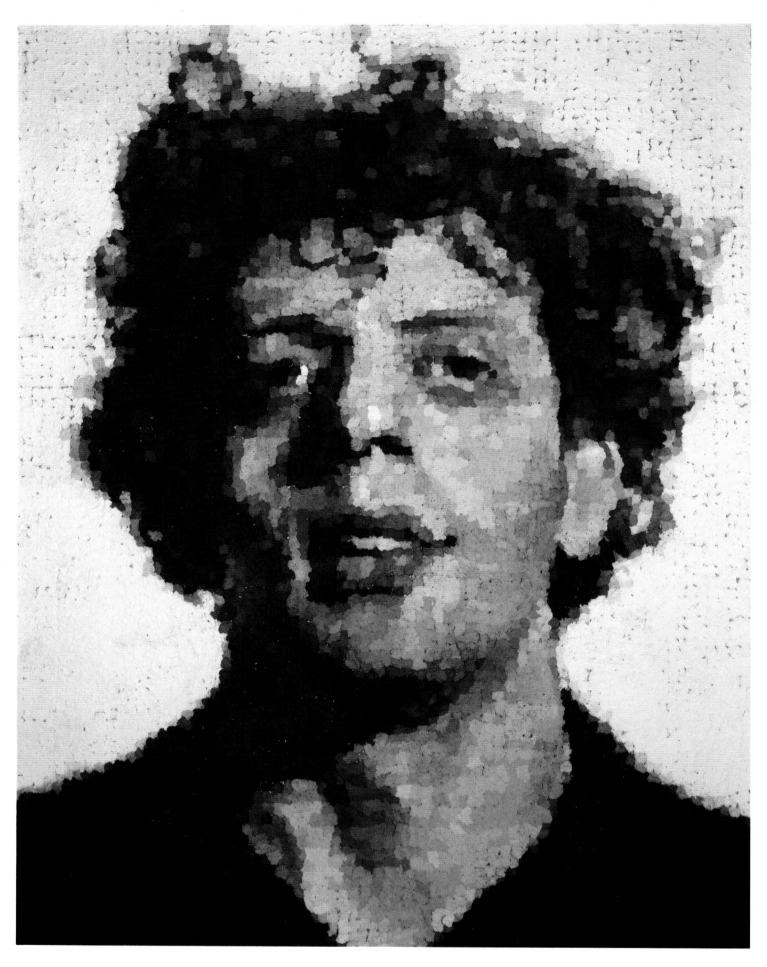

287. *Phil.* 1983 (151). Wet pulp paper on canvas, 92½ x 72½". Private collection, Illinois

288. *John/Progression*. 1983 (154). Litho ink on paper, 30 x 80". The Pace Gallery, New York

289. *Mark/Progression*. 1983 (155). Litho ink on paper, 30 x 80". Private collection, Sweden

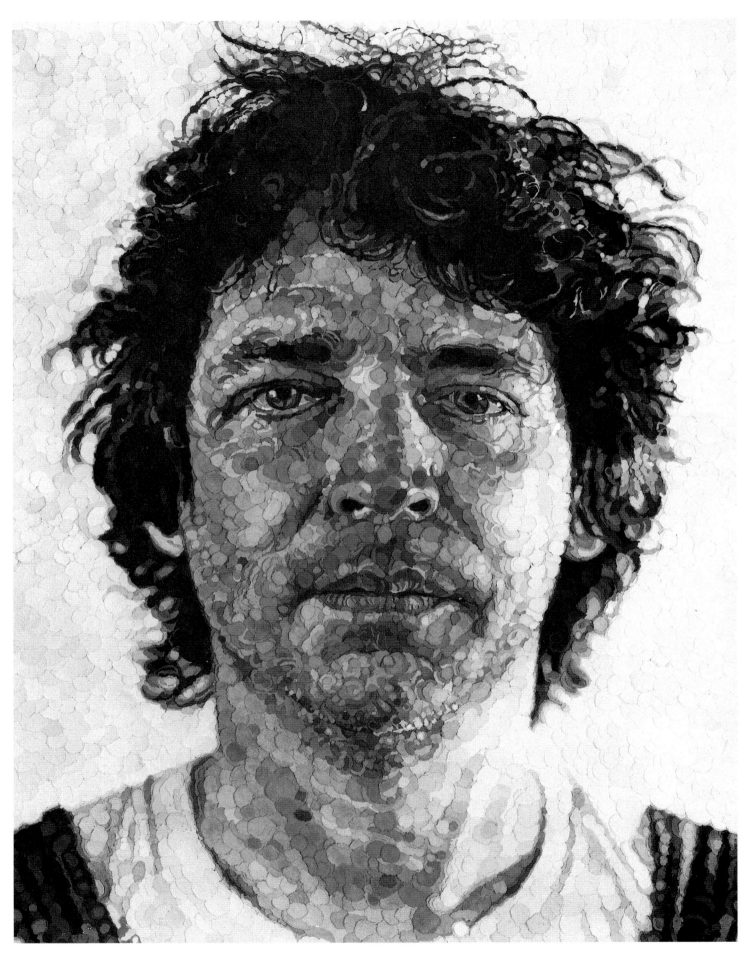

290. *Jud/Collage.* 1982 (144). Pulp-paper collage on canvas, 96 x 72". Virginia Museum of Fine Arts, Richmond. Gift of the Sydney and Francis Lewis Foundation

291. *Leslie/Collage.* 1982 (145).
Pulp-paper collage on canvas, 24 x 20".
Private collection, New York

292. *Phyllis/Collage.* 1982 (146).
Pulp-paper collage on canvas, 24 x 20".
Private collection, New York

293. *Dick/Collage.* 1983 (147).
Pulp-paper collage on canvas, 48 x 38".
Private collection, Colorado

294. *Phyllis/Wet Pulp.* 1983 (148). Pulp paper on canvas, 48 x 38".
The Pace Gallery, New York

295. *Self-Portrait/Wet Pulp.* 1983 (149). Pulp paper on canvas, 54 x 40".
Fuji Television Gallery, Japan

296. *John/Color Fingerprint.* 1983 (152).
Litho ink on paper, 30 x 22½".
Fuji Television Gallery, Japan

297. *Mark/Color Fingerprint.* 1983 (153).
Litho ink on paper, 30 x 22½".
Jan Krugier Gallery, New York

298. *John/Fingerprint.* 1984 (156).
Litho ink on paper, 48 x 38".
Private collection, New York

299. *Mark/Fingerprint.* 1984 (157).
Litho ink on paper, 49 x 38¼".
Private collection, Connecticut

300. *Mark/Fingerpainting.* 1984 (159).
Oil on canvas, 24 x 20".
Private collection, Illinois

301. *John/Fingerpainting.* 1984 (160).
Oil on canvas, 24 x 20". Collection
Diane and David Goldsmith, California

302. *Phyllis/Collage.* 1984 (161). Pulp-paper collage on canvas, 96 x 72". Private collection, Japan

303. *Marta.* 1984 (168).
Litho ink on silk paper, 19½ x 15½".
Collection Glenys and Kermit Birchfield, Georgia

304. *Arne.* 1984 (162).
Litho ink on silk paper, 19½ x 15½".
Collection David and Jeanine Smith, California

305. *Georgia/Fingerpainting.* 1984 (158).
Oil on canvas, 48 x 38."
Fuji Television Gallery, Japan

306. *Jane.* 1984 (163).
Litho ink on silk paper, 19½ x 15½".
Private collection

307. *Fanny.* 1984 (164). Litho ink on silk paper, 19½ x 15½". The Parrish Art Museum, Southampton, New York. Gift of the Friends of the Collection Committee

308. *Leslie.* 1984 (165).
Litho ink on silk paper, 19½ x 15½".
Collection Judith Harney, New York

309. *Georgia.* 1984 (166).
Litho ink on silk paper, 19½ x 15½".
Collection Georgia Close, New York

310. *Maggie.* 1984 (167).
Litho ink on silk paper, 19½ x 15½".
Collection Maggie Close, New York

311. *Emily.* 1984 (169).
Litho ink on silk paper, 19½ x 15½".
Hokin Gallery, Florida

312. *Shirley.* 1984 (170).
Litho ink on silk paper, 19½ x 15½".
Collection Sidney and George Perutz, Texas

313. *Bob.* 1984 (171).
Litho ink on silk paper, 19½ x 15½".
Private collection, Maryland

314. *Milly.* 1984 (172). Litho ink on silk paper, 19½ x 15½". Private collection, Maryland

315. *Fanny.* 1984 (173). Litho ink on gray paper, 24 x 18". Private collection, New York

316. *Sidney.* 1984 (174). Stamp-pad ink on paper, 30 x 22¼". Collection Sydney and Francis Lewis, Virginia

318. *Emily.* 1984 (175). Litho ink on gray paper, 24 x 18". The Pace Gallery, New York

317. *Georgia.* 1985 (176). Wet pulp paper on canvas, 96 x 72". Collection Sidney and George Perutz, Texas

319. *Georgia/Fingerpainting.* 1986 (181). White oil-based ink on black acrylic-washed and gessoed canvas, 48¼ x 38⅛". Collection Sidney and George Perutz, Texas

320. *Fanny/Fingerpainting.* 1985 (177). Oil on canvas, 102 x 84". National Gallery of Art, Washington, D.C. Lila Acheson Wallace Fund

321. *Alex*. 1987 (190). Oil on canvas, 100 x 84". The Toledo Museum of Art, Ohio. Gift of The Apollo Society

322. *Leslie/Pastel.* 1985 (178). Pastel and watercolor on formed paper, 42 x 32".
Private collection, New York

323. *Leslie/Fingerprint.* 1985 (179). Ink on silk paper, 24 x 18". Whereabouts unknown

324. *Leslie/Watercolor I.* 1986 (184). Watercolor on paper, 30½ x 22¼". Collection James and Barbara Palmer, Pennsylvania

325. *Marta/Fingerpainting.* 1986 (182). White oil-based ink on black acrylic-washed and gessoed canvas, 24 x 20".
Private collection, New York

326. *Susan.* 1987 (191). Oil on canvas, 24 x 20". Collection Louis K. and Susan Pear Meisel, New York

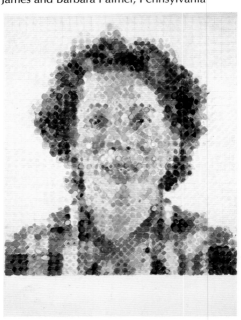

327. *Leslie/Watercolor II.* 1986 (185). Watercolor and gouache on paper, 30½ x 22¼". Collection Sidney and George Perutz, Texas

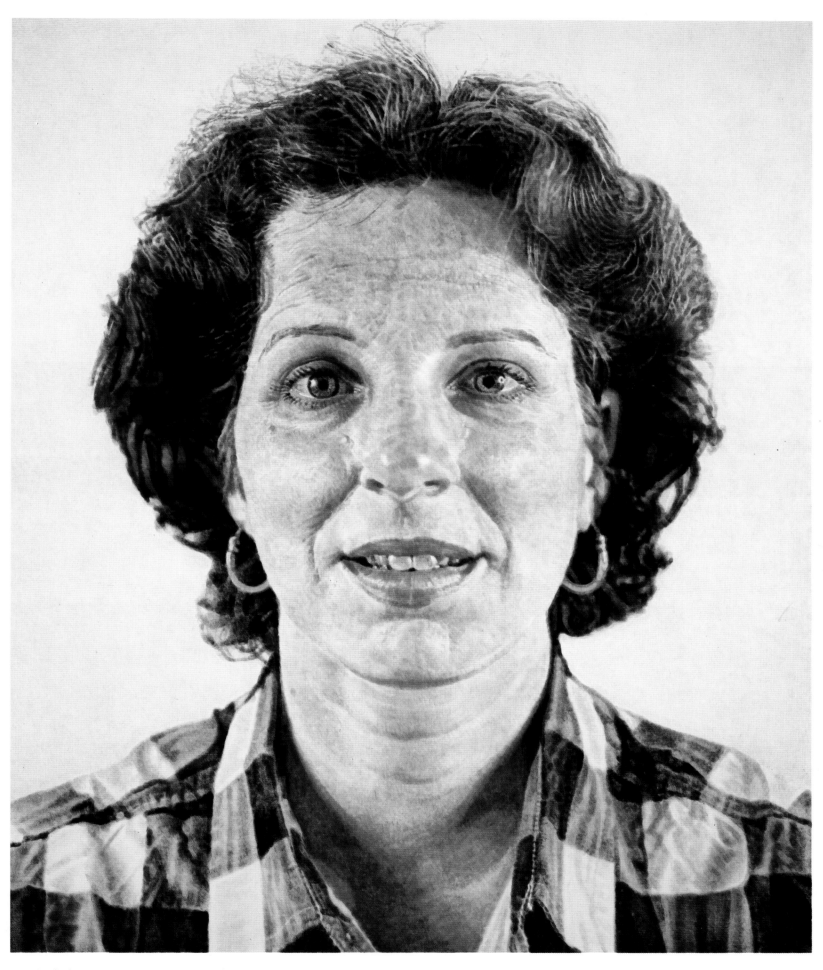

328. *Leslie/Fingerpainting.* 1986 (180). Oil on canvas, 102 x 84". Collection Mr. and Mrs. Michael S. Ovitz, California

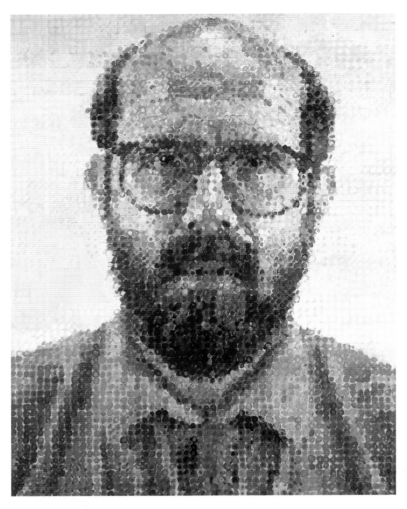

329. *Self-Portrait.* 1986 (183). Oil on canvas, 54½ x 42¼".
Collection David and Jeanine Smith, California

330. *Lucas II.* 1987 (188). Oil on canvas, 36 x 30".
Collection the artist

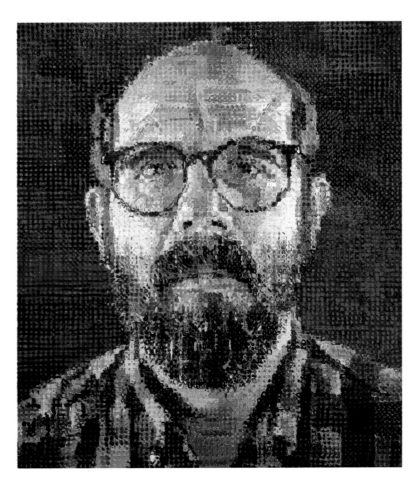

331. *Self-Portrait.* 1987 (189). Oil on canvas, 72 x 60".
Collection Sidney and George Perutz, Texas

332. *Cindy II.* 1988 (194). Oil on canvas, 72 x 60".
Private collection, New York

333. *Lucas I.* 1987 (187). Oil on canvas, 100 x 84". The Metropolitan Museum of Art, New York.
Purchase 1987, Lila Acheson Wallace Gift and Gift of Arnold and Milly Glimcher

334. *Francesco I.* 1988 (192). Oil on canvas, 100 x 84". Private collection, Ohio

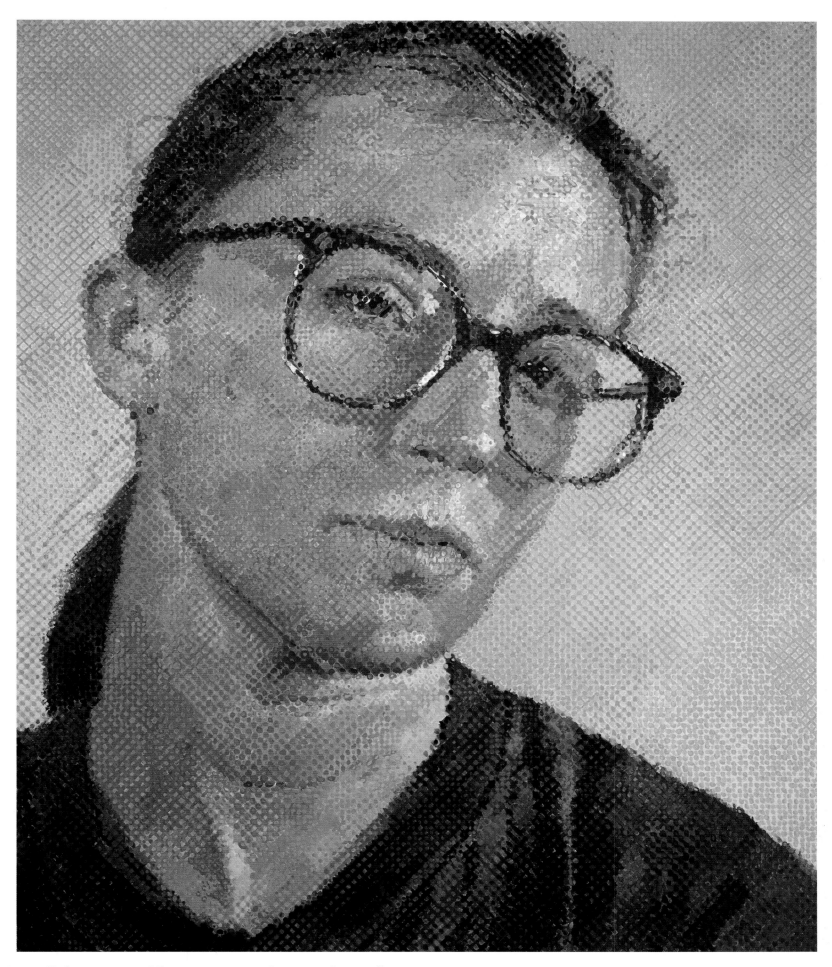

335. *Cindy I.* 1988 (193). Oil on canvas, 102 x 84". Private collection, Illinois

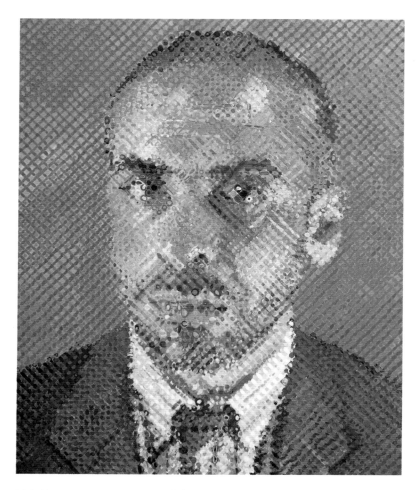

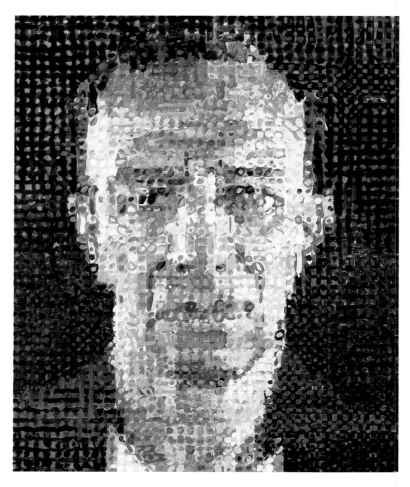

336. *Francesco II.* 1988 (195). Oil on canvas, 72 x 60".
Private collection, New York

337. *Alex II.* 1989 (196). Oil on canvas, 36 x 30".
Collection the artist

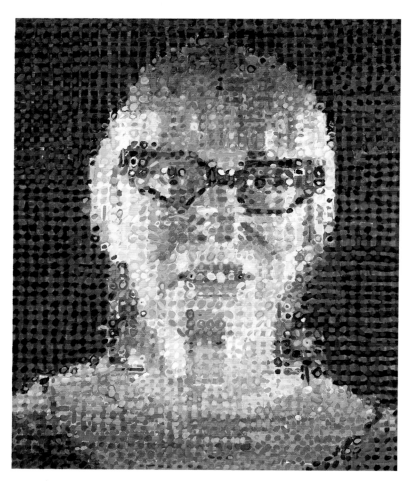

338. *Janet.* 1989 (197). Oil on canvas, 36 x 30".
The Pace Gallery, New York

339. *Elizabeth.* 1989 (198). Oil on canvas, 72 x 60".
Private collection

340. *Eric.* 1990 (201). Oil on canvas, 100 x 84". Private collection

341. *Judy.* 1989 (199). Oil on canvas, 72 x 60". Private collection

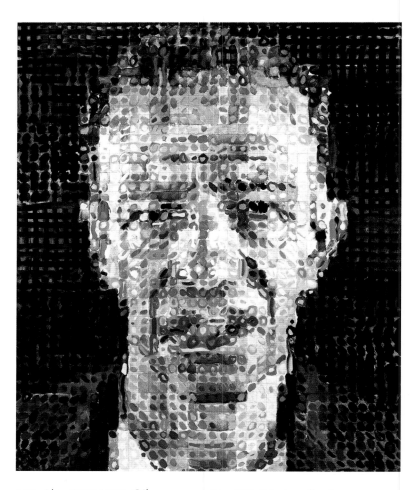

342. *Alex.* 1990 (200). Oil on canvas, 36 x 30". Private collection

343. *Bill.* 1990 (202). Oil on canvas, 72 x 60". Private collection

NOT ILLUSTRATED
Linda. 1979 (109).
Oil on paper, 30 x 22½".
Private collection
Linda. 1979 (110).
Oil on paper, 30 x 22½".
Private collection
Robert/Charcoal. 1980 (116).
Charcoal on paper, 42¾ x 30¼".
Private collection
Arne. 1983 (150).
Wet pulp paper on canvas, 24 x 20".
Private collection
Marta. 1986 (186).
Litho ink on silk paper, 18 x 24".
Private collection, New York

DAVIS CONE

Davis Cone's career began approximately five years after Photorealism's formative years ended in 1973; he is, in my opinion, the only true second-generation Photorealist. By 1973, the ideas and images of the movement had been established and widely disseminated by exhibitions and publications, and numerous young artists attempted to follow in the footsteps of the leaders. Almost all found this task to be too difficult and demanding, and of this early group of younger artists, only one, Davis Cone, succeeded. (Later on, in the eighties, there were indeed more successes, most notably, in the work of Dudley, Fox, Gniewek, Heinze, Jacot, and Milici.) By using the term "second generation" and referring to the work of the eighties artists, I do not mean to imply that such artists are derivative. On the contrary, they have all brought to the style new ideas and imagery as well as differing, but always skilled and disciplined, techniques.

In his career, Cone has focused unwaveringly on old movie theaters, both urban and suburban, as his subject matter. Although Richard Estes explored the same image in several paintings in 1968, it has since been Cone's exclusive domain. His obsession with the classic American movie theater is similar to John Baeder's with the American diner, but Cone is less interested in pure documentation than Baeder is. He has used his selected image in many different ways, as a challenge to his extremely well developed technical prowess. Cone has chosen photos shot from various angles, utilizing different lighting situations, and taken in all kinds of weather. He has learned to portray fluorescent, incandescent, and neon light. He has painted both day and night images and all sorts of weather—whether sunny, gray, rainy, or misty. Cone's attention to detail, his self-discipline, and his feeling for composition, form, and color have served to make him one of the most consistent of Photorealist artists.

Illustrated here are all 41 works Cone created in the eighties, 31 of which are paintings and 10 watercolors.

344. *Show*. 1980 (1). Acrylic on canvas, 64½ x 41".
O. K. Harris Works of Art, New York

345. *Silver Frolics*. 1980 (2). Acrylic on canvas, 38 x 48".
Private collection, Massachusetts

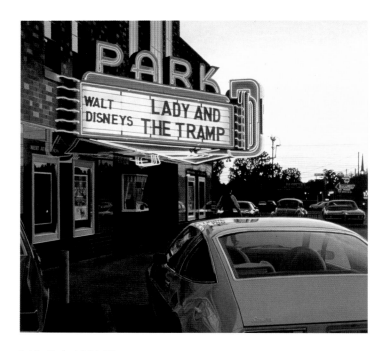

346. *Park.* 1980 (3).
Acrylic on canvas, 43½ x 47".
Private collection, Pennsylvania

347. *Wilkes.* 1981 (6). Acrylic on canvas, 45 x 45".
Collection Richard Brown Baker, New York

348. *Martin.* 1980 (4).
Acrylic on canvas,
35½ x 47½".
Private collection,
Switzerland

349. *Wink.* 1981 (7). Acrylic on canvas, 42½ x 47½".
Collection Barry and Susan Paley, New York

350. *Martin: Talledega.* 1981 (8). Acrylic on canvas,
43 x 40". Private collection, New York

351. *Thompson*. 1980 (5). Acrylic on canvas, 55 x 39". Private collection, Switzerland

352. *Avon.* 1982 (9). Acrylic on canvas, 60 x 41½". Private collection, England

353. *Sam Eric.* 1982 (10). Acrylic on canvas, 30¾ x 40½". Private collection, Florida

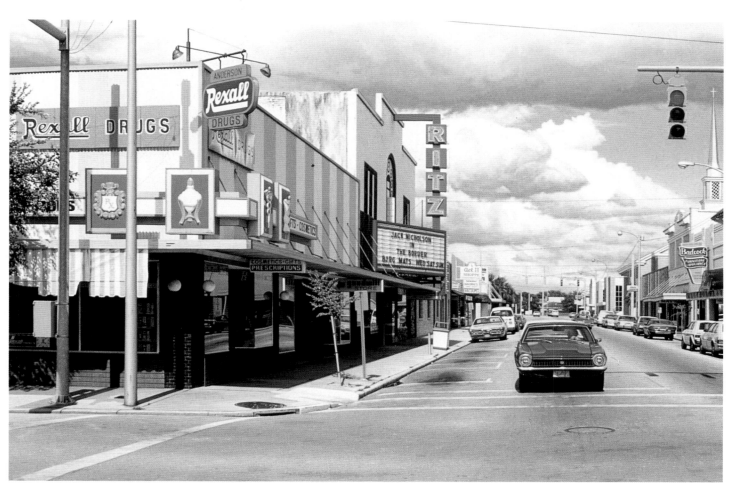

354. *Ritz.* 1982 (11). Acrylic on canvas, 37 x 54". Private collection, Tennessee

355. *Marion.* 1982 (12). Acrylic on canvas, 47 x 40".
Private collection, Florida

356. *Time.* 1983 (15). Acrylic on canvas, 59¼ x 45¾".
Private collection, New York

357. *Pitman.* 1983 (13).
Acrylic on canvas, 54 x 39¾".
Private collection, Switzerland

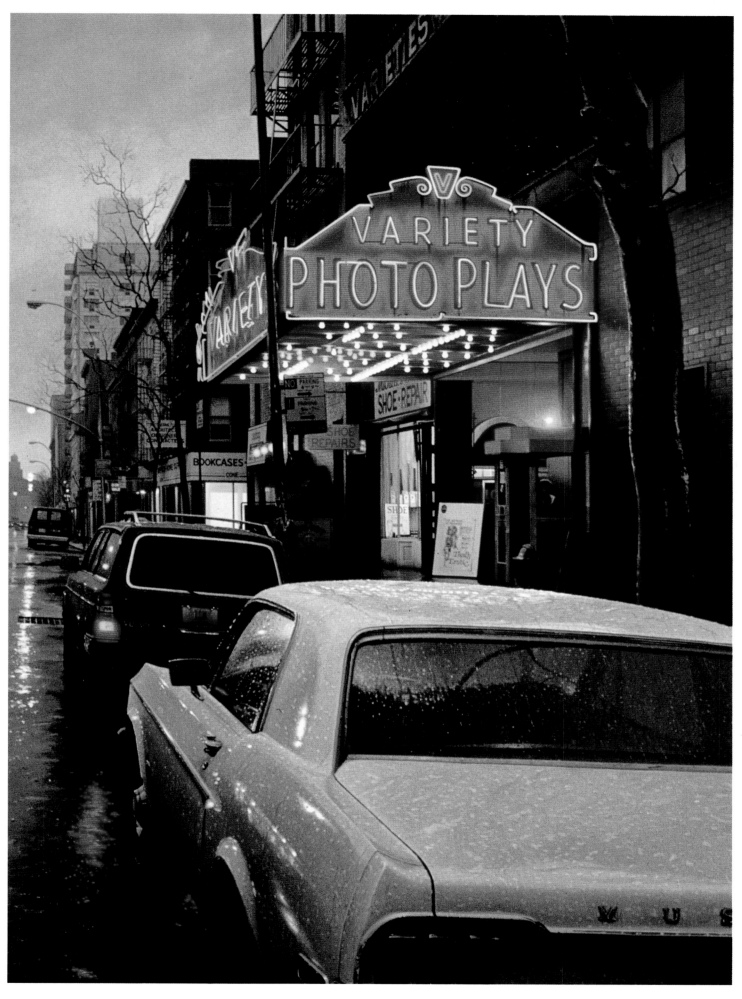

358. *Variety Photoplays.* 1983 (14). Acrylic on canvas, 50½ x 37½". Private collection, New York

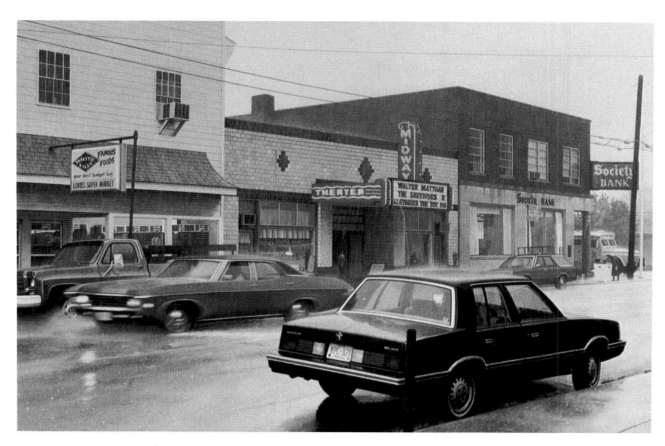

359. *Midway.* 1984 (16). Acrylic on canvas, 33½ x 49". Private collection, Pennsylvania

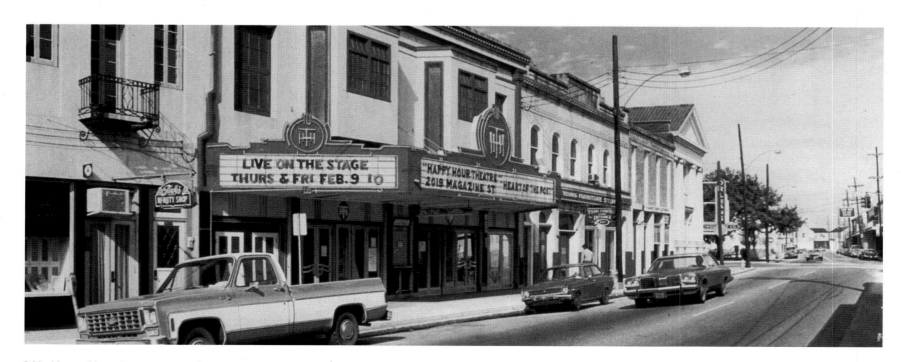

360. *Happy Hour.* 1984 (17). Acrylic on canvas, 29 x 74". Virlane Foundation, Louisiana

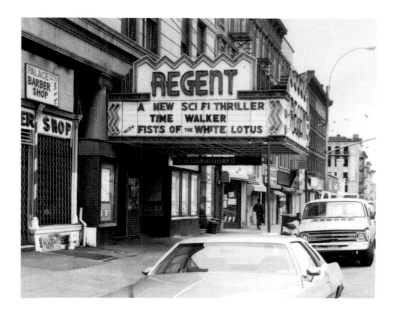

361. *Marianne.* 1984 (18). Acrylic on canvas, 40½ x 59½".
Private collection

362. *Regent.* 1985 (19). Acrylic on canvas, 42½ x 51½".
Private collection, New York

363. *Knox.* 1985 (20). Watercolor on paper, 9 x 15½".
Private collection, New York

364. *Empire.* 1985 (22). Watercolor on
paper, 15 x 10". Collection Louis K.
and Susan Pear Meisel, New York

365. *Colonia.* 1985 (21).
Watercolor on paper, 10½ x 15".
Collection Richard Brown Baker, New York

366. *Bad Axe.* 1985 (24).
Watercolor on paper, 12 x 16".
Private collection, New York

367. *State.* 1986 (25). Watercolor on paper,
14 x 19½". Collection Dale C. and Alexandra
Zetlin Jones, New York

368. *Colonia with Boy on Rail.* 1986 (26).
Watercolor on paper, 13 x 16". High Museum of Art,
Atlanta, Georgia. Purchase

369. *Marion with Three Cars.* 1985 (23). Acrylic on canvas, 48 x 38½". Private collection, New York

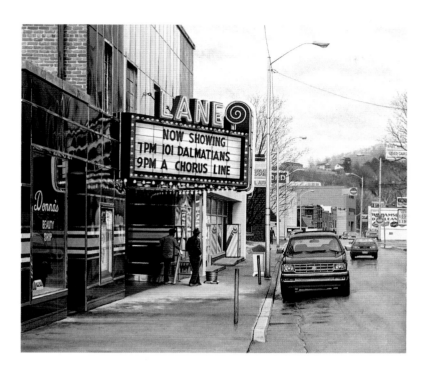

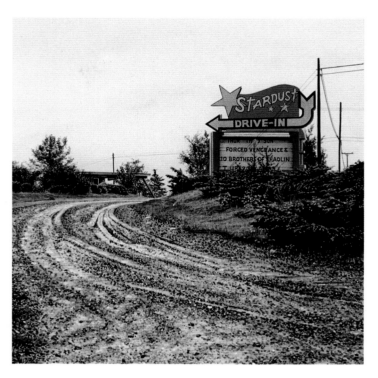

370. *Lane.* 1986 (27). Watercolor on paper, 14 x 15".
Private collection, New York

371. *Stardust Drive-In.* 1986 (28). Watercolor on paper, 11 x 10½".
Private collection, New York

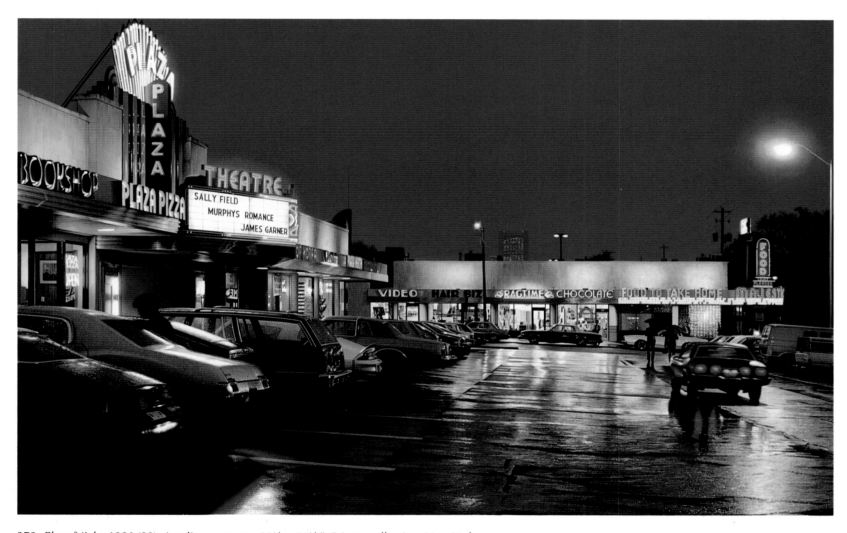

372. *Plaza/Night.* 1986 (29). Acrylic on canvas, 35½ x 56¼". Private collection, New York

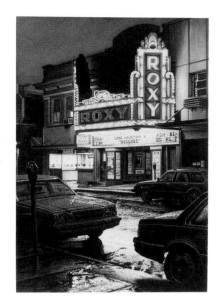

373. *Roxy.* 1987 (31).
Watercolor on paper, 16¾ x 11¼".
Private collection, New York

374. *Everett.* 1987 (32). Watercolor on paper, 12 x 17½".
Collection the artist

375. *The Senator.* 1988 (37). Acrylic on canvas,
13 x 18½". Private collection

376. *Criterion Center.* 1987 (30). Acrylic on canvas, 39 x 58½".
Private collection, New York

377. *Rosa Drive-In.* 1988 (36).
Acrylic on canvas, 13 x 19½".
Private collection

378. *Cinema.* 1988 (34).
Acrylic on canvas, 15¼ x 29".
Private collection, New York

379. *Cozy.* 1990 (41).
Acrylic on canvas, 15¾ x 23".
Collection Donna and Neil Weisman, New Jersey

380. *Cameo.* 1988 (33). Acrylic on canvas, 37 x 45¼". Private collection, France

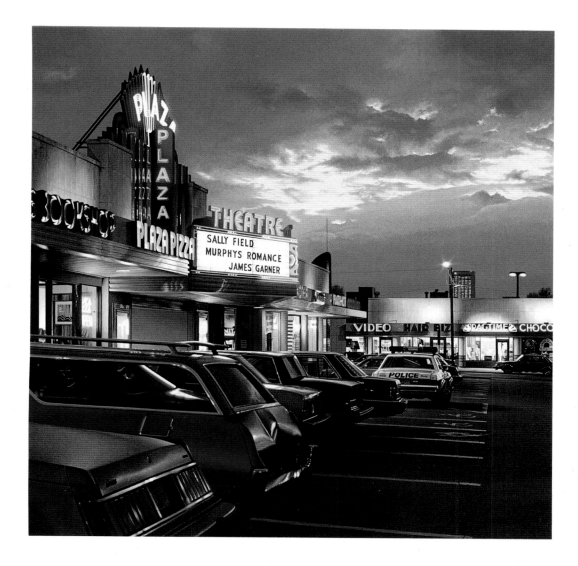

381. *Plaza—Twilight.*
1988 (35).
Acrylic on canvas,
30¼ x 30¼".
Collection Donna
and Neil Weisman,
New Jersey

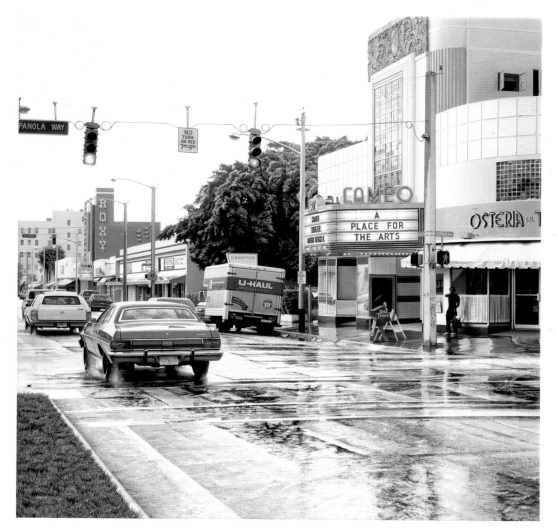

382. *Cameo in the Rain.*
1989 (39).
Acrylic on canvas,
30 x 30¼".
Private collection,
Switzerland

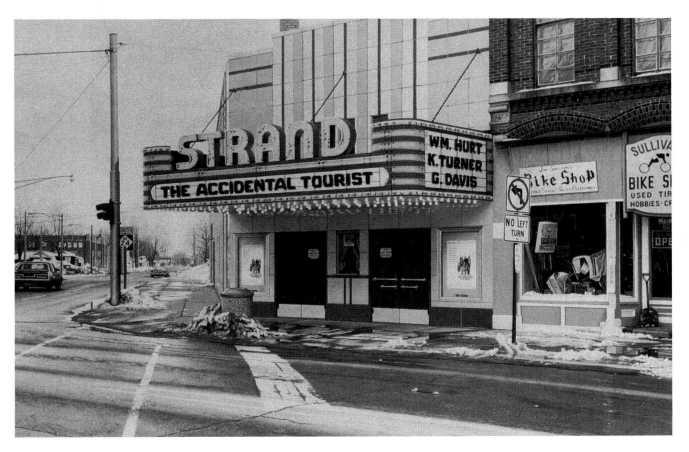

383. *Strand.* 1989 (38). Acrylic on canvas, 38½ x 57½". Private collection

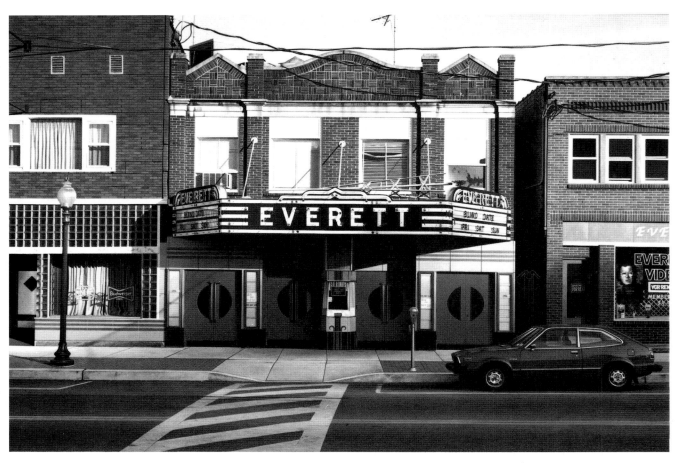

384. *Everett.* 1990 (40). Acrylic on canvas, 38 x 54½". Collection Michael Rakosi, New York

During the formative years of Photorealism, the imagery in Cottingham's paintings was based primarily on the signage and lettering found on storefronts, in all their variations. His painting technique was quite graphic in that there was little shading and gradation of color; the works were painted almost entirely in solid, even colors. And it seemed that Cottingham's earlier involvement in the advertising world was responsible for the character of his work. Interestingly, a painting technique like Cottingham's is quite easily translated to printmaking. It is therefore no surprise that the artist has devoted much time in recent years to prints and, in fact, has produced more print editions than any of the other Photorealists.

As the eighties progressed, Cottingham became interested in railroad cars as subjects. Their shapes, forms, colors, textures, and signage all presented challenges to his customary formula, yet there was a common factor that tied this new set of artistic ideas to the earlier ones. The angled, upward, textureless view of Cottingham's storefronts from the seventies gradually gave way to a textured, coarse, and gritty surface, emulating that of box cars. The multicolored neon, plastic, and metal signs of the earlier years became monochromatic, with only a dash or two of flat colors to depict the railroad logos. Yet, in the clearly graphic simplicity of these logos, Cottingham found one aspect that united both the old and the new paintings.

The major effort in Cottingham's railroad car series is *Twenty-seven Heralds,* a group of paintings that was exhibited as a single mural (pls. 429–55). There are other boxcar and logo paintings in the Heralds series, but they differ greatly from one another in size and format.

As the eighties came to an end, so too did Cottingham's fascination with signs and logos. The final works of the decade still focus on railroad cars, but now the real points of interest in these single-colored, muted surfaces are wheels, ladders, couplings, protuberances, and attachments. Because of Cottingham's use of textured

ROBERT COTTINGHAM

paint and shadows, these works take on something of the appearance of reliefs or sculptures. The images, which go beyond even the Photoreal, almost seem to exist in actuality instead of being merely painted.

Of Cottingham's 85 paintings between 1980 and 1989, 74 are illustrated herein. There are 148 works on paper, of which a selection of 19 are shown. All the unillustrated works of the period are listed. *Photo-Realism* documented 192 Cottingham works. This volume brings the total, therefore, to 425, making Cottingham the most prolific of the Photorealists, both in paintings and in prints.

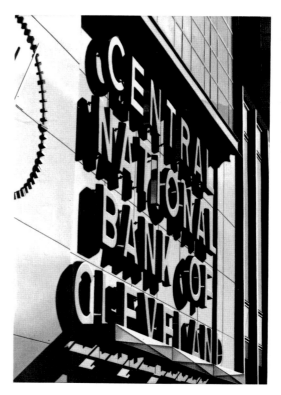

385. *Western Wear.* 1980. Oil on canvas, 32 x 32".
Private collection

386. *Central National Bank of Cleveland.* 1980.
Oil on canvas, 33½ x 22½". Private collection

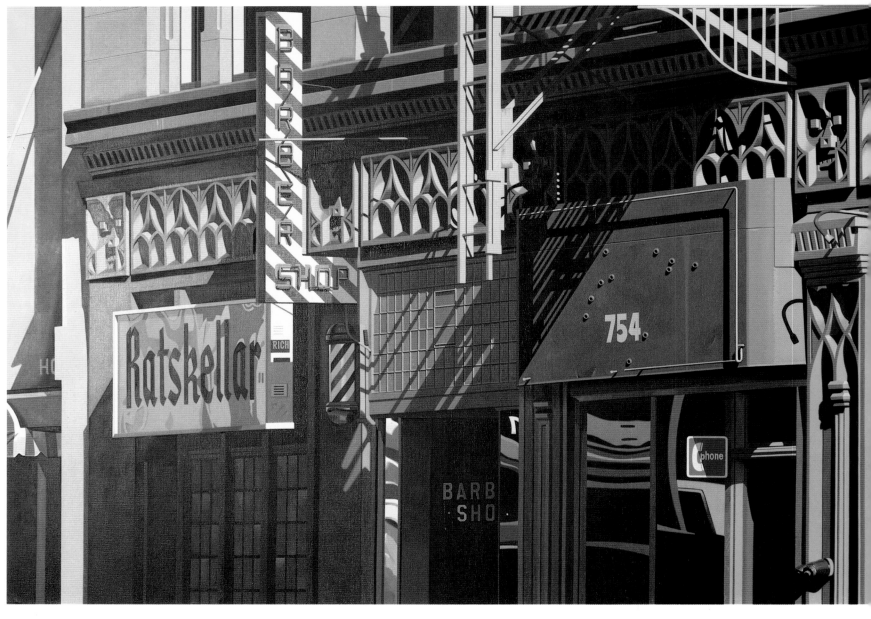

387. *Barrera-Rosa's.* 1985. Oil on canvas, 59⅛ x 168¼". Private collection, Switzerland

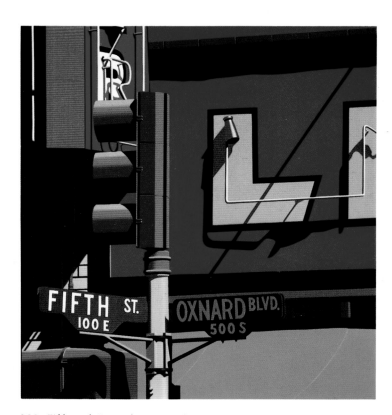

388. *Fifth and Oxnard.* 1985. Oil on wood panel, 17 x 15¼".
Private collection

389. *Ritz Bar.* 1986. Oil on canvas, 78 x 78".
Private collection

390. *Rialto*. 1986. Oil on canvas, 78 x 78".
Private collection

391. *Jewel*. 1986. Oil on canvas, 78 x 78".
Private collection

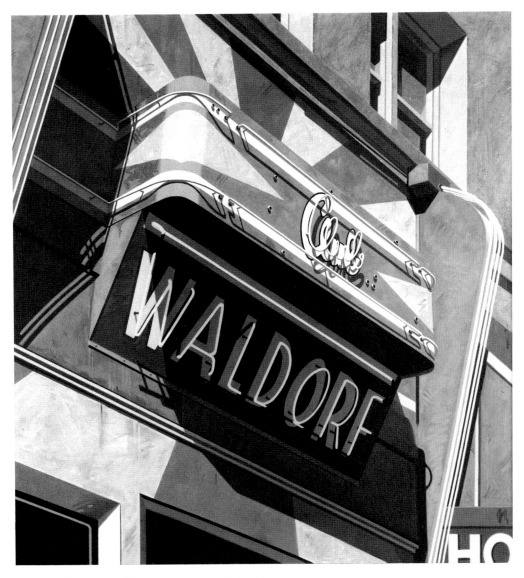

392. *Waldorf.* 1986. Oil on canvas, 28 x 25". Collection
Pierre and Sylvie Mirabaud, Switzerland

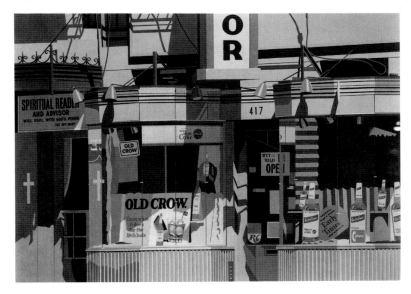

393. *Old Crow.* 1983. Oil on canvas, 46 x 60".
Private collection

394. *Ral's.* 1983. Oil on canvas, 41¾ x 58⅛".
Private collection

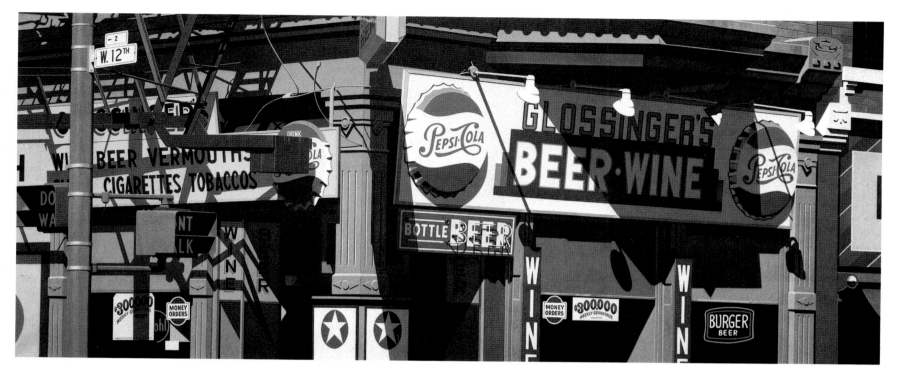

395. *Glossinger's.* 1984. Oil on canvas, 50 x 120". Private collection

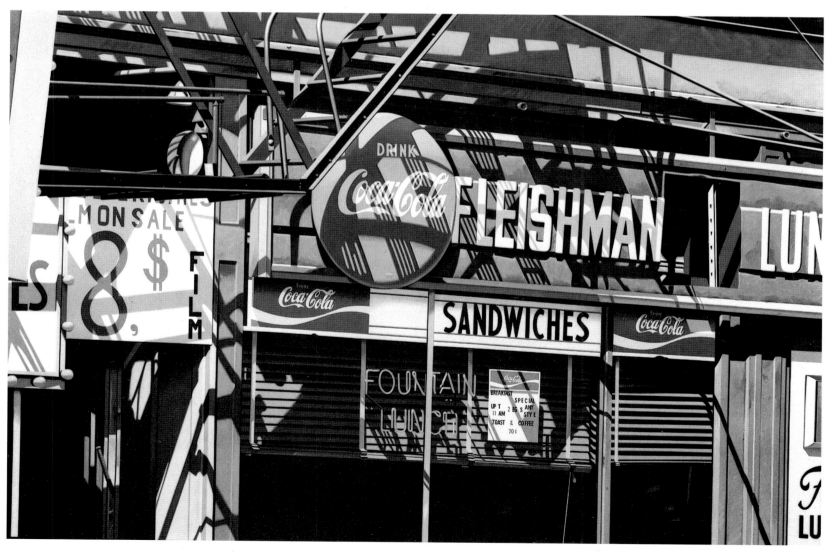

396. *Fleishman.* 1982. Oil on canvas, 48 x 72". Private collection

397. *Keen Kottons.* 1981. Oil on canvas, 32 x 32".
Private collection

398. *While-U-Wait.* 1981. Oil on canvas, 32 x 32".
Private collection

399. *Kresge's.* 1981.
Oil on canvas, 96 x 66".
Virlane Foundation,
Louisiana

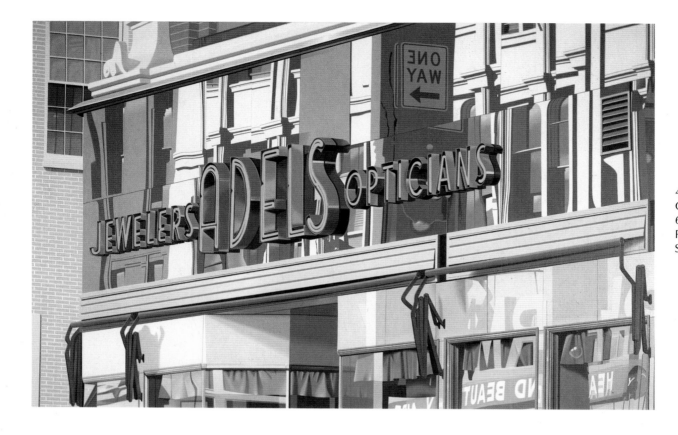

400. *Adels.* 1980.
Oil on canvas,
61½ x 96".
Private collection,
Switzerland

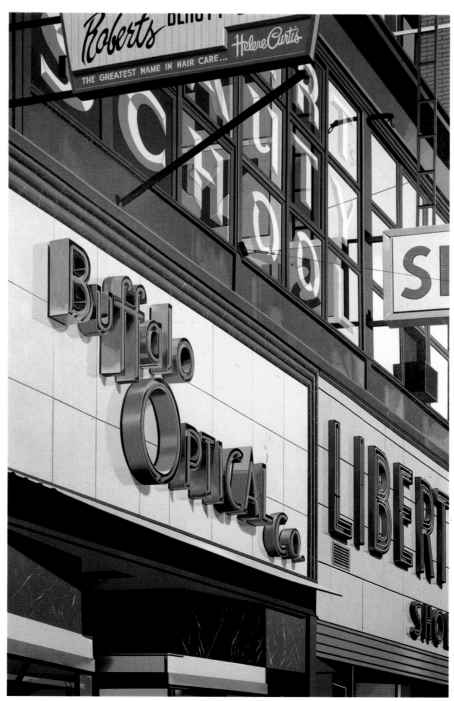

401. *Buffalo Optical.* 1981.
Oil on canvas, 96 x 60".
Birmingham Museum
of Art, Alabama

402. *11th Street.* 1982. Acrylic on canvas, 21⅛ x 31⅛". Private collection

403. *Hairstylists.* 1982. Acrylic on canvas, 21⅛ x 31⅛". Private collection, Indiana

404. *J. C.* 1982. Acrylic on canvas, 21⅛ x 31⅛". Private collection

405. *Radio City Deli.* 1980. Oil on canvas, 32 x 32". Private collection

406. *Billy's.* 1980. Oil on canvas, 49 x 66". Private collection

407. *Joseph's Liquor.* 1980. Oil on canvas, 32 x 32".
Private collection

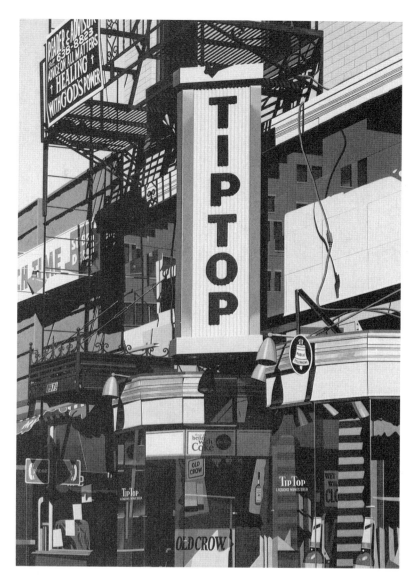

408. *Tip-Top.* 1981. Oil on canvas, 96 x 65".
Private collection

409. *Cafe-Bar.* 1980. Oil on canvas, 61½ x 96". Herbert F. Johnson Museum of Art, Cornell University, Ithaca, New York.
Purchased with Funds from the National Endowment for the Arts and individual donors

410. *Nite*. 1986. Oil on canvas, 84 x 60". Private collection

411. *Barber Shop*. 1988. Oil on canvas, 32 x 32".
Private collection

412. *Play*. 1988. Oil on canvas, 32 x 32". Private collection

413. *Orph.* 1989. Oil on canvas, 60 x 90". Private collection, Switzerland

414. *Blues.* 1987. Oil on canvas, 78 x 78". Private collection

415. *Starr.* 1988. Oil on canvas, 49 x 72". Private collection

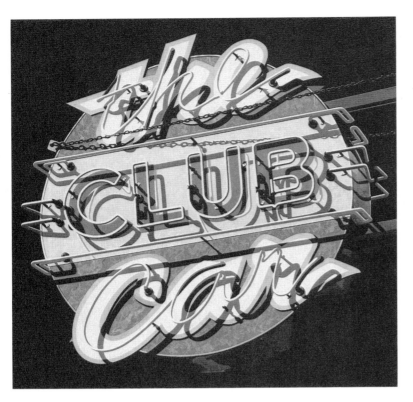

416. *The Club Car*. 1989. Acrylic on canvas, 32 x 32".
Collection Bruce Vinokour, California

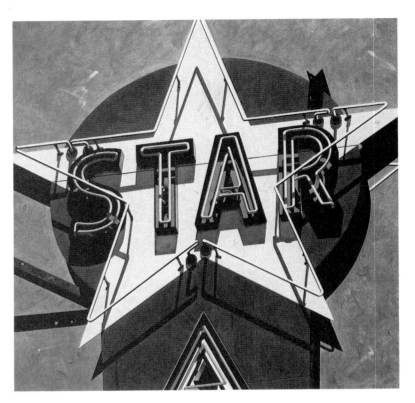

417. *Star*. 1989. Acrylic on canvas, 78 x 78".
Private collection

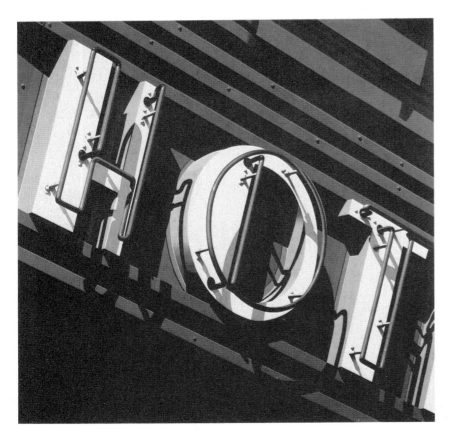

418. *Hot*. 1988. Oil on canvas, 60 x 60". Private collection

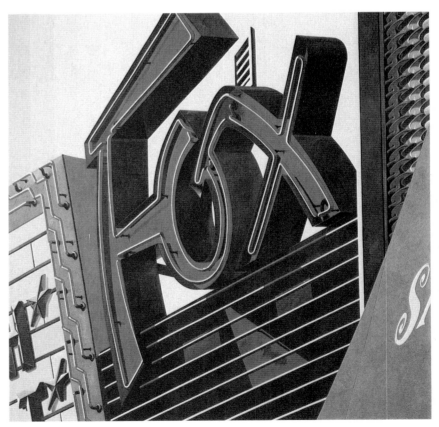

419. *Fox*. 1988. Oil on canvas, 78 x 78". Private collection

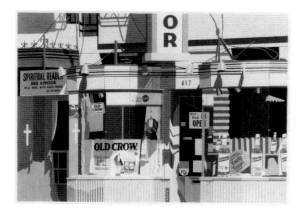

420. *Old Crow.* 1982.
Acrylic on paper, 20½ x 28⅜".
Whereabouts unknown

421. *Ral's.* 1983.
Watercolor on paper, 12⅝ x 17½".
Louis K. Meisel Gallery, New York

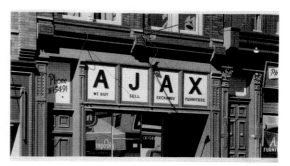

422. *Ajax.* 1983.
Acrylic on paper, 18½ x 33¾".
Whereabouts unknown

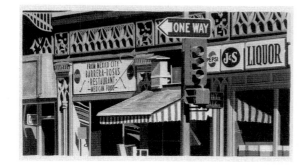

423. *Barrera-Rosa's.* 1983.
Acrylic on paper, 13⅛ x 23¾".
Private collection, Switzerland

424. *Rialto.* 1985.
Watercolor on paper, 17⅞ x 18".
Whereabouts unknown

425. *Golden Gopher.* 1984.
Acrylic on paper, 13¾ x 33⅜".
Collection Pierre and Sylvie Mirabaud, Switzerland

426. *Wichita.* 1985. Gouache on paper, 30 x 40".
Whereabouts unknown

427. *Ritz Bar.* 1986. Watercolor on paper,
10¾ x 10¾". Whereabouts unknown

428. *Q.* 1987. Gouache on paper, 10⅝ x 10⅝".
Whereabouts unknown

429–55. *Twenty-seven Heralds.* 1988. Acrylic on paper laid down on canvas, each 22 x 32". Collection Bruce R. Lewin, New York.
From left to right, top to bottom: *North Western; Great Northern; Pennsylvania Railroad; Cotton Belt Route; Missouri Pacific; Southern Pacific; New Haven; Illinois Central; Northern Pacific; Burlington Northern; Union Pacific; B&O; Milwaukee Road; New York Central; Jersey Central; Atlantic Coast Line; Chessie Line; Reading Lines; Santa Fe; Lackawanna; Nickel Plate Road; Erie; Maine Central; Wabash; Frisco; Soo Line; Rock Island*

456. *Santa Fe.* 1987. Oil on canvas, 78 x 78". Private collection

457. *N*. 1987. Oil on canvas, 78 x 78". Private collection

458. *Great Northern*. 1988. Oil on canvas, 78 x 78". Private collection, Switzerland

459. *Rolling Stock Series No. 12 (For Patti).* 1989. Acrylic and sand on canvas, 61½ x 47½". Private collection

460. *Rolling Stock Series No. 18 (For Leslie G.).* 1990. Acrylic and sand on canvas, 57¾ x 80". Private collection

461. *Rolling Stock Series No. 2 (Miner)*. 1989. Acrylic and sand on canvas, 66 x 122". Private collection

462. *Rolling Stock Series No. 3 (C&O)*. 1989. Acrylic and sand on canvas, 61 x 84". Private collection

463. *Rolling Stock Series No. 4 (For Chuck)*. 1989.
Acrylic and sand on canvas, 72 x 106". Private collection

464. *Rolling Stock Series No. 6 (For Aurelia)*. 1989.
Acrylic and sand on canvas, 32³/₄ x 72". Private collection

465. *Rolling Stock Series No. 7 (For Jim)*. 1989.
Acrylic and sand on canvas, 74 x 29³/₄". Private collection

466. *Rolling Stock Series No. 9 (For Reid)*. 1989. Acrylic and sand on canvas, 72 x 72". Private collection

467. *Rolling Stock Series No. 11 (For Kyle)*. 1989. Acrylic and sand on canvas, 51¾ x 85". Private collection

NOT ILLUSTRATED (Where no collection credits are given, whereabouts are unknown.)

Oils

Ritz Hotel. 1982.
Acrylic on canvas, 21$^1/_8$ x 31$^1/_8$".
Private collection

Nite. 1985.
Oil on canvas, 39 x 28".
Private collection

Waldorf. 1985.
Oil on canvas, 28 x 25".
Private collection

Rialto. 1986.
Oil on wood panel, 30 x 30".
Private collection

Star. 1986.
Oil on canvas, 32 x 32".
Private collection

Blues. 1987.
Oil on canvas mounted on wood, 30 x 30".
Private collection

N. 1988.
Oil on canvas, 32 x 32".
Private collection

Rolling Stock Series No. 1 (For Bryan). 1989.
Acrylic, sand, and paper on canvas, 23 x 23".
Private collection

Rolling Stock Series No. 5 (Pool Car). 1989.
Acrylic and sand on canvas, 84 x 57".
Private collection

Rolling Stock Series No. 8 (For Jane). 1989.
Acrylic and sand on canvas, 60$^1/_2$ x 93$^1/_4$".
Private collection

Rolling Stock Series No. 10 (For Molly). 1989.
Acrylic and sand on canvas, 88$^3/_4$ x 45$^3/_8$".
Private collection

Works on Paper

Radio City Deli. 1980.
Acrylic on paper, 10$^1/_2$ x 10$^1/_2$".

Radio City Deli. 1980.
Acrylic on paper, 10$^1/_2$ x 10$^1/_2$".

Cold Beer. 1980.
Acrylic on paper, 10$^1/_2$ x 10$^1/_2$".

Keen Kottons. 1980.
Acrylic on paper, 18$^1/_4$ x 18$^1/_4$".

Tip-Top. 1981.
Acrylic on paper, 26$^1/_2$ x 18"

While-U-Wait. 1981.
Acrylic on paper, 18 x 18$^1/_4$".

Buffalo Optical. 1981.
Acrylic on paper, size unknown

11th Street. 1982.
Acrylic on paper, 16$^1/_2$ x 24$^1/_4$"

Hairstylists. 1982.
Acrylic on paper, 16$^1/_2$ x 24$^1/_4$"

The Spot. 1982.
Watercolor on paper, 28$^1/_2$ x 21" (sheet size)

Abelson's Jewelers. 1982.
Watercolor on paper, 28$^1/_2$ x 21" (sheet size)

Roger's. 1982.
Acrylic on paper, 13$^3/_4$ x 23$^3/_4$"

J. C. 1982.
Acrylic on paper, 16$^3/_4$ x 24$^1/_4$"

Starr. 1982.
Acrylic on paper, 16$^5/_8$ x 24$^1/_2$"

Fleishman. 1982.
Watercolor on paper, 21 x 29$^3/_4$"

Old Crow. 1982.
Watercolor on paper, 18$^1/_4$ x 26"

Ritz Hotel. 1982.
Acrylic on paper, 16$^3/_4$ x 24$^1/_4$"

Hall's Diner. 1982.
Watercolor on paper, 21 x 25$^1/_2$" (sheet size)

Willey's. 1982.
Watercolor on paper, 39 x 17" (sheet size)

W. T. 1982.
Watercolor on paper, 15 x 22$^1/_4$"

Ral's. 1983.
Acrylic on paper, 18$^1/_4$ x 25"

109. 1983.
Watercolor on paper, 10$^1/_2$ x 10$^1/_2$"

Carry Out. 1983.
Watercolor on paper, 24$^1/_4$ x 16$^1/_2$"
Collection Glenn C. Janss, Idaho

Starr. 1983.
Watercolor on paper, 15 x 22$^1/_8$"

Glossinger's. 1983.
Acrylic on paper, 13$^3/_4$ x 33$^1/_2$"

M. 1983.
Watercolor on paper, 16$^3/_4$ x 11$^7/_8$"

Glossinger's. 1983.
Watercolor on paper, 13$^3/_4$ x 33$^1/_2$".
Collection Mrs. Harry Mann, Ohio

Ajax. 1983.
Acrylic on paper, 18$^1/_2$ x 33$^3/_4$"

We Buy. 1983.
Watercolor on paper, 18$^1/_2$ x 14"

Barrera-Rosa's. 1983.
Acrylic on paper, 13$^3/_4$ x 37$^1/_2$"

Barrera-Rosa's. 1983.
Watercolor on paper, 13$^1/_4$ x 37$^1/_2$"

Golden Gopher. 1984.
Watercolor on paper, 13$^3/_4$ x 33$^3/_8$"

Hotel Lindy. 1984.
Gouache on paper, 6$^3/_8$ x 9"

Golden. 1984.
Gouache on paper, 9$^3/_8$ x 13$^1/_2$"

Hotel Lindy. 1984.
Watercolor on paper, 9$^3/_8$ x 13$^1/_2$"

Hotel Lindy. 1984.
Gouache on paper, 9$^3/_8$ x 13$^1/_2$"

One Way. 1984.
Gouache on paper, 13$^1/_4$ x 10$^1/_2$"

Pepsi. 1984.
Gouache on paper, 5$^3/_4$ x 4$^1/_4$"

One Way. 1984.
Watercolor on paper, 24$^7/_8$ x 21$^1/_2$"

Don't Walk. 1985.
Watercolor on paper, 9$^3/_8$ x 32$^3/_8$"

Don't Walk. 1985.
Gouache on paper, 9$^1/_4$ x 32$^3/_8$"

Don't Walk. 1985.
Gouache on paper, 14$^1/_4$ x 19$^1/_4$"

Golden Gopher. 1985.
Gouache on paper, 27$^3/_4$ x 67"

Nite. 1985.
Watercolor on paper, 13 x 9$^1/_4$"

Nite. 1985.
Watercolor on paper, 29$^1/_4$ x 21"

Nite. 1985.
Gouache on paper, 13 x 9$^1/_4$".
Collection Sidney and George Perutz, Texas

Fifth and Oxnard. 1985.
Watercolor on paper, 19$^3/_8$ x 19$^1/_2$"

Fifth and Oxnard. 1985.
Watercolor on paper, 14$^1/_8$ x 12$^3/_4$"

Fifth and Oxnard. 1985.
Watercolor on paper, 9$^3/_4$ x 9$^3/_4$"

Fifth and Oxnard. 1985.
Watercolor on paper, 7 x 6$^1/_4$"

Fifth and Oxnard. 1985.
Gouache on paper, 9$^3/_4$ x 9$^3/_4$"

Fifth and Oxnard. 1985.
Gouache on paper, 6$^1/_4$ x 6$^1/_4$"

Waldorf. 1985.
Gouache on paper, 11 x 9$^7/_8$".
Collection Sidney and George Perutz, Texas

Waldorf. 1985.
Watercolor on paper, 11 x 9$^7/_8$"

Rialto. 1985.
Watercolor on paper, 9$^3/_4$ x 9$^3/_4$"

Rialto. 1985.
Gouache on paper, 18 x 18"
Rialto. 1985.
Gouache on paper, 9³/₄ x 9³/₄"
Nite. 1985.
Gouache on paper, 29¹/₄ x 20¹/₂"
Star. 1986.
Gouache on paper, 32 x 32"
Jewel. 1986.
Gouache on paper, 16³/₈ x 16³/₈"
Ritz Bar. 1986.
Gouache on paper, 19 x 19"
Ritz Bar. 1986.
Watercolor and pencil on paper, 19 x 19"
Star. 1986.
Watercolor on paper, 10⁵/₈ x 10⁵/₈"
Jewel. 1986.
Watercolor on paper, 10³/₄ x 10³/₄"
Ritz Bar. 1987.
Gouache on paper, 10³/₄ x 10³/₄"
Jewel. 1987.
Gouache on paper, 10³/₄ x 10³/₄"
Blues. 1987.
Gouache on paper, 10³/₄ x 10³/₄"
Santa Fe. 1987.
Watercolor on paper, 10³/₄ x 10³/₄"
Santa Fe. 1987.
Watercolor on paper, 22³/₄ x 22³/₄"
Zachary. 1987.
Watercolor on paper, 11¹/₈ x 11¹/₈"
N. 1987.
Gouache on paper, 10³/₄ x 10³/₄"
Play. 1987.
Gouache on paper, 10³/₄ x 10³/₄"
Barber Shop. 1987.
Gouache on paper, 10³/₄ x 10³/₄"
Q. 1987.
Gouache on paper, 10⁵/₈ x 10⁵/₈"
Q. 1987.
Gouache on paper, 21¹/₂ x 21¹/₂"
Q. 1987.
Watercolor on paper, 10⁵/₈ x 10⁵/₈"
Blues. 1987.
Watercolor on paper, 10³/₄ x 10³/₄"
Blues. 1987.
Watercolor on paper, 18 x 18".
Columbus Museum of Art, Ohio
Blues. 1987.
Gouache on paper, 18 x 18"

Q. 1987.
Watercolor and gouache on paper, 21¹/₂ x 21¹/₂"
Blues. 1987.
Gouache on paper, 4⁷/₈ x 4⁷/₈"
N. 1987.
Watercolor on paper, 10³/₄ x 10³/₄"
N. 1987.
Watercolor on paper, 16¹/₄ x 16¹/₄"
N. 1987.
Gouache on paper, 16¹/₄ x 16¹/₄"
Barber Shop. 1987.
Watercolor on paper, 10³/₄ x 10³/₄"
Barber Shop. 1987.
Watercolor on paper, 15³/₄ x 15³/₄"
Play. 1987.
Watercolor on paper, 10³/₄ x 10³/₄"
Hall's Diner. 1988.
Gouache on paper, 20³/₈ x 28¹/₈".
Collection Donna and Neil Weisman, New Jersey
Starr. 1988.
Gouache on paper, 16¹/₈ x 23¹/₂"
Rio. 1988.
Gouache on paper, 19¹/₂ x 19¹/₂"
Great Northern. 1988.
Watercolor on paper, 10¹/₂ x 10¹/₂"
Rialto. 1988.
Gouache on paper, 9³/₄ x 9³/₄"
C & O. 1988.
Gouache on paper, 21³/₈ x 29¹/₂"
Miner. 1989.
Gouache on paper, 8⁵/₈ x 15⁵/₈"
Miner. 1989.
Gouache on paper, 13¹/₂ x 13¹/₂"
Composition with Ladder. 1989.
Gouache on paper, 10³/₈ x 10³/₈"
BN 615996. 1989.
Gouache on paper, 6¹/₄ x 11"
Study (For Chuck). 1989.
Gouache on paper, 20 x 7⁵/₈"
Study (For Bryan). 1989.
Gouache on paper, 9³/₈ x 9³/₈"
Study for Portal. 1989.
Gouache on paper, 13⁵/₈ x 17³/₄"
Portal. 1989.
Gouache on paper, 18¹/₄ x 13¹/₂"
90. 1989.
Gouache on paper, 16¹/₄ x 8"
Pool Car. 1989.
Gouache on paper, 12¹/₄ x 12¹/₄"
Miner. 1989.
Watercolor and gouache on paper, 8⁵/₈ x 15⁵/₈"

Miner. 1989.
Watercolor and gouache on paper, 8³/₈ x 12¹/₈"
Miner. 1989.
Watercolor and gouache on paper, 13¹/₂ x 13¹/₂"
Miner. 1989.
Watercolor and gouache on paper, 13⁵/₈ x 7"
Composition with Ladder. 1989.
Watercolor and gouache on paper, 10³/₈ x 10³/₈"
BN 615996. 1989.
Watercolor and gouache on paper, 6¹/₄ x 11¹/₄"
Study (For Chuck). 1989.
Watercolor and gouache on paper, 11¹/₄ x 16¹/₂"
Study (For Chuck). 1989.
Watercolor on paper, 20 x 7⁵/₈"
Study (For Chuck). 1989.
Watercolor and gouache on paper, 20⁷/₈ x 6³/₄"
Study (For Bryan). 1989.
Watercolor and ink on paper, 9³/₈ x 9³/₈"/
Pool Car. 1989.
Watercolor and gouache on paper, 12¹/₄ x 12¹/₄"
Pool Car. 1989.
Watercolor and gouache on paper, 16¹/₂ x 11¹/₄"
90. 1989.
Watercolor and gouache on paper, 16¹/₄ x 8"
Rolling Stock Series Study No. 6 (For Aurelia). 1989.
Gouache on paper, 8³/₄ x 18¹/₂"
Rolling Stock Series Study No. 6 (For Aurelia). 1989.
Gouache on paper, 7³/₄ x 17¹/₄"
Rolling Stock Series Study No. 7 (For Jim). 1989.
Gouache on paper, 17¹/₂ x 7"
Rolling Stock Series Study No. 9 (For Reid). 1989.
Gouache on paper, 17 x 17"
Rolling Stock Series Study No. 12 (For Patti). 1989.
Gouache on paper, 14⁵/₈ x 11¹/₄"
Rolling Stock Series Study No. 13 (For Leslie C.). 1989.
Gouache on paper, 11¹/₄ x 11¹/₄"
Rolling Stock Series Study No. 13 (For Leslie C.). 1989.
Gouache on paper, 12¹/₈ x 12¹/₈"
Rolling Stock Series Study No. 14 (For Jimmy). 1989.
Gouache on paper, 12 x 19³/₈"
Rolling Stock Series Study No. 14 (For Jimmy). 1989.
Gouache on paper, 12 x 17"
Rolling Stock Series Study No. 15 (For Guzzy). 1989.
Gouache on paper, 17¹/₂ x 13¹/₂"
Rolling Stock Series Study No. 15 (For Guzzy). 1989.
Gouache on paper, 17¹/₂ x 11¹/₂"
Rolling Stock Series Study No. 16 (For Andrew). 1989.
Gouache on paper, 13 x 13"
Rolling Stock Series Study No. 19 (For Charlotte). 1989.
Gouache on paper, 12¹/₈ x 6¹/₈"

468. *Miner.* 1989.
Gouache on paper, 13⅝ x 7".
Whereabouts unknown

469. *Study (For Chuck).* 1989. Gouache on paper,
11¼ x 16⅜". Collection Glenn C. Janss, Idaho

470. *Pool Car.* 1989.
Gouache on paper, 16½ x 11¼".
Whereabouts unknown

471. *Study (For Chuck).*
1989. Gouache on
paper, 20½ x 6¾".
Whereabouts unknown

472. *Study for Portal.* 1989.
Gouache on paper, 19¾ x 17½".
Whereabouts unknown

473. *Miner.* 1989. Goauche on paper, 8⅜ x 11⅞".
Whereabouts unknown

474. *Rolling Stock Series Study No. 26
(For Michael G.).* 1990.
Gouache on paper, 11 x 7¾".
Collection Louis K. and
Susan Pear Meisel, New York

475. *Rolling Stock Series Study No. 11 (For Kyle).* 1989.
Gouache on paper, 15¾ x 21".
Whereabouts unknown

476. *Rolling Stock Series Study No. 43 (For Frances).*
1990. Watercolor and gouache on paper, 11¼ x 11¼".
Collection Louis K. and Susan Pear Meisel, New York

477. *Rolling Stock Series Study No. 8 (For Jane).* 1989.
Gouache on paper, 12⅜ x 19".
Whereabouts unknown

DON EDDY

Like Close, Flack, and Schonzeit, Eddy is an artist grouped under the banner of Photorealism whose work is really on the fringe of the movement. For a brief period in 1970–71, Eddy's work did coincide with "classical" Photorealism in its subject matter and imagery. Because of the paintings produced during that time, Eddy is rightly considered a full-fledged member of the group. As the seventies progressed, however, he began to drift onto a parallel track; his work still related to that of the more orthodox Photorealists, but developed its own distinctive characteristics.

From the very beginning, Eddy's technique had always been different. He developed a system of airbrush painting in which thousands of small dots of color were sprayed for an almost Pointillist effect. The colors he used, and still uses, are not the reds, yellows, blues, and blacks traditionally employed to obtain all the others. Through experimentation and research, Eddy found that three colors—phthalocyanine green, burnt sienna, and dioxazine purple—when optically mixed, produce a richer black and, when sprayed in transparent layers, result in an optically alive and complete color palette. It is known that painters in Renaissance Florence used the same colors to achieve similar effects using traditional techniques; Eddy has transferred this approach to a contemporary painting system and has achieved a visually unique color palette.

In the eighties, Eddy continued to use photo-derived images, but he also retained the slightly out-of-sync quality that marked his work almost from the start. Experimenting with complex, repeated images, he made variations on these that used negative space and different juxtapositions (reminiscent at times of Schonzeit's work). It was almost as if his paintings were Photorealist, but placed in the slightly time-shifted, or physics-altered, universe of science fiction.

Toward the end of the decade, Eddy returned to more traditional still-life and landscape images, making them into strange diptychs and triptychs of sometimes unequal-sized canvases. Today, Eddy is still a diehard experimenter. His formalist pictorial style has

remained stable, a mirror of the physical; his intuition, driven by a strong intellect, has expanded the content of his work. As a result, his paintings have evolved into visual experiences that combine elements of both the emotional and the spiritual.

Of the approximately 125 Eddy works thought to exist by 1980, *Photo-Realism* documented 107, of which 93 were illustrated. This volume illustrates all 70 works done since 1980.

478. *G-IV*. 1980 (108).
Acrylic on linen, 40 x 30".
Private collection

479. *G-V*. 1980 (109). Acrylic on linen, 60" diameter. Private collection

480. *C/I*. 1980 (110). Acrylic on canvas, 30 x 30".
Private collection

481. *C/II*. 1980 (111). Acrylic on canvas, 30 x 30".
Private collection

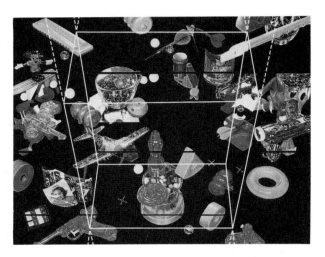

482. *C/IV/A*. 1981 (113). Acrylic on canvas, 30 x 38".
Private collection

483. *C/IV/B*. 1981 (114). Acrylic on canvas, 30 x 38".
Private collection, New York

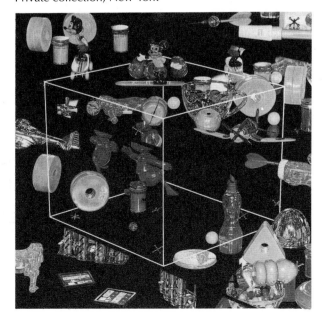

484. *C/V/A*. 1981 (116). Acrylic on canvas, 36 x 36".
Collection William and Susan Kleinman, Indiana

485. *C/V/B (Mickey and the Magic Flute)*. 1981 (117).
Acrylic on canvas, 36 x 36". Private collection

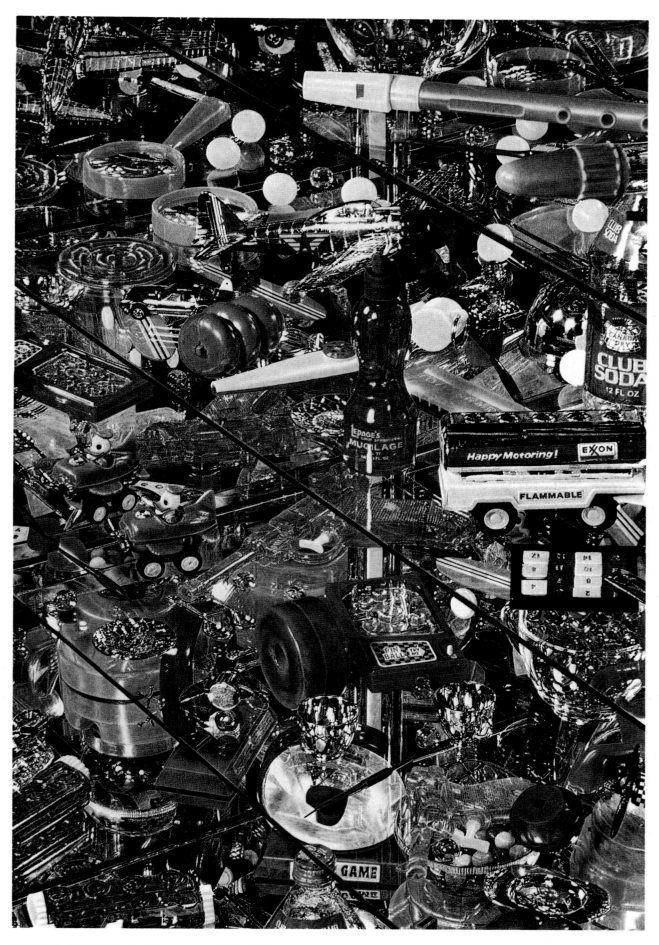

486. *C/III*. 1981 (112). Acrylic on canvas, 73 x 48".
Private collection, Colorado

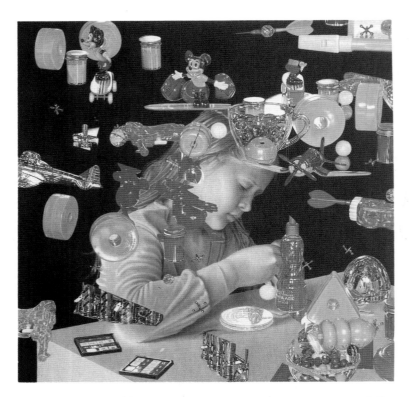

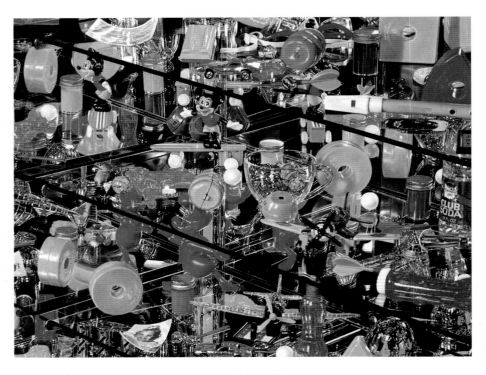

487. *C/V/C (Spirit of the Space)*. 1981 (118). Acrylic on canvas, 36 x 36". Collection Karen and Rick Cohler, Illinois

488. *C/VI/A*. 1982 (121). Acrylic on canvas, 30 x 40". Collection Zoë and Joel Dictrow, New York

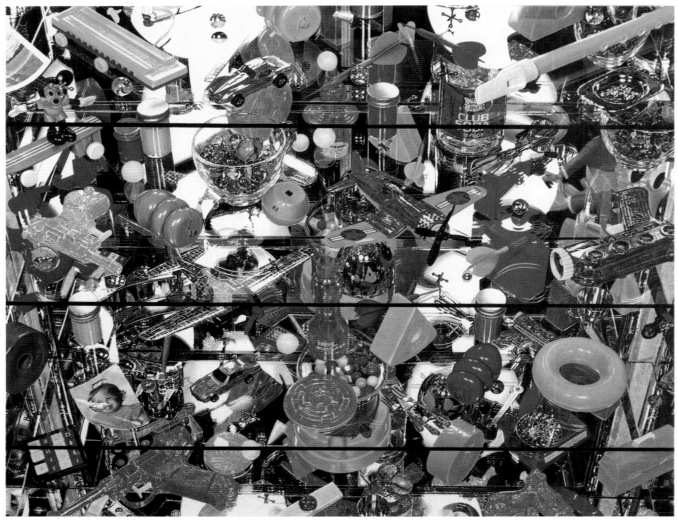

489. *C/IV/C*. 1981 (115). Acrylic on canvas, 60 x 78". Private collection, Tennessee

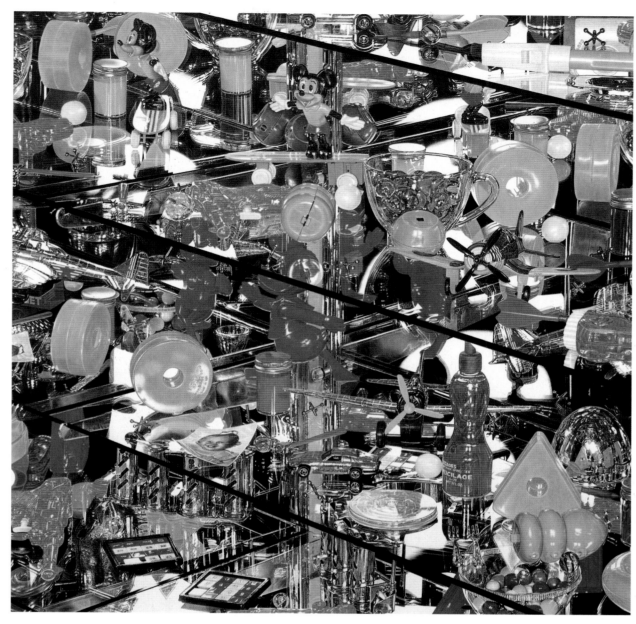

490. *C/V/D.* 1982 (120). Acrylic on canvas, 60 x 60". Private collection

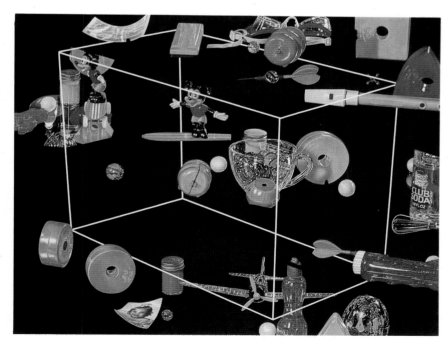

491. *C/VI/B (Mickey in a Half Moon Midnight).* 1982 (122).
Acrylic on canvas, 31 x 40". Private collection

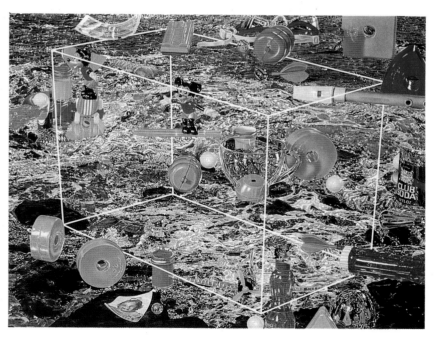

492. *C/VI/C/B.N. (Un Diluvio di Speranza).* 1982 (123).
Acrylic on canvas, 31 x 40". The Honolulu Advertiser, Inc., Hawaii

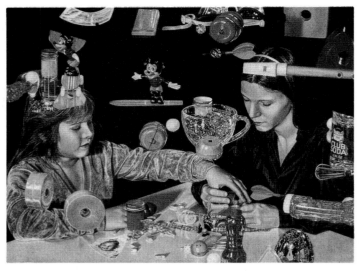

493. *C/VI/D (Then There Were Two)*. 1982 (124). Acrylic on canvas, 31 x 40". Louis K. Meisel Gallery, New York

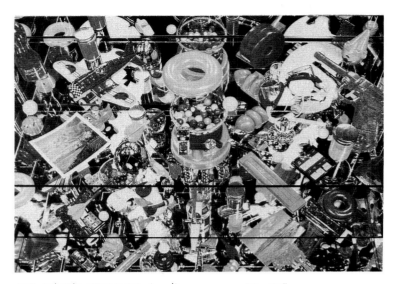

494. *C/VII/B*. 1983 (127). Acrylic on canvas, 40 x 56". Collection Mr. and Mrs. Bob M. Cohen, California

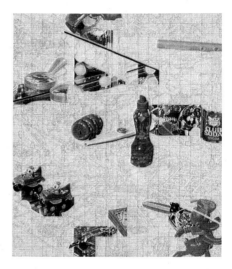

495. *Morocco Study*. 1981 (119). Acrylic on board, 12 x 10". Private collection

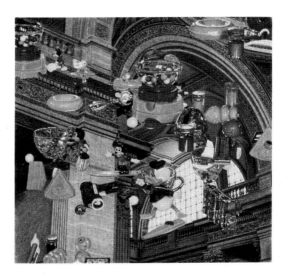

496. *Daydreamer*. 1984 (133). Acrylic on canvas, 24 x 24". Private collection, Texas

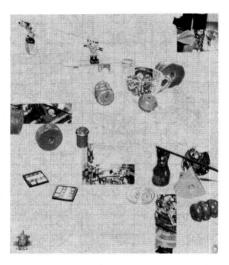

497. *Coventry Study*. 1985 (135). Acrylic on Masonite, 12 x 10". Stephens Inc., Arkansas

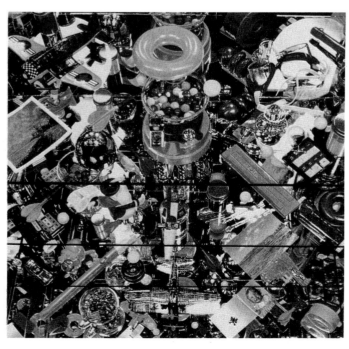

498. *C/VII/A*. 1983 (126). Acrylic on canvas, 40 x 40". Private collection

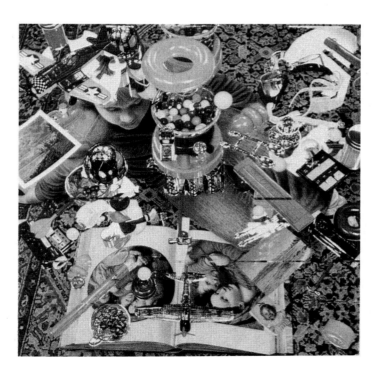

499. *C/VII/E (Dreamreader)*. 1984 (131). Acrylic on canvas, 40 x 40". Private collection

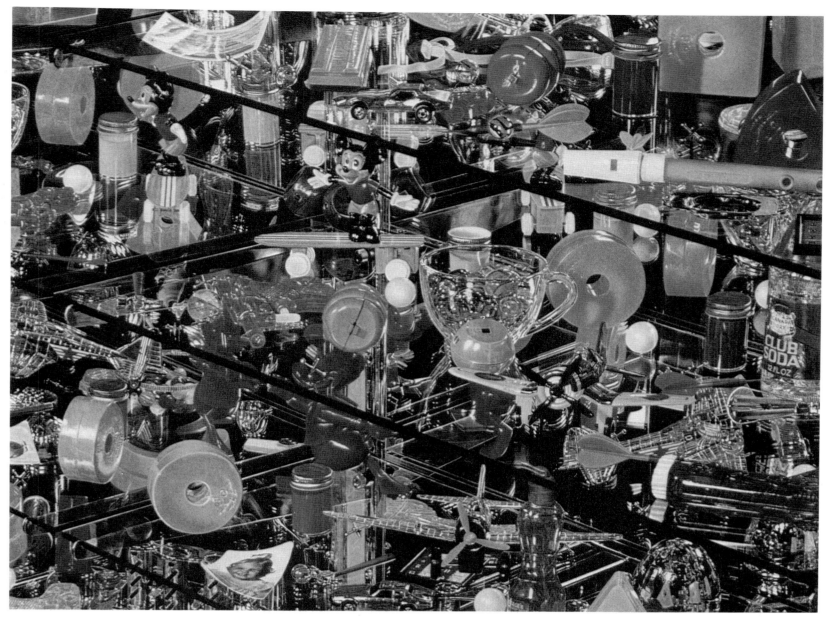

500. *C/VI/E*. 1983 (125). Acrylic on canvas, 60 x 78". Private collection

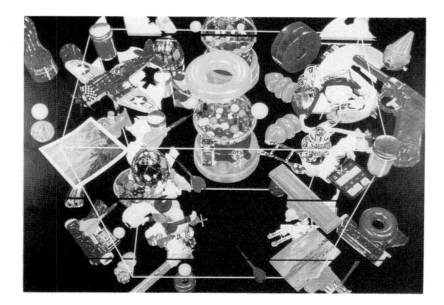

501. *C/VII/C*. 1983 (128). Acrylic on canvas, 40 x 56".
Private collection

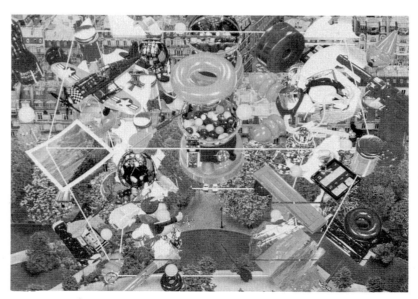

502. *C/VII/D (Paris Spring)*. 1984 (129).
Acrylic on canvas, 40 x 56". Private collection

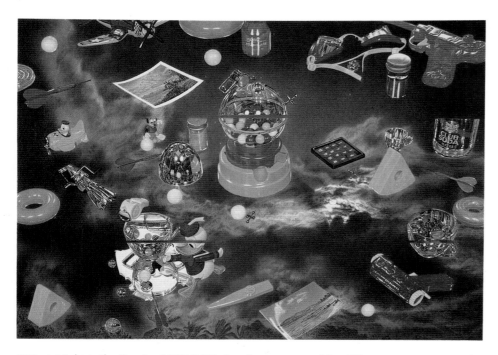

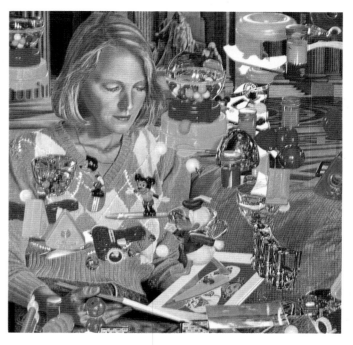

503. *A Night in the Tropics.* 1985 (136). Acrylic on canvas, 34 x 48".
Private collection, Connecticut

504. *JC-1.* 1984 (130). Acrylic on canvas, 30¼ x 30¼".
Private collection

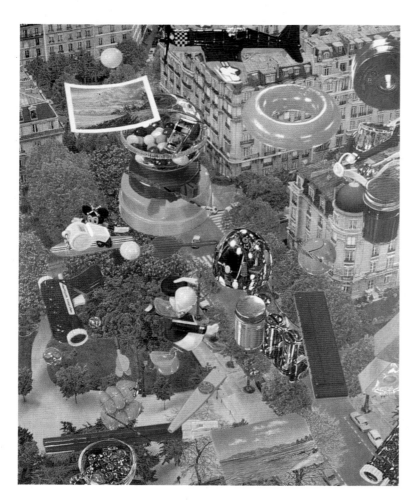

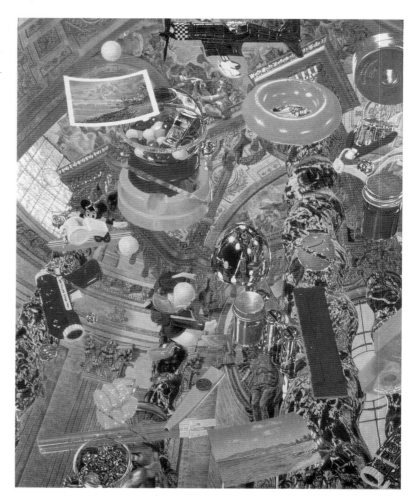

505. *C/VIII/B (An American in Paris).* 1985 (134). Acrylic on canvas, 55 x 44".
Collection Mrs. Harry Mann, Ohio

506. *Altar Boy Daydreamer.* 1985 (137). Acrylic on canvas, 55 x 44".
Collection Dr. Michael Goodman, California

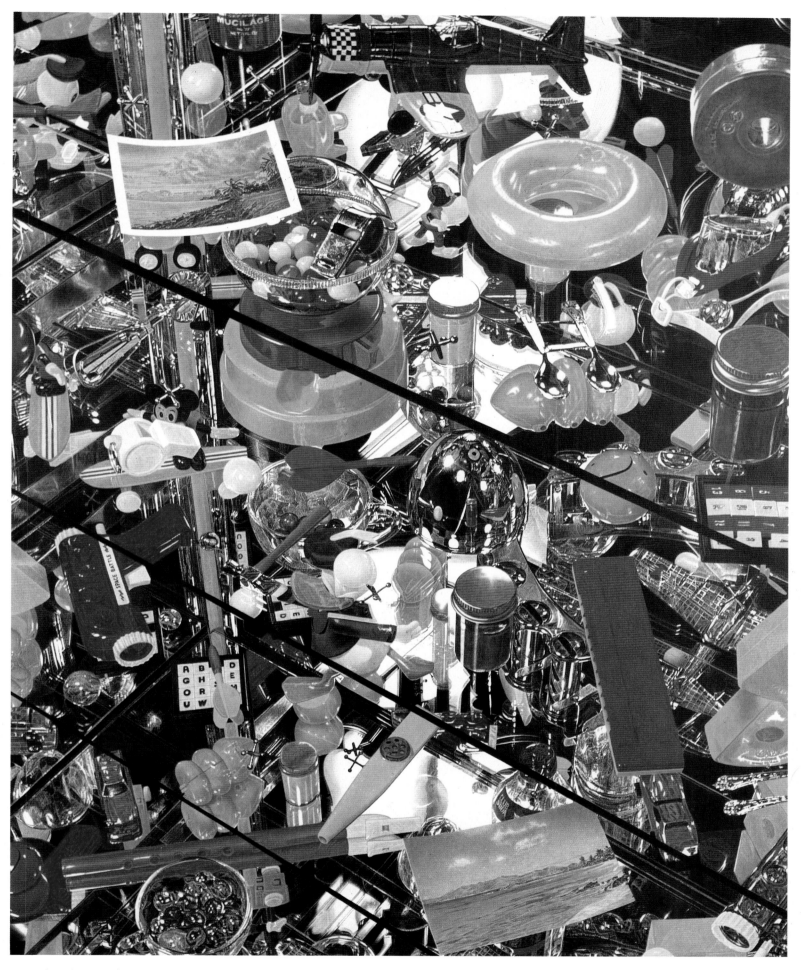

507. *C/VIII/A*. 1984 (132). Acrylic on canvas, 75 x 60". Collection Joan and Alan Safir, New York

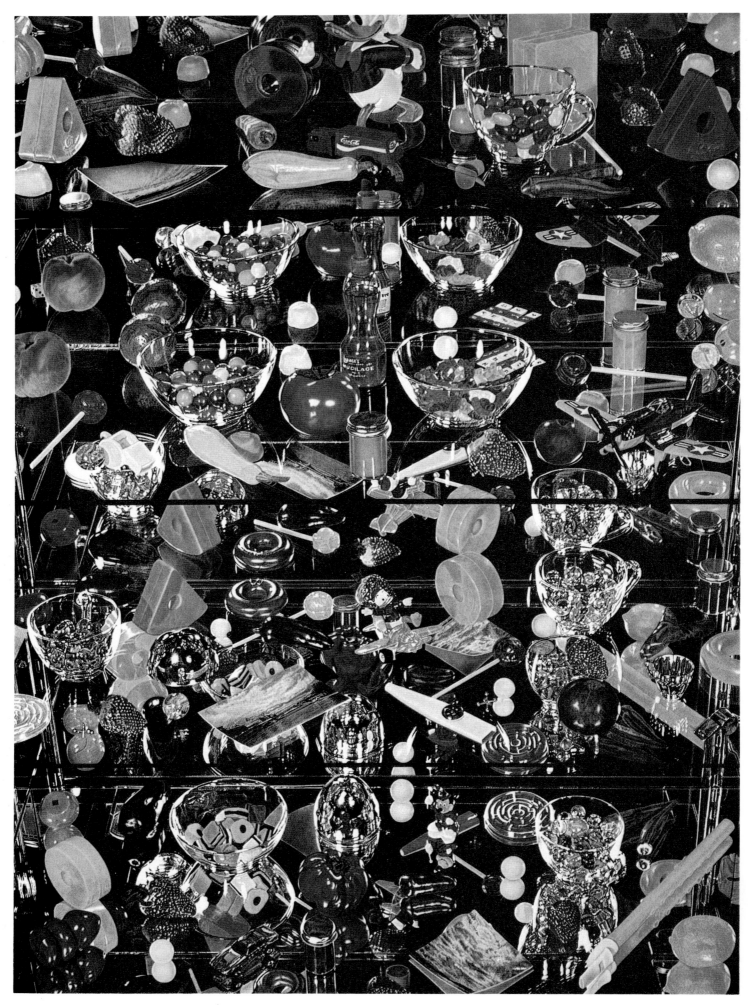

508. *Dreamreader's Cabinet II*. 1986 (142). Acrylic on canvas, 70 x 50". Private collection

509. *Dreamreader's Cabinet.* 1985 (138). Acrylic on canvas, 50 x 60". Private collection, France

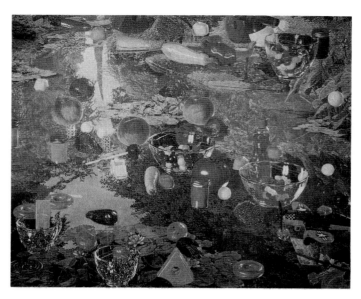

510. *Daydreamer in Bellagio.* 1985 (139). Acrylic on canvas, 50 x 60". Collection Marcia Rodrigues, California

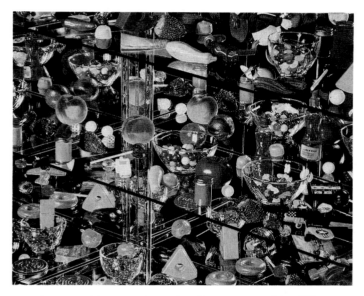

511. *Autumn Light.* 1986 (141). Acrylic on canvas, 50 x 60". The Honolulu Advertiser, Inc., Hawaii

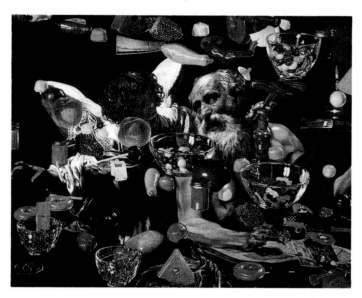

512. *Jerome's Dilemma.* 1986 (140). Acrylic on canvas, 40 x 48". Collection Mr. and Mrs. Sydney Besthoff III, Louisiana

513. *Persistent Memories I.* 1986 (144). Acrylic on canvas, 48 x 48". Collection Anita and Arnold Rosenstein, California

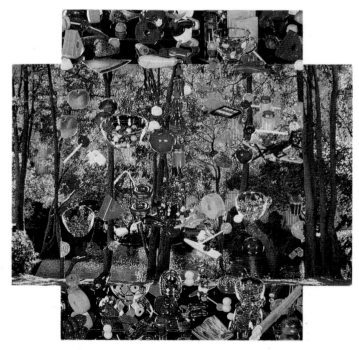

514. *Arcadian Delusion.* 1987 (146). Acrylic on canvas, 48 x 48". Collection Sidney and George Perutz, Texas

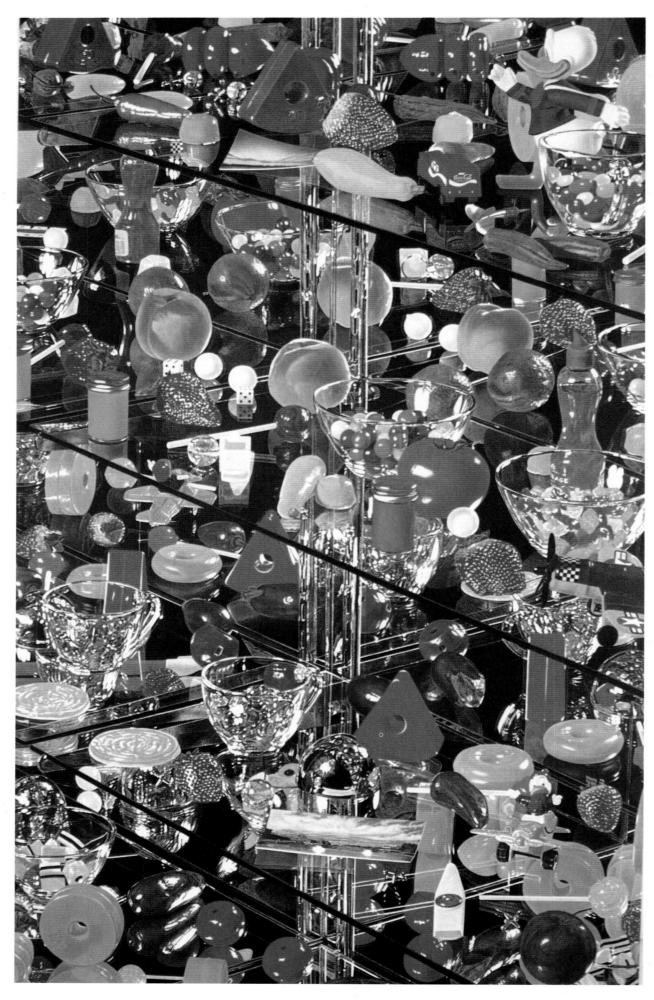

515. *Dreamreader's Cabinet III.* 1987 (147). Acrylic on canvas, 80 x 50".
Collection Sidney and George Perutz, Texas

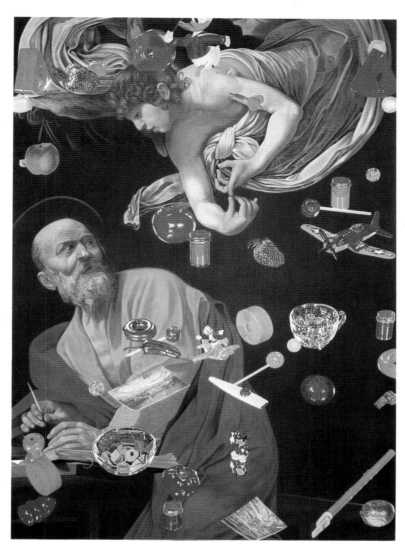

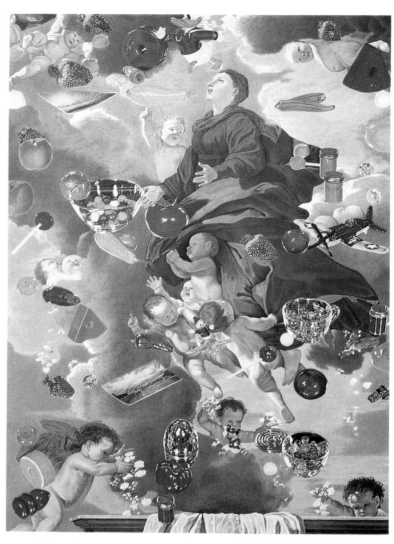

516. *Matthew's Dilemma.* 1986 (143). Acrylic on canvas, 56 x 40".
Private collection

517. *Altar Boy Daydreamer II.* 1987 (145). Acrylic on canvas, 56 x 40".
Flint Institute of Arts, Michigan. Museum Purchase in Memory of Mary
Mallory Davis

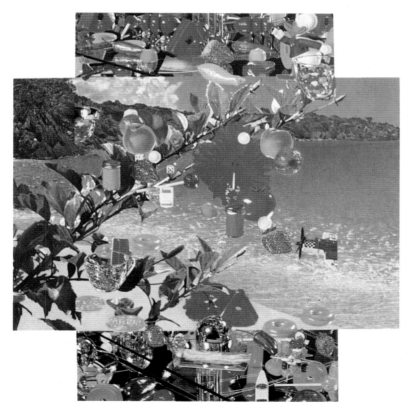

518. *Persistent Memories II.* 1987 (148). Acrylic on canvas, 50 x 48".
Private collection

519. *Dreamreader's Cabinet V.* 1988 (150). Acrylic on canvas, 30 x 38".
Collection Linda and Jeffrey Smith, New York

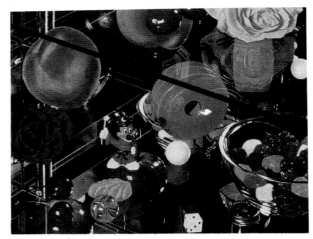

520. *Dreamreader's Cabinet VI.* 1988 (151). Acrylic on canvas, 30 x 38". Private collection

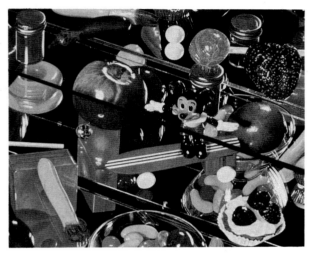

521. *Dreamreader's Cabinet VII.* 1988 (153). Acrylic on canvas, 30 x 36". Private collection

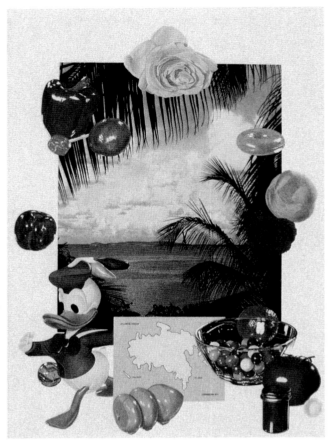

522. *Escape from Dog Island.* 1988 (155). Acrylic on canvas, 55 x 40". Private collection, Minnesota

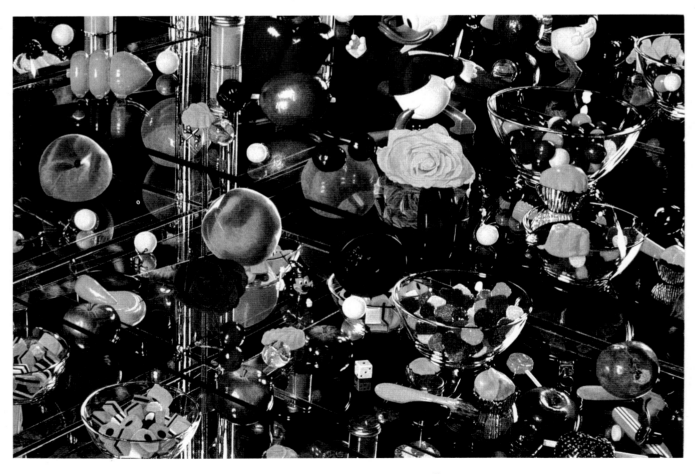

523. *Dreamreader's Cabinet IV.* 1988 (149). Acrylic on canvas, 48 x 70". Private collection, Minnesota

524. *After the Harvest.* 1988 (154). Acrylic on canvas, 40 x 55".
Private collection

525. *Dreamreader's Harvest II.* 1989 (159). Acrylic on canvas, 48 x 66".
Private collection, Minnesota

526. *Persistent Memories III.* 1988 (152). Acrylic on canvas, 60 x 40".
Private collection

527. *An American in Paris II.* 1988 (156). Acrylic on canvas, 60 x 40".
Private collection

529. *Night Traveler III.* 1989 (166). Acrylic on Masonite, 12 × 12". The Capital Group, Inc., California

528. *Visitation.* 1990 (175). Acrylic on board, 14 x 10". Collection Anita and Arnold Rosenstein, California

530. *The Twenty-Fifth Time Zone.* 1989 (167). Acrylic on canvas, 30 x 45". Collection Judy and Noah Liff, Tennessee

531. *Dreamreader's Table III.* 1989 (168). Acrylic on canvas, 45 x 30". Private collection, Colorado

532. *Dreamreader's Table V.* 1990 (171). Acrylic on canvas, 50 x 50". Private collection, Switzerland

533. *Supplicant Way.* 1990 (170). Acrylic on canvas, 60 x 40". Private collection, Switzerland

534. *Dreamreader's Table IV.* 1990 (169). Acrylic on canvas, 40 x 60".
Private collection

535. *Silence Bright.* 1990 (174). Acrylic on canvas, 32 x 48".
Nancy Hoffman Gallery, New York

536. *Morning Light.* 1990 (172). Acrylic on canvas and canvas board,
39¼ x 81½" overall. The Capital Group, Inc., California

537. *Dreamreader's Table VI.* 1990 (173). Acrylic on canvas, 48 x 66".
Nancy Hoffman Gallery, New York

538. *Transfigured Evening.* 1990 (176). Acrylic on canvas, 32 x 48".
Nancy Hoffman Gallery, New York

539. *Clearing II.* 1990 (177). Acrylic on canvas, 32 x 48".
Nancy Hoffman Gallery, New York

540. *Dreamreader's Table.* 1989 (160). Acrylic on canvas, 24 x 24". Private collection

541. *Clearing.* 1989 (162). Acrylic on canvas, 30 x 44". Private collection

542. *Dreamreader's Table: Offering.* 1989 (161). Acrylic on canvas, 24 x 24". Private collection

543. *Dreamreader's Harvest.* 1989 (157). Acrylic on canvas, 50 x 50". Collection Judy and Noah Liff, Tennessee

544. *Memory and Imagination.* 1989 (158). Acrylic on canvas, 50 x 50". Private collection, Minnesota

545. *Passage A.* 1989 (163). Acrylic on canvas, 32 x 32". Private collection

546. *Passage B.* 1989 (164). Acrylic on canvas, 32 x 32". Private collection

547. *Passage C.* 1989 (165). Acrylic on canvas, 32 x 32". Private collection

RICHARD ESTES

Since the sixties, Richard Estes has been the leading artist of Photo-realism. His work has progressed steadily from year to year with new visions and expanding goals, yet has remained within the orthodox definition of Photorealism. The main advance as Estes moved through the eighties has been the expansion of his imagery into amazing panoramic urban views, seeming to encompass entire cities.

The earliest panoramas are *Horatio* and *Waverly Place* (pls. 548 and 552) of 1980, but the expanse really opens up with *Union Square* (pl. 572) of 1985. *View of Paris (Pont Alexandre)* (pl. 582) of 1986 is the first to give the effect of an overview of the whole city. From Paris, Estes went on to paint Rome, London, Florence, Barcelona, and finally Tokyo and Hiroshima.

After thus broadening the panorama, Estes began in the late eighties to portray cityscapes from high places, as in *Central Park, Looking North from Belvedere Castle* (1987; pl. 574), *View of Barcelona* (1988; pl. 596), and *View from Twin Peaks* (pl. 597), his final work of 1990.

In 1989, Estes returned to the approach first seen in *Accademia* (c. 1980; pl. 550) and *View toward La Salute, Venice* (1980; pl. 549) for his fascinating paintings of the Staten Island Ferry (pls. 599–601). In these works, and in his subway scenes and high panoramas, he invented a way to paint what appears to be two entirely different points of focus—the close-up and the distant panorama—as part of one canvas. Neither the eye nor the camera can capture images in this way, but Estes convinces us that it can be done.

Records of Estes's work are not definitive, but he probably has done about 215 works as a Photorealist. Among *Photo-Realism* (86), this work (68), and *Richard Estes: The Complete Paintings 1966–1985* (181), we have illustrated a total of 211 different works.

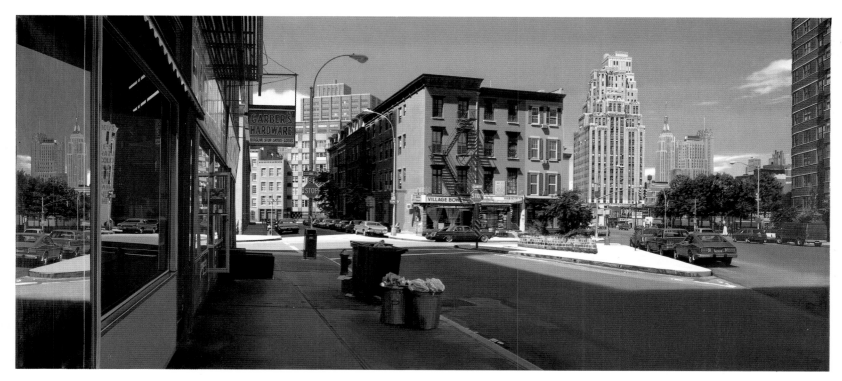

548. *Horatio*. 1979–80 (5). Oil on canvas, 30 x 60". Private collection

179

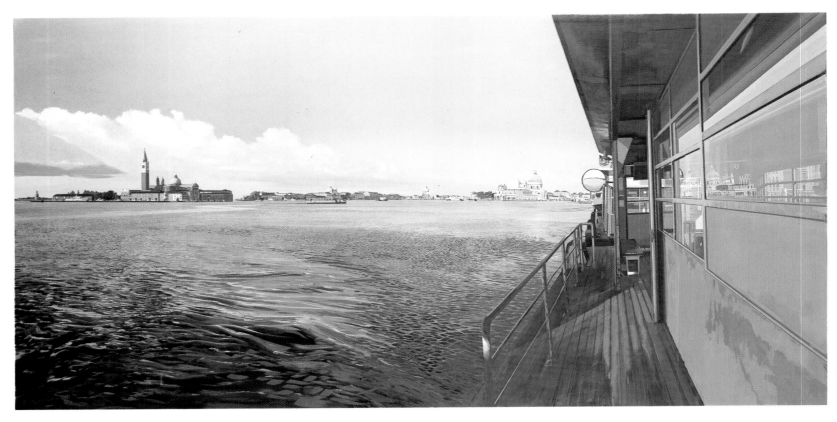

549. *View toward La Salute, Venice.* 1980 (6). Oil on canvas, 36 x 72". Private collection

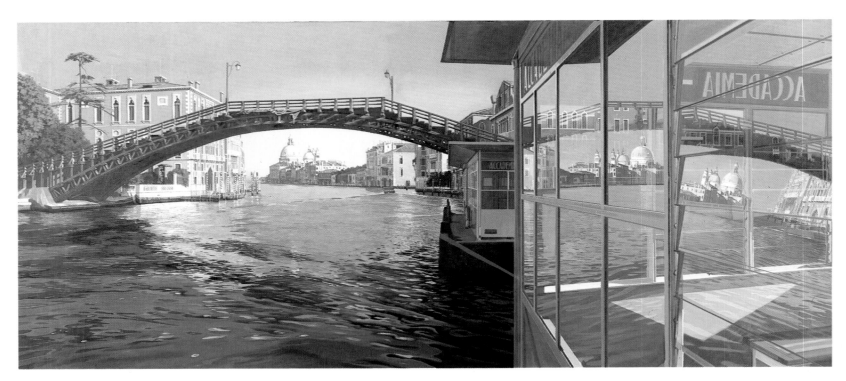

550. *Accademia.* c. 1980 (10). Oil on canvas, 24 x 54". Collection the artist

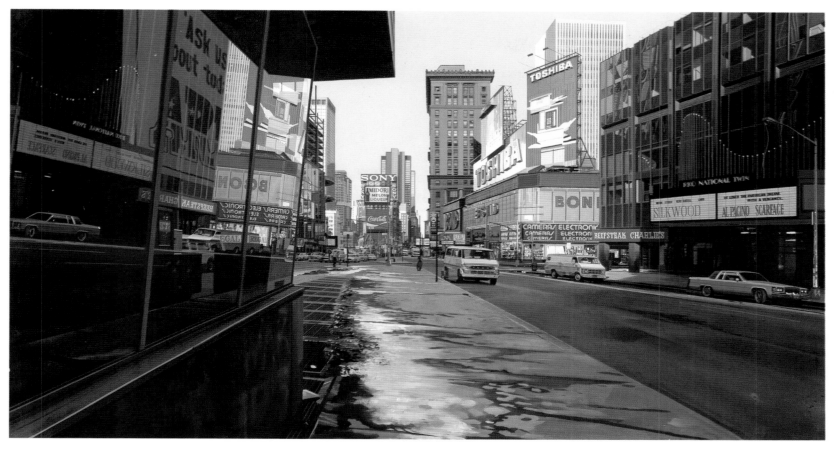

551. *Times Square at 3:53 P.M., Winter.* 1985 (37). Oil on canvas, 27 x 49". Collection Louis K., Susan Pear, and Ari Ron Meisel, New York

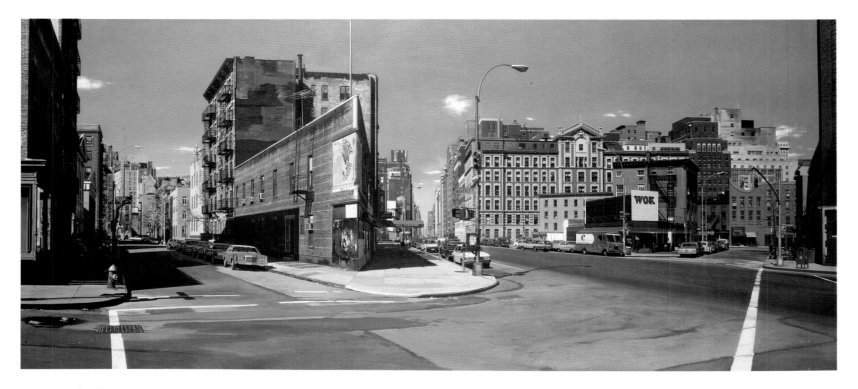

552. *Waverly Place.* 1980 (8). Oil on canvas, 36½ x 80⅜". Hirshhorn Museum and Sculpture Garden, Smithsonian Institution, Washington, D.C.

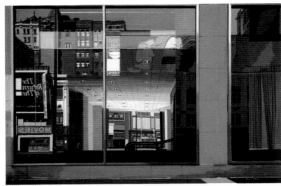

553. *Allied Chemical.* 1981 (11).
Oil on board, 14 x 20".
Private collection

554. *Bus Interior.* 1981 (12).
Oil on board, 14 x 20".
Private collection, Switzerland

555. *Eiffel Tower Restaurant.* 1981 (14).
Oil on board, c. 14 x 20".
Private collection

556. *Cafeteria, Vatican.* 1981 (19).
Oil on board, 14 x 20".
Private collection

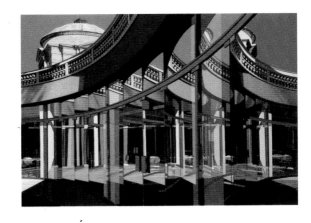

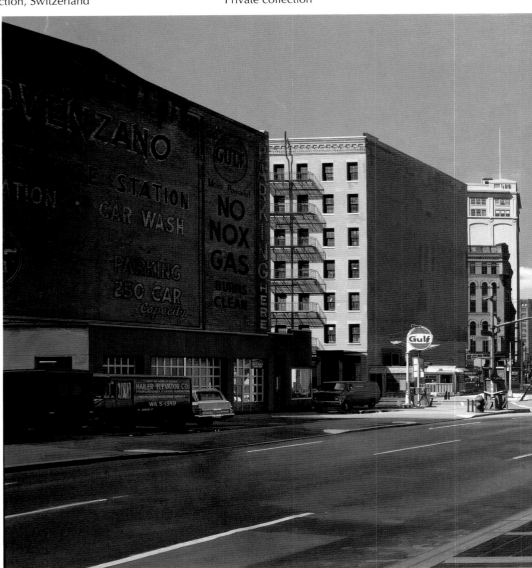

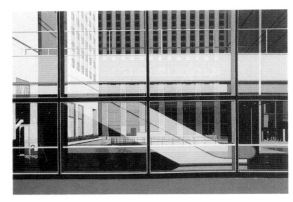

557. *Untitled (Escalator).* 1981 (18).
Oil on board, 14 x 20".
Private collection, New York

558. *Teddy's.* 1982 (22).
Oil on canvas, 38 x 88".
Private collection

559. *View of the RCA Building
from the Fifteenth Floor.* 1980 (7).
Oil on canvas board, 21 x 12".
Private collection, New York

560. *Opera.* 1983 (26).
Oil on canvas, 48 x 34".
Private collection

561. *Flughafen (Airport).* 1981 (15).
Oil on canvas board, 14 x 20".
Fujii Gallery, Japan

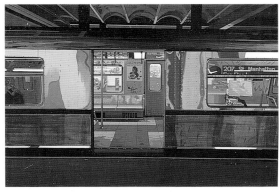

562. *U-Bahn (Subway).* 1980 (9).
Oil on board, 14 x 20".
Fujii Gallery, Japan

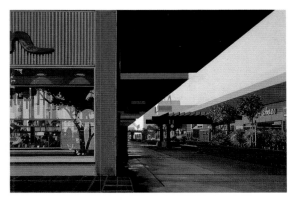

563. *Passages (Shopping Center—Lakewood Mall).* 1981 (17). Oil on board, 14 x 20".
Private collection, Ohio

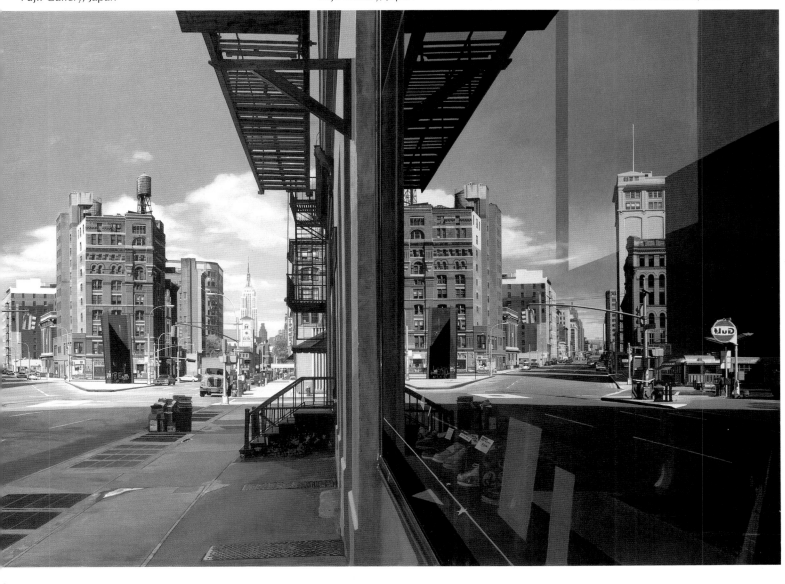

564. *Salzburg.* 1982 (21).
Oil on board, 20 x 14½".
Private collection

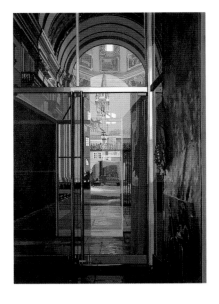

565. *Chase Manhattan.* 1981 (13).
Oil on canvas, 28 x 18".
Private collection

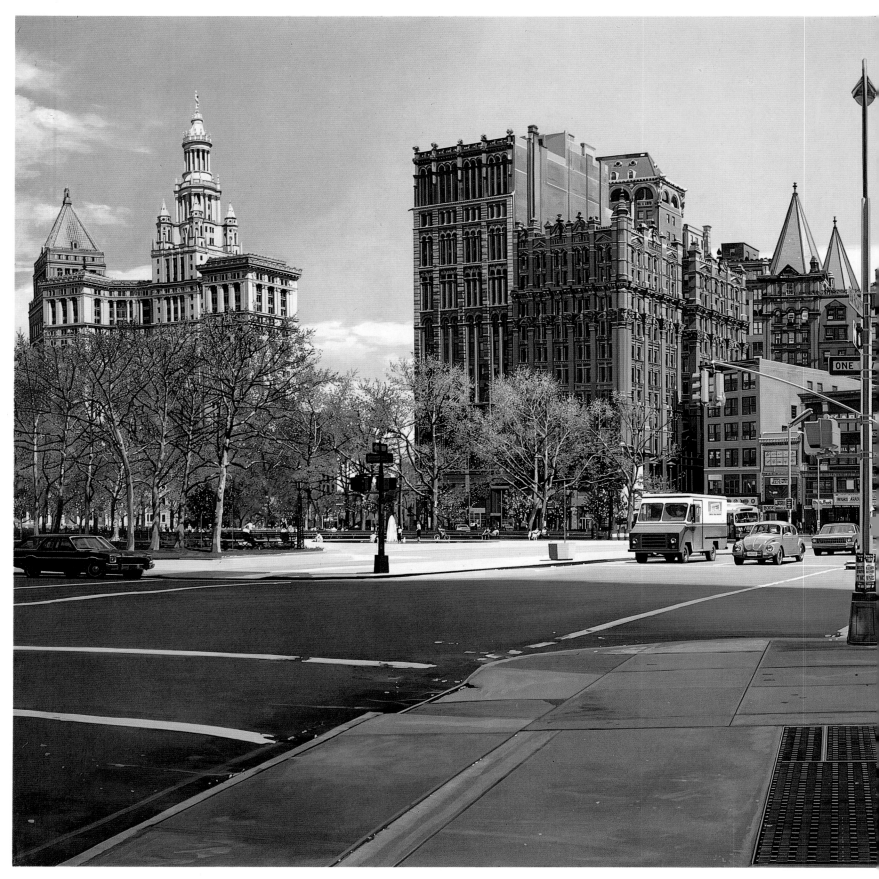

566. *Prescriptions Filled (Municipal Building)*. 1983 (27). Oil on canvas, 36 x 72". Private collection

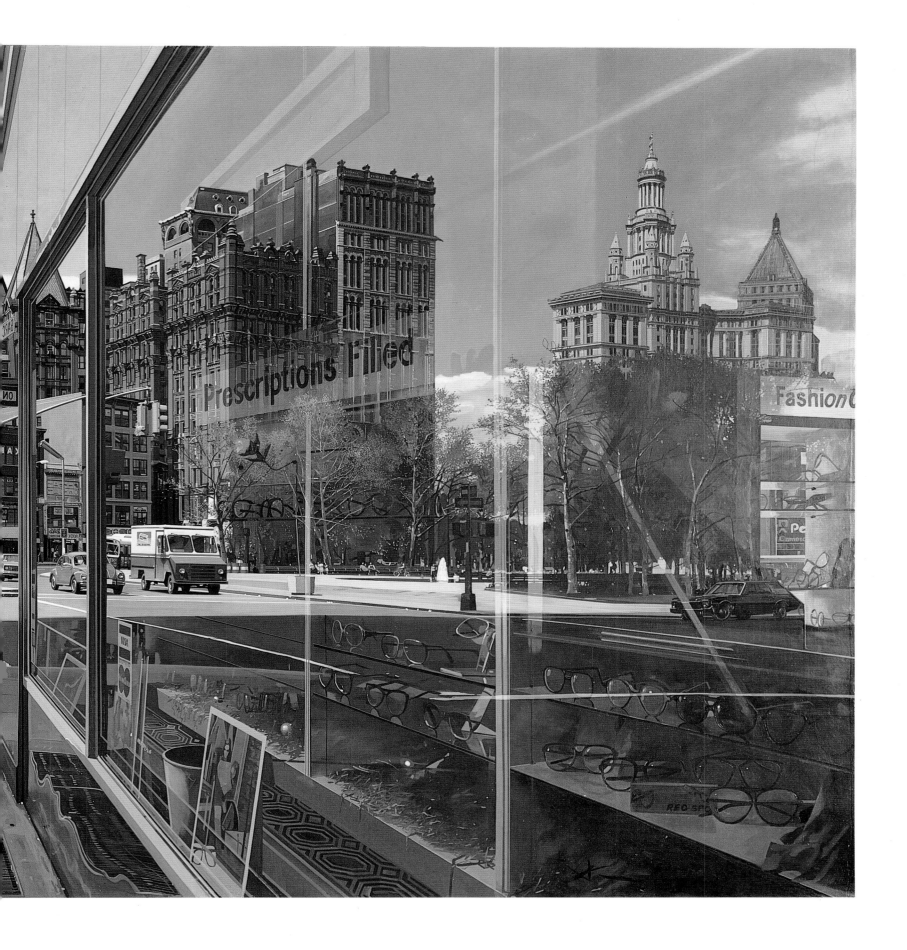

567. *Home Cooking—Heros.* 1983 (24). Oil on canvas, 24 x 36". Private collection

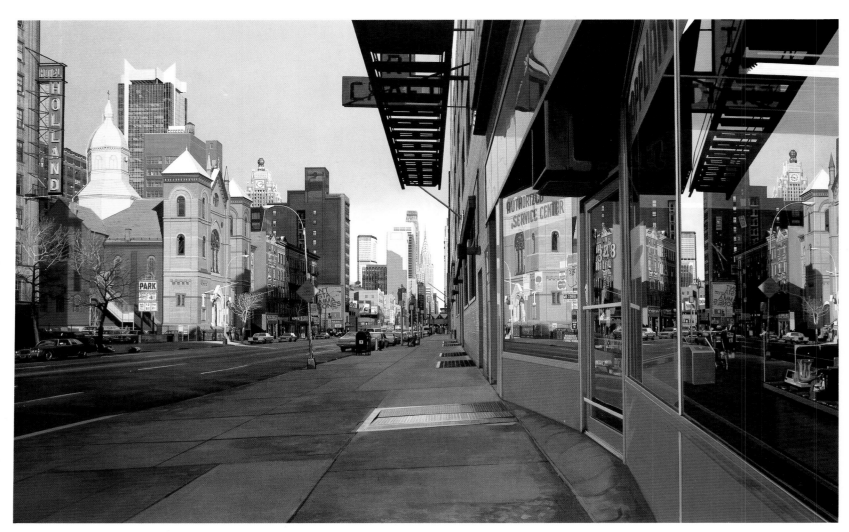

568. *Holland Hotel.* 1984 (31). Oil on canvas, 45 x 71½". Private collection, Switzerland

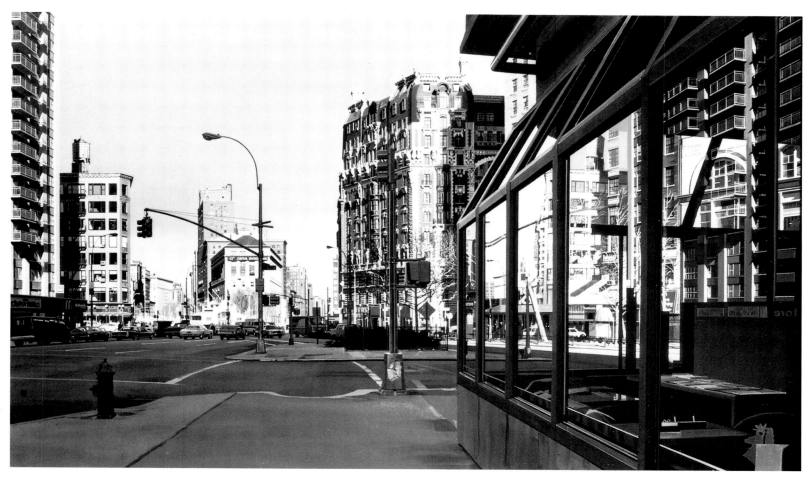

569. *Broadway at 70th Street.* 1985 (35). Oil on canvas, 30 x 50". Private collection

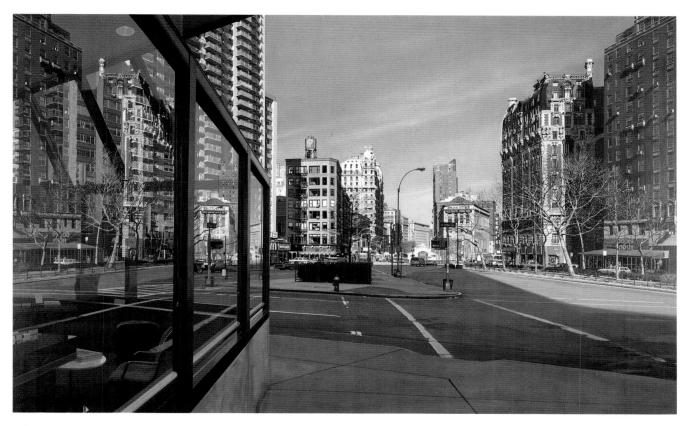

570. *McDonald's.* 1981 (16). Oil on canvas, 34 x 55". Private collection

571. *Oenophilia.* 1983 (25).
Oil on canvas, 24 x 42".
Private collection, Switzerland

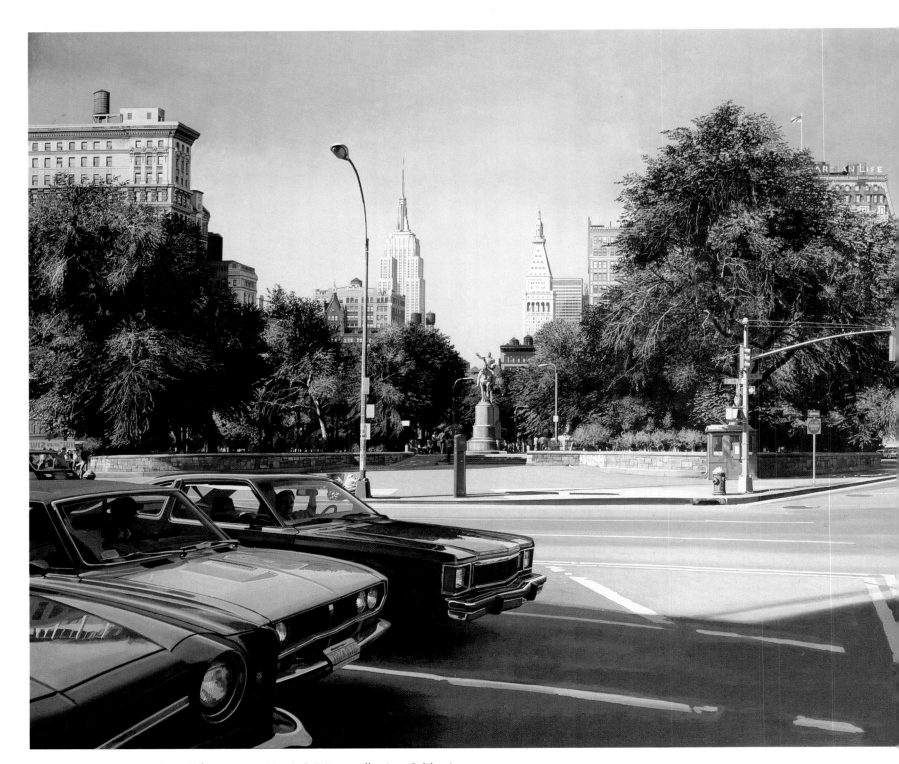

572. *Union Square.* 1985 (38). Oil on canvas, 38 x 89". Private collection, California

573. *Art Institute of Chicago.* 1984 (29).
Oil on canvas, 36 x 48".
Art Institute of Chicago

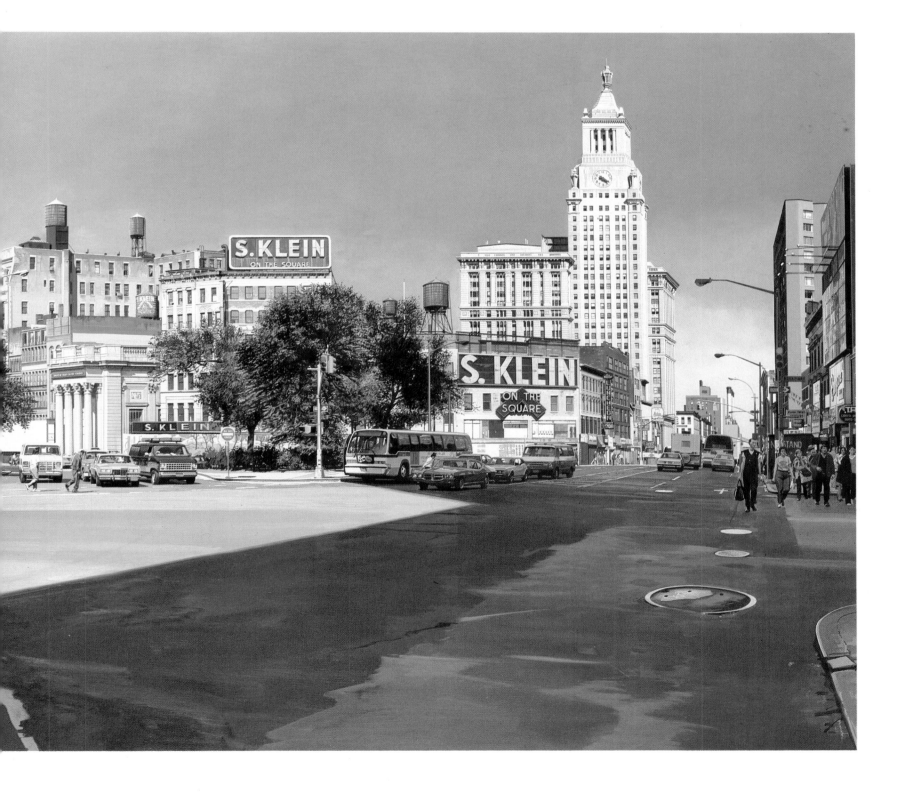

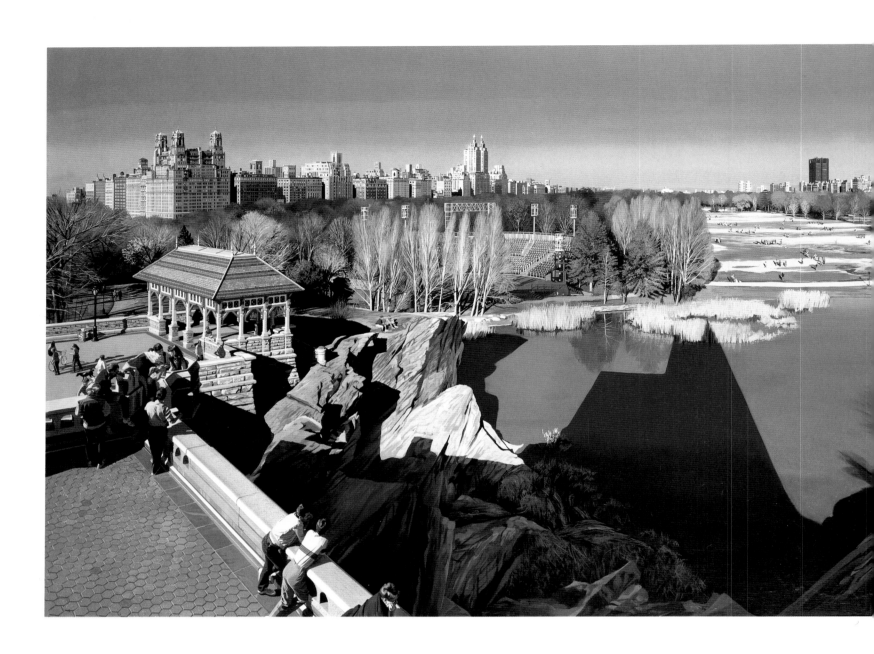

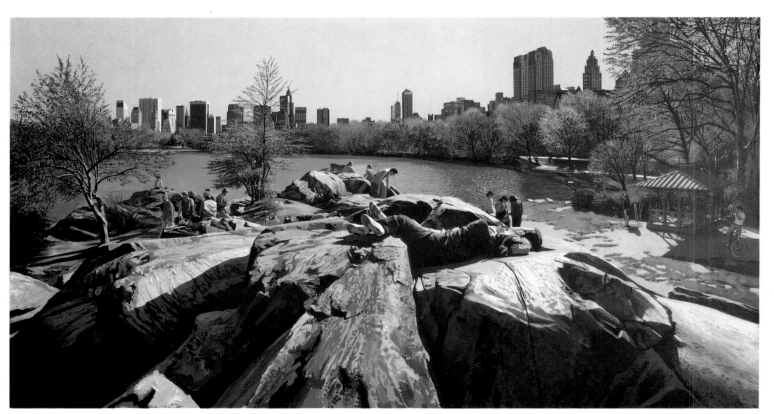

575. *Sunday Afternoon in the Park*. 1989 (55). Oil on canvas, 24 x 44½".
Allan Stone Gallery, New York

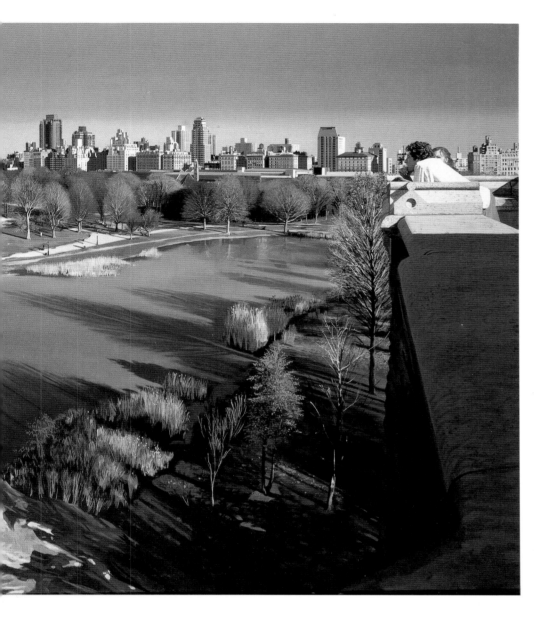

574. *Central Park, Looking North from Belvedere Castle.* 1987 (46).
Oil on canvas, 36 x 86". Private collection

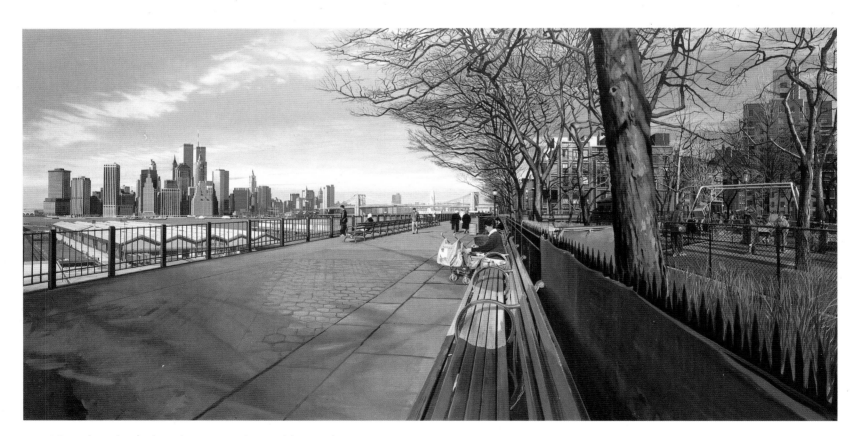

576. *View of Manhattan from the Promenade, Brooklyn Heights.* 1989 (56).
Oil on canvas, 36 x 72". Private collection, California

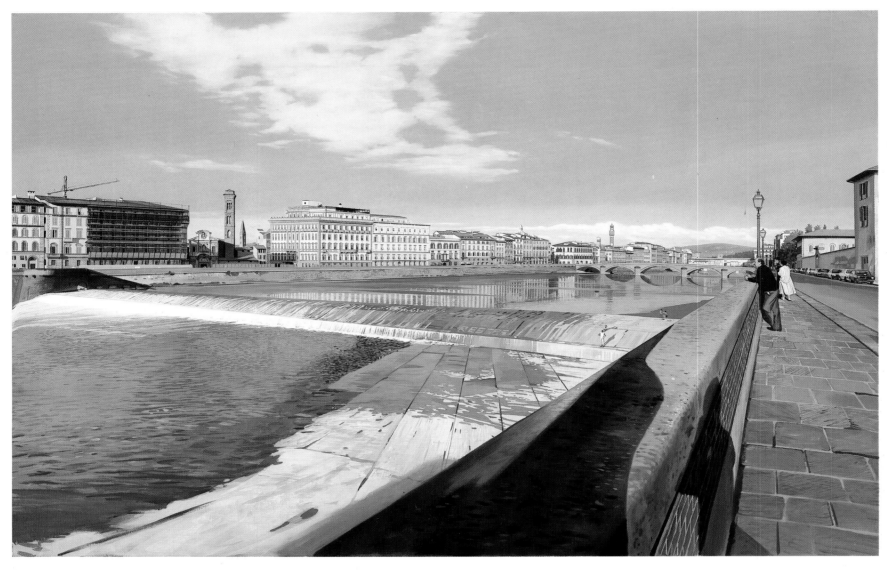

577. *View of Florence*. 1985 (39). Oil on canvas, 30 x 46". Private collection

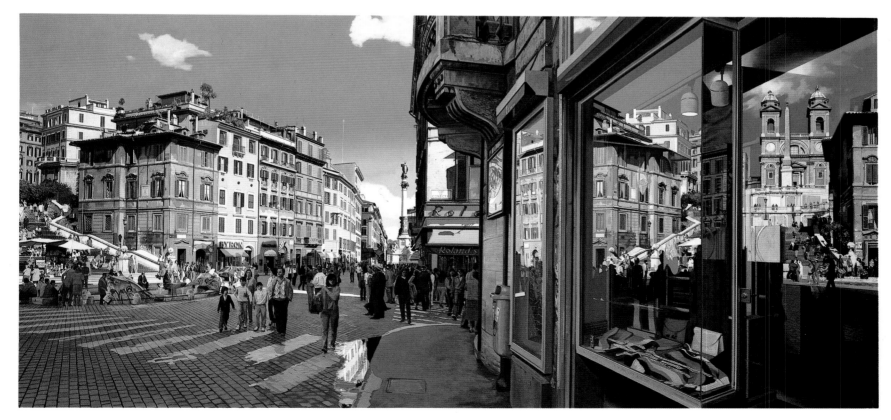

578. *Piazza di Spagna, Roma*. 1986 (44). Oil on canvas, 36 x 73". Private collection, California

579. *Pont du Carrousel.* 1984 (33). Oil on canvas, 36 x 72". Private collection, Washington, D.C.

580. *View of the Pont Neuf, Paris.* 1985 (40).
Oil on canvas board, 17 x 27½". Collection the artist

581. *Place Vendôme.* 1986 (45). Oil on board, 20 x 29".
Collection Laila and Thurston Twigg-Smith, Hawaii

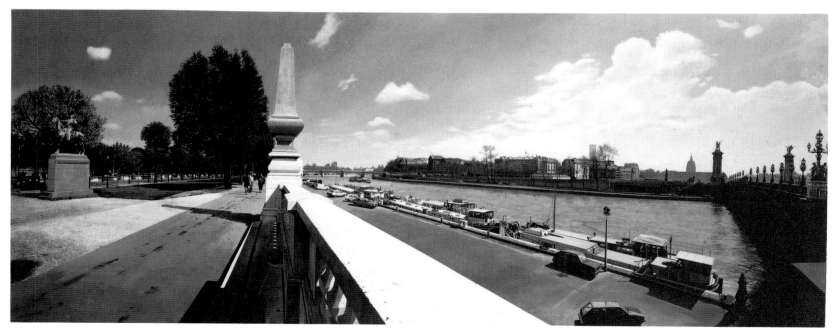

582. *View of Paris (Pont Alexandre).* 1986 (43). Oil on canvas, 36 x 89". Private collection, California

583. *Bus Stop, Lincoln Center.* 1985 (41).
Oil on board, 19½ x 15¼".
Collection the artist

584. *Study for Broadway at Lincoln Center*.
1983 (28). Gouache on board, 19½ x 16".
PieperPower Companies, Inc., Wisconsin

585. *Broadway at Lincoln Center No. 1.*
1983–85 (34). Acrylic on board, 23 x 18".
Private collection, New York

586. *Broadway and 64th,
Spring '84.* 1984 (30).
Oil on canvas, 40 x 72".
Collection Martin
Z. Margulies, Florida

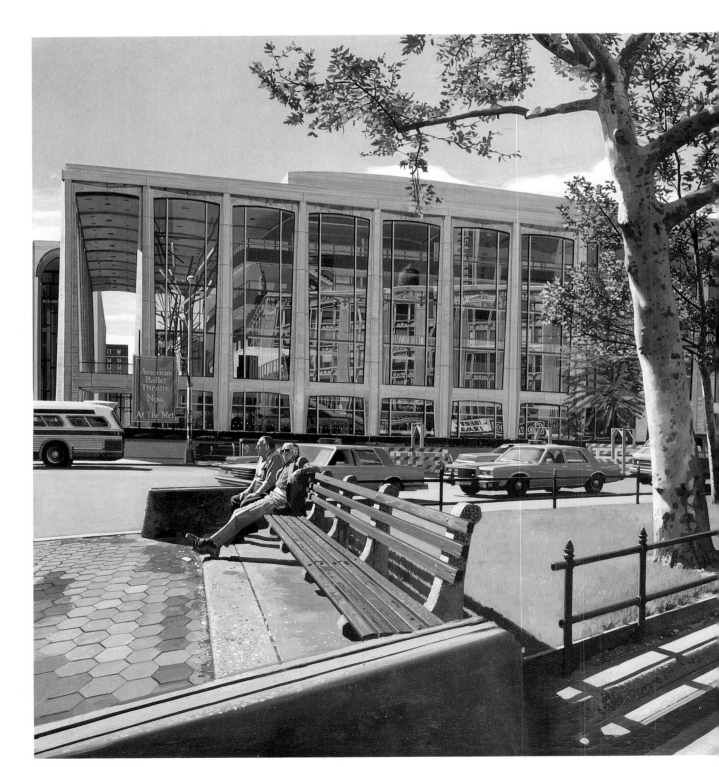

587. *Broadway at Lincoln Center No. 2.* 1983 (23).
Acrylic on board, 17 x 22".
Private collection, Switzerland

588. *Hotel Empire.* 1987 (47). Oil on canvas, 37½ x 87".
Collection Louis K. and Susan Pear Meisel, New York

589. *Philharmonic Hall,
Lincoln Center.* 1985 (42).
Oil on canvas board, 20 x 15½".
Collection the artist

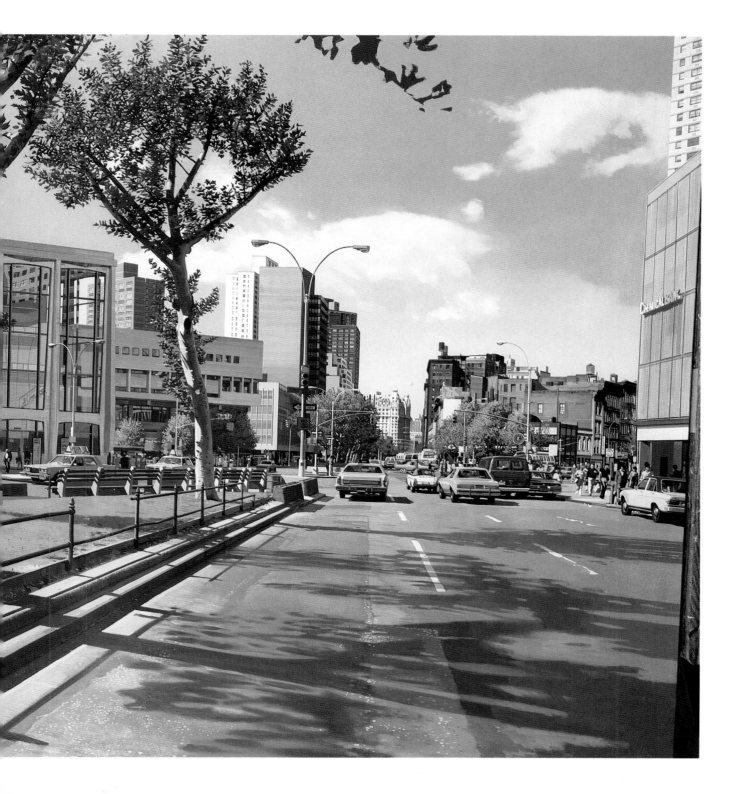

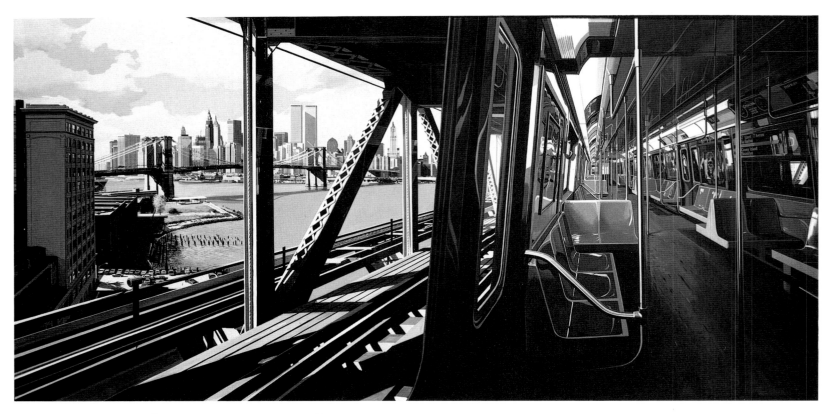

590. *D Train.* 1988 (51). Oil on canvas, 36 x 72". Private collection, New York

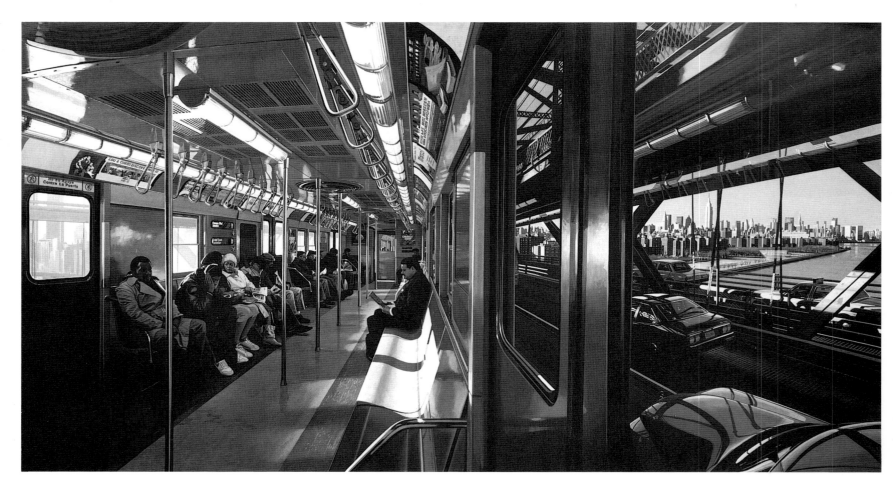

591. *Williamsburg Bridge.* 1987 (48). Oil on canvas, 36 x 66". Private collection, Switzerland

592. *The Michelangelo.* 1988 (52). Oil on paper laid down on canvas, 14³/₄ x 24³/₈". Private collection, Switzerland

593. *Columbus Circle, Maine Monument.* 1989 (54). Oil on canvas, 27 x 46". Allan Stone Gallery, New York

594. *View of 34th Street from 8th Avenue.* 1979 (4). Oil on canvas, 91 x 91". Private collection

595. *Tower Bridge.* 1989 (53). Oil on canvas, 29 x 66". Private collection, California

596. *View of Barcelona.*
1988 (50).
Oil on canvas, 40 x 88".
Private collection

597. *View from Twin Peaks.* 1990 (68). Oil on canvas, 36 x 72". Private collection, California

598. *Staten Island Ferry.* 1987 (49). Oil on canvas, 36 x 84". Private collection, California

599. *Staten Island Ferry.* 1989 (57). Oil on canvas board, 14 x 22". Private collection, New York

600. *On the Staten Island Ferry Looking toward Manhattan (L'Embarquement pour Cythère)*. 1989 (58). Oil on canvas, 48 x 74". Private collection

601. *Staten Island Ferry Slip (L'Embarquement pour Cythère II)*. 1989 (59). Oil on canvas, 36 x 74". Private collection, Switzerland

602. *View of Hiroshima.* 1990 (61). Oil on canvas, 39½ x 63". Allan Stone Gallery, New York

603. *Shinjuku.* 1989 (60). Oil on canvas, 36 x 72". Allan Stone Gallery, New York

604. *Six Views of Edo: Shinjuku I.* 1989 (62). Acrylic and gouache on illustration board, 18 x 24¹⁄₂". Allan Stone Gallery, New York

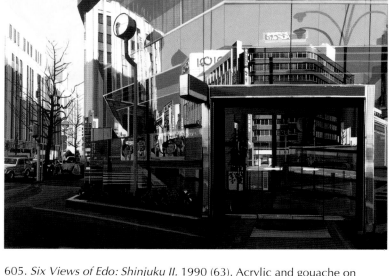

605. *Six Views of Edo: Shinjuku II.* 1990 (63). Acrylic and gouache on illustration board, 20 x 28". Allan Stone Gallery, New York

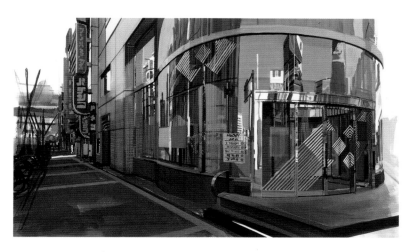

606. *Six Views of Edo: Shinjuku III.* 1990 (64). Acrylic and gouache on illustration board, 16¹⁄₂ x 27¹⁄₂". Allan Stone Gallery, New York

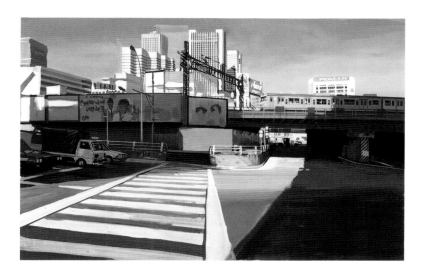

607. *Six Views of Edo: Shinjuku IV.* 1990 (65). Acrylic, gouache, and oil on illustration board, 17³⁄₄ x 27". Allan Stone Gallery, New York

608. *Six Views of Edo: Shinjuku V.* 1990 (66). Acrylic and gouache on illustration board, 16¹⁄₂ x 24¹⁄₂". Allan Stone Gallery, New York

609. *Six Views of Edo: Ueno.* 1990 (67). Acrylic and gouache on illustration board, 18 x 21³⁄₄". Allan Stone Gallery, New York

610. *Eat'n Time*. 1969 (1). Oil on Masonite, 18 x 24".
Private collection, New York

611. *Sandwiches, Hamburgers, Frankfurters.* 1970 (3).
Acrylic on paper, 14¼ x 22". Private collection, New York

612. *Portrait of Marguerite Yourcenar.*
1985 (36). Oil on canvas, 36 x 18".
Fonds National d'Art Contemporain,
Ministère de la Culture, de la
Communication, des Grands Travaux
et du Bicentenaire, France

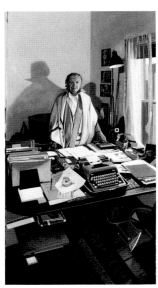

613. *Old Police Headquarters,
New York City.* 1984 (32).
Oil on canvas board, 20¼ x 15".
Collection the artist

614. *Number Five Broadway.*
1969 (2). Oil on Masonite,
48 x 32". Private collection

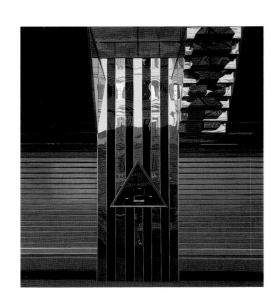

615. *Andy Capp.* 1982 (20).
Oil on board, 19½ x 17½".
Collection Mr. and Mrs.
Charles Herman, Missouri

204

AUDREY FLACK

Audrey Flack, a major Photorealist, is also one of the most innovative artists of the past twenty-five years. When the seventies ended, so did Flack's work as an orthodox Photorealist. In the early eighties, she painted just twelve photo-derived, but decidedly not Photorealist, works.

Flack spent much of the decade in experimentation. For a year or so, she concentrated on photography and produced a portfolio of dye-transfer prints of the original photographs. She also devoted some time to on-site, impromptu watercolors, which were shown at several galleries. In the same period, Flack wrote a book entitled *Art and Soul*.

Above all, the eighties were a time when Flack worked seriously at beginning a second career as a sculptor. In each and every medium, Flack's work has been marked by her own special style, and the sculpture is no exception. Its imagery and message are pure Flack, both in the flamboyance and in the juxtaposition of objects (first seen, in the paintings, as two-dimensional, collage-like compositions and now as three-dimensional, sculptural forms). The artist's technical skills in sculpture are equal to those she has demonstrated with brush, pen, pencil, and camera. Most of the sculptures completed in the eighties are illustrated herein (pls. 616, 648–57).

All 12 of the photo-derived paintings that Flack produced during the eighties are illustrated herein. In addition, there are 5 major works on paper, 14 minor works on paper (the postcard series), and 11 examples of the bronzes (each work in the editions of the bronzes differs slightly from the others). Her career total of Photorealist paintings therefore stands at 66 plus the 14 postcards; all but 2 of these works (early sunsets) are illustrated in our two volumes.

616. *Medicine Woman.* 1989 (77). Polychromed and gilded bronze cast, 19" high with base. One of an edition of six. Louis K. Meisel Gallery, New York

617. *We Are All Light and Energy.* 1981 (59). Oil over acrylic on canvas, 46 x 66".
Private collection, Switzerland

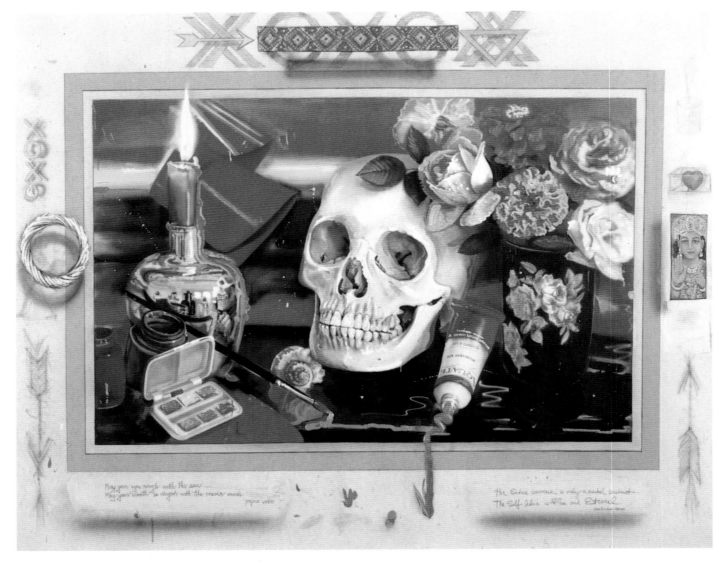

618. *Invocation.* 1983 (61). Oil over acrylic on canvas, 64 x 80".
Collection the artist

619. *Isis.* 1983 (66).
Oil over acrylic on canvas, 60 x 60".
Collection the artist

620. *Hannah: Who She Is.* 1982 (60).
Oil over acrylic on canvas, 84 x 60".
The National Museum of
Women in the Arts,
Washington, D.C.
Purchased with funds
donated anonymously

621. *Still Life with Bread and Cheese from Luis Menéndez.* 1979 (53d). Gouache and watercolor on paper, 4¹/₂ x 5¹/₄". Collection the artist

622. *Still Life (with Tea Cup) from Chardin.* 1980 (53n). Gouache and watercolor on paper, 7¹/₂ x 6¹/₂". Private collection

623. *Flowers in a Crystal Bowl.* 1980 (53l). Gouache and watercolor on paper, 4 x 5¹/₂". Private collection, New York

624. *Parrot, Tulips, and Peapods from De Heem.* 1979 (53e). Gouache and watercolor on paper, 7¹/₂ x 5". Collection Glenn C. Janss, Idaho

625. *Sacra Famiglia from Bernardino Luini.* 1979 (53f). Gouache and watercolor on paper, 6 x 4³/₄". Collection the artist

626. *Cybele and the Four Seasons from Breughel.* 1979 (53g). Gouache and watercolor on paper, 9³/₈ x 6³/₈". Louis K. Meisel Gallery, New York

627. *Flowers in a Bronze Vase from Bosschaert the Younger.* 1979 (53h). Gouache and watercolor on paper, 12 x 9³/₈". Fort Wayne Museum of Art, Indiana

628. *Still Life with Cherries from Louise Moillon.* 1979 (53i). Gouache and watercolor on paper, 7¹/₈ x 5³/₈". Private collection

629. *Floral with Bird from Malaine.* 1979 (53j). Gouache and watercolor on board, 5¹/₂ x 4". Private collection

630. *Still Life with Roses.* 1980 (53k). Gouache and watercolor on paper, 8 x 5¹/₂". Private collection

631. *Floral Chameleon, Flowers in a Niche from Savery.* 1980 (53m). Gouache and watercolor on paper, 7¹/₄ x 5". PieperPower Companies, Inc., Wisconsin

632. *Beverly's Peppers.* 1984 (68). Pastel on paper, 25 x 17". Danforth Museum of Art, Massachusetts

633. *Banana Split Sundae.* 1985 (69). Colored pencil and pastel on paper, 16½ x 23¼". Louis K. Meisel Gallery, New York

634. *Velvet Flowers.* 1980 (55). Acrylic on paper, 23¼ x 15½". Private collection, Illinois

635. *Monarch and Rose.* 1980 (56). Acrylic on paper, 15 x 21½". Private collection, New York

636. *Roman Beauties (Small Version).* 1985 (70). Oil and acrylic on canvas, 24 x 34". Collection Dale C. and Alexandra Zetlin Jones, New York

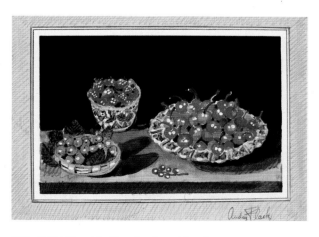

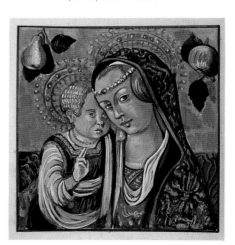

637. *Vanitas Still Life from Pieter Claesz.* 1979 (53a). Gouache and watercolor on paper, 5¼ x 7½". Private collection

638. *Still Life with Cherries from Van Soon.* 1979 (53c). Gouache and watercolor on paper, 4 x 5½". Guild Hall Museum, East Hampton, New York

639. *Madonna and Child from Carlo Crivelli.* 1979 (53b). Gouache and watercolor on paper, 6½ x 6¼". Collection the artist

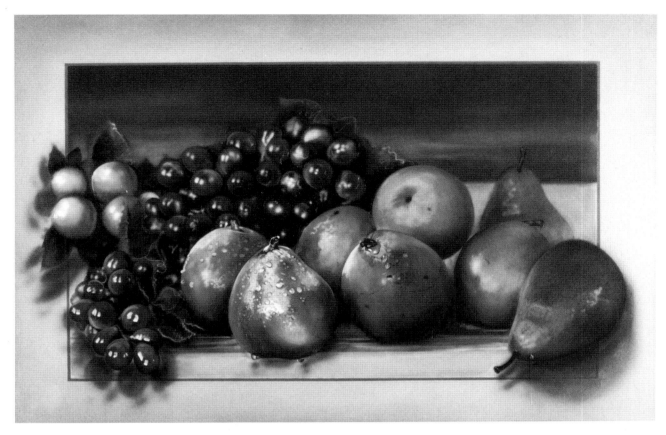

640. *A Pear to Heade and Heal.* 1983 (62). Oil over acrylic on canvas, 38 x 56". Private collection, California

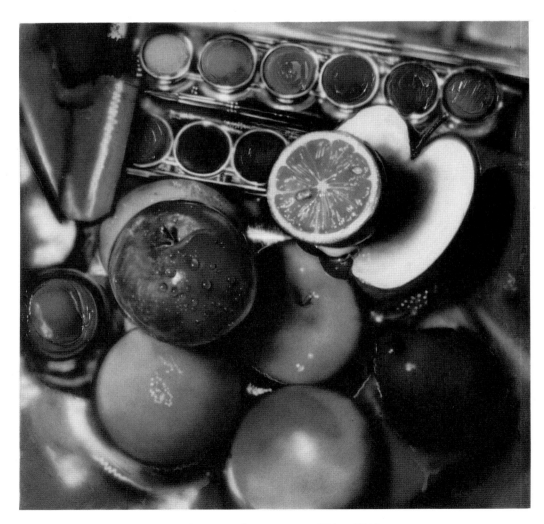

641. *Energy Apples.* 1980 (58). Oil over acrylic on canvas, 47³/₄ x 48¹/₄".
Collection Louis K. and Susan Pear Meisel, New York

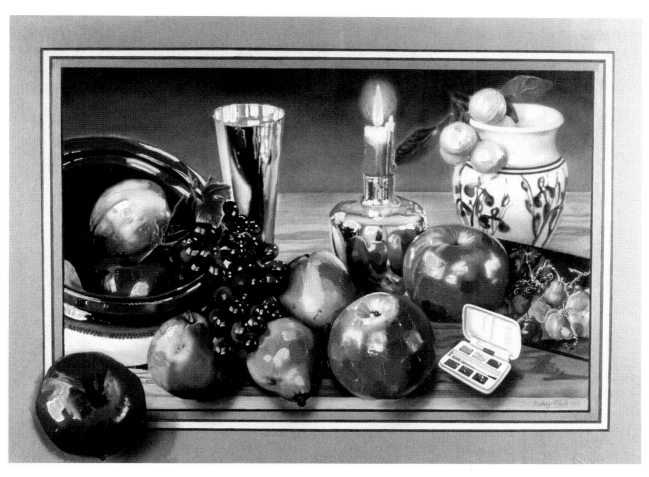

642. *Roman Beauties.* 1983 (65). Oil over acrylic on canvas, 54 x 74".
Collection Mr. and Mrs. Sydney Besthoff III, Louisiana

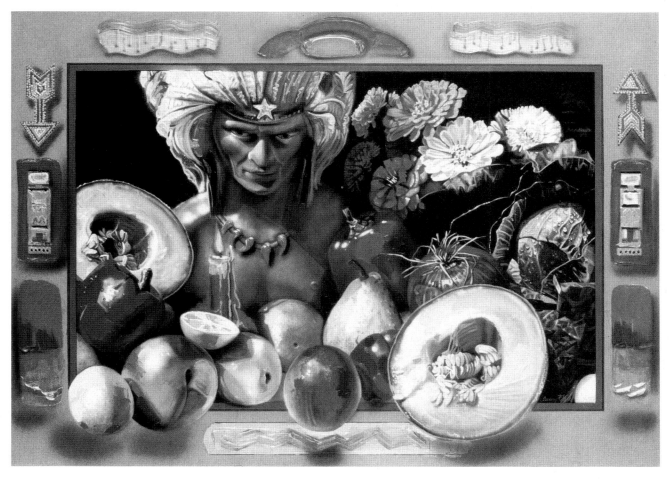

643. *Fruits of the Earth.* 1983 (67). Oil over acrylic on canvas, 54 x 74".
Private collection, New York

644. *Rainbow Christ.* 1983 (63).
Acrylic and oil on canvas with
painted wood frame, 31 x 17¹/₂ x 6¹/₂".
Collection the artist

645. *Self-Portrait.* 1980 (57).
Oil and crayon on paper, 32¹/₂ x 30".
Private collection, California

646. *Sojourner Truth.* 1980 (54).
Oil and acrylic on canvas, 62 x 48".
Collection the artist

647. *Baba.* 1983 (64). Oil over acrylic on canvas, 90 x 156". Private collection, Colorado

648. *Islandia, Goddess of the Healing Waters.* 1988 (72). Patinated and gilded bronze cast, 66½ x 26 x 38".
One of an edition of six. New York City Technical College, Brooklyn

649. *Angel with Heart Shield.* 1984 (71).
Bronze cast, 9¼" high with base.
One of an edition of six.
Collection Ari Ron Meisel, New York

650. *Receiver of the Sun
(Sun Goddess).* 1990 (80).
Polychromed resin with objects,
33½" high with base.
Louis K. Meisel Gallery,
New York

651. Maquette for *Civitas.* 1988 (73).
Patinated and gilded bronze cast,
with cast-glass flame and marble orb,
57 x 12 x 17". One of an edition of six.
Collection Donna and Neil
Weisman, New Jersey

652. *Egyptian Rocket Goddess.* 1990 (78). Patinated bronze cast, 42" high with base. One of an edition of six.
Private collection, Ontario

653. *American Athena.* 1989 (76). Patinated bronze cast with gilded ornament and mother-of-pearl inlay, 37 x 13½ x 16". One of an edition of six.
Collection Donna and Neil Weisman, New Jersey

654. *Diana.* 1988 (74). Gold-plated bronze cast with jewels, 30" high with base. One of an edition of six.
Collection Robert and Fredi Consolo, Florida

655. *The Art Muse.* 1988 (75). Gold-plated bronze cast with jewels, 26" high with base. One of an edition of six.
Louis K. Meisel Gallery, New York

656. *Civitas: Four Visions (Gateway to the City of Rock Hill).* 1990–91 (79). Patinated and gilded bronze cast, 13' high without base. One of an edition of six. City of Rock Hill, South Carolina

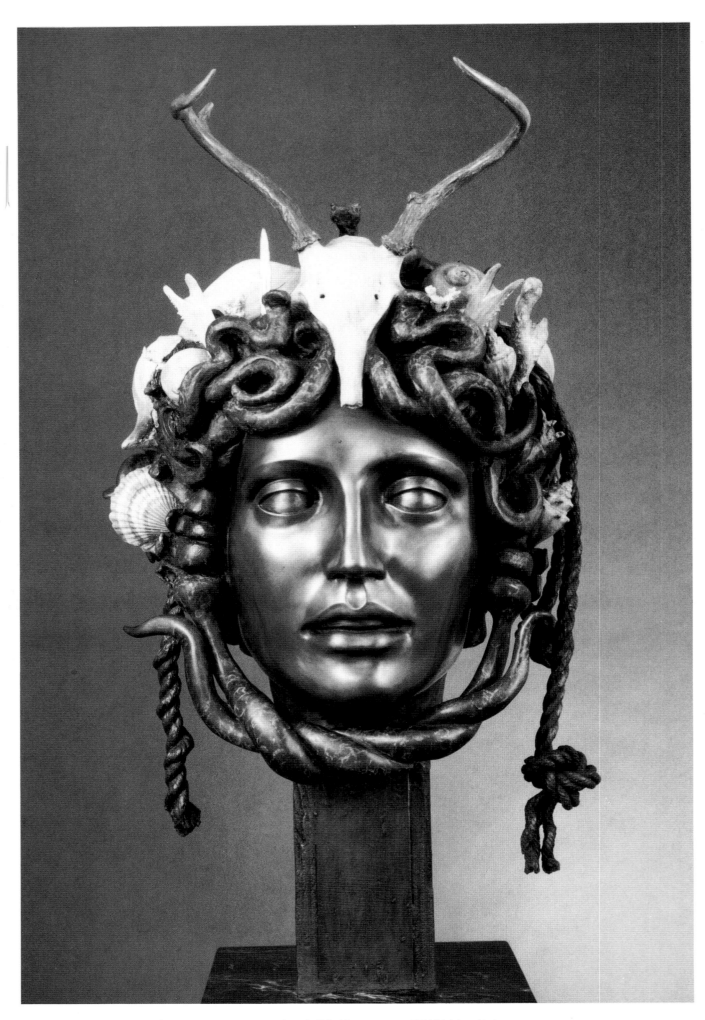

657. *Colossal Head of Medusa*. 1991 (81). Patinated and gilded bronze cast, 35½" high with base. One of an edition of six. Private collection, New York

FRANZ GERTSCH

Franz Gertsch is the only artist truly associated with Photorealism to have no connection whatever with the American art world. He has spent most of his life in the Swiss Alps—totally apart from the forces and influences of the New York art scene, which have shaped the careers of all the other Photorealists. Yet Gertsch has independently produced a body of work that has arrived at the same conclusions as the Photorealists; his work is Photorealism at its finest.

That Gertsch's subject has always been people may be seen in two of his early works reproduced here. *Saintes Maries de la Mer II* (pl. 658) is one of three paintings from the early seventies depicting the artist's daughters. *At Luciano's House* (pl. 659) shows Gertsch's bohemian friends during a carefree period in the European art world.

In the eighties, however, Gertsch focused exclusively on the female face, with the only exception being one self-portrait. His works in oil on canvas were very large, starting at eight to twelve feet as a minimum, and have remained so for the last twenty years. The only smaller paintings are three 52-inch-square versions of *Christina,* of which *Christina IV* (pl. 669) is illustrated here.

Gertsch's paintings invariably recall those of Chuck Close, but the vague similarity in subject matter is all that links them. Close is about *how* to paint, while Gertsch is about *what* to paint. Close is accidentally part of Photorealism, Gertsch is accidentally not part of Photorealism. Close is cool, Gertsch is highly emotional. Gertsch's paintings are about the person and personality of the subject, Close's subjects are objects. Gertsch is about aesthetics, Close about ideas.

In 1986, Gertsch decided that he would seriously devote himself to woodcut printmaking. His first piece was so well received that he has essentially given up painting to concentrate totally on this new medium. His images are predominantly female faces, but he has also depicted landscapes. The scale is huge, many times life size, as were the major paintings. The colors—muted, subtle, and compatible with the medium—are varied within each edition. There is perhaps no other artist in the world making more beautiful and significant prints at present.

Gertsch's catalogue raisonné shows a total of 74 paintings before he turned to printmaking—56 on canvas and 18 works on paper. Of these, 12 are illustrated herein.

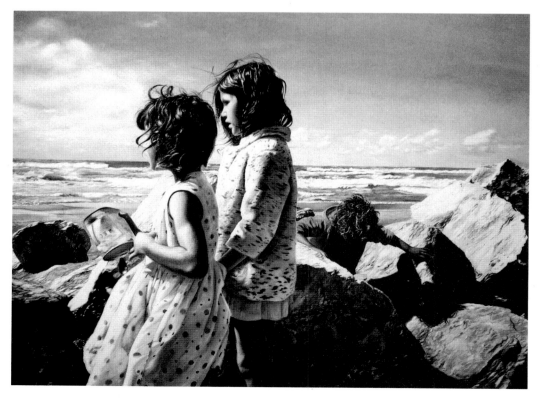

658. *Saintes Maries de la Mer II.* 1971. Acrylic on unprimed linen, 117½ x 156¼". Louis K. Meisel Gallery, New York

219

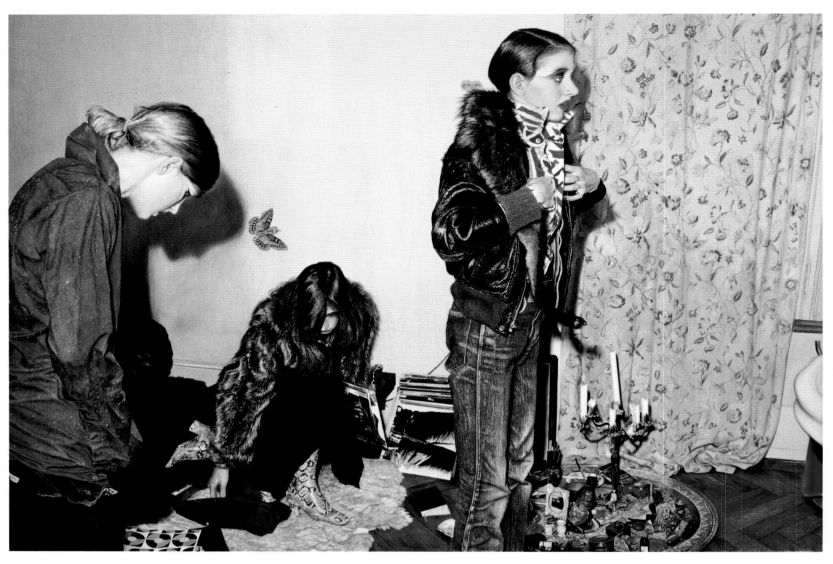

659. *At Luciano's House.* 1973. Acrylic on unprimed canvas, 96 x 140". Private collection, California

660. *Irène V.* 1981. Gouache on paper, 17½ x 24".
Private collection, Switzerland

661. *Irène VI.* 1981. Gouache on paper, 20 x 24".
Collection Donna and Neil Weisman, New Jersey

662. *Irène.* 1980. Acrylic on unprimed canvas, 100 x 153". Collection Louis K. and Susan Pear Meisel, New York

663. *Irène VIII.* 1981. Gouache on paper, 19 x 24".
Louis K. Meisel Gallery, New York

664. *Irène VII.* 1981. Gouache on paper, 17½ x 24".
Louis K. Meisel Gallery, New York

665. *Tabea.* 1981. Acrylic on unprimed canvas, 101 x 154". Private collection, Switzerland

666. *Verena*. 1982. Acrylic on unprimed canvas, 86½ x 126". Private collection, Switzerland

667. *Christina I.* 1983. Acrylic on unprimed canvas, 93 x 103½". Private collection, Tennessee

668. *Johanna IV*. 1985. Mixed mediums on board, 29¹/₂ x 29¹/₂". Private collection, Michigan

669. *Christina IV*. 1983. Acrylic on unprimed canvas, 52 x 52". Collection Donna and Neil Weisman, New Jersey

By 1972, the year he showed at Documenta, Ralph Goings was known worldwide for his paintings of pickup trucks. They had become icons of Photorealism, along with Blackwell's motorcycles, Bell's gumball machines, Bechtle's cars, Eddy's storefronts, Flack's dressing tables, and Close's faces. By the mid-seventies, however, Goings had all but abandoned the trucks in favor of the interiors of diners, coffee shops, and other inexpensive eateries. Some of the best of these paintings depict chrome-and-formica diner interiors, viewed from one end down the entire length of the counter, with a row of stools to the side.

A subseries to these interiors features the objects found on their counters and tables: ketchup and mustard bottles, napkin holders, creamers, sugar shakers, ashtrays, and assorted eating utensils. Goings has painted a large number of such still lifes and continues to add to the series. While these works vary from three or four inches to three or four feet, they relate more to the traditional still life in their size and scale than do the still lifes done by the other Photorealists. Such works by Charles Bell, David Parrish, Ben Schonzeit, and Audrey Flack, for instance, all achieve a scale that goes beyond anything done prewar and even premodernism.

Recently, however, Goings has in fact painted a few large-scale, close-up still lifes. Since both the full diner interiors and the still-life details seem to have become somewhat limiting for Goings, it will prove interesting to see where he turns next for imagery.

By 1990, Goings had produced 240 works in oil and watercolor. *Photo-Realism* showed 73 works and listed 68. Of the works done in the eighties, 88 are illustrated herein and the remaining 11 are listed.

RALPH GOINGS

670. *Amsterdam Diner.* 1980 (146). Oil on canvas, 44 x 60". Private collection, New York

671. *Engine.* 1980 (149). Oil on canvas, 26 x 36".
Collection Alex Weber, New Jersey

672. *Perth Diner Still Life.* 1980 (151). Oil on canvas, 26 x 36".
Private collection, Washington, D.C.

673. *Blue Diner with Figures.* 1981 (158). Oil on canvas, 48 x 62½". Collection Martin Z. Margulies, Florida

674. *Still Life with Hot Sauce.* 1980 (154). Oil on canvas,
28 x 30". Private collection, New York

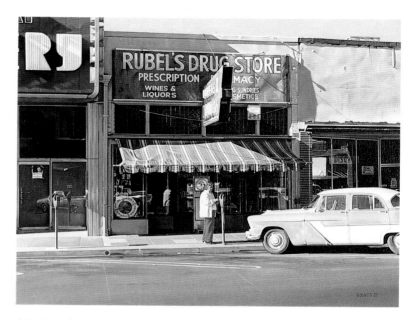

675. *Rubel's Drugs.* 1981 (166). Oil on canvas, 28 x 36".
Private collection, New York

676. *Still Life with Peppers.* 1981 (162). Oil on canvas, 38 x 52". Collection Jack and Harriet Stievelman, New York

677. *Booth Group.* 1980 (147).
Watercolor on paper, 8½ x 10½".
Private collection

678. *Diner Stools.* 1980 (157).
Watercolor on paper, 8 x 14".
Collection Marcia Rodrigues, California

679. *B. L. and T. with Fries.* 1980 (148).
Watercolor on paper, 7½ x 11".
Private collection

680. *Blueberry Pie.* 1980 (152).
Watercolor on paper, 10 x 10¾".
Louis K. Meisel Gallery, New York

681. *Still Life with Mustard.* 1980 (153).
Watercolor on paper, 9¼ x 10".
Private collection, Michigan

682. *Tin with Sugars.* 1980 (150).
Watercolor on paper, 10 x 7¾".
Collection Edward F. Gray, New York

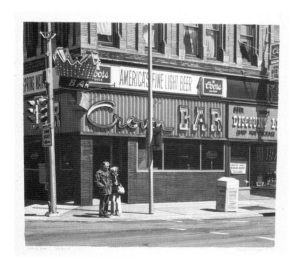

683. *Crown Bar, Cheyenne.* 1981 (159).
Watercolor on paper, 10½ x 11".
Private collection

684. *Red Napkin Holder.* 1981 (161).
Gouache on paper, 11 x 11".
Collection Louis K. and Susan Pear Meisel, New York

685. *S.S. Pierce.* 1981 (163).
Watercolor on paper, 8 x 9⅝".
Private collection, Washington, D.C.

686. *Still Life with Morning Light.* 1981 (164).
Gouache on paper, 20½ x 22".
Private collection, Massachusetts

687. *Still Life with Mirror.* 1981 (165).
Gouache on paper, 10 x 11".
Collection Richard and Gloria Manney, New York

688. *Still Life with Hot Pepper.* 1981 (167).
Watercolor on paper, 9½ x 11".
PieperPower Companies, Inc., Wisconsin

689. *Double Ketchup.* 1981 (168).
Gouache on paper, 11½ x 12½".
Private collection, New York

690. *Red Menu.* 1981 (171).
Watercolor on paper, 9 x 10½".
Private collection, New York

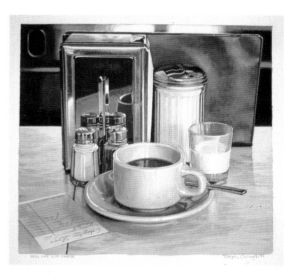

691. *Still Life with Check.* 1981 (173).
Watercolor on paper, 11¼ x 12".
Collection Louis K. and Susan Pear Meisel, New York

692. *Schoharie Diner.* 1979 (145). Oil on canvas, 48 x 64".
Collection Richard and Gloria Manney, New York

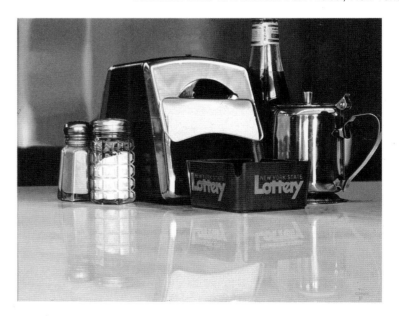

693. *Lottery.* 1981 (169). Oil on canvas, 28 x 36".
Collection Mrs. Norval E. Green, Indiana

694. *Village Diner.* 1981 (172). Oil on canvas, 44 x 60". Collection Gibbs family, Massachusetts

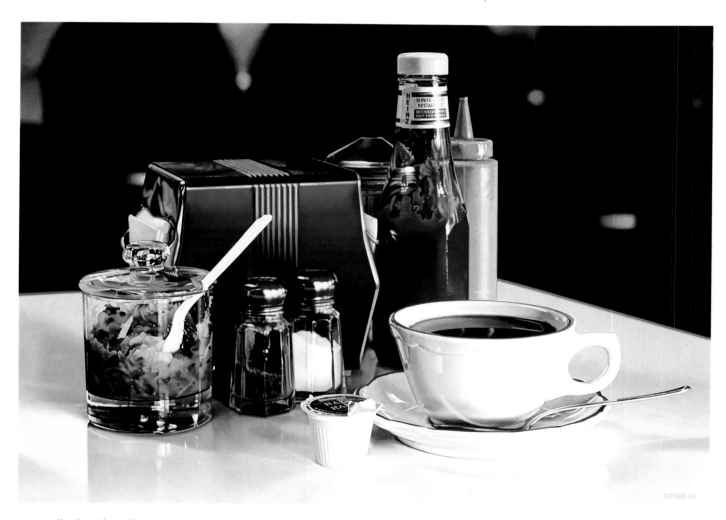

695. *Still Life with Coffee.* 1982 (174). Oil on canvas, 38½ x 52½". Private collection, Massachusetts

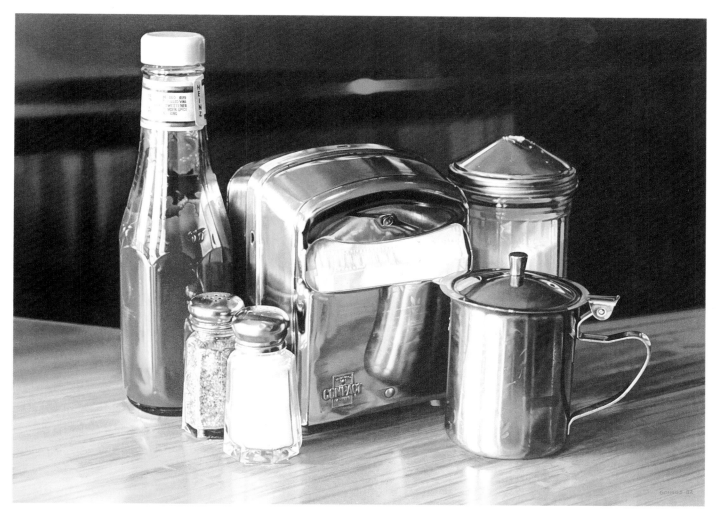

696. *Still Life with Creamer.* 1982 (177). Oil on canvas, 38 x 52". Collection Jesse Nevada Karp, New York

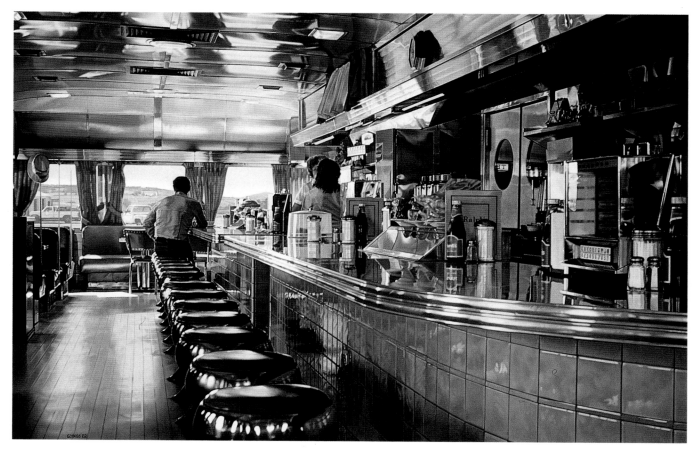

697. *Ralph's Diner.* 1982 (179). Oil on canvas, 44¼ x 66½". Private collection, Massachusetts

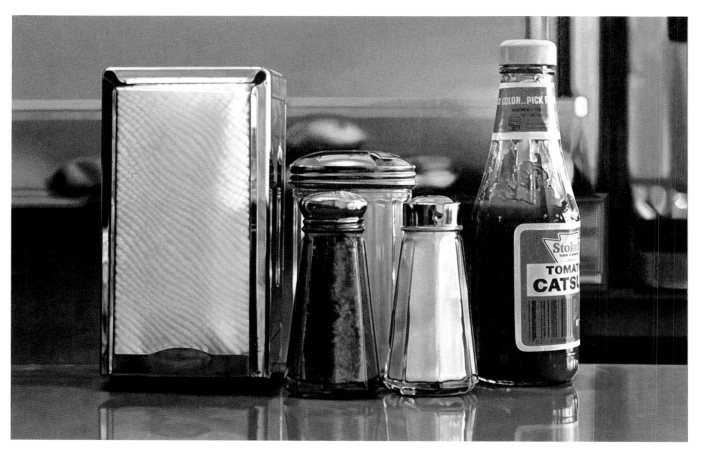

698. *Still Life—Color Pick.* 1982 (182). Oil on canvas, 40 x 60". Private collection, California

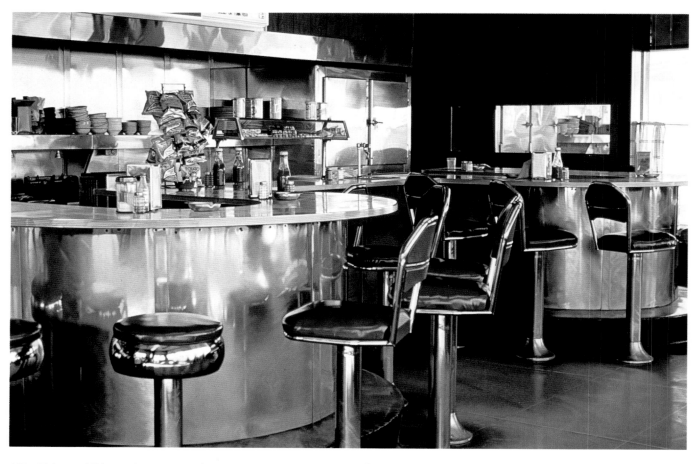

699. *Richmond Diner.* 1983 (183). Oil on canvas, 40 x 58". Private collection, Missouri

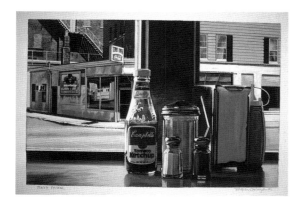

700. *Tony's Diner.* 1982 (175).
Watercolor on paper, 9 x 13".
Private collection

701. *Burger.* 1982 (176).
Watercolor on paper, 8 x 10¾".
Louis K. Meisel Gallery, New York

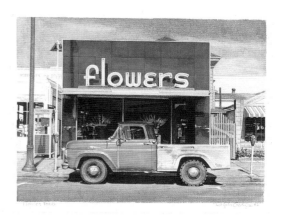

702. *Flowers Ford.* 1982 (180).
Watercolor on paper, 9 x 11¾".
Southland Corporation, Texas

703. *Pepper Detail No. 3A.* 1983 (194).
Watercolor on paper, 9 x 12½".
Private collection, New Jersey

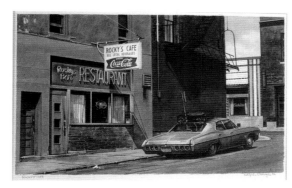

704. *Rocky's Cafe.* 1982 (178).
Watercolor on paper, 20¾ x 26½".
Collection Donna and Neil Weisman, New Jersey

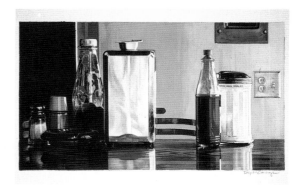

705. *Still Life and Hot Sauce.* 1983 (192).
Watercolor on paper, 9 x 15½".
Private collection, New Jersey

706. *Red Pick-Up.* 1983 (187).
Watercolor on paper, 10½ x 14".
Private collection, New York

707. *Fry Cook.* 1982 (181).
Watercolor on paper, 10 x 12".
Collection Richard and Gloria Manney, New York

708. *Pepper Detail No. 3.* 1983 (193).
Watercolor on paper, 9 x 9".
Collection Jesse Nevada Karp, New York

709. *Still Life No. 2.* 1983 (186).
Watercolor on paper, 10 x 10".
Private collection

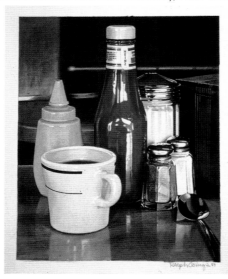

710. *Still Life Group.* 1983 (188).
Watercolor on paper, 10 x 8".
Collection Glenn C. Janss, Idaho

711. *Tidynap.* 1983 (189).
Watercolor on paper, 10½ x 10½".
Collection Dennis Sisco and Alex Lesko, Connecticut

712. *Diner Interior with Coffee Urns*. 1984 (203). Oil on canvas, 44 x 66". Private collection, Tennessee

713. *Still Life Close-Up.* 1984 (198).
Oil on canvas, 48½ x 48½".
Private collection, New York

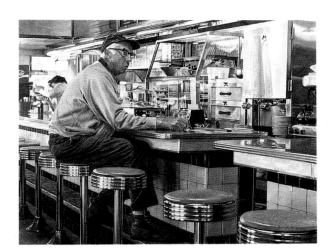

714. *Pink Tile—Unadilla Diner.* 1985 (211).
Watercolor on paper, 12 x 15".
Collection Gibbs family, Massachusetts

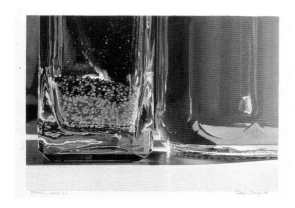

715. *Pepper Detail No. 3A.* 1983 (194).
Watercolor on paper, 9 x 12½".
Private collection, New Jersey

716. *Chevy Tailgate.* 1983 (195).
Watercolor on paper, 11 x 16¼".
Collection Donna and Neil Weisman, New Jersey

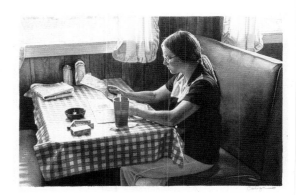

717. *Woman Reading in Booth.* 1983 (196).
Watercolor on paper, 11 x 16½".
Stephens Inc., Arkansas

718. *Shaker.* 1983 (197).
Watercolor on paper, 9¼ x 11".
Collection Lauren and John Howard, New York

719. *Diner Objects.* 1984 (199).
Gouache on paper, 9 x 12".
Private collection, California

720. *Diner Still Life.* 1984 (200).
Gouache on paper, 9 x 12".
Collection Larry Gutsch, New York

721. *Still Life Close-Up.* 1984 (204).
Watercolor on paper, 9½ x 14¾".
Collection Marcia Rodrigues, California

722. *Still Life.* 1984 (202).
Gouache on paper, 9 x 12".
H. J. Heinz Company, Pennsylvania

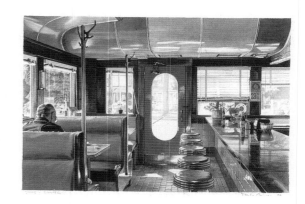

723. *Diner—Summer (Red Door).* 1984 (205).
Watercolor on paper, 9½ x 14".
Private collection, England

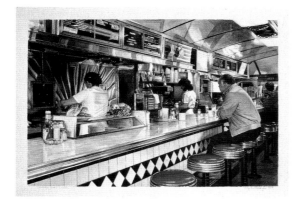

724. *Country Girl Diner.* 1985 (208).
Watercolor on paper, 11 x 16".
Collection Linda and Robert Hess, Indiana

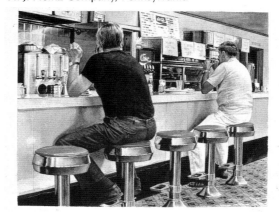

725. *Diner Counter—Two Men.* 1985 (207).
Watercolor on paper, 10 x 12½".
Private collection, California

726. *Untitled with Ketchup Bottle.* 1985 (210).
Watercolor on paper, 9 x 12½".
Private collection

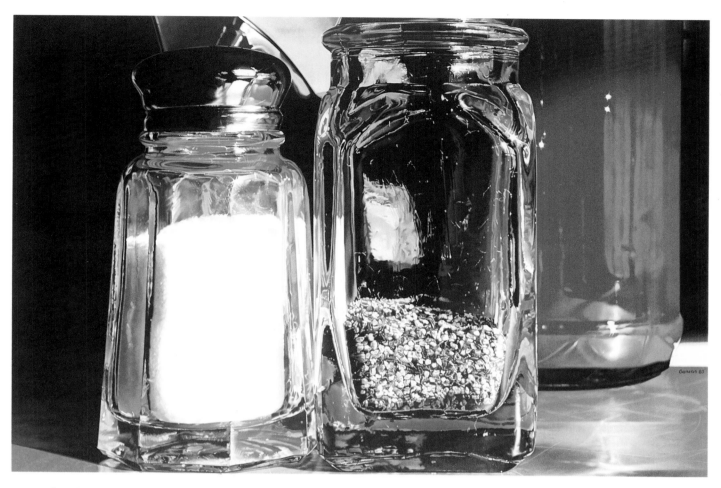

727. *Salt and Pepper.* 1983 (191). Oil on canvas, 36 x 52". Private collection, Maryland

728. *Windows.* 1984 (201). Oil on canvas, 44 x 66". Private collection

729. *Two Waitresses—Afternoon Break*. 1986 (215). Oil on canvas, 44 x 62". Collection Donna and Neil Weisman, New Jersey

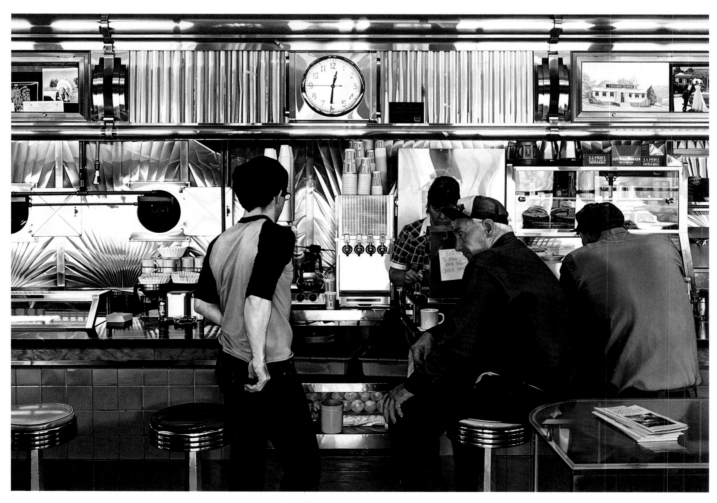

730. *Collins Diner*. 1986 (212). Oil on canvas, 48 x 68". Tampa Museum of Art, Florida

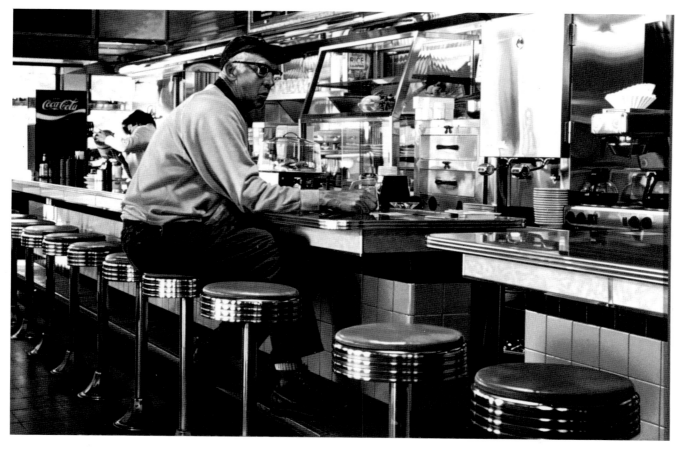

731. *Diner with Pink Tile.* 1986 (213). Oil on canvas, 40 x 60". Private collection

732. *Country Girl Diner.* 1985 (209). Oil on canvas, 48 x 68". Private collection, New York

733. *Diner 10 A.M.* 1986 (214).
Watercolor on paper, 13 x 19¼".
Collection Howard and Judy Tullman, Illinois

734. *Pie and Iced Tea.* 1987 (217).
Watercolor on paper, 15 x 21¾".
Collection Michael Rakosi, New York

735. *Vinyl Booths.* 1987 (218). Watercolor on paper,
9 x 19". Collection Nancy Cooper and the late
Ronald Harrison Cooper, California

736. *Blue Tile and Water Glass.* 1988 (221).
Watercolor on paper, 21 x 18".
Private collection, Switzerland

737. *Waitress—Unadilla Diner.* 1984 (206). Oil on canvas, 48 x 68".
Private collection, Switzerland

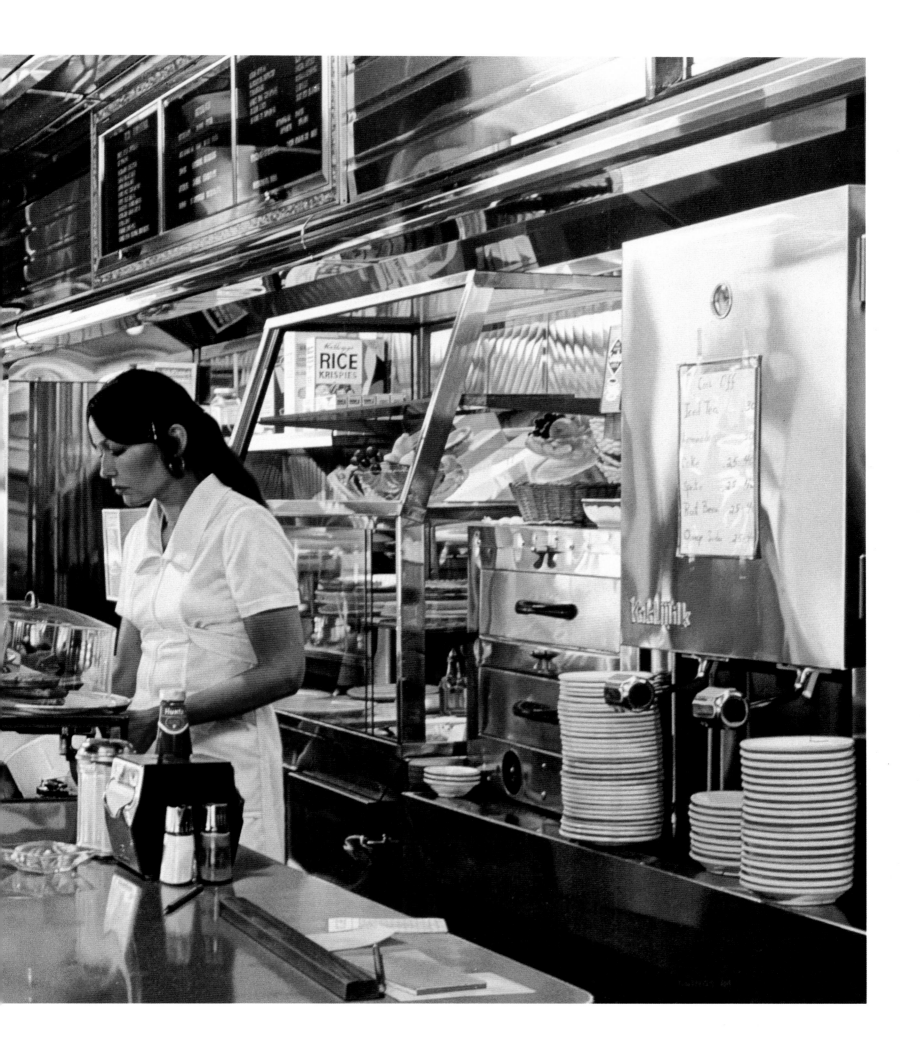

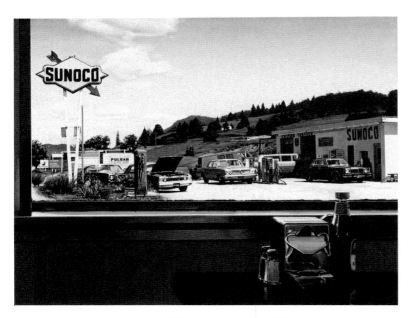

738. *Sunoco.* 1986–90 (234). Oil on canvas, 28 x 36".
Collection the artist

739. *Blue Tile with Ice Water.* 1987 (216). Oil on canvas, 48 x 48".
Private collection

740. *Still Life with Red Mat.* 1988 (223). Oil on canvas, 44 x 62". Collection Lauren and John Howard, New York

741. *Original Hot Sauce.* 1988 (225). Oil on canvas, 48 x 54".
Collection Gloria and Gerald Lushing, California

742. *Grand Gorge Diner.* 1988 (226). Oil on canvas, 48 x 53¼".
Collection Mr. and Mrs. Bob M. Cohen, California

743. *America's Favorite.* 1989 (228). Oil on canvas, 30 x 35".
Private collection, Switzerland

744. *Steak Sauce.* 1989 (231). Oil on canvas, 40 x 40".
Virlane Foundation, Louisiana

745. *Blue Tablecloth.* 1987 (220). Oil on canvas, 28 x 30".
Private collection, Switzerland

746. *Still Life—Back View.* 1990 (236). Oil on linen, 28 x 30".
Collection Donna and Neil Weisman, New Jersey

747. *Five-Spot Interior.* 1990 (235). Oil on canvas, 40 x 57".
Collection Philippe Santini, France

748. *Red Devil.* 1989 (229). Oil on canvas, 30 x 38".
Collection Jack and Harriet Stievelman, New York

749. *Ketchup—Close-Up.* 1990 (237). Oil on canvas, 44 x 60". Private collection, Europe

750. *Village Cafe.* 1990 (240). Oil on canvas, 68 x 72". Collection Barbara and Arnold Falberg, New York

751. *Pumpkin Pie.* 1979 (143).
Watercolor on paper, 7 x 9¹/₂".
Collection Marcia Rodrigues, California

752. *Tux.* 1988 (222).
Watercolor on paper, 15 x 22¹/₂".
Collection Daniel M. Honigman, Michigan

753. *Salt.* 1989 (232).
Acrylic on paper, 12¹/₂ x 13".
Collection the artist

754. *Still Life with Rose.* 1989 (230).
Watercolor on paper, 17 x 15".
Collection Judy and Noah Liff, Tennessee

755. *Still Life with Vinegar.* 1979 (142).
Watercolor on paper, 11 x 11³/₈".
Collection Mr. and Mrs. Nathan Gelfman, New York

NOT ILLUSTRATED

Donut. 1980 (150).
Watercolor on paper, 7 x 11".
Dunkin' Donuts, Massachusetts

Hot Sauce and Mustard. 1980 (156).
Watercolor on paper, 11 x 8¹/₂".
Private collection, California

Kelsey's Still Life. 1981 (160).
Watercolor on paper, 15¹/₂ x 16³/₄".
Collection Martin and Christine Taplin, Florida

Cream and Sugar. 1981 (170).
Watercolor on paper, 9¹/₂ x 11".
Private collection, Florida

Detail No. 2. 1983 (184).
Watercolor on paper, 21 x 21¹/₂".
Private collection, California

Donut Jar with Still Life. 1983 (190).
Watercolor on paper, 9 x 15".
Private collection, California

Airstream Winter. 1987 (219).
Watercolor on paper, 12 x 16".
Collection Wade F. B. Thompson, New York

Creamer. 1988 (224).
Watercolor on paper, 9³/₄ x 6¹/₂".
Collection Max Palevsky, California

Cafe De Palma Still Life. 1988 (227).
Watercolor on paper, 15 x 23¹/₄".
Collection Mr. and Mrs. Eugene Victor Thaw, New York

Red Counter Still Life. 1989 (233).
Acrylic on board, 14¹/₂ x 12".
Private collection, France

Lemon Pie. 1990 (238).
Oil on canvas, 8 x 10".
Collection Dr. and Mrs. Howard Berk, New York

756. *Red Napkin Holder.* 1990 (239).
Watercolor on paper, 7¹/₄ x 10³/₄".
Collection Donna and Neil Weisman, New Jersey

757. *Iced Tea with Lemon.* 1979 (144).
Watercolor on paper, 8 x 9¹/₂".
Collection James and Barbara Palmer, Pennsylvania

JOHN KACERE

In 1969, John Kacere completed the first example of what was to become his signature theme: a painting of a woman (three times life size), clad in purple panties and a yellow slip, cropped just above the knees and just above the waist. By focusing on the details of the lingerie and utilizing the female torso as surface, Kacere turned what might have been a purely figurative image into a still life. Throughout the seventies, he continued to create numerous variations of this erotic icon, which became strongly identified with Photorealism in its formative years.

In 1983, with *Allison Again S–83* (pl. 774), Kacere made an abrupt change in his imagery; six more works of a similar nature followed during 1984–85 (pls. 775–80). In these paintings, the scale returned to about life size and the subject expanded to include the entire figure of the model, always reclining, asleep. All that had been exposed before in a Kacere was covered by shiny satin sheets, and what had never been seen before—arms, legs, and faces—is shown. These works, Kacere's attempt to answer his critics by varying his central image, are ultimately unsuccessful. The abundance of fabric and the patterned wallpaper backgrounds confuse the compositions and prevent an effective focal point.

In 1986, Kacere produced only one painting, a version of *Ileana* (pl. 788) that is, in my opinion, one of his best ever. Unlike the earlier *Ileana '85* (pl. 771) and the later *Claire '87* (pl. 789), it was monochromatic, simple, focused, and stunning. In 1987, Kacere painted four more of the full-length sleeping figures (pls. 781–84) as well as *Claire '87*.

By 1988, the artist returned wholeheartedly to his classic imagery, experimenting boldly with color and texture. With *Joelle* (pl. 803) and *Claire* (pl. 804) in 1989 and *Tracy* (pl. 807) and *Joni* (pl. 808) in 1990, Kacere finished the decade with some of the finest, most beautiful variations to date.

The artist made 52 paintings in the eighties, and all are illustrated herein.

758. *Lauren '80*. 1980 (1). Oil on canvas, 50 x 70".
Private collection, Saudi Arabia

759. *Debbie '80*. 1980 (4). Oil on canvas, 70 x 52".
Private collection, Saudi Arabia

760. *Linda W. '80.* 1980 (2). Oil on canvas, 62 x 80". Private collection, Colombia

761. *Linda W. II '80.* 1980 (3). Oil on canvas, 38 x 58". Private collection, Saudi Arabia

762. *Marisa '80.* 1980 (6). Oil on canvas, 52 x 62". Collection Robert Taubman, California

763. *Patricia '80.* 1980 (5). Oil on canvas, 40 x 60". Private collection, Saudi Arabia

764. *Suzanne '81*. 1981 (7). Oil on canvas, 48 x 70".
Private collection, Florida

765. *Lauren '81*. 1981 (8). Oil on canvas, 50 x 64".
Private collection, France

766. *Soroya '81*. 1981 (9). Oil on canvas, 40 x 62". Private collection, France

767. *Greta '81*. 1981 (10). Oil on canvas, 50 x 70".
Private collection, Switzerland

768. *Ileana II '82*. 1982 (13). Oil on canvas, 48 x 70".
Private collection, France

769. *Cynthia '82*. 1982 (12). Oil on canvas, 48 x 70". Private collection, Florida

770. *Ileana '82.* 1982 (11). Oil on canvas, 48 x 72". Private collection

771. *Ileana '85.* 1985 (24). Oil on canvas, 48 x 80".
Private collection, Japan

772. *Ileana '83.* 1983 (16). Oil on canvas, 48 x 66".
Private collection, England

773. *Joelle '83*. 1983 (17). Oil on canvas, 60 x 50". Private collection, France

774. *Allison Again S–83*. 1983 (18). Oil on canvas, 38 x 78". Collection Saul Steinberg, New York

775. *Lauren '84*. 1984 (19). Oil on canvas, 40 x 80".
Private collection, France

776. *Caroline '84*. 1984 (20). Oil on canvas, 42 x 80".
Collection Jesse Nevada Karp, New York

777. *Suzanne '84*. 1984 (21). Oil on canvas, 34 x 76".
Private collection, Texas

778. *Emma '84*. 1984 (22). Oil on canvas, 40 x 80".
Private collection, Tennessee

779. *Pat '84*. 1984 (23). Oil on canvas, 36 x 78".
Collection the artist

780. *Allison '85*. 1985 (25). Oil on canvas, 38 x 64".
Private collection, Switzerland

781. *Caroline '87*. 1987 (30). Oil on canvas, 38 x 80".
Private collection, Switzerland

782. *Phyllis '87*. 1987 (31). Oil on canvas, 38 x 78".
Collection the artist

783. *Tara '87*. 1987 (28). Oil on canvas, 40 x 80".
Collection Dr. and Mrs. Edward Cooper, Pennsylvania

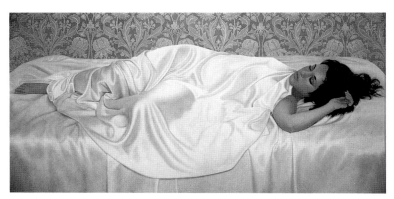

784. *Tracy '87*. 1987 (29). Oil on canvas, 40 x 80".
Collection Vincent Crisci, New York

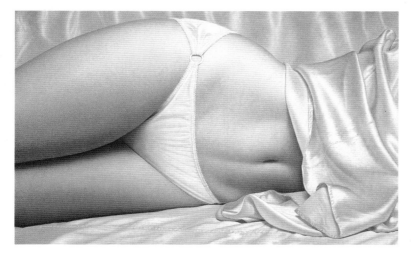

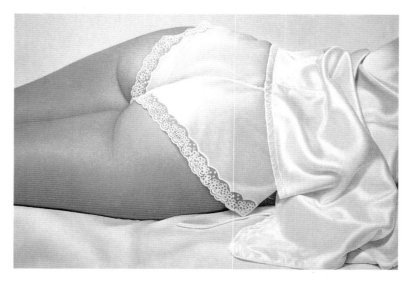

785. *Allison '83.* 1983 (15).
Oil on canvas, 44 x 68".
Private collection, New York

786. *Barbara '85.* 1985 (26).
Oil on canvas, 48 x 70".
Private collection, England

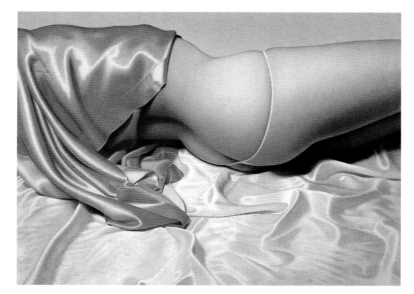

787. *Marisa '82.* 1982 (14).
Oil on canvas, 52 x 70".
Private collection, France

788. *Ileana '86.* 1986 (27).
Oil on canvas, 45½ x 69½".
Collection Nathan Gantcher,
New York

789. *Claire '87.* 1987 (32).
Oil on canvas, 40 x 60".
Private collection, Switzerland

790. *Tracy '89.* 1989 (34).
Oil on canvas, 30 x 40".
Whereabouts unknown

791. *Anne '88.* 1988 (33). Oil on canvas, 40 x 60". Private collection, Switzerland

792. *Linda '89.* 1989 (35). Oil on canvas, 40 x 60".
Private collection, Italy

793. *Valerie '89.* 1989 (36). Oil on canvas, 40 x 60".
Collection Joseph and Lynda Jurist, New York

794. *Pat '89.* 1989 (37). Oil on linen, 40 x 60". Private collection, France

795. *Dara '89.* 1989 (38). Oil on linen, 40 x 60".
Private collection, France

796. *Ileana '89.* 1989 (40). Oil on canvas, 20 x 30".
Private collection, Switzerland

797. *Julia '89.* 1989 (43). Oil on canvas, 40 x 60". Private collection, France

798. *Valerie II '89*. 1989 (41). Oil on canvas, 40 x 56".
Private collection, Switzerland

799. *Roxanne '89*. 1989 (42). Oil on canvas, 40 x 56".
Private collection, France

800. *Louisa '89*. 1989 (39). Oil on linen, 40 x 60". Louis K. Meisel Gallery, New York

801. *Roxanne II '89*. 1989 (44). Oil on canvas, 42 x 56".
Private collection, France

802. *Krista '89*. 1989 (46). Oil on canvas, 32 x 40".
Private collection, France

803. *Joelle '89*. 1989 (45). Oil on canvas, 40 x 60". Private collection, Switzerland

804. *Claire '89*. 1989 (47). Oil on canvas, 40 x 32". Private collection, Switzerland

805. *Barbara '90.* 1990 (49). Oil on linen, 30 x 40".
Collection Mr. and Mrs. Sydney Besthoff III, Louisiana

806. *Linda '90.* 1990 (50). Oil on canvas, 30 x 40".
Private collection, Italy

807. *Tracy '90.* 1990 (51). Oil on canvas, 20 x 30". Private collection, Italy

808. *Joni '90.* 1990 (52). Oil on canvas, 40 x 60". Private collection, California

809. *Linda '89.* 1989 (48). Oil on canvas, 40 x 60". Private collection, France

RON KLEEMANN

Ron Kleemann became famous—and his works almost synonymous with Photorealism—when he began painting close-ups of racing cars in the early seventies, at the beginning of the movement. Soon afterward, he turned to close-ups of trucks as his primary subject and quickly made them another great icon of Photorealism. One of these dazzling works (*P-R* pl. 675) was acquired by the Museum of Modern Art, another (*P-R* pl. 703) by the Solomon R. Guggenheim Museum.

Kleemann continued with the truck image until 1983, when he began a series of challenging experiments with subject matter and changes in scale. He touched on political documentation and comment with *Cultivating Washington* (pl. 827) in 1983. He tried night scenes with odd lighting in two paintings of county fairs (pls. 840 and 833) in 1983 and 1984. He experimented with interior shots, tentatively at first with two small paintings of lobbies (pls. 838 and 839) in 1983 and then confidently in works depicting the interior of Grand Central Terminal in New York City (pls. 834–36). The very best of the interiors, in terms of color, composition, and appeal, is *Ronald's McDonald* (pl. 853) of 1986. Kleemann's work with odd scale changes was more interesting, however, first with *Grown Men* (pl. 852) and then with *Superman on Lois Lane* (pl. 857) and *Pecker Heads* (pl. 855).

Ultimately, in the last three years of the decade, Kleemann returned with great enthusiasm to a subject he had touched on in 1974 and 1975 as part of the truck series—the fire engine. His work since then has been devoted exclusively to this Great American Machine, and his first painting of the nineties, *Double Entendre* (pl. 863), must be regarded as one of his three or four greatest masterpieces.

Kleemann has done 122 paintings. Of these, 60 were illustrated and 3 listed in *Photo-Realism;* 2 more earlier works have been discovered since that first volume and are illustrated herein. All 42 paintings and 15 watercolors of the eighties are reproduced in this volume.

810. *Saint Louis Mustang.* 1980 (66). Acrylic on canvas, 18 x 24".
Collection Louis K. and Susan Pear Meisel, New York

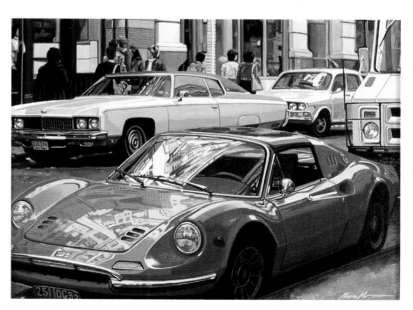

811. *Dino.* 1983 (84). Acrylic on board, 12 x 16".
Collection Louis K. and Susan Pear Meisel, New York

812. *Hobbs Tub, A Version.* 1981 (73).
Acrylic on board, 12 x 16".
Collection Louis K. and Susan Pear Meisel, New York

813. *Hobbs Tub.* 1982 (73a).
Acrylic on board, 12 x 16".
Collection Bruce Vinokour, California

814. *Truck Stop.* 1982 (74).
Acrylic on paper, 12 x 16".
Stephens Inc., Arkansas

815. *White Knight.* 1982 (75).
Acrylic on paper, 12 x 15".
PieperPower Companies, Inc., Wisconsin

816. *Police Horse Trailer.* 1982 (76).
Acrylic on board, 15⅞ x 11⅞".
Collection Donna and Neil Weisman, New Jersey

817. *La Leche.* 1982 (77).
Acrylic on board, 15⅞ x 11⅞".
Collection Pierre and Sylvie Mirabaud, Switzerland

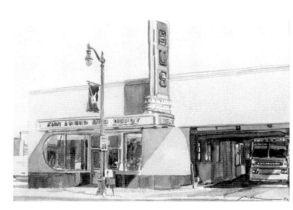

818. *Tunnel Tug.* 1982 (78).
Acrylic on board, 12 x 16".
Private collection

819. *Ann Arbor Depot.* 1982 (79).
Watercolor on paper, 9 x 12".
Collection the artist

820. *Stottville Rescue.* 1982 (81).
Watercolor on paper, 7⅛ x 9½".
Private collection

821. *Yellow Engine.* 1982 (80).
Acrylic on board, 9½ x 9¼".
Collection the artist

822. *Saint Charles Newy.* 1982 (82).
Acrylic on board, 9 x 12".
Private collection

823. *Columbus Day.* 1981 (69).
Acrylic on paper, 10¾ x 13½".
Private collection, New York

825. *Red Fire Engine.* 1983 (86). Watercolor on paper, 12 x 16". Collection Gunnar Kleemann, New York

824. *Cavalry Cade.* 1980 (68). Acrylic on canvas, 36 x 48". Private collection, Sweden

826. *La France.* 1983 (85). Acrylic on board, 12 x 16". Private collection, Switzerland

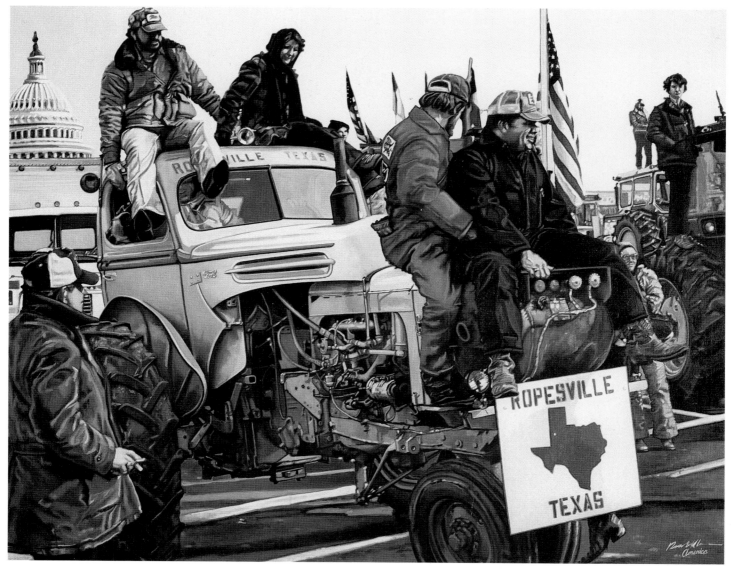

827. *Cultivating Washington.* 1983 (90). Oil on canvas, 40 x 50". Collection Sarah Woolworth Kleemann, New York

828. *Sear's Point 'Vettes.* 1985 (105). Oil on canvas, 22 x 37½".
Private collection

829. *Gil's La France.* 1981 (70). Watercolor on paper, 11 x 14".
Private collection, Switzerland

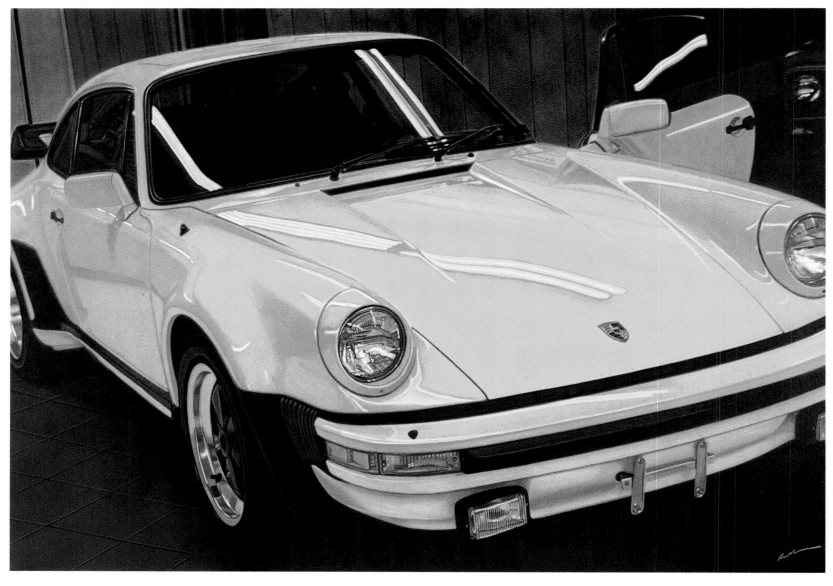

830. *Yellow Porsche.* 1980 (67). Acrylic on canvas, 45¼ x 63". Private collection, New York

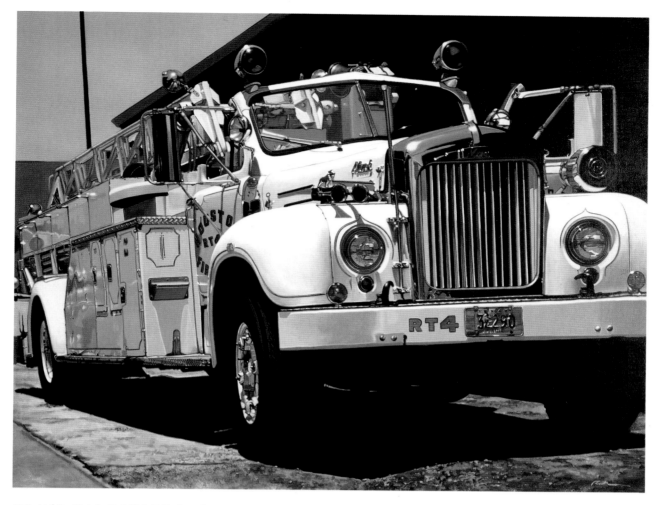

831. *White Knight II.* 1981 (71). Acrylic on canvas, 42 x 54". Private collection

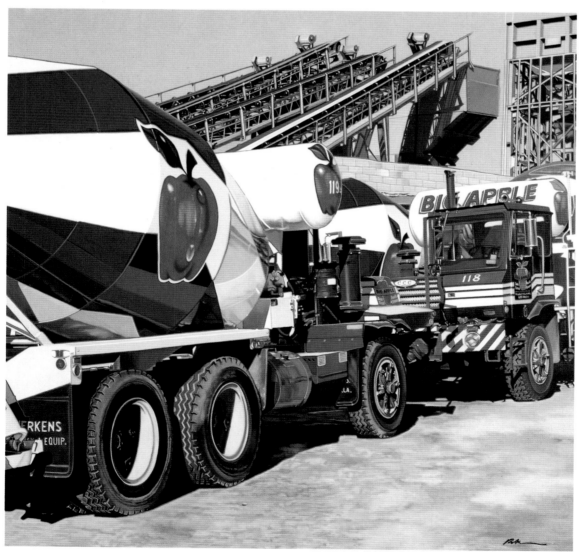

832. *Apple Cross-Over.* 1981 (72). Oil on canvas, 47 x 48". Private collection, California

833. *Pot of Gold, Dutchess County Fair, Rhinebeck, N.Y.* 1984 (91).
Oil on canvas, 24 x 36". Collection the artist

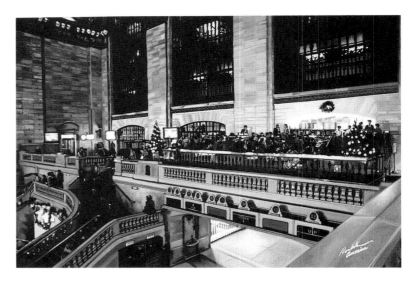

834. *America's Opening Night.* 1984 (93).
Oil on canvas, 24 x 36". Collection the artist

835. *Grand Ballroom, Cafe Central.* 1987 (113). Oil on canvas,
50 x 40". Collection Lorraine and Michael Muller, New York

836. *Grand Ballroom, Lorraine and Michael
at Seventy-five.* 1987 (114). Acrylic on museum
board, 16 x 10¼". Collection Lorraine and
Michael Muller, New York

837. *Pretzel Vender.* 1984 (92).
Oil on canvas, 12 x 14".
Private collection, England

838. *XX on Xmas.* 1983 (88). Oil on linen, 15 x 20".
Private collection, California

839. *230 Park Avenue.* 1983 (89). Oil on canvas, 15 x 22".
Collection Sarah Woolworth Kleemann, New York

840. *Columbia County Fair, Chatham, N.Y.* 1983 (87). Oil on canvas, 30 x 40". Collection Dale C. and Alexandra Zetlin Jones, New York

841. *Johnny Rutherford.* 1984 (99).
Watercolor and ink on paper, 5³/₄ x 8³/₄".
Collection the artist

842. *Ferraris.* 1984 (100).
Watercolor and ink on paper, 5³/₄ x 8³/₄".
Collection the artist

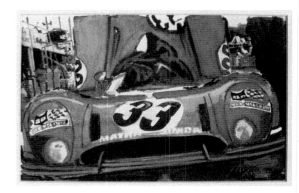

843. *Matra.* 1984 (101).
Watercolor and ink on paper, 5³/₄ x 8³/₄".
Collection the artist

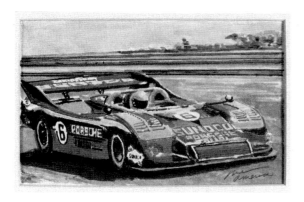

844. *Mark Donahue at Speed.* 1984 (96).
Watercolor and ink on paper, 5³/₄ x 8³/₄".
Collection the artist

845. *Jody Schechter in the Six-Wheeler.* 1984 (94).
Watercolor and ink on paper, 5³/₄ x 8³/₄".
Collection the artist

846. *Nikki Lauda.* 1984 (95).
Watercolor and ink on paper, 5³/₄ x 8³/₄".
Collection the artist

847. *A. J. Foyt.* 1984 (97).
Watercolor and ink on paper, 5³/₄ x 8³/₄".
Collection the artist

849. *Indy Infield.* 1987 (115). Acrylic on board, 12 x 16". Private collection, New York

848. *John Watson.* 1984 (98).
Watercolor and ink on paper, 5³/₄ x 8³/₄".
Collection the artist

850. *Study for Hard Rock Cafe.* 1985 (104).
Watercolor on paper, 8½ x 5½".
Collection the artist

851. *Study for Ronald's McDonald.* 1986 (108).
Watercolor on paper, 8½ x 6½".
Private collection, Georgia

852. *Grown Men.* 1985 (103). Oil on linen, 40 x 50". Collection the artist

853. *Ronald's McDonald.* 1986 (109). Oil on linen, 60 x 48". Private collection, Switzerland

854. *Hard Cafe on the Rock.* 1987 (112). Oil on linen, 90 x 60". Private collection, New York

856. *Study for Pecker Heads.*
1986 (107).
Watercolor on paper, 8¹/₂ x 6".
Collection the artist

855. *Pecker Heads.* 1987 (111). Oil on linen, 72 x 50".
Private collection, California

857. *Superman on Lois Lane.* 1986 (110). Oil on linen, 31 x 61".
Private collection, New York

858. *Mayflower Crossing—Plymouth Rock 1978.* 1980 (65). Acrylic on canvas, 40 x 54".
Private collection, California

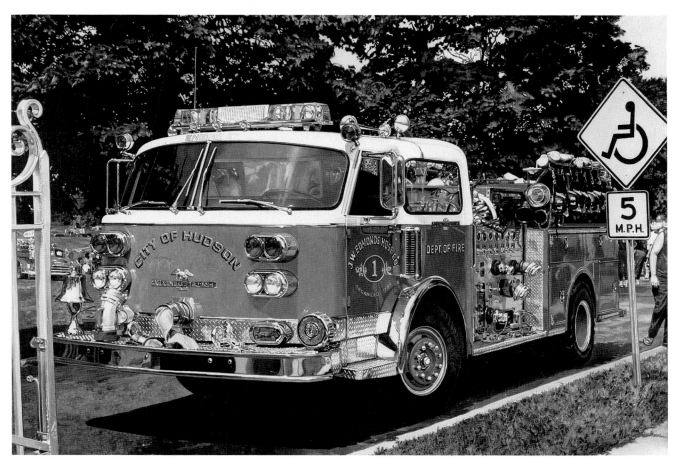

859. *Volunteer 1.* 1988 (116). Oil on canvas, 48 x 68". Private collection, Switzerland

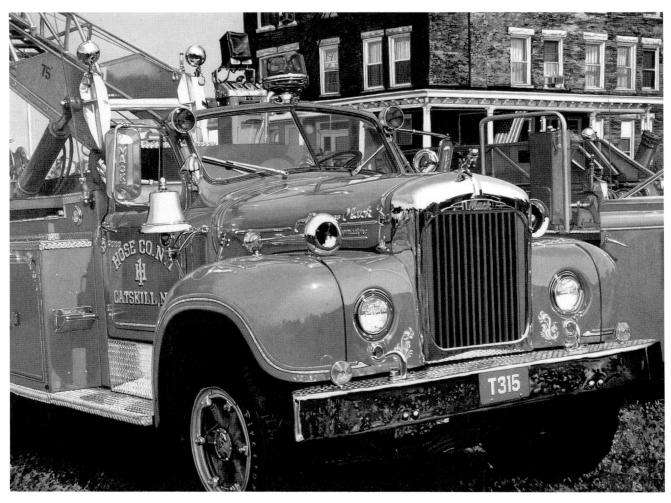

860. *Iron "B" Mac and Rosewater.* 1988 (117). Oil on linen, 50 x 66". Private collection, Switzerland

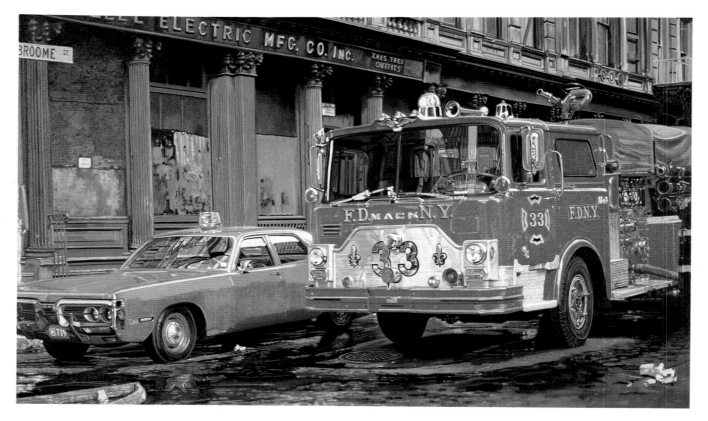

861. *A Hose, a Rose Is a Rose, a Hose.* 1989 (118). Oil on linen, 36 x 60". Collection Mr. and Mrs. Roger D. Hecht, New York

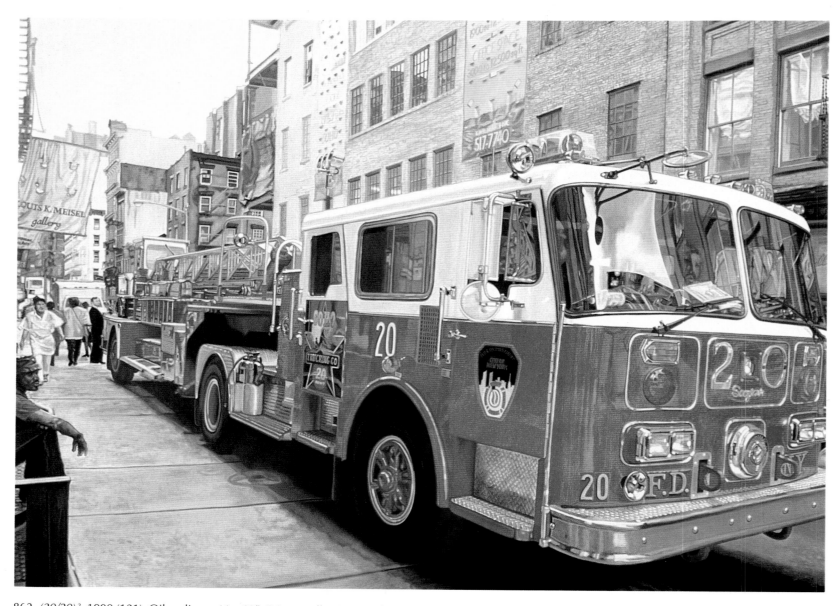

862. *(20/20)²*. 1990 (121). Oil on linen, 44 x 60". Private collection, Michigan

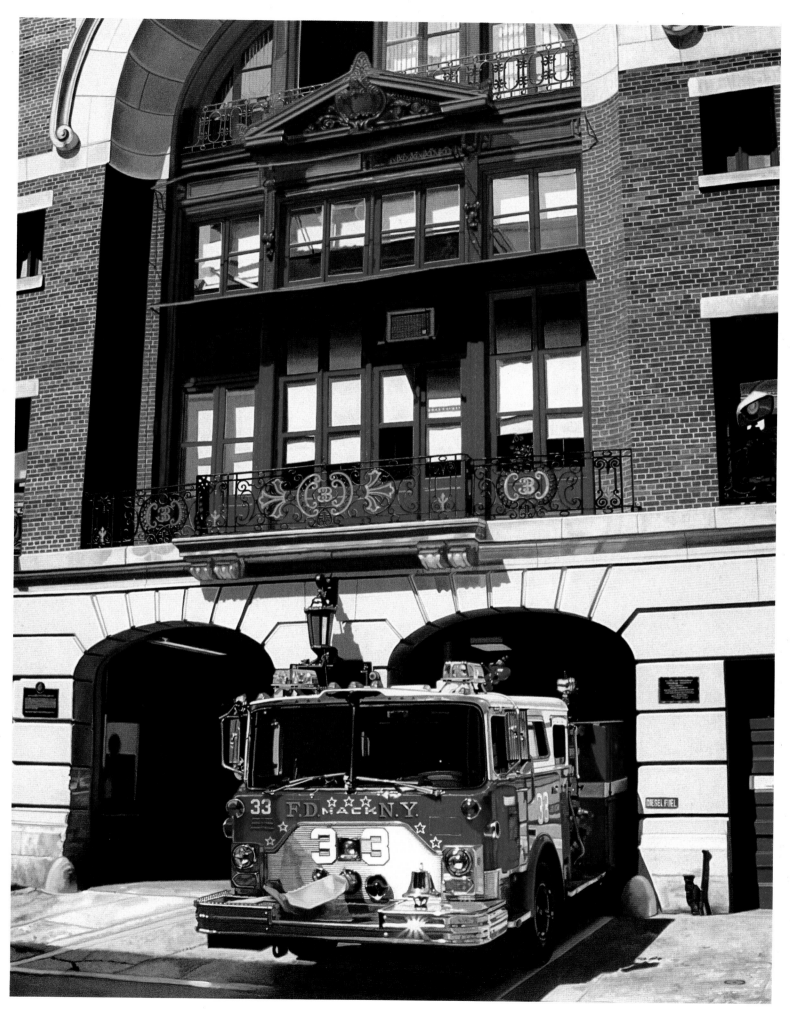

863. *Double Entendre.* 1990 (120). Oil on linen, 82 x 62". Private collection, Switzerland

864. *Forbee Brothers Corporation.*
c. 1982 (83). Acrylic on board,
size unknown. Forbee Brothers
Corporation

865. *The Paley Family (Paleolithic).* 1984 (102).
Oil on board, 12 x 18".
Collection Barry and Susan Paley, New York

866. *The Van Austynes—Ron, Rita, Josh,
Jacob, and Mandy.* 1985 (106). Oil on linen,
16 x 16". Private collection, New York

867. *Bay City Rollers—Their
Own Cross.* 1979 (64).
Acrylic on canvas, 42 x 54".
Forbes Collection,
New York

868. *Perfect Vision.* 1989 (119). Oil on linen, 44 x 66". Private collection, California

RICHARD McLEAN

During the formative years of Photorealism, and of Richard McLean's career, the artist first took his subjects from photographs in horse magazines. These earliest works, primarily of racehorses, were almost an extension of Pop Art in their use of media images. By 1973, however, he had begun to take his own photographs. While McLean then chose to concentrate more on show horses, he was still influenced by the way the magazines had shown their subjects—generally centered in the frame and in a middle range.

In 1981, a totally new element entered the McLean composition: the horse trailer. Juxtaposed with the horses, the trailers made for more complex compositions. The next major change in the artist's work appeared in 1984, as he moved the horse back in the composition and made a series of beautiful landscapes to which the animal is simply incidental. *Valley* (pl. 922) in 1987 and *Mendacino Marine* (pl. 926) in 1988 are two of the finest examples of this series.

During the eighties, McLean accepted a few commissions. Somewhat surprisingly, these externally generated works—in particular, *Seattle Slew* (pl. 908) and *Zoffany with Eddie Delahoussaye Up* (pl. 896)—were some of the best McLean has ever done. *Slew* comes close to his great *Sheba* (*P-R* pl. 759) of 1978 in its exquisitely detailed treatment of the horse's coat, muscles, veining, color, and face. *Zoffany* is clearly the best of McLean's racehorses (a seventies image but executed with the skills, knowledge, and experience of 1987).

A "sidebar" to the horse paintings is the series of horses' paraphernalia McLean has rendered as still lifes. Dating from 1975, these noteworthy works (all watercolors but one) are pure little exercises in composition.

The newest image in McLean's repertoire may be seen in the paintings prominently featuring a series of personable dogs. He had included a dog in his first painting of the eighties, *Standing Figures with Bag Lunch* (pl. 869); this Dalmatian is one of his best pieces of painting to date. It wasn't until the end of the decade (1989–90) that he returned to the dog as a major subject—one that will surely be elaborated in the nineties.

McLean has painted 140 works. *Photo-Realism* illustrated 68 and listed 6 more (5 of those are illustrated herein, along with 2 early works discovered

since 1980; the only unillustrated work left from before 1980 is a watercolor of *Miss Paulo's,* showing the same image as *P-R* pl. 728). In the eighties, there were 22 oils (all illustrated herein) and 42 watercolors, of which 3 are listed and not illustrated. Therefore, the two books illustrate 136 of the 140 works.

869. *Standing Figures with Bag Lunch.* 1980 (79). Oil on canvas, 43 x 56". Collection Louis K. and Susan Pear Meisel, New York

870. *Intrepid's Highlight.* 1982 (94). Oil on canvas, 39 x 60".
Private collection, New York

871. *Red Rider.* 1981 (86). Oil on canvas, 36 x 42".
Private collection, France

872. *Jack Magill's Bourbon Jet.* 1981 (81). Oil on canvas, 50 x 68". Collection Jack and Harriet Stievelman, New York

873. *The Sheik*. 1983 (104). Oil on canvas, 49¾ x 68". Private collection, Florida

874. *Winnemucca*. 1983 (100). Oil on canvas, 45 x 68". Collection Jesse Nevada Karp, New York

875. *Untitled (Lakeport)*. 1982 (89).
Watercolor on paper, 12 x 17".
PieperPower Companies, Inc., Wisconsin

876. *The Sheik*. 1983 (102).
Watercolor on paper, 12¼ x 15⅜".
Collection Donna and Neil Weisman, New Jersey

877. *English Sorrel with Blue Trailer*. 1981 (87).
Watercolor on paper, 10 x 15". Collection Donna and Neil Weisman, New Jersey

878. *Stockton Leopard*. 1982 (93).
Watercolor on paper, 11 x 15¼".
Private collection, Oklahoma

879. *T. J.'s Jet Moon*. 1982 (97).
Watercolor on paper, 13¼ x 17¾".
Collection Jesse Nevada Karp, New York

880. *Blue Boy*. 1983 (99).
Watercolor on paper, 12 x 16½".
Private collection, Massachusetts

881. *Untitled*. 1982 (95). Watercolor on
paper, 6 x 9". Collection Robert Bechtle and
Whitney Chadwick, California

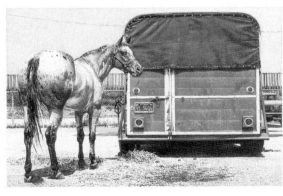

882. *Roan Appy with American Trailer*. 1983 (101).
Watercolor on paper, 11½ x 17".
Private collection, Missouri

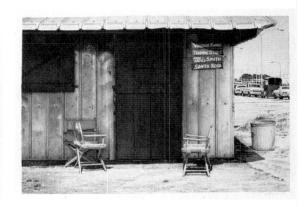

883. *Vintage Farms*. 1981 (85).
Watercolor on paper, 9¾ x 14¼".
Private collection, California

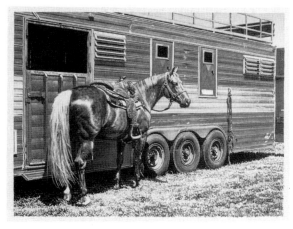

884. *Sunduster*. 1983 (98).
Watercolor on paper, 12 x 15¼".
Louis K. Meisel Gallery, New York

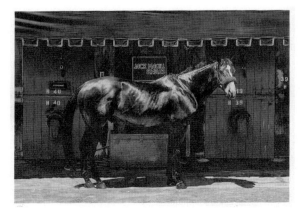

885. *Jack Magill's Bourbon Jet*. 1981 (82).
Watercolor on paper, 11 x 15".
Private collection, New York

886. *Activated Charcole*. 1983 (105).
Watercolor on paper, 13¼ x 16¾".
Southland Corporation, Texas

887. *English Sorrel with Blue Trailer.* 1982 (88). Oil on canvas, 45 x 68". Private collection, Colorado

888. *Still Life with Graffito.* 1981 (83).
Watercolor on paper, 13 x 10".
Private collection, New York

889. *Still Life with Hanging Harness (Karla).*
1981 (84). Watercolor on paper, 12 x 10".
Private collection, Oklahoma

890. *Still Life with Prize Ribbon—Green Bucket.*
1983 (103). Watercolor on paper, 11 x 9¼".
Collection Marcia Rodrigues, California

891. *Zeno.* 1982 (91).
Watercolor on paper, 11½ x 12½".
Private collection, Connecticut

892. *Intrepid's Highlight.* 1982 (90).
Watercolor on paper, 12¼ x 16⅛".
Private collection, New York

893. *Peppermint Filly.* 1982 (92).
Watercolor on paper, 11 x 13".
Private collection, Florida

894. *Oregon Pinto at Smith Rock.* 1986 (119). Oil on canvas, 35 x 67". Private collection, Ohio

895. *Cordelia Chestnut.* 1984 (109). Oil on canvas, 50 x 68". Private collection, California

896. *Zoffany with Eddie Delahoussaye Up.* 1987 (125). Oil on canvas, 38 x 55". Private collection, England

897. *California Landscape with Fences.* 1984 (110). Oil on canvas, 34 x 60". Southland Corporation, Texas

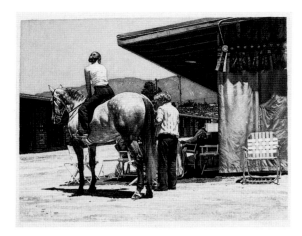

898. *Dardanella.* 1980 (78).
Watercolor on paper, 11 x 14".
Private collection, Massachusetts

899. *Still Life with Hanging Harness.* 1980 (77). Watercolor on paper, 11⅝ x 8". Collection Glenn C. Janss, Idaho

900. *Still Life with Red Lariat.* 1984 (107).
Watercolor on paper, 12 x 14¾".
Southland Corporation, Texas

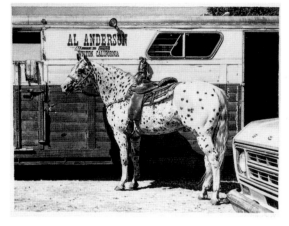

901. *Santa Rosa Leopard.* 1984 (106).
Watercolor on paper, 12 x 15".
Private collection, Maryland

902. *Kahlúa Lark.* 1980 (80).Watercolor on paper, 5 x 7½". California College of Arts and Crafts, Oakland

903. *Bar-D Scatter.* 1984 (108).
Watercolor on paper, 11 x 15⅛".
Private collection, Nevada

904. *Sorrel Filly Grazing.* 1985 (116). Oil on canvas, 24 x 56". Collection the artist

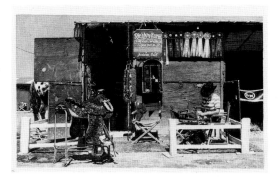

906. *Western Tableau with Fancy Saddle.* 1988 (130). Watercolor on paper, 12³⁄₄ x 20". Collection Mr. and Mrs. Charles B. Moss, Jr., Colorado

905. *Still Life with Prize Ribbon.* 1979 (75). Oil on canvas, 50 x 45". Private collection, Wisconsin

907. *Self-Portrait.* 1982 (96). Watercolor and gouache on paper, 30 x 22". Collection the artist

908. *Seattle Slew.* 1985 (112). Oil on canvas, 42 x 60". Private collection, New York

909. *Barnyard Still Life with Paint Pony.* 1987 (122). Watercolor on paper, 11½ x 20". Private collection, Illinois

910. *Cordelia Chestnut.* 1985 (115). Watercolor on paper, 12½ x 18". Southland Corporation, Texas

911. *Way Out East (Portrait of Paul Brach).* 1987 (121). Watercolor on paper, 9 x 20". Collection the artist

912. *Petaluma Pastoral (Letter to Edward Hicks).* 1986 (120). Watercolor on paper, 8 x 18". Collection Louis K. and Susan Pear Meisel, New York

913. *Small Marine with White Mare.* 1987 (126). Gouache on paper, 3 x 7½". Collection the artist

914. *Slew o' Gold.* 1986 (118). Oil on canvas, 42 x 76". Private collection, New York

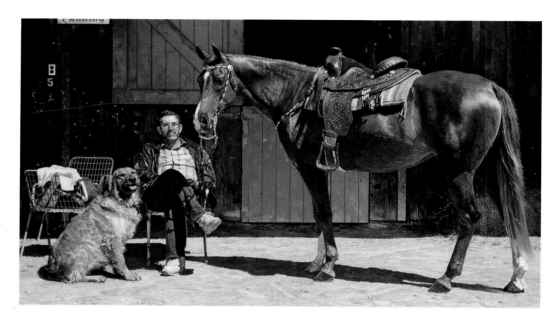

915. *Zoffany with Eddie Delahoussaye Up.* 1987 (124). Watercolor on paper, 10¼ x 14½". Private collection, England

917. *Western Tableau with Golden Retriever (Samantha).* 1990 (139). Oil on canvas, 42 x 76". Virlane Foundation, Louisiana

916. *Watsonville Truffle.* 1988 (127). Watercolor on paper, 11 x 14½". Collection Mr. and Mrs. Charles B. Moss, Jr., Colorado

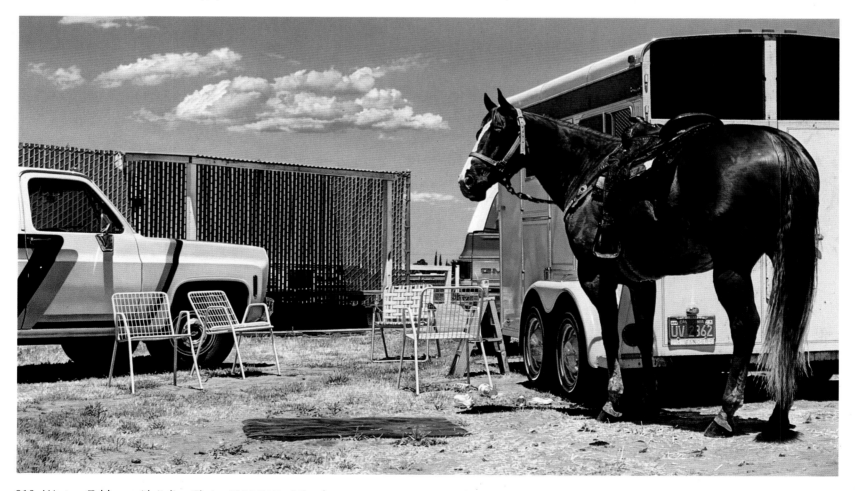

918. *Western Tableau with Italian Chairs.* 1986 (117). Oil on canvas, 50 x 86". Private collection, Massachusetts

919. *Paso Fino with Family Whippet (Manoso Lace).* 1989 (133). Watercolor on paper, 12 x 19¹/₂". Collection Donna and Neil Weisman, New Jersey

920. *Vacaville Chestnut.* 1989 (135). Watercolor on paper, 12 x 18". Private collection, California

921. *Hap's Jumper.* 1988 (131). Watercolor on paper, 12 x 19". Private collection, Tennessee

922. *Valley.* 1987 (123). Oil on canvas, 44 x 100". Pacific Telesis Group, San Francisco

923. *Paint Filly with Blue Wraps.*
1990 (137). Watercolor on paper,
13 x 13". Collection Donna and Neil
Weisman, New Jersey

924. *Nicole's Smokey Doc.* 1990 (136).
Watercolor on paper, 13 x 16½".
Private collection, Switzerland

925. *Susan with Command.*
1990 (138). Watercolor on paper,
6¾ x 6¾". Collection Louis K. and
Susan Pear Meisel, New York

926. *Mendocino Marine.* 1988 (128). Oil on canvas, 27 x 68". Private collection, Switzerland

927. *Dancing Brave on Newmarket Heath.* 1988 (129). Oil on canvas, 36 x 70". Private collection, England

928. *Hap's Jumper.* 1989 (132). Oil on linen, 46 x 72". Collection Mr. and Mrs. Bob M. Cohen, California

929. *Paso Fino with Family Whippet (Slew).* 1989 (134). Oil on canvas, 44 x 72". Collection Lauren and John Howard, New York

930. *Sheba.* 1977 (64). Watercolor on paper, 10¾ x 12". Collection Louis K. and Susan Pear Meisel, New York

931. *Negam.* 1979 (73). Watercolor on paper, 12¼ x 14½". Collection Donna and Neil Weisman, New Jersey

932. *Spotted Gelding with Blue Trailer.* 1979 (74). Watercolor on paper, 12 x 15". Private collection, Maryland

933. *Portrait of David Ellis.* 1979 (76). Watercolor on paper, 10 x 16". Private collection, New Jersey

934. *Rancho del Mar.* 1978 (68). Watercolor on paper, 12½ x 9". Louis K. Meisel Gallery, New York

935. *Mac.* 1978 (69). Watercolor on paper, 9¾ x 14". Private collection

NOT ILLUSTRATED

Western Tableau with Italian Chairs. 1984 (111). Watercolor on paper, 11¼ x 19½". Collection the artist

Seattle Slew. 1985 (113). Watercolor on paper, 11½ x 18". Private collection, New York

Seattle Slew. 1985 (114). Watercolor on paper, 12½ x 17½". Private collection, New York

936. *Western Tableau with English Sheepdog (Tucker).* 1990 (140). Oil on canvas, 48 x 68". Collection the artist

Jack Mendenhall began producing paintings that demonstrated his mature style and imagery in 1971. Although it was not until three years later that he made his debut in New York, he had been included previously in four local California group exhibitions. Since Mendenhall arrived in New York late and had in fact only that one exhibition during the seventies, there was not much exposure to his work; it remained peripheral to the central energy of the movement. He did, however, stake out a territory with his unique subject matter. In pursuing it exclusively for two full decades, he has firmly secured a position for himself as one of the important Photorealists.

Mendenhall's subject has always been interiors—more specifically, the interiors of homes portrayed in decoration magazines such as *Architectural Digest* and *HG*. Yet the difference in Mendenhall's rooms is that they are almost always just a bit outside the realm of the supposedly "tasteful" rooms shown in the magazines. Usually a bit overdone and somewhat tacky, they might even be the interiors of the houses seen in Bechtle's paintings from the same period.

Mendenhall's technique has improved in the course of his career. His room settings have become a bit more "sophisticated," and he has been more prolific in the eighties. His four solo shows have helped to make his work more accessible, while giving him a wider audience as well.

Mendenhall has included people in about half his paintings. When this element is added, the image takes on a distinctly narrative quality, and a viewer can easily conjure up some story taking place in the room. In works by Bechtle, McLean, Goings, and even Estes, the addition of people also channels the scene in a specific direction, but the figures are simply one element among many in the composition. Mendenhall's people push the picture through narrative to the edge of illustration, yet all along he is appropriating and satirizing illustration itself.

JACK MENDENHALL

Of the 37 works Mendenhall completed in the eighties, 34 are illustrated herein and 3 are listed.

937. *Lobster Tails for Dinner.* 1980 (2). Oil on canvas, 45 x 49½". Private collection, Canada

938. *Mirrored Dining Room with Red Chairs.* 1980 (1). Oil on canvas, 78 x 77". Private collection, Michigan

939. *Mirrored Table with Decanters.* 1981 (3). Oil on canvas, 72$\frac{1}{2}$ x 68$\frac{1}{2}$".
Private collection, New York

940. *Couple on Terrace.* 1981 (4). Oil on canvas, 44$\frac{1}{2}$ x 50".
Private collection, Ohio

941. *Dining Room with Red Roses.* 1981 (5). Oil on canvas, 55 x 61$\frac{1}{2}$".
Private collection, Sweden

942. *Yellow Tulips and Dinner Setting.* 1981 (6). Oil on canvas, 51 x 59".
Private collection, California

943. *Interior with Ocean View.* 1981 (7). Oil on canvas, 57½ x 58½".
Collection Carole Bayer Sager, California

944. *Garden Table Setting.* 1982 (8). Oil on canvas, 40 x 46".
Private collection, Maryland

945. *Table Setting with Figure.* 1982 (9). Oil on canvas, 76 x 52".
Collection Alice Zimmerman, Tennessee

946. *Dining Room with Arbor.* 1983 (12). Oil on canvas, 51¼ x 61".
Collection the artist

947. *Interior with Skyline.* 1984 (17).
Oil on canvas, 62 x 57".
Collection Paul Sack,
California

948. *Interior with Elephant.* 1984 (18). Oil on canvas, 60 x 55¼".
Collection Dr. and Mrs. Edward C. Cooper, Pennsylvania

949. *Untitled.* 1986 (22). Oil on canvas, 62 x 53".
Private collection, New York

950. *Interior with Figures I.* 1983 (13). Watercolor on paper, 13½ x 17½". Collection Glenn C. Janss, Idaho

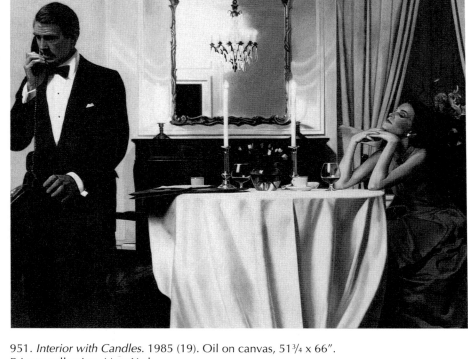

951. *Interior with Candles.* 1985 (19). Oil on canvas, 51¾ x 66". Private collection, New York

953. *Sunlit Room with Palm.* 1984 (16). Watercolor on paper, 13¾ x 16¾". Private collection

952. *Living Room with Skyline View.* 1985 (21). Watercolor on paper, 11¾ x 11¾". Collection Joseph and Lynda Jurist, New York

954. *Untitled.* 1985 (20). Watercolor on paper, 14¼ x 18¾". Private collection

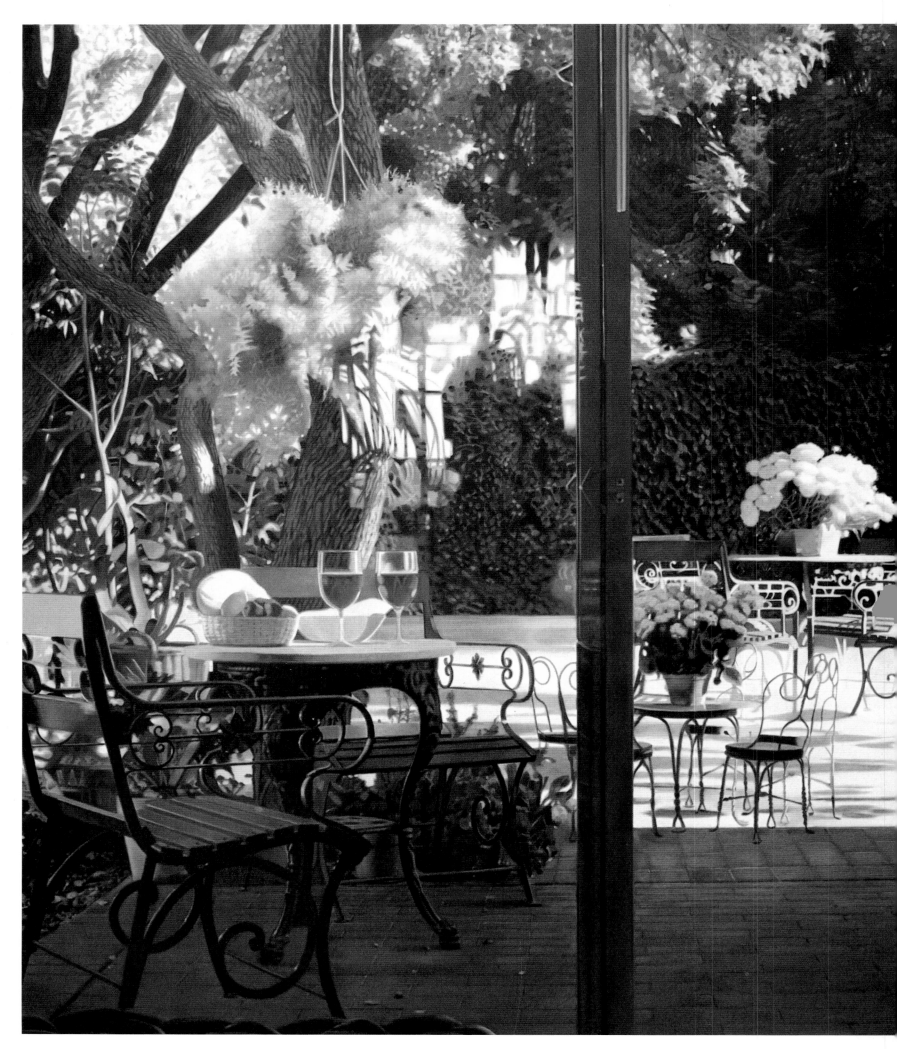

955. *Patio View.* 1983 (10). Oil on canvas, 51¾ x 64¾". Collection Mr. and Mrs. Sydney Besthoff III, Louisiana

956. *Untitled.* 1983 (11). Oil on board, 13 x 14¼".
Collection Mr. and Mrs. Lowell Shindler, New York

957. *Interior with Figures II.* 1983 (14). Watercolor on paper, 13 x 17½".
Private collection, New York

958. *Jacuzzi Whirlpool Bath's Lumière Collection.* 1986 (23). Oil on canvas, 44 x 76". Collection the artist

959. *Interior with Heartlight.* 1987 (25). Oil on canvas, 58 x 72½". Collection Mrs. Robert Saligman, Pennsylvania

960. *Interior with Burt and Carole.* 1986 (24). Oil on canvas, 69¾ x 61¾″. Collection Carole Bayer Sager, California

961. *Interior with Kim.* 1987 (26). Oil on canvas, 49 x 71½". Private collection, Switzerland

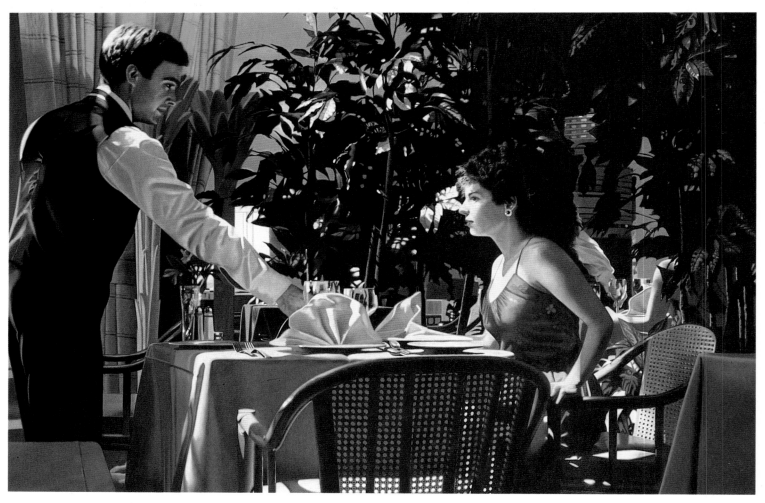

962. *Kim at The Claremont.* 1988 (27). Oil on linen, 51¾ x 75¾". Private collection, Switzerland

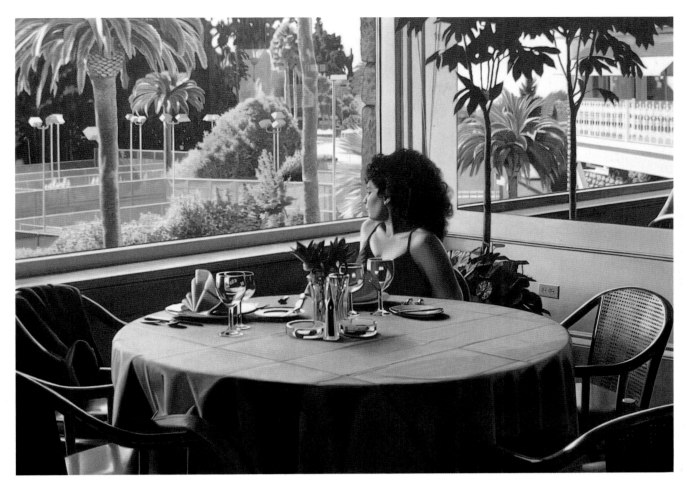

963. *The Frontier Room.* 1988 (28). Oil on linen, 48½ x 66". Collection Mr. and Mrs. Charles B. Moss, Jr., Colorado

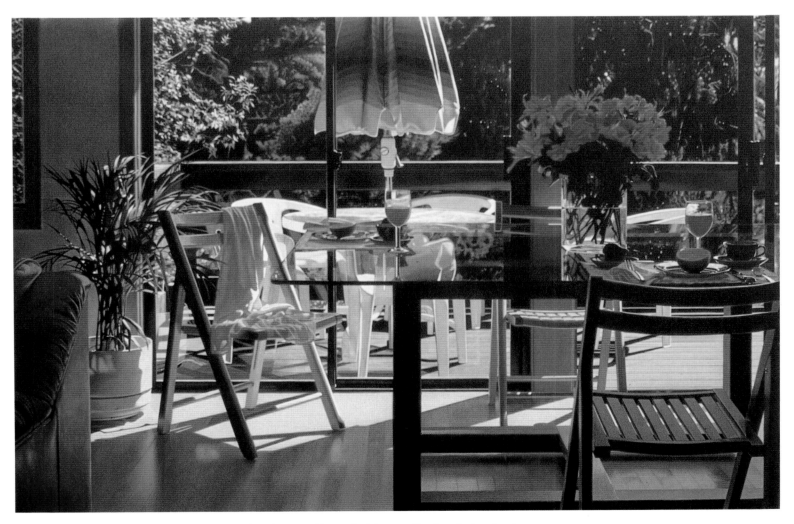

964. *Interior with Pink Chemise.* 1988 (29). Oil on linen, 50¾ x 74". Private collection, Switzerland

965. *Kim on the Deck.* 1989 (30). Oil on linen, 52 x 74½".
Collection Judy and Noah Liff, Tennessee

966. *Afternoon Sun.* 1989 (31). Oil on linen, 50½ x 75".
Virlane Foundation, Louisiana

967. *Tiburon Interior.* 1990 (32). Oil on canvas,
62½ x 52½". Collection the artist

968. *Kim and Morning Juice.* 1990 (33). Oil on linen, 50 x 74".
Collection the artist

NOT ILLUSTRATED

Exterior with Rolls Royce. 1983 (15).
Watercolor on paper, 13 x 20".
Collection Michael H. Epstein, California

View of Tiburon No. 2. 1990 (34).
Watercolor on paper, 16½ x 16½".
Collection the artist

Tiburon Still Life with View. 1990 (36).
Watercolor on paper, 17¼ x 17½".
Collection the artist

969. *View of Tiburon No. 3.* 1990 (35).
Oil on linen, 54½ x 53¾".
Collection the artist

970. *Oriental Carpet and Sunlight.* 1990 (37).
Watercolor on paper, 14¼ x 13¾".
Collection the artist

DAVID PARRISH

By 1972, when David Parrish had his first one-man show, Photorealism was beginning to take hold as the first important movement of the decade. And Parrish's large-scale, almost life-size motorcycles were as mainline Photorealist as an image could get. Like racing cars, fire engines, trucks, storefronts, and gumball machines, motorcycles were images of popular culture that were nearly impossible to paint without the camera and the photograph as tools. Each and every one of these classic Photorealist images was immediately embraced as new, exciting material for the art world.

Because of the technical demands of the style, Photorealist artists were generally limited in their output, averaging four to ten works a year. Parrish, who displayed the finest, most exacting, and impeccably smooth brushwork of the group, painted only two or three works a year.

In 1987, Parrish abandoned motorcycles as a subject and became a still-life painter. The first three paintings of this new series focus on porcelain birds and kitschy souvenirs and toys. Complex and intricate works, they relate to the large-scale, abstracted motorcycles from 1979, 1980, and 1981. In no way, however, do they predict the blockbuster paintings that were to follow.

In 1988, Parrish completed two paintings (pls. 972 and 981), each featuring a great superstar, Marilyn and Elvis, portrayed as a nostalgic porcelain figure. The strong visual and emotional content of these paintings, expressed in their subject matter, scale, and technique, overwhelms the viewer. In 1989, the scale grew larger and the imagery more direct—and who could top Presley and Monroe but the almost mythological James Dean, who dominated the year for Parrish in two works (pls. 982 and 988). The third that year was *Fred and Ginger* (pl. 983), with silver shoes symbolically representing Fred Astaire and Ginger Rogers.

Wonder Woman and Sylvester Stallone as Rocky began the year 1990 (pl. 984), then Marilyn returned with Al Jolson (pl. 989). The

last two paintings of the year and the decade, though, are the most haunting and wrenching of all. The first, entitled *Double Feature* (pl. 990) is a huge depiction of a porcelain Humphrey Bogart flanked by a toy cowboy and Indian. The work is a true tribute to the vision, skill, and mind of David Parrish. The final work is probably the strongest effort yet—*Liz (Cleopatra)* (pl. 991).

Parrish has done 28 paintings in the eighties; all but one are illustrated herein.

971. *Daddy Bob (Fourth of July)*. 1982 (35).
Oil on canvas, 84 x 96". Private collection, France

313

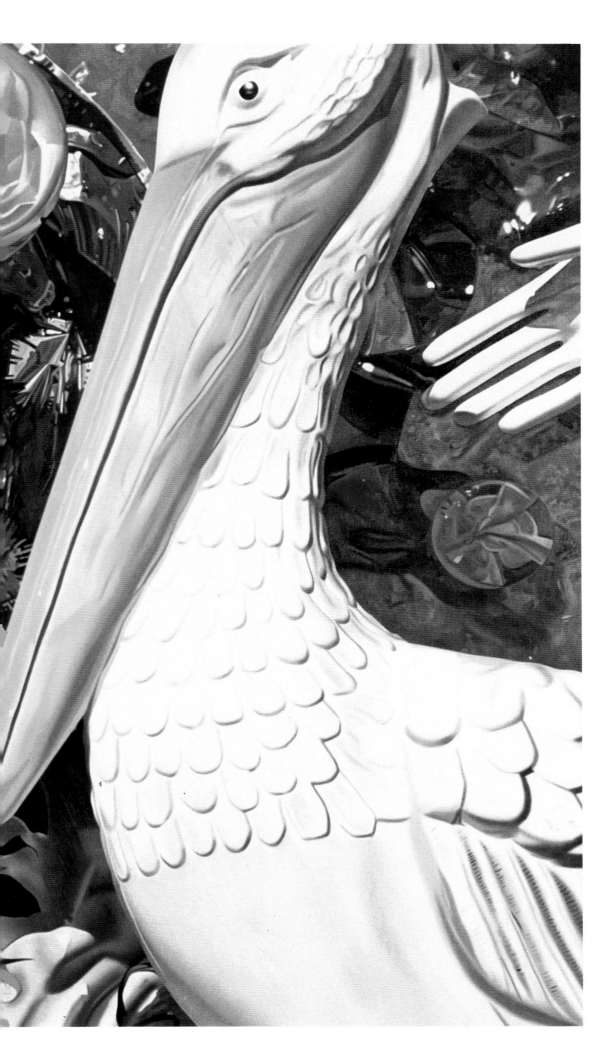

972. *Marilyn.* 1988 (51).
Oil on canvas, 72 x 108".
Louis K. Meisel Gallery,
New York

973. *Royal Chevy.* 1981 (33). Oil on canvas, 83 x 55¼".
Montgomery Museum of Fine Arts, Alabama.
Montgomery Museum of Fine Arts Association Purchase

974. *K.C. Suzuki.* 1982 (34). Oil on canvas, 90 x 63".
Private collection, Florida

975. *Bessemer Road.* 1980 (31). Oil on canvas, 90½ x 61".
Private collection, Switzerland

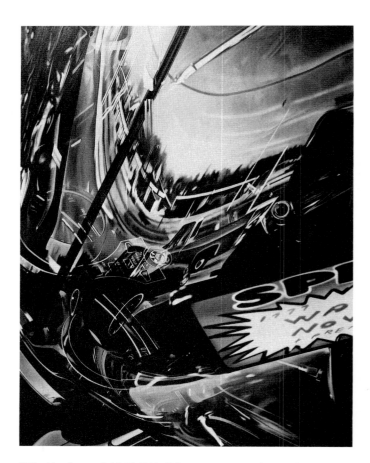

976. *Northwood.* 1981 (32). Oil on canvas, 84½ x 64½".
Private collection, Pennsylvania

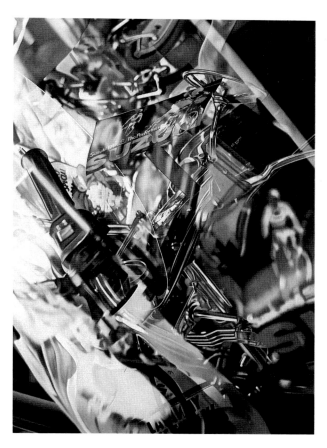

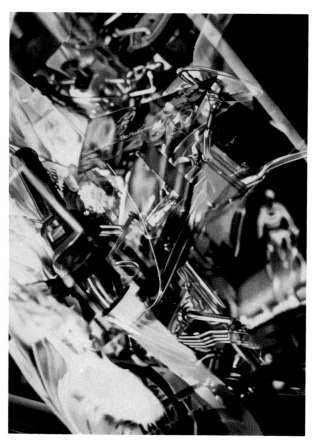

977. *Suzuki II*. 1983 (36). Oil on canvas, 72 x 47½".
Collection the artist

978. *Suzuki Special (Suzuki III)*. 1983 (37). Oil on canvas,
90 x 63". Private collection, California

979. *All Happy*. 1985 (40). Oil on canvas, 19½ x 25".
Collection the artist

980. *Black Cat*. 1985 (39). Oil on canvas, 29 x 43½".
Collection the artist

981. *Elvis.* 1988 (50). Oil on canvas, 74 x 104¼". Collection Judy and Noah Liff, Tennessee

982. *Curtain Call.* 1989 (52). Oil on canvas, 72 x 108". Private collection, New York

983. *Fred and Ginger.* 1989 (54). Oil on canvas, 61 x 92". Collection Donna and Neil Weisman, New Jersey

984. *Rocky.* 1990 (55). Oil on canvas, 72 x 102". Virlane Foundation, Louisiana

985. *Pink Flight.* 1986 (44). Oil on canvas, 77 x 58". Private collection, Switzerland

986. *Venezia*. 1987 (46). Oil on canvas, 63 x 90". Private collection, California

987. *Pow-Wow*. 1988 (49). Oil on canvas, 62¼ x 93". Private collection, Switzerland

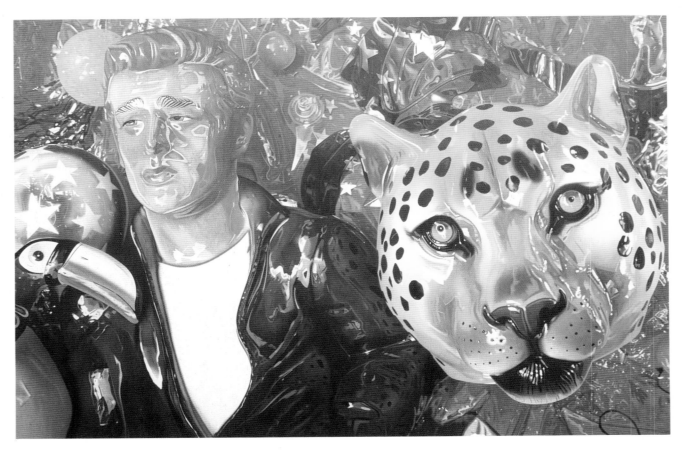

988. *See the Jaguar.* 1989 (53). Oil on canvas, 72 x 108". Collection Andrew Paquette and Barry Fishman

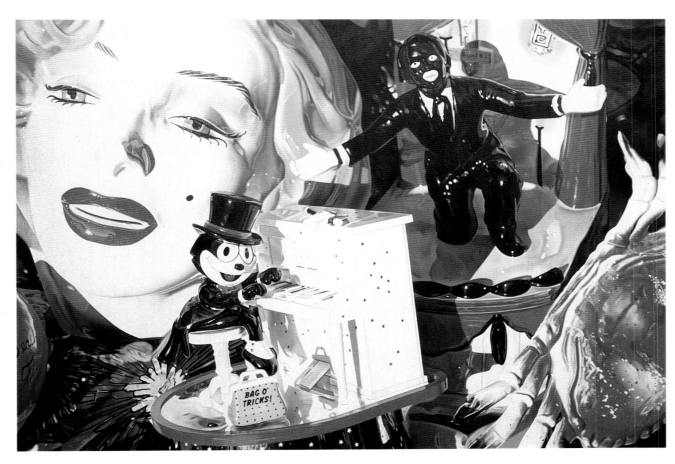

989. *Broadway Babies.* 1990 (56). Oil on canvas, 70 x 102". Collection Donna and Neil Weisman, New Jersey

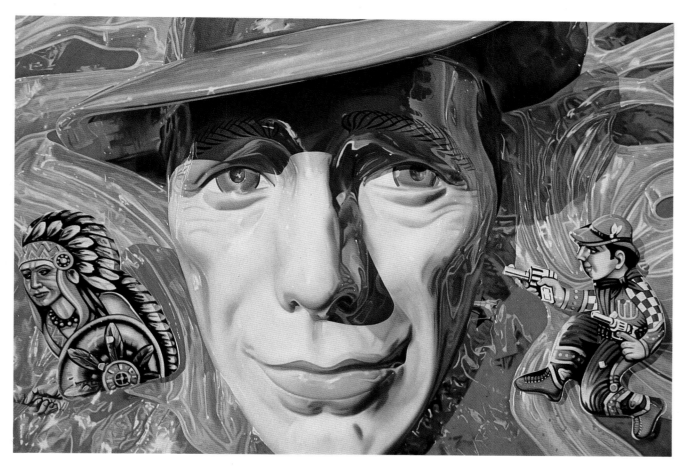

990. *Double Feature*. 1990 (57). Oil on canvas, 70 x 102". Private collection, Ontario

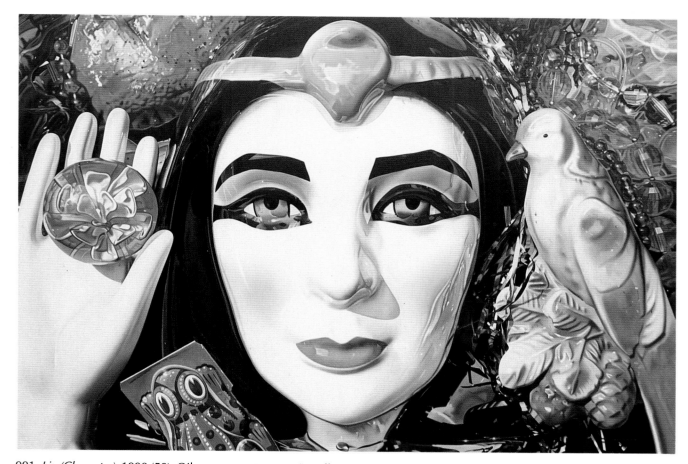

991. *Liz (Cleopatra)*. 1990 (58). Oil on canvas, 70 x 102". Collection Bruce R. Lewin, New York

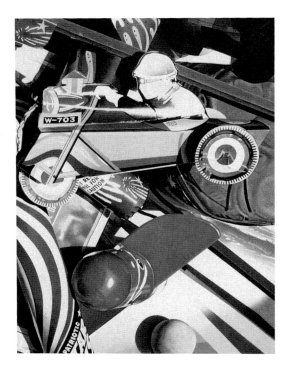

992. *Easy Rider.* 1986 (42). Oil on canvas, 40 x 30".
Private collection, Sweden

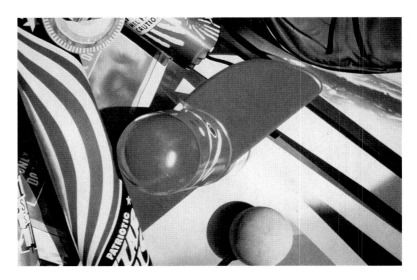

993. *Sunrise.* 1986 (41). Oil on canvas, 47½ x 71¾".
Huntsville Museum of Art, Alabama.
Huntsville Museum Association Purchase

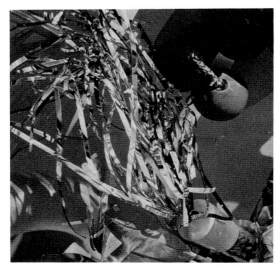

994. *Tinsel.* 1986 (43). Oil on canvas, 12 x 12".
Private collection, Alabama

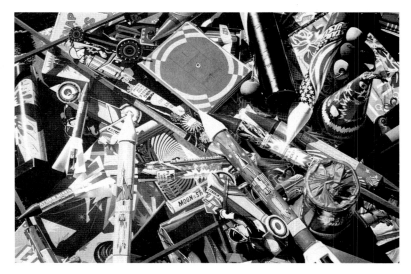

995. *Star Cruiser.* 1985 (38). Oil on canvas, 29 x 43½".
Private collection, Tennessee

996. *See-Saw.* 1986 (45). Oil on canvas, 63 x 90".
Collection the artist

997. *Panama City Beach.* 1987 (47).
Oil on canvas, 77 x 53".
Collection the artist

NOT ILLUSTRATED
Out on a Limb. 1987 (48).
Oil on canvas, 62 x 93".
Private collection

JOHN SALT

The eighties found John Salt in England, painting in his studio from photographs he had taken in America. Aside from one atypical work, *Ironmongers* (pl. 1002), Salt's subjects were similar to those he had explored in the seventies. *Deserted Impala with Red Door* (pl. 1016) of 1983 is classic Salt, but *Junked Red Pick-up* (pl. 1014) and *Untitled Wrecks* (pl. 1015) represent more of a repetition than an advance.

Salt produced only seven oil paintings in the eighties, along with twenty-three watercolors. Perhaps the best of the Photorealists at the demanding discipline of watercolor, Salt has made major advances in the eighties with regard to scale and imagery. *Side Street Parking* of 1987 (pl. 1018) is an example of one of the finest large watercolors ever done. Among Salt's masterful works of 1990 (pls. 1026–28, 1030), *Street Profile with Grain Elevators* is reminiscent of Edward Hopper's work.

Of Salt's total works, 89 were shown in *Photo-Realism* and 7 listed (we can now illustrate 4 of those, plus 2 others discovered recently). Of the 7 new oils and 23 watercolors, only 2 watercolors are missing. Therefore, the two volumes illustrate 123 of the 128 existing works.

998. *Torn Purple Interior.* 1970 (23).
Oil on canvas, 56 x 78".
Private collection

999. *Silver Plymouth in Woods.* 1979 (94).
Oil on canvas, 41¾ x 63½".
Collection Richard Brown Baker, New York

325

1000. *Neglected Vehicle*. 1980 (99). Oil on canvas, 42 x 63". Private collection, Holland

1001. *Chevrolet Surge*. 1981 (101). Oil on canvas, 42 x 63½". Collection Martin Z. Margulies, Florida

1002. *Ironmongers.* 1981 (103). Oil on canvas, 42 x 63½". Scottish National Gallery of Modern Art, Edinburgh

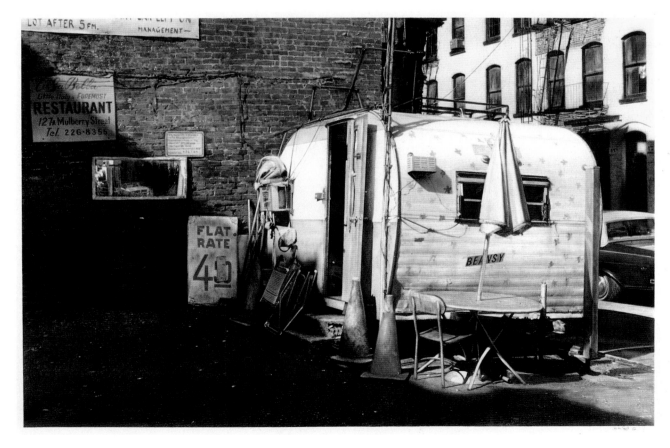

1003. *Beansy.* 1982 (106). Watercolor on paper, 35½ x 48½". Collection Richard and Gloria Manney, New York

1004. *Tractor and Bicycle, Fall.* 1978 (91a). Watercolor on paper, 11 x 17". Collection Mr. and Mrs. W. Jaeger, New York

1005. *Winter, Mott Street.* 1979 (95). Watercolor on paper, 12½ x 18". Collection Albert Ratcliffe, New York

1006. *Yellow Tractor.* 1979 (96). Watercolor on paper, 12 x 18". Collection Louis K. and Susan Pear Meisel, New York

1007. *Yellow Volkswagen, Newport, R.I.* 1979 (97). Watercolor on paper, 12 x 17½". Private collection, New York

1008. *Red/Green Automobile.* 1980 (98). Watercolor on paper, 11¼ x 16¾". Private collection

1009. *Farm Yard with Red Pick-Up.* 1981 (102). Watercolor on paper, 13 x 18". Collection Michael Rakosi, New York

1010. *Chevrolet at Rest.* 1982 (104). Watercolor on paper, 12 x 18".
Collection Martin Z. Margulies, Florida

1011. *Parked Riviera.* 1982 (105). Watercolor on paper, 12 x 17½".
Collection Louis K. and Susan Pear Meisel, New York

1012. *Untitled (White Washer).* 1982 (107). Watercolor on paper,
11½ x 17". Collection Mrs. Norvel E. Green, Indiana

1013. *Dodge Dart in Shadows.* 1983 (108). Watercolor on paper,
11½ x 16¾". Collection Jesse Nevada Karp, New York

1014. *Junked Red Pick-Up.* 1984 (110). Watercolor on paper, 11½ x 17".
Collection Donna and Neil Weisman, New Jersey

1015. *Untitled Wrecks.* 1984 (111). Watercolor on paper, 11½ x 17¼".
Collection Martin and Wendy Mull, California

1016. *Deserted Impala with Red Door.* 1983 (109). Oil on canvas, 42 x 63½". Private collection, France

1017. *Trailer House.* 1986 (116). Oil on canvas, 42 x 63". Collection Jesse Nevada Karp, New York

1018. *Side Street Parking.* 1987 (119). Watercolor on paper, 37½ x 56½". Louis K. Meisel Gallery, New York

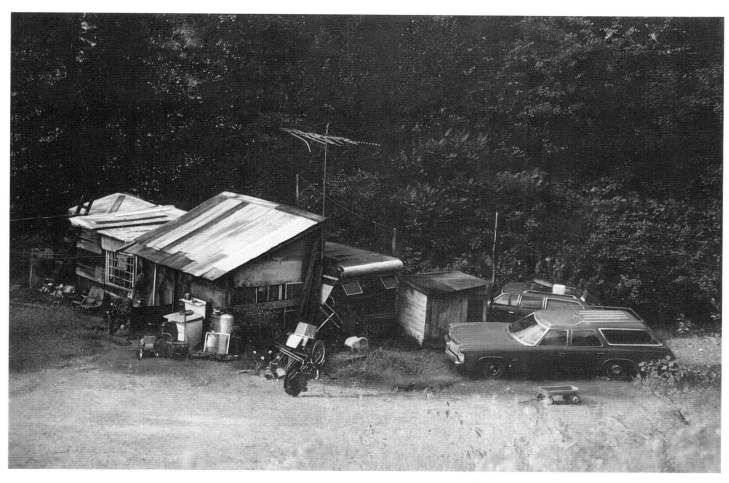

1019. *Untitled.* 1989 (122). Oil on canvas, 42 x 64". Virlane Foundation, Louisiana

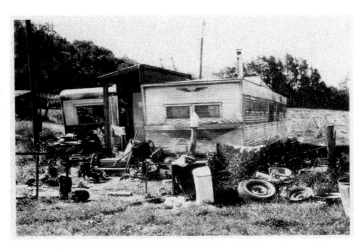

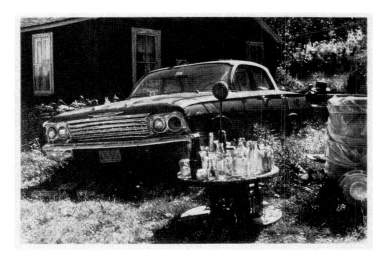

1020. *Light Blue Trailer Home.* 1984 (112). Watercolor on paper, 11³/₄ x 17¹/₂". Collection Michael Rakosi, New York

1021. *Untitled.* 1984 (113). Watercolor on paper, 11³/₄ x 17¹/₂". Collection Martin and Wendy Mull, California

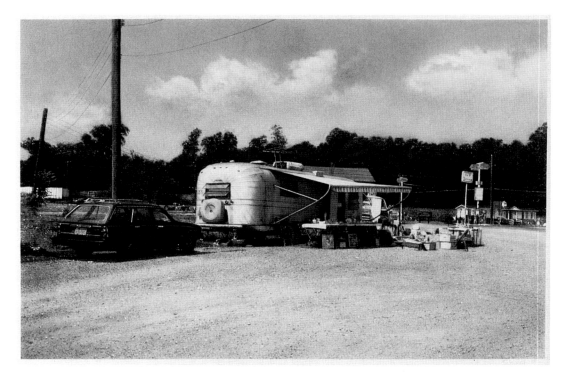

1022. *Mobile Home on Gravel.* 1988 (120). Watercolor on paper, 18¹/₂ x 27³/₄". Collection Mr. and Mrs. Charles B. Moss, Jr., Colorado

1023. *Red Barn with Junkyard.* 1986 (114). Watercolor on paper, 19 x 28¹/₄". Louis K. Meisel Gallery, New York

1024. *Green Chevy Nova.* 1987 (117). Watercolor on paper, 11½ x 17".
Private collection

1025. *Two Cars in a Field.* 1987 (118). Watercolor on paper, 11½ x 17¾".
Collection Robert A. Mann, Ohio

1026. *Untitled.* 1990 (124). Watercolor on paper, 11¼ x 17¼".
Private collection, France

1027. *Porch and Camper.* 1990 (125). Watercolor on paper, 11¼ x 17¼".
Collection the artist

1028. *Chevy in Driveway.* 1990 (126). Watercolor on paper, 11¼ x 17¼".
PieperPower Companies, Inc., Wisconsin

1029. *Green Chevy with Trailer.* 1988 (121). Watercolor on paper,
12½ x 19½". Collection Howard and Judy Tullman, Illinois

NOT ILLUSTRATED
Pontiac Station Wagon with Two Trailers. 1980 (100).
Watercolor on paper, 11¼ x 16¾".
Collection Richard Brown Baker, New York
Trailer Park. 1986 (115).
Watercolor on paper, 12 x 18".
Collection the artist

1030. *Street Profile with Grain Elevators.* 1990 (127). Watercolor on paper, 24¼ x 36½"
Louis K. Meisel Gallery, New York

1031. *Untitled.* 1989–90 (123). Oil on linen, 43½ x 66½". Louis K. Meisel Gallery, New York

334

BEN SCHONZEIT

Ben Schonzeit, whose work in the mid-seventies had a major impact on Photorealism, is not in fact an orthodox Photorealist in the sense that Blackwell, Kleemann, Bechtle, Cottingham, or Estes is. Schonzeit's work in the early seventies combined several disparate images, each superimposed upon the others, to create a collaged juxtaposition with a hint of Surrealism. His work from 1972 to 1977, the prime years of Photorealism, was consistent with the definitions of the style. He painted still lifes primarily, but there were also portraits (reminiscent of Close's work) and some major landscapes.

In the eighties, Schonzeit has done no true Photorealist work. However, since he has been one of the major figures of the movement and was one of the thirteen artists accorded a full chapter in *Photo-Realism,* I have endeavored to follow his career and show where he has gone with his art—as I have with Flack, Close, and Eddy, three other artists whose work has veered away in the last decade from pure Photorealism.

Schonzeit's present work is virtually all photo-derived and photographically assisted. Many of the breakthroughs and advances of Photorealism, which have been utilized by artists working in other areas, are also part of Schonzeit's working methods. Throughout his career, Schonzeit has refused to be confined to any one area of subject matter, and the same interest in varied images continues today.

Schonzeit has produced a large body of work. *Photo-Realism* illustrated and listed 187 works, which are probably all he did in the years covered in that book. The illustrations here give an overview of Schonzeit's work in the past decade. There has been no attempt, however, to continue with a full documentation of his work; that must be left to a future catalogue of his career.

1032. *A Brooklyn Bridge.* 1980. Oil on canvas, 84 x 144". Private collection

1033. *Vase*. 1980. Oil on linen, 84 x 72".
Private collection

1034. *Easel Painting*. 1980. Acrylic on canvas, 72 x 72".
Collection Mrs. Morton Hornick, New York

1035. *China Fans*. 1981. Oil on linen, 84 x 90".
Collection Klaus Luders, Germany

1036. *Palm and Red Wall*. 1982. Oil on linen, 48 x 48".
Collection James McCole, California

1037. *Two-Inch Brush.* 1981. Oil on linen, 72 x 38". Collection Jean Valente Blacker, New York

1038. *Three-Inch Brush.* 1981. Oil on canvas, 60 x 48". Collection James Uffelman, New York

1039. *Wasted Brush.* 1982. Oil on linen, 66 x 36". Collection Mr. and Mrs. William Egert, New York

1040. *Two Gilt Figures.* 1982. Oil on linen, 72 x 72". Collection the artist

1041. *Shanghai.* 1982. Oil on canvas, 96 x 84". ARCO, California

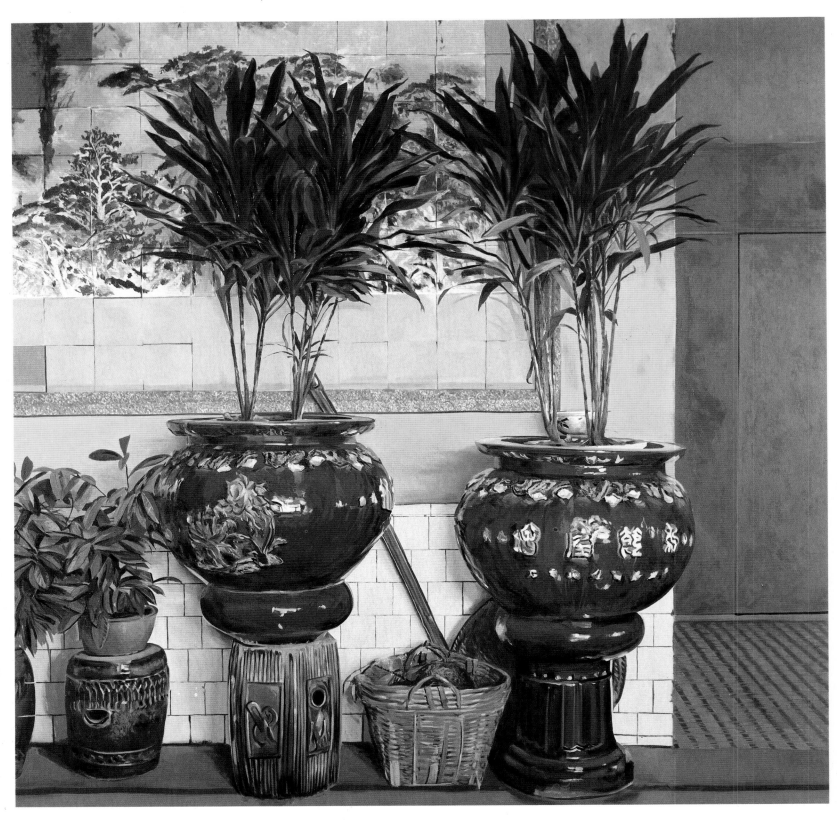

1042. *Blue Pots.* 1982. Oil on linen, 72 x 72". Private collection, Arizona

1043. *Like Ringing a Bell.* 1983. Acrylic on canvas, 90 x 120".
Collection Tom Mount, California

1044. *From inside the Clock.* 1983. Acrylic on paper laid down on
linen, 48 x 48". Collection Mr. and Mrs. Allen Samson, Wisconsin

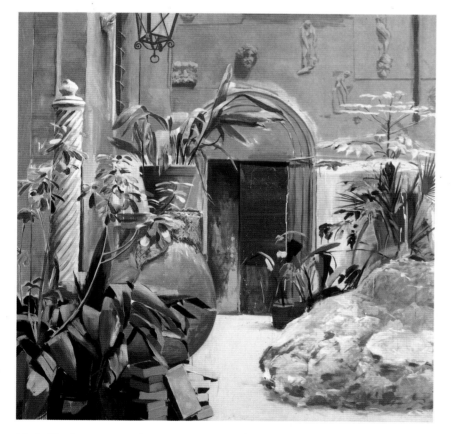

1045. *The Renovation of Rome II.* 1984. Acrylic on canvas, 72 x 72".
Collection Mr. and Mrs. Donald Levine, Indiana

1046. *North Sea Mecox.* 1985. Acrylic on canvas, 46 x 67".
Private collection, Ohio

1047. *Postmortem.* 1985. Acrylic on canvas, 90 x 132". Collection Tom Mount, California

1048. *Two and One.* 1985. Acrylic on canvas with louvered door, 96 x 160". Collection the artist

1049. *Aalto Blue.* 1985. Acrylic on canvas, 60 x 66".
Collection Mr. and Mrs. Bertrand Warnod, France

1050. *Aalto Peach.* 1985. Acrylic on canvas, 66 x 72".
Collection Mrs. Jerome Berman, Florida

1051. *Aalto Yellow.* 1985. Acrylic on canvas,
60 x 66". Private collection, Florida

1052. *Aalto Red.* 1986. Acrylic on canvas, 66 x 72". Collection John Keller, Illinois

1053. *The Island.* 1987. Acrylic on canvas, 78 x 84".
Collection Anita Rosenstein, California

1054. *Yellow Lily.* 1987.
Acrylic on canvas, 60 x 27".
Irving Galleries, Florida

1055. *Burano Rose.* 1987. Acrylic on canvas, 54 x 66".
Collection Mr. and Mrs. Alvin Myerberg, Maryland

1056. *Golden West.* 1988. Acrylic on canvas, 78 x 66".
Collection Mr. and Mrs. J. Siegel, Connecticut

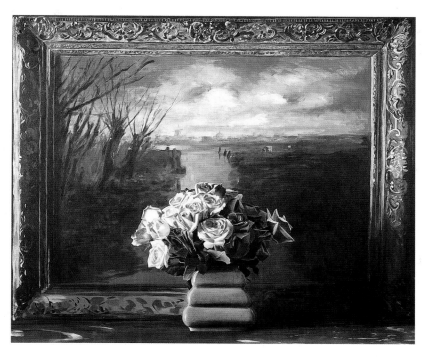

1057. *Caribe with Figure.* 1988. Acrylic on canvas, 72 x 75".
Collection Tom Mount, California

1058. *Roses with Dutch Landscape.* 1989. Acrylic on canvas, 60 x 72".
Collection Mr. and Mrs. Mark Shumate, Colorado

1059. *Amaryllis with Three Drawings.* 1988.
Acrylic on linen, 66 x 36". Private collection

1060. *Amaryllis II.* 1988. Acrylic on canvas,
60 x 30". Collection Mr. and Mrs. Eugene
Applebaum, Michigan

1061. *Degas.* 1988. Acrylic on canvas, 66 x 44".
Canon USA, New York

1062. *Fairfield Pond Lane.* 1986. Acrylic on canvas, 36 x 66". Private collection, Massachusetts

NOT ILLUSTRATED
Speckled Vase. 1988.
Acrylic on canvas, 46 x 66".
Collection Joseph Kerzner, Ontario
The Ginger Jar. 1989.
Acrylic on canvas, 66 x 72".
Collection Mr. and Mrs. William Billings, Illinois

1063. *The White Barn.* 1987. Acrylic on linen, 54 x 84". Arthur Andersen & Company, New York

1064. *Sag Road.* 1986. Acrylic on canvas, 24 x 60". Collection Mariette Gomez, New York

1065. *Two Trees.* 1986. Acrylic on canvas, 78 x 90". The Brooklyn Museum, New York

RANDY DUDLEY

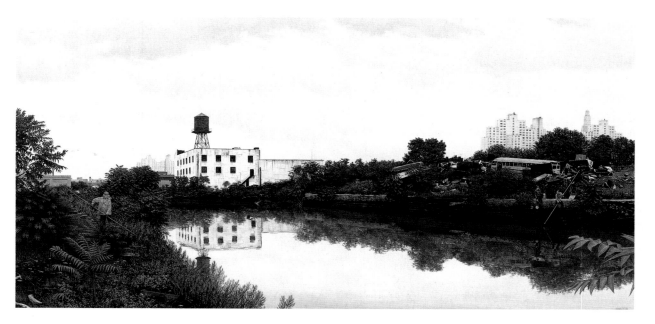

1066. *Gowanus Canal from 2nd St.* 1986. Oil on canvas, 28½ x 58". The Brooklyn Museum, New York.
Purchase Gift of Charles Allen

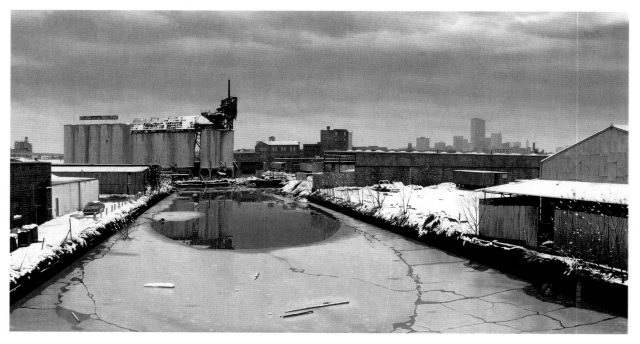

1067. *5th Street Basin.* 1989. Oil on canvas, 28½ x 54". Collection David and Diane Goldsmith, California

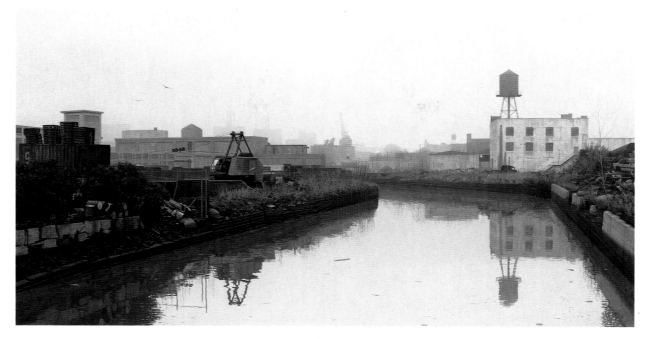

1068. *North from 3rd St.* 1989. Oil on canvas, 28½ x 54". Collection Dr. Thomas A. Mathews, Washington, D.C.

1069. *South from 3rd St. Bridge.* 1989. Oil on canvas, 28½ x 54". Private collection, Switzerland

1070. *Dutch Kills Creek—Greenpoint.* 1990. Oil on canvas, 28½ x 54". Private collection, Switzerland

STEPHEN FOX

1071. *Signs of Life.* 1986. Oil on canvas, 28 x 45".
Collection Dr. and Mrs. Sidney Cohen, Pennsylvania

1072. *Rest Stop.* 1987. Oil on canvas, 28¼ x 58".
Collection Michael Rakosi, New York

1073. *Switching Tracks.* 1988. Oil on canvas, 30½ x 42". Collection David Wright, Massachusetts

1074. *Landscape in Forward Motion*. 1989. Oil on linen, 42 x 58". Collection Lauren and John Howard, New York

1075. *Roadside*. 1990. Oil on canvas, 25¹/₂ x 40".
Collection Dr. and Mrs. Howard Berk, New York

1076. *Roadside (Lunar Influence)*. 1990. Oil on canvas, 24¹/₂ x 46¹/₂".
Collection Dr. and Mrs. Edward C. Cooper, Pennsylvania

ROBERT GNIEWEK

1077. *Chinatown No. 7*. 1990. Oil on linen, 40 x 56". Private collection, Tennessee

1078. *South Villa, Hong Kong*. 1990. Oil on linen, 38 x 58". Private collection

1079. *Times Square, New York City, No. 2*. 1990. Oil on linen, 38 x 60". Louis K. Meisel Gallery, New York

1080. *Delft Theater*. 1990. Oil on linen, 36 x 58". Private collection, New York

GUS HEINZE

1081. *West River Flowing East.* 1988.
Acrylic on gessoed panel, 40 x 51".
Collection Mr. and Mrs. Paul Frimmer,
California

1082. *Earth First No. 7.* 1988.
Acrylic on gessoed panel, 40 x 48".
Collection Mr. and Mrs. Michael Towbes,
California

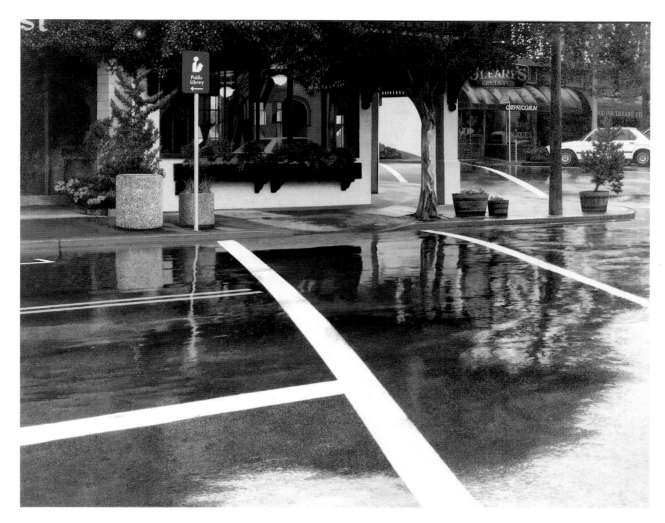

1083. *Reflective Intersection.* 1989. Acrylic on gessoed panel, 45 x 57". Collection Nancy and Sid Cohen, California

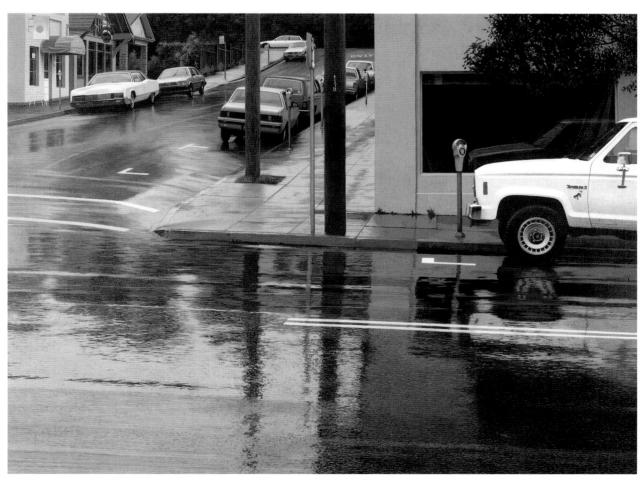

1084. *Seven Point One.* 1989. Acrylic on gessoed panel, 40 x 53". Modernism Inc., San Francisco

DON JACOT

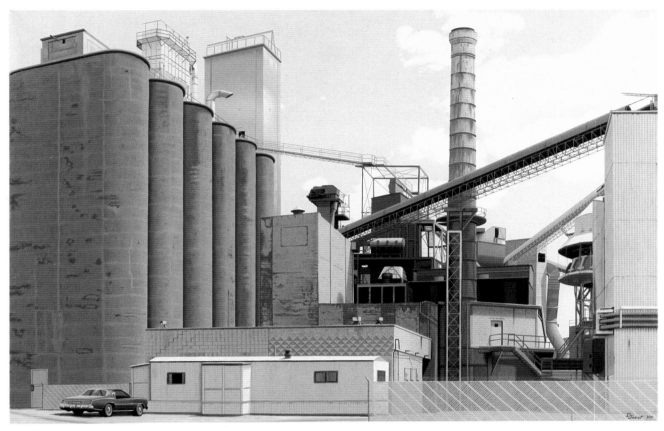

1085. *Industrial Landscape.* 1987. Oil on linen, 28 x 42". Private collection, Michigan

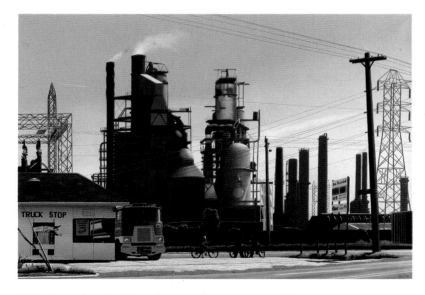

1086. *Petrochemical Complex near River Rouge.* 1987.
Oil on linen, 26 x 38". Private collection, Michigan

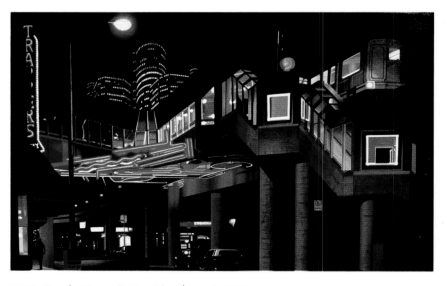

1087. *People Mover Station (Greektown).* 1989.
Oil on linen, 24 x 36". Private collection, Michigan

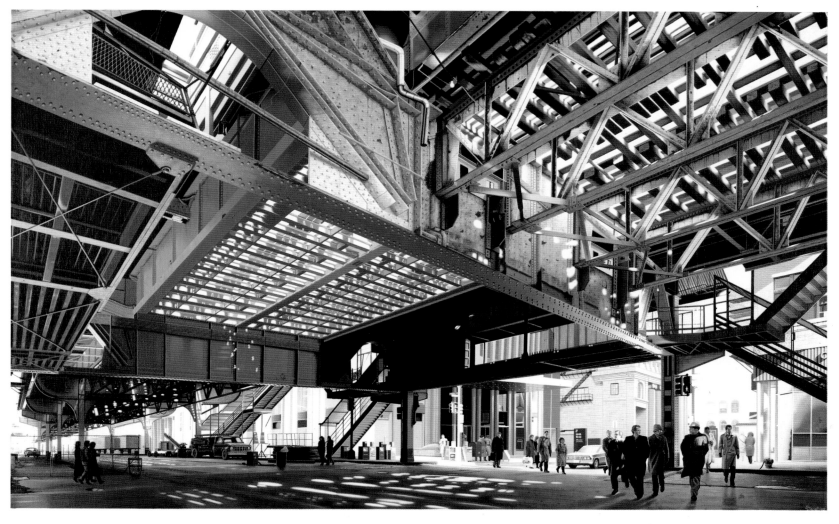

1088. *Under the Elevated Tracks (Chicago)*. 1989. Oil on linen, 38 x 60". Private collection, Switzerland

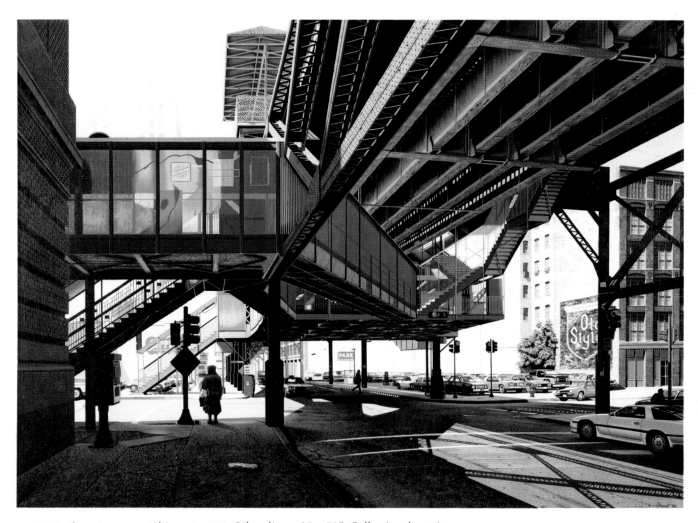

1089. *Northwest Passage (Chicago)*. 1990. Oil on linen, 38 x 50". Collection the artist

REYNARD MILICI

1090. *The Sandbox*. 1988.
Oil on Masonite, 30⅝ x 43⅞".
Private collection,
Tennessee

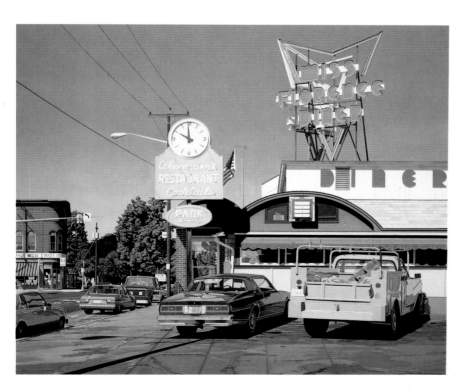

1091. *Miss Flo's*. 1989. Oil on Masonite, 42¾ x 50¾".
Louis K. Meisel Gallery, New York

1092. *Three Barrels*. 1989. Oil on Masonite, 41 x 45".
Private collection, New York

1093. *Red Convertible.* 1990. Oil on Masonite, 39 x 54". Private collection, New York

1094. *H. Johnson's.* 1990.
Oil on Masonite, 36 x 36".
Private collection,
Ontario

SELECTED EXHIBITIONS, BIBLIOGRAPHIES, AND BIOGRAPHIES

GROUP EXHIBITIONS

1980 "American Figure Painting 1950–1980," The Chrysler Museum, Norfolk, Va.

"Aspects of Photorealism," Randolph-Macon Woman's College, Lynchburg, Va.

"Aspects of the 70s: Directions in Realism," Danforth Museum, Framingham, Mass.

"The Figurative Tradition and The Whitney Museum of American Art: Painting and Sculpture from the Permanent Collection," Whitney Museum of American Art, New York

"The Morton G. Neumann Family Collection," National Gallery of Art, Washington, D.C.

"Realism/Photorealism," Philbrook Art Center, Tulsa, Okla.

1980–81 "Assignment Aviation—The Stuart M. Speiser Photo-Realist Collection," National Air and Space Museum (Smithsonian Institution), Washington, D.C.

1981 "The Image in American Painting and Sculpture, 1950–1980," Akron Art Museum, Ohio

"Seven Photorealists—From New York Collections," The Solomon R. Guggenheim Museum, New York

"Toyama Now '81," The Museum of Modern Art, Toyama, Japan

1981–82 "Real, Really Real, Super Real: Directions in Contemporary American Realism," San Antonio Museum of Art, Tex.; traveled to: Indianapolis Museum of Art, Ind.; Tucson Museum of Art, Ariz.; Museum of Art, Carnegie Institute, Pittsburgh, Pa.

1981–83 "Contemporary American Realism Since 1960," traveling exhibition: Pennsylvania Academy of the Fine Arts, Philadelphia; Virginia Museum, Richmond; Oakland Museum, Calif.; tour sponsored by the United States International Communication Agency: Gulbenkian Foundation, Lisbon; Salas de Exposiciones de Bellas Artes (Recoletos), Madrid; Kunsthalle Nuremberg

"Super Realism: From the Morton G. Neumann Family Collection," Kalamazoo Institute of Arts, Mich.; The Art Center, Inc., South Bend, Ind.; Springfield Art Museum, Mo.; Dartmouth College Museum and Galleries, Hanover, N.H.; DeCordova and Dana Museum, Lincoln, Mass.; Des Moines Art Center, Iowa; Terra Museum of American Art, Evanston, Ill.

1982 "An Appreciation of Realism," Munson-Williams-Proctor Institute Museum of Art, Utica, N.Y.

"Contemporary Realism," Brainerd Art Gallery, State University College of Arts and Science, Potsdam, N.Y.; Plaza Gallery, State University Plaza, Albany, N.Y.

"Contemporary Realism," three-gallery exhibition: "Still Life," The Gallery at Hastings-on-Hudson, N.Y.; "Landscape," The Museum Gallery, White Plains Public Library, N.Y.; "The Figure," The Castle Gallery, College of New Rochelle, N.Y.

"Louis K. Meisel at Galerie Isy Brachot," Brussels

"Photographs by the Photorealists," Fort Wayne Museum of Art, Ind.; Cleveland Museum of Art, Ohio; Ball State Museum, Muncie, Ind.

"Photo-Réalisme 'Dix Ans Après,'" Galerie Isy Brachot, Paris

1983 "The American Photorealists—An Anthology," Fischer Fine Art, London

"Realism Now," The Museum of Modern Art, Saitama, Japan

"Watercolor in America," Joseloff Gallery, Hartford Art School, University of Hartford, Conn.

1983–85 "Assignment: Aviation—The Stuart M. Speiser Photo-Realist Collection," Smithsonian Institution traveling exhibition: Anchorage Historical and Fine Arts Museum, Alaska; Denver Museum of Natural History, Colo.; Maryland Science Center, Baltimore; Columbus Museum of Arts and Sciences, Ga.; Neville Public Museum, Greenbay, Wis.; The Dane G. Hanson Memorial Museum, Logan, Kans.; Longview Museum and Art Center, Tex.; Colorado Springs Fine Arts Center, Colo.; Springfield Art Museum, Mo.; Fine Arts Center at Cheekwood, Nashville, Tenn.; Historical and Creative Arts Center, Lufkin, Tex.; Amarillo Art Center, Tex.; Santa Fe Community College Art Gallery, Gainesville, Fla.

1984 "America Seen: Contemporary American Artists View America," Adams-Middleton Gallery, Dallas, Tex.

"Aspects of Realism," Walter Moos Gallery, Toronto

"Autoscape: The Automobile in the American Landscape," Whitney Museum of American Art, Stamford, Conn.

"Through the Looking Glass: Reflected Images in Contemporary Art," The Heckscher Museum, Huntington, N.Y.

1985 "American Realism," William Sawyer Gallery, San Francisco, Calif.

"American Realism: The Precise Image," traveling exhibition, Japan: The Isetan Museum of Art, Tokyo; The Daimaru Museum, Osaka; Yokohama Takashimaya Gallery, Yokohama

"Photorealist Watercolors," Acme Art, San Francisco, Calif.

"Realism: Contemporary Americans," Hooks-Epstein Galleries, Houston, Tex.

1985–86 "A Decade of American Realism: 1975–1985," Wichita Art Museum, Kans.

1985–88 "American Realism—20th-Century Drawings and Watercolors from the Glenn C. Janss Collection," San Francisco Museum of Modern Art, Calif.; DeCordova and Dana Museum, Lincoln, Mass.; Archer M. Huntington Art Gallery, University of Texas, Austin; Mary and Leigh Block Gallery, Northwestern University, Evanston, Ill.; Williams College Museum of Art, Williamstown, Mass.; Akron Art Museum, Ohio; Madison Art Center, Wis.; Boise Art Museum, Idaho

1987 "The Urban Landscape," Louis K. Meisel Gallery, New York

1989 "Robert Bechtle, Chuck Close, Robert Cottingham, Malcolm Morley, Sigmar Polke," Pat Hearn Gallery, New York

1989–90 "Trains and Planes: The Influence of Locomotion in American Painting," traveling exhibition: Sherry French Gallery, New York; Roberson Center for the Arts, Binghamton, N.Y.; National Academy of Sciences, Washington, D.C.; Evansville Museum of Arts, Ind.; The Noyes Museum, Oceanville, N.J.

1990 "Amerikansk Fotorealism," Art Now Gallery, Gothenburg, Sweden

1991 "Motion as Metaphor: The Automobile in Art," Virginia Beach Center for the Arts, Va.

"Photorealism: The Early Years," Isidore Ducasse Fine Arts, New York

"In Sharp Focus: Super Realism," Nassau County Museum of Art, Roslyn, N.Y.

"Traffic Jam—The Automobile in Art," New Jersey Center for Visual Arts, Summit

1991–92 "American Realism and Figurative Art: 1952–1990," traveling exhibition, Japan: The Miyagi Museum of Art, Sendai; Sogo Museum of Art, Yokohama; The Tokushima Modern Art Museum, Tokushima; The Museum of Modern Art, Shiga, Otsu;. Kochi Prefectural Museum of Folk Art, Kochi

"Photo-Realism Revisited," Museum of Art, Fort Lauderdale, Fla.

"Six Takes on Photo-Realism," Whitney Museum of American Art at Champion, Stamford, Conn.

GROUP BIBLIOGRAPHY

ARTICLES

"A Classic Theme: The Nude and Nearly Nude—The Lonely Look of American Realism." *Life*, Oct. 1980, pp. 74–82.

Meisel, Louis K. "Fifteen Years of Photo-Realism." *Horizon* 23, no. 11, Nov. 1980, pp. 52–59, ill.

Goodyear, Frank H., Jr. "American Realism since 1960: Beyond the Perfect Green Pea." *Portfolio*, Nov./Dec. 1981, pp. 72–81.

Karmel, Pepe. "Photographs by the Photorealists." *Art in America*, May 1981, pp. 140–41.

Kuspit, Donald B. "What's Real in Realism?" *Art in America* (Special Issue: Realism), Sept. 1981, pp. 84–95, ill.

Perreault, John. "Photorealing in the Years." *The SoHo Weekly News*, Oct. 20, 1981, p. 64.

Schjeldahl, Peter. "Realism on the Comeback Trail." *The Village Voice*, Nov. 1981, pp. 11–17.

Yoskowitz, Robert. "Photos by the Photo Realists." *Arts*, Mar. 1981, pp. 25–26.

Perreault, John. "Realisms." *Art Express* 2, no. 2, Mar./Apr. 1982, pp. 34–38.

Hanson, Bernard. "Handsome Watercolors at University of Hartford's Joseloff Gallery." *Hartford Courant*, Nov. 13, 1983.

Ligocki, Gordon. "Photorealism Holds On to 1980s Audiences." *The Times* (Hammond, Ind.), July 3, 1987, p. B–7.

Papadopoulou, Bia. "Intellectual and Artistic Movements: American Photorealism." *Politea* ("State") *Magazine* (Athens), June 1988, pp. 73–75.

Grimaldi, Mary Moore. "Trains and Planes: The Influence of Locomotion in American Painting." *Dialogue* (Evansville, Ill.), May/June 1990, p. 30.

Raynor, Vivien. "By Train and Plane and, Oh Yes, the Car." *The New York Times*, Apr. 29, 1990, p. 20–N.J. section.

Harrison, Helen A. "Focusing In on Super-Realism." *The New York Times*, Apr. 2, 1991, p. 11–L.I. section.

Lipson, Karin. "It's Not Real, It's Super-Realism!" (review). *Newsday*, Nassau edition, part II, Apr. 26, 1991, p. 85.

Parks, Steve. "The Grand Museum Tour." *Newsday*, Nassau edition, part II, May 3, 1991, pp. 84–85, 100.

Schwartz, Constance. "In Sharp Focus: Super-Realism." *Sunstorm*, Apr. 1991, pp. 27–29, ill.

Raynor, Vivien. "Differences Outweigh Similarities in Photo-Realism." *The New York Times*, Jan. 5, 1992, p. 16–Conn. section.

CATALOGUES

Arthur, John. *Realism/Photorealism*. Philbrook Art Center, Tulsa, Okla., 1980.

Brown, J. Carter. *The Morton G. Neumann Family Collection: Selected Works*. Foreword by Sam Hunter. National Gallery of Art, Washington, D.C., 1980.

Perreault, John. *Aspects of the 70s: Directions in Realism*. Foreword by Joy L. Gordon. Danforth Museum, Framingham, Mass., 1980.

Styron, Thomas W. *American Figure Painting 1950–1980*. The Chrysler Museum, Norfolk, Va., 1980.

Chase, Linda. *Super Realism from the Morton G. Neumann Family Collection* (traveling exhibition). Kalamazoo Institute of Arts, Mich., 1981.

Danoff, Michael, and Carolyn Kinder Carr. *The Image in American Painting and Sculpture, 1950–1980*. Akron Art Museum, Ohio, 1981.

Martin, Alvin, Linda Nochlin, and Philip Pearlstein. *Real, Really Real, Super Real: Directions in Contemporary American Realism*. San Antonio Museum of Art, Tex., 1981.

Messer, Thomas M. "Photorealism." In *Toyama Now '81*. The Museum of Modern Art, Toyama, Japan, 1981.

Tabak, Lisa Dennison. *Seven Photorealists from New York Collections*. The Solomon R. Guggenheim Museum, New York, 1981.

Hildreth, Joe. *Contemporary Realism*. Brainerd Art Gallery, State University College of Arts and Sciences, Potsdam, N.Y., 1982.

Manning, John. *An Appreciation of Realism*. Munson-Williams-Proctor Institute Museum of Art, Evanston, Ill., 1982.

Photo-Réalisme: Dix Ans Après. Galerie Isy Brachot, Paris, 1982.

The American Photorealists—An Anthology. Fischer Fine Art, London, 1983.

Kuwabara, Sumio, and Tamon Miki. *Realism Now*. Museum of Modern Art, Saitama, Japan, 1983.

Martin, Alvin. *America Seen: Contemporary American Artists View America*. Adams-Middleton Gallery, Dallas, Tex., 1984.

Perkins, Pamela Gruninger. *Autoscape: The Automobile in the American Landscape*. The Whitney Museum of American Art at Champion, Stamford, Conn., 1984.

Arthur, John. *American Realism: The Precise Image*. Isetan Museum of Art, Tokyo, 1985.

Spencer, Howard DaLee. *A Decade of American Realism: 1975–1985*. Wichita Art Museum, Kans., 1985.

Martin, Alvin. *American Realism: Twentieth-Century Drawings and Watercolors from the Glenn C. Janss Collection*. Harry N. Abrams, Inc., New York, in association with the San Francisco Museum of Modern Art, Calif., 1986.

Arthur, John. *American Realism and Figurative Art: 1952–1990*. Miyagimus Museum of Art et al., Japan, 1991.

Cohen, Nancy. Introduction to *Traffic Jam—The Automobile in Art*. New Jersey Center for Visual Arts, Summit, 1991.

Ferrulli, Helen. *Six Takes on Photo-Realism*. The Whitney Museum of American Art at Champion, Stamford, Conn., 1991.

Photorealism: The Early Years. Isidore Ducasse Fine Arts, New York, 1991.

Schwartz, Constance. Introduction to *In Sharp Focus: Super Realism*. Nassau County Museum of Art, Roslyn, N.Y., 1991.

Scott, Sue. *Motion as Metaphor—The Automobile in Art*. Virginia Beach Center for the Arts, Va., 1991.

BOOKS

Arthur, John. *Realist Drawings and Watercolors: Contemporary Works on Paper*. Boston: New York Graphic Arts Society/Little, Brown & Co., 1980.

Lindey, Christine. *Superrealist Painting and Sculpture*. New York: William Morrow & Co., Inc., 1980.

Lucie-Smith, Edward. *Art in the Seventies*. Oxford, Eng.: Phaidon Press Ltd., 1980.

Meisel, Louis K. *Photo-Realism*. New York: Harry N. Abrams, Inc., 1980.

Goodyear, Frank H., Jr. *Contemporary American Realism since 1960*. Boston: New York Graphic Society, in association with The Pennsylvania Academy of the Fine Arts, 1981.

Arthur, John. *Realists at Work: Studio Interviews and Working Methods of 10 Leading Contemporary Painters*. New York: Watson-Guptill Publications, 1983.

Robins, Corinne. *The Pluralist Era—American Art, 1968–1981*. New York: Harper & Row Publishers, Inc., 1984.

Silk, Gerald, et al. *Automobile and Culture*. New York: Harry N. Abrams, Inc., 1984.

Hunter, Sam, and John Jacobus. *Modern Art: Painting, Sculpture, Architecture*. 2nd ed. New York: Harry N. Abrams, Inc., 1985.

Lucie-Smith, Edward. *American Art Now*. New York: William Morrow & Co., Inc., 1985.

Arnason, H. H. *History of Modern Art: Painting, Sculpture, Archi-tecture.* 3rd ed. New York: Harry N. Abrams, Inc., 1986.

Janson, H. W. *History of Art.* 3rd ed., revised and expanded by Anthony Janson. New York: Harry N. Abrams, Inc., 1986.

Martin, Alvin. *American Realism—20th-Century Drawing and Watercolors from the Glenn C. Janss Collection.* New York: San Francisco Museum of Modern Art in association with Harry N. Abrams, Inc., 1986.

Sarnoff, Richard. "Return to Realism." In *An American Renais-sance: Painting and Sculpture since 1940.* Edited and with an introduction by Sam Hunter. New York: Abbeville Press Pub-lishers, 1986.

Mathey, François. *American Realism—A Pictorial Survey from the Early Eighteenth Century to the 1970s.* New York: Rizzoli International Publications, Inc., 1978.

Britt, David, ed. *Modern Art: Impressionism to Post-Modernism.* Boston: Bulfinch Press (Little, Brown & Co.), 1989.

Fichner-Rathus, Lois. *Understanding Art.* 2nd edition. Englewood Cliffs, N.J.: Prentice Hall, 1989.

Hartt, Frederick. *Art: A History of Painting, Sculpture, Architecture.* 3rd edition. New York: Harry N. Abrams, Inc., 1989.

Ward, John L. *American Realist Painting 1945–1980.* Ann Arbor, Mich.: UMI Research Press, 1989.

Goodard, Donald. *American Painting.* Introduction by Robert Rosenblum. New York: Hugh Lauter Levin Association, Inc., 1990.

JOHN BAEDER

Born: 1938, South Bend, Ind.
Education: 1960, Auburn University, Ala.

SOLO EXHIBITIONS
1980 Graphics 1 & 2, Boston, Mass.
 O. K. Harris Works of Art, New York
1982 O. K. Harris Works of Art, New York
 Thomas Segal Gallery, Boston, Mass.
1983 Cumberland Gallery, Nashville, Tenn.
1984 O. K. Harris Works of Art, New York
1986 "Paintings and Artifacts," Zimmerman-Saturn Gallery, Nash-ville, Tenn.
1987 O. K. Harris Works of Art, New York
1988 "John Baeder: Americana Photographs," Zimmerman-Saturn Gallery, Nashville, Tenn.
 Modernism, San Francisco, Calif.
1989 O. K. Harris Works of Art, New York
1991 O. K. Harris Works of Art, New York

GROUP EXHIBITIONS
1981 Proctor Art Center, Bard College, Annadale-on-Hudson, N.Y.
 "Visions of New York City: American Paintings, Drawings, and Prints of the Twentieth Century," Tokyo Metropolitan Museum of Art, Japan
1983 "Contemporary Images, Watercolor 1983," University of Wisconsin, Oshkosh
 "Urban Documents," Cooper-Hewitt Museum, New York
1983–84 "Painting New York," Museum of the City of New York
1984 "Aspects of Contemporary American Realism," Jerald Mel-berg Gallery, Charlotte, N.C.
1989 "City Reflections," Levinson Kane Gallery, Boston, Mass.
1990 "Carsinart: The Automobile Icon," Pensacola Museum of Art, Fla.
 "Realist Watercolors," Palmer Museum of Art, The Pennsylvania State University, University Park
1991 "Get Real," North Miami Center of Contemporary Art, Fla.
 "Perspectives on Realism: 1950–1991," Louis Stern Galleries, Beverly Hills, Calif.

ARTICLES
Donker, Peter p. "School of Realism Runs to (Top) of Class at Dan-forth." *Sunday Telegram* (Framingham, Mass.), May 25, 1980.
Canaday, John. "Painters Who Put the Real World in Sharp Focus." *Smithsonian,* Oct. 1981.
Stevens, Elisabeth. "Reality through Contemporary Artist's Eyes." *Baltimore Sun,* Oct. 25, 1981.
Carlsen, Robert. "Pictorial Odyssey along the Great American Roadside." *National Motorist,* Feb. 1983.
"The Great American Motel." *Reader's Digest,* May 1983.
Hieronymus, Clara. "Gas, Food, and Lodging—John Baeder Nos-talgia," *The Tennesseean,* Dec. 5, 1983.
Kissle, Howard. "Best of the Best." *W,* Nov. 19–26, 1983.
Pousner, Howard. "Roadside Rambler." *Atlanta Journal,* Jan. 11, 1983.
Raynor, Vivien. "Plainfield Gallery: Big Strides in a Short Career." *The New York Times,* Jan. 23, 1983.
"Artist John Baeder Appreciates Diners." *The Tennesseean,* July 22, 1984.
Eliasoph, Philip. "America on Wheels: Whitney Show Explores Our Paved-over Paradise." *Southern Connecticut News,* Apr. 8, 1984.
Kohen, Helen. "Making Art on a Big Scale." *Miami Herald,* Feb. 19, 1984.
Schwan, Gary. "Is What You See All You Get from Illusionist Art?" *The Post* (West Palm Beach, Fla.), Feb. 26, 1984.
"This Summer, Get the Picture." *Forbes,* July 16, 1984.
Zimmer, William. "At the Castle Gallery, a Clear Case of Art Imi-tating Life." *The New York Times,* Dec. 7, 1986, p. 50.

CATALOGUES
Armstrong, Tom. Introduction to *Visions of New York City.* Tokyo Metropolitan Museum of Art, 1981.
Miller, Steven. *Painting New York.* Museum of the City of New York, 1983.
Arthur, John. *Realist Watercolors.* Palmer Museum of Art, The Pennsylvania State University, University Park, 1990.

BOOKS
Baeder, John. *Diners.* 1988. 5th printing. New York: Harry N. Abrams, Inc., 1978.
———. *Gas, Food, Lodging.* New York: Abbeville Press Publishers, 1982.

ROBERT BECHTLE

Born: 1932, San Francisco, Calif.
Education: 1954, B.A., California College of Arts and Crafts, Oakland
 University of California, Berkeley
1958, M.F.A., California College of Arts and Crafts, Oakland

SOLO EXHIBITIONS
1980 "Robert Bechtle: Matrix/Berkeley 33," University Art Muse-um, Berkeley, Calif.
1981 O. K. Harris Works of Art, New York
1984 O. K. Harris Works of Art, New York
1987 O. K. Harris Works of Art, New York
1991 Gallery Paule Anglim, San Francisco, Calif.
 "Robert Bechtle: New Work," San Francisco Museum of Modern Art, Calif.
 Daniel Weinberg Gallery, Santa Monica, Calif.

GROUP EXHIBITIONS
1981 "Changes: Art in America 1881–1981," Marquette Universi-ty, Milwaukee, Wis.
 "Insights," The New Gallery, Cleveland, Ohio
 Proctor Art Center, Bard College, Annandale-on-Hudson, N.Y.
1982 "Drawings by California Painters," Long Beach Art Museum, Calif.; Oakland Museum, Calif.
1983 "American Interiors," California Palace of the Legion of Honor, San Francisco
 "Bay Area Art of the Sixties," University of California, Davis
 "Drawings by Fifty California Artists," Modernism, San Francisco, Calif.
 "Faces since the Fifties—A Generation of American Portraiture," Center Gallery, Bucknell University, Lewisburg, Pa.
1983–85 "West Coast Realism," Laguna Beach Museum of Art, Calif.; traveled to: Museum of Art, Fort Lauderdale, Fla.; Cen-ter for Visual Arts, Illinois State University, Normal; Fresno Art Center, Calif.; Louisiana Arts and Science Center, Baton Rouge; Museum of Art, Bowdoin College, Brunswick, Maine; Colorado Springs Fine Arts Center, Colo.; Spiva Art Center, Joplin, Mo.; Beaumont Art Museum, Tex.; Sierra Nevada Museum of Art, Reno, Nev.; Edison Community College, Fort Meyers, Fla.
1985 "Photorealist Watercolors," Acme Art, San Francisco, Calif.
1988 "Spanish Watercolors: Robert Bechtle and Richard McLean," Wiegand Gallery, Belmont, Calif.
1989 "A Decade of American Drawing, 1980–89," Daniel Wein-burg Gallery, Los Angeles, Calif.
 Pat Hearn Gallery, New York
1990 "California A-Z and Return," Butler Institute of American Art, Youngstown, N.Y.
 "Carsinart: The Automobile Icon," Pensacola Museum of Art, Fla.
1991 "Against the Grain: Images in American Art, 1960–1990," Southern Alleghenies Museum of Art, Loretto, Pa.
 "American Life in American Art; Selections from the Permanent Collection," Whitney Museum of American Art, New York

ARTICLES
Larson, Kay. "Art: Dead-End Realism." *New York,* Oct. 26, 1981.
Raynor, Vivien. "Pooling of Resources Produces Stimulating Suc-cess." *The New York Times,* Feb. 7, 1982.
Russell, John. "In Connecticut: Contemporary Classics at Aldrich." *The New York Times,* Aug. 4, 1989.
Raynor, Vivien. "Seeing Beauty or Problems." *The New York Times,* Oct. 6, 1991, p. 14–N.J.

CATALOGUES
Drawings by California Painters. Long Beach Art Museum, Calif., 1982.
Faces since the Fifties—A Generation of American Portraiture. Center Gallery, Bucknell University, Lewisburg, Pa., 1983.
Gamwell, Lynn. *West Coast Realism.* Laguna Beach Museum of Art, Calif., 1983.
Zona, Louis. Introduction to *California A-Z and Return.* Butler Insti-tute of American Art, Youngstown, Ohio, 1990.
Binai, Paul. *Against the Grain: Images in American Art, 1960–1990.* Southern Alleghenies Museum of Art, Loretto, Pa., 1991.

BOOKS
Hopkins, Henry. *Fifty West Coast Artists.* San Francisco: Chronicle Books, 1981.
Broder, Patricia Janis. *The American West: The Modern Vision.* Boston: Little, Brown & Co., 1984.

CHARLES BELL

Born: 1935, Tulsa, Okla.
Education: 1957, B.B.A., University of Oklahoma, Norman

SOLO EXHIBITIONS
1980 Louis K. Meisel Gallery, New York
1983 Hokin/Kaufman Gallery, Chicago, Ill.
 Louis K. Meisel Gallery, New York
1986 Louis K. Meisel Gallery, New York
1988 Modernism, San Francisco, Calif.
1989 Louis K. Meisel Gallery, New York
1991 Louis K. Meisel Gallery, New York

GROUP EXHIBITIONS
1980 "Still Life—A Selection of Contemporary Paintings," The Gallery, School of Art, Kent State University, Ohio; Tangeman Fine Arts Gallery, University of Cincinnati, Ohio
1982 "The Long Island Collections, a Century of Art 1880–1980," Nassau County Museum of Fine Art, Roslyn, N.Y.
 "Still Life/Interiors," Contemporary Art Center, New Orleans, La.
1983 "Toys," Greenville County Museum of Art, S.C.
1983–85 "American Art: Post–World War II Painting and Sculp-ture from the Solomon R. Guggenheim Museum," Birming-ham Museum of Art, Ala.
1987 "Collector's Choice," Philbrook Art Center, Inc., Tulsa, Okla.
 "Directions in American Realism," Fort Wayne Museum of Art, Ind.
 "Realism: The New Generation," R. H. Love Modern, Chicago, Ill.
 "Toys," Gallery Henoch, New York
1987–88 "Abstraction, Non-Objectivity and Realism: Twentieth-Century Paintings from the Solomon R. Guggenheim Muse-um," Picker Art Gallery, Colgate University, Hamilton, N.Y.
1989 "Oklahoma Artists: Centennial Exhibition," Charles B. God-dard Center for Visual and Performing Arts, Ardmore, Okla.
1990 "The 80s: A Post Pop Generation," Southern Alleghenies Museum of Art, Loretto, Pa.
 "Spotlight on Oklahoma: 11 Oklahoma Artists," Oklahoma City Art Museum

ARTICLES
Yoskowitz, Robert. "Review." *Arts,* Jan. 1981, p. 31.
Colby, Joy Hakanson. "New Realism Wins with Its Eye Appeal." *The Detroit News,* Dec. 23, 1984, p. 4E.
Jensen, Dean. "Collection by Pieper: Art for Business' Sake." *Mil-waukee Sentinel,* Mar. 13, 1984, part 4, pp. 1, 7, ill.
Perreault, John. "Charles Bell." *Antique Toy World* (Chicago) 14, no. 1, Jan. 1984, cover ill., pp. 8–12, ill.
Soutif, Daniel. "Pictures and an Exhibition." *Artforum Internation-al,* Mar. 1991, ill. p. 88.

CATALOGUES
Perreault, John. *Charles Bell: Marbles and Toys.* Louis K. Meisel Gallery, New York, 1983.
Binai, Paul. Foreword to *The 80s: A Post Pop Generation.* Southern Alleghenies Museum of Art, Loretto, Pa., 1990.

BOOKS
Geldzahler, Henry. *Charles Bell: The Complete Works 1970–1990.* New York: Harry N. Abrams, Inc., 1991.

TOM BLACKWELL

Born: 1938, Chicago, Ill.
Teaching: 1978, Keene State College, N.H., guest professor, summer
1980, Dartmouth College, Hanover, N.H., artist in residence, fall
1981, University of Arizona, Tucson, artist in residence, March
1985–89, School of Visual Arts, New York

SOLO EXHIBITIONS
1980 Louis K. Meisel Gallery, New York
 "Selected Works, 1970–80," Hopkins Center, Dartmouth College, Hanover, N.H.
1981 University of Arizona Museum of Art, Tucson
1982 Louis K. Meisel Gallery, New York
1985 "New Paintings," The Currier Gallery of Art, Manchester, N.H.
1986 Carlo Lamagna Gallery, New York

GROUP EXHIBITIONS
1982 "Masterworks by Artists of New England," The Currier Gallery of Art, Manchester, N.H.
1983 Hood Museum, Dartmouth College, Hanover, N.H.
 "Recent Acquisitions," The Currier Gallery of Art, Manchester, N.H.
1984 "Watercolors from the Collection," The Currier Gallery of Art, Manchester, N.H.

ARTICLES
Chase, Linda. "Tom Blackwell, 1970–1980." *Arts,* Dec. 1980, pp. 154–55, ill.
Yoskowitz, Robert. "Review." *Arts,* Jan. 1981, p. 31.
Aceti, Diana. "The Fine Art of Photo Realism." *Dodge National Forum* 5, no. 1, 1982, pp. 6–9, ill.
Klien, Ellem Lee. "Tom Blackwell." *Arts,* May 1986.

Raynor, Vivien. "Tom Blackwell." *The New York Times,* May 2, 1986.

"West Coast Art at the End of This Century." *Bijutso Techo* (Tokyo) 43, no. 640, July 1991, p. 80, ill. p. 94.

CATALOGUES

Chase, Linda. *Tom Blackwell: Selected Works 1970–1980.* Museum and Galleries, Hopkins Center, Dartmouth College, Hanover, N.H., 1980.

BOOKS

Finch, Christopher. *American Watercolors.* New York: Abbeville Press Publishers, 1986.

CHUCK CLOSE

Born: 1940, Monroe, Wash.
Education: 1958–62, B.A., University of Seattle
1961, Yale Summer School of Music and Art, Norfolk, Conn.
1962–64, B.F.A., M.F.A., Yale University School of Art and Architecture, New Haven, Conn.
1964–65, Fulbright Grant to Vienna; studied at the Akademie der Bildenen Kunste

SOLO EXHIBITIONS

1980–81 "Close Portraits," retrospective exhibition, The Walker Art Center, Minneapolis, Minn.; traveled to: The Saint Louis Art Museum, Mo.; Museum of Contemporary Art, Chicago, Ill.; The Whitney Museum of American Art, New York

1982 "Chuck Close Photographs," California Museum of Photography, University of California, Riverside; University Art Museum, University of California, Berkeley

1982–83 "Chuck Close: Paperworks," Richard Gray Gallery, Chicago, Ill.; John Stoller Gallery, Minneapolis, Minn.; Jacksonville Art Museum, Fla.; Greenberg Gallery, Saint Louis, Mo.

1983 "Chuck Close: Recent Work," The Pace Gallery, New York

1984–85 "Chuck Close Paper Works," Herbert Palmer Gallery, Los Angeles, Calif.; traveled to: Spokane Center of Art, Cheney, Wash.; Milwaukee Art Museum, Wis.; Northern Illinois University Art Gallery, De Kalb; Columbia Museum, S.C.

1985 "Chuck Close Large Scale Photographs," Fraenkel Gallery, San Francisco, Calif.

"Chuck Close: Photographs," Pace/MacGill Gallery, New York

"Chuck Close: Works on Paper," Contemporary Arts Museum, Houston, Tex.

"Exhibition of Chuck Close," Fuji Television Gallery, Tokyo

1986 "Chuck Close Maquettes," Pace/MacGill Gallery, New York

"Chuck Close: Recent Work," The Pace Gallery, New York

1987 "Chuck Close Drawings 1974–1986," The Pace Gallery, New York

"Chuck Close Polaroids," Aldrich Museum of Contemporary Art, Ridgefield, Conn.

1988 "Chuck Close: New Paintings," The Pace Gallery, New York

1991 "Chuck Close: Recent Paintings," The Pace Gallery, New York

GROUP EXHIBITIONS

1980 "American Figure Painting," The Chrysler Museum, Norfolk, Va.

"American Portraiture Drawings," National Portrait Gallery, Washington, D.C.

"American Realism of the Twentieth Century," Morris Museum of Arts and Sciences, Morristown, N.J.

"The Figurative Tradition and The Whitney Museum of American Art: Paintings and Sculpture from the Permanent Collection," The Whitney Museum of American Art, New York

"Portraits Real and Imagined," Guild Hall Museum, East Hampton, N.Y.

"Printed Art: A View of Two Decades," The Museum of Modern Art, New York

"Self-Portraits: An Exhibition of Art on View at the Seagram Building," New York

1980–81 "American Painting of the Sixties and Seventies," Montgomery Museum of Art, Ala.; traveled to: Museum of Fine Arts, Saint Petersburg, Fla.; Joslyn Art Museum, Omaha, Nebr.; Columbus Museum of Art, Ohio; Colorado Springs Fine Art Center, Colo.; Sierra Nevada Museum of Art, Reno, Nev.

1981 "20 Artists: Yale School of Art 1950–1970," Yale University Art Gallery, New Haven, Conn.

1981–82 "American Prints: Process and Proofs," The Whitney Museum of American Art, New York

"Inside/Out, Self Beyond Likeness," Sullivan Gallery, Newport Harbor Art Museum, Newport Beach, Calif.; traveled to: Portland Art Museum, Oreg.; Joslyn Art Museum, Omaha, Nebr.

"Instant Photography," Stedelijk Museum, Amsterdam

"Photographer as Printmaker: 140 Years of Photographic Printmaking," traveling exhibition organized by the Arts Council of Great Britain: Ferens Art Gallery, Hull; The Cooper Gallery, Barnsley; Castle Museum, Nottingham; The Photographer's Gallery, London

1982 "Great Big Drawings," Hayden Gallery, Massachusetts Institute of Technology, Cambridge

"Homo Sapiens: The Many Images," The Aldrich Museum of Contemporary Art, Ridgefield, Conn.

"The Human Figure," Contemporary Arts Center, New Orleans, La.

"Late 20th-Century Art," Worcester Art Museum, Mass.

"Making Paper," American Craft Museum, New York

"Momentbild: Kunstlerphotographie," Kestner-Gessellschaft, Hanover, Germany

"New American Graphics 2: An Exhibition of Contemporary American Prints," Madison Art Center, University of Wisconsin

"Surveying the Seventies," The Whitney Museum of American Art, Fairfield County Branch, Conn.

1982–83 "Black & White," Leo Castelli Gallery, New York

"New Portraits behind Faces," Dayton Art Institute, Ohio

1983 "Faces since the 50s: A Generation of American Portraiture," Center Gallery, Bucknell University, Lewisburg, Pa.

"New Work, New York," Newcastle Polytechnic Gallery, Newcastle-upon-Tyne, England; traveled to: Harrowgate Gallery, Harrowgate, England

"Photographic Visions by Martha Alf, Chuck Close, Robert Cumming, David Hockney, Robert Rauschenberg, Ed Ruscha," Los Angeles Center for Photographic Studies, Calif.

"Self-Portraits," Linda Farris Gallery, Seattle, Wash.; traveled to: Los Angeles Municipal Art Gallery, Calif.

1984 "Drawings 1974–1984," Hirshhorn Museum and Sculpture Garden, Washington, D.C.

"The First Show: Painting and Sculpture from Eight Collections, 1940–1980," Museum of Contemporary Art, Los Angeles, Calif.

"The Modern Art of the Print: Selections from the Collection of Lois and Michael Torf," Williams College Art Museum, Williamstown, Mass.; traveled to: Museum of Fine Arts, Boston, Mass.

"Paper Transformed—A National Exhibition of Paper Art," Turman Gallery, Indiana State University, Terre Haute

1985 "Self-Portrait Today," The Museum of Modern Art, Saitama, Japan

"Workshop Experiments: Clay, Paper, Fabric, Glass," Brattleboro Museum and Art Center, Vt.

1985–86 "Self Portrait: The Photographer's Persona, 1840–1985," The Museum of Modern Art, New York

1986 "An American Renaissance: Painting and Sculpture since 1940," Museum of Art, Fort Lauderdale, Fla.

"Big and Small," Israel Museum, Jerusalem

"The Changing Likeness: Twentieth-Century Portrait Drawings," The Whitney Museum of American Art at Philip Morris, New York

"Contemporary Work from the Pace Gallery," Moody Gallery of Art, University of Alabama, Tuscaloosa

"New Etchings," Pace Editions, New York

"Nude, Naked, Stripped," Hayden Gallery, Massachusetts Institute of Technology, Cambridge, Mass.

"The Real Big Picture," The Queens Museum, New York

"70s into 80s," Museum of Fine Arts, Boston, Mass.

"Viewpoint: The Artist as Photographer," Summit Art Center, N.J.

1987 "The Monumental Image," Sonoma University, Calif.

1988 "Made in the 60s: Painting and Sculpture from the Permanent Collection of the Whitney," Whitney Museum of American Art, Downtown Branch at Federal Reserve Plaza, New York

"1988, the World of Art Today," Milwaukee Art Museum, Wis.

1988–89 "Identity: Representation of the Self," The Whitney Museum of American Art, Downtown Branch at Federal Reserve Plaza, New York

1989 "The Face," The Arkansas Arts Center, Little Rock

"Field and Frame: Meyer Shapiro's Semiotics of Painting," New York Studio School, New York

1990 "The Humanist Icon," Bayly Art Museum, University of Virginia, Charlottesville; The New York Academy of Art, New York; Edwin A. Ulrich Museum of Art, Wichita State University, Kans.

ARTICLES

Bourdon, David. "Chuck Close: Portraits." *Vogue,* Jan. 1980, p. 27.

Cavaliere, Barbara. "Art Reviews—Chuck Close." *Arts* 54, no. 6, Feb. 1980, p. 33.

Diamonstein, Barbaralee. "Chuck Close: I'm Some Kind of a Slow Motion Cornball." *ARTnews* 79, no. 6, Summer 1980, pp. 112–16.

Kertess, Klaus. "Figuring It Out." *Artforum* 19, no. 3, Nov. 1980, pp. 30–35.

Schwartz, Ellen. "New York Reviews: Chuck Close at Pace." *ARTnews* 79, no. 1, Jan. 1980, p. 157.

Simon, Joan. "Close Encounters." *Art in America* 68, no. 2, Feb. 1980, pp. 81–83.

Bass, Ruth. "New York Reviews—Chuck Close (The Whitney Museum of American Art)." *ARTnews* 80, no. 9, Nov. 1981, p. 189.

Canaday, John. "Painters Who Put the World in Focus." *Smithsonian,* Oct. 1981, pp. 68–77.

Casademont, Joan. "Close Portraits." *Artforum* 20, no. 2, Oct. 1981, p. 74.

Glueck, Grace. "Artist Chuck Close: I Wanted to Make Images That Knock Your Socks Off!" *The New York Times,* June 10, 1981.

Goodyear, Frank H., Jr. "American Realism since 1960: Beyond the Perfect Green Pea." *Portfolio,* Nov./Dec. 1981, pp. 72–81.

Hoelterhoff, Manuela. "Close-Ups by Close." *The Wall Street Journal,* Apr. 17, 1981.

Hughes, Robert. "Close, Closer, Closest." *Time,* Apr. 27, 1981, p. 60.

Kramer, Hilton. "Chuck Close's Break with Photography." *The New York Times,* Apr. 19, 1981.

———. "Portraiture: The Living Art." *Bazaar* 3232, Mar. 1981, pp. 14, 28.

McClain, Matthew. "Realist Blockbuster Stirs Controversy: Interview with Curator Frank Goodyear." *The New Art Examiner,* Dec. 1981, pp. 7–27.

Perreault, John. "Encounters of the Close Kind." *The SoHo Weekly News,* Apr. 29, 1981.

Wallach, Amei. "Looking Closer at Chuck Close." *Newsday,* Apr. 19, 1981.

Wilson, William. "The Chilly Charms of Close." *Los Angeles Times,* June 8, 1981.

Wolff, Theodore F. "Huge, Photographically Exact Paintings of Faces That Signify . . . What?" *Christian Science Monitor* (West ed.), Apr. 29, 1981.

Cebulski, Frank. "Close to Photography." *Artweek,* Apr. 17, 1982.

Baker, Kenneth. "Leaving His Fingerprints." *Christian Science Monitor,* Aug. 12, 1983.

Cottingham, Jane. "An Interview with Chuck Close." *American Artist,* May 1983, pp. 62–67, 102–5.

Danoff, I. Michael. "Chuck Close's Linda." *Arts* 57, no. 5, Jan. 1983, pp. 110–111.

Peters, Lisa. "Reviews: Chuck Close." *Arts* 57, no. 9, May 1983, p. 52.

Sandback, Amy Baker, and Ingrid Sischy. "A Progression of Chuck Close: Who's Afraid of Photography?" *Artforum* 22, no. 9, May 1984, p. 50.

Grundberg, Andy. "Chuck Close at Pace/MacGill." *Art in America* 73, no. 5, May 1985, p. 174.

Hagen, Charles. "Chuck Close/Pace/MacGill." *Artforum* 23, no. 8, Apr. 1985, pp. 96–97.

Hartman, Rose. "Close Encounters." *American Photographer* 14, no. 4, Apr. 1985, p. 8.

Jordon, Jim. "A Question of Scale." *Artweek,* July 13, 1985, p. 10.

Close, Chuck. "New York in the Eighties: A Symposium." *The New Criterion,* Summer 1986, pp. 12–14.

Davis, Douglas. "The Return of the Nude." *Newsweek,* Sept. 1, 1986, pp. 78–79.

Grundberg, Andy. "A Big Show That's about Something Larger Than Style." *The New York Times,* Feb. 23, 1986.

Poirier, Maurice. "Chuck Close." *ARTnews* 85, no. 5, May 1986, p. 127.

Raynor, Vivien. "Chuck Close." *The New York Times,* Feb. 28, 1986.

Close, Chuck. "New York Studio Events (excerpts from 1982 studio talk by the artist)." *Independent Curators Incorporated Newsletter,* Fall 1987.

Johnson, Ken. "Photographs by Chuck Close." *Arts,* May 1987, pp. 20–23.

McGill, Douglas C. "Art People: (A Life Saving Metier)." *The New York Times,* Oct. 23, 1987.

Daxland, John. "Up Close and Personal." *The Daily News* (New York), Oct. 1, 1988.

Grundberg, Andy. "Blurring the Lines—Dots?—Between Camera and Brush." *The New York Times,* Oct. 16, 1988.

Kimmelman, Michael. "Chuck Close" (review). *The New York Times,* Oct. 7, 1988.

Lyon, Christopher. "Chuck Close." *ARTnews,* Dec. 1988.

"Pop to Neo Geo and Beyond." *Bijutsu Techo* (Tokyo), Oct. 1988.

Finch, Christopher. "Color Close-Ups." *Art in America,* Mar. 1989, pp. 113–14, 118, 161.

Goldring, Nancy. "Identity: Representations of the Self." *Arts,* Mar. 1989.

Hixson, Kathryn. "Chuck Close." *Arts,* May 1989.

McKenzie, Michael. "The Continuing History of Photography, the Next 150 Years," *Sunstorm,* Dec. 1989.

Nesbitt, Lois. "Chuck Close." *Artforum,* Jan. 1989.

Raven, Arlene. "I to Eye." *The Village Voice,* Jan. 31, 1989.

Westfall, Stephen. "Chuck Close." *Flash Art,* Jan./Feb. 1989.

Woodward, Richard. "Documenting an Outbreak of Self-Presentation." *The New York Times,* Jan. 22, 1989.

Canogar, Daniel. "Five Minutes of Glory." *Lapiz,* Feb. 1990.

Close, Chuck. "Transcending Prejudice: An Inside Look at Peer Review." *Vantage Point,* Spring 1990.

Twardy, Chuck. "An Eye for Art." *The Orlando Sentinel,* Feb. 25, 1990.

CATALOGUES

Castleman, Riva. *Printed Art: A View of Two Decades.* Museum of Modern Art, New York, 1980.

Gelburd, Gail. *American Realism of the 20th Century.* Morris Museum of the Arts and Sciences, Morristown, N.J., 1980.

Kalan, Mitchell D. *American Painting of the Sixties and Seventies.* Montgomery Museum of Fine Arts, Ala., 1980.

Lyons, Lisa, and Mart Friedman. *Close Portraits.* Walker Art Center, Minneapolis, Minn., 1980.

Sadik, Marvin, and Harold Francis Phister. *American Portrait Drawings.* National Portrait Gallery, Washington, D.C., 1980.

Spaeth, Eloise. *Portraits, Real and Imagined.* Guild Hall Museum, East Hampton, N.Y., 1980.

Badger, Gerry. *Photographer as Printmaker: 140 Years of Photographic Printmaking.* Belmont Press Arts Council of Great Britain, Northampton, 1981.

Barents, Els. *Instant Fotographie.* The Stedelijk Museum, Amsterdam, 1981.

Gomwell, Lynn, and Victoria Kogan. *Inside/Out: Self beyond Likeness.* Newport Harbor Art Museum, Newport Beach, Calif., 1981.

Shestack, Alan, and André Forge. *20 Artists: Yale School of Art 1950–1970.* Yale University Art Gallery, New Haven, Conn., 1981.

Goldman, Judith. *American Prints: Process and Proofs.* The Whit-

ney Museum of American Art, New York, in association with Harper & Row Publishers, New York, 1982.

Haenlein, Carl. *Momentbuild: Kunstler Photographie*. Kestner Gesellschaft, Hanover, Germany, 1982.

Monett, Alexandra. *The Human Figure*. The Contemporary Arts Center, New Orleans, La., 1982.

Phillips, Lisa. *Surveying the Seventies*. The Whitney Museum of American Art, Fairfield County Branch, Conn., 1982.

Houk, Pamela. *New Portraits: Behind Faces*. The Dayton Art Institute, Ohio, 1983.

Jacobs, Joseph. *Faces since the 50s: A Generation of American Portraiture*. Center Gallery, Bucknell University, Lewisburg, Pa., 1983.

Perreault, John. *Chuck Close*. The Pace Gallery, New York, 1983.

Brown, Julia, and Bridget Johnson, eds. *The First Show: Painting and Sculpture from Eight Collections*. Museum of Contemporary Art, Los Angeles, Calif., in association with Arts Publishers, Inc., New York, 1984.

Gettings, Frank. *Drawings 1974–1984*. Foreword by Abraham Lerner. Smithsonian Institution, Hirshhorn Museum and Sculpture Garden, Washington, D.C., 1984.

Exhibition of Chuck Close. Fuji Television Gallery, Tokyo, 1985.

Pillsbury, Edmund p. *Chuck Close: Works on Paper*. Contemporary Arts Museum, Houston, Tex., 1985.

Taylor, Susan. *Workshop Experiments: Clay, Paper, Fabric, Glass*. Foreword by Alison Devine. Brattleboro Museum and Art Center, Vt., 1985.

Cummings, Paul. *The Changing Likeness: Twentieth-Century Portrait Drawings*. The Whitney Museum of American Art at Philip Morris, New York, 1986.

Friis-Hansen, Dana. *Nude, Naked, Stripped*. Hayden Gallery, List Visual Art Center, Massachusetts Institute of Technology, Boston, 1986.

Glimcher, Arnold. *Chuck Close: Recent Work* (interview). The Pace Gallery, New York, 1986.

Heiferman, Marvin. *The Real Big Picture*. The Queens Museum of New York, 1986.

Heiting, Manfred, Gert Koshofer, and Hans Staubach. *50 Years of Modern Color Photography*. Photokina, Cologne, Germany, Sept. 1986.

Hunter, Sam., ed. *An American Renaissance: Painting and Sculpture since 1940*. Museum of Art, Fort Lauderdale, Fla., 1986.

Bowman, Russell. *1988, the World of Art Today*. Milwaukee Art Museum, Wis., 1988.

Kertess, Klaus. *Chuck Close, New Paintings*. The Pace Gallery, New York, 1988.

Wolfe, Townsend. *The Face*. The Arkansas Arts Center, Little Rock, 1989.

Schjeldahl, Peter. *Chuck Close: Recent Paintings*. The Pace Gallery, New York, 1991.

BOOKS

Hills, Patricia, and Roberta K. Tarbell. *The Figurative Tradition and The Whitney Museum of American Art*. New York: The Whitney Museum of American Art, in association with the University of Delaware Press, Newark, 1980.

Johnson, Ellen H., ed. *American Prints and Printmakers*. New York: Doubleday and Co., 1980.

Vogt, Paul. *Contemporary Painting*. New York: Harry N. Abrams, Inc., 1981.

Johnson, Ellen H. *American Artists on Art from 1940 to 1980*. New York: Harper & Row, 1982.

Oldenburg, Richard E. *The Museum of Modern Art: The History of the Collection*. New York: Harry N. Abrams, Inc., 1984.

Billeter, Erika. *Das Selbstportrait*. Lausanne, Switzerland: Musée Cantonal des Beaux-Arts, 1985.

Kramer, Hilton. *The Revenge of the Philistines: Art and Culture, 1972–1984*. New York: The Free Press, 1985.

Finch, Christopher. *American Watercolors*. New York: Abbeville Press, 1986.

Lyons, Lisa, and Robert Storr. *Chuck Close*. New York: Rizzoli International Publications, Inc., 1987.

DAVIS CONE

Born: 1950, Augusta, Ga.
Education: 1968–72, B.A., Mercer University, Macon, Ga.
1972–73, University of Georgia, Athens

SOLO EXHIBITIONS
1979 O. K. Harris Works of Art, New York
1981 O. K. Harris Works of Art, New York
1982 O. K. Harris Works of Art, New York
1983–84 "Davis Cone: Theater Paintings 1977–1983," Georgia Museum of Art, University of Georgia, Athens; Hunter Museum of Art, Chattanooga, Tenn.
1984 O. K. Harris Works of Art, New York
1988 O. K. Harris Works of Art, New York
1991 O. K. Harris Works of Art, New York

GROUP EXHIBITIONS
1979–80 "Southern Realism," Mississippi Museum of Art, Jackson; traveled to: University of Mississippi Museum, Oxford; Roanoke Fine Arts Center, Va.; Montgomery Museum of Art, Ala.; Pensacola Museum of Art, Fla.
1981 "Visions of New York City: American Paintings, Drawings, and Prints of the Twentieth Century," Tokyo Metropolitan Museum of Art

1985 "Night Lights—19th and 20th Century American Nocturnes," Taft Museum, Cincinnati, Ohio
1987 "Nocturnes and Nightmares," Florida State University Gallery and Museum, Tallahassee
"Urban Visions: The Contemporary Artist and New York," Adelphi University, Garden City, N.Y.
1991 "Get Real," North Miami Center of Contemporary Art, Fla.

ARTICLES
English, John. "Grand Illusions." *Atlanta Weekly* (*Atlanta Journal/Constitution*), Aug. 3, 1980, pp. 16–19, 25.
Kuspit, Donald B. "Southern Realism at the University of Mississippi Museum." *Art in America*, Dec. 1980, p. 156.
Morris, Merrill. "Close-Up: Davis Cone." *Athens* (Ga.) *Observer*, July 8, 1982, p. 4.
Adair, Sally. "Cone Exhibit: One Man Show at Art Museum." *Banner Herald/Daily News* (Athens, Ga.), Oct. 29, 1983, p. 5.
Elmore, Heidi. "Davis Cone Showcases Showplaces." *New Arts Review*, June 1983, pp. 7–8, 15.
Fox, Catherine. "Vanishing Movie Theatres Are Vital in Davis Cone's Realist Paintings." *Atlanta Journal/Constitution*, Nov. 13, 1983, p. 7H.
Kalber, Elaine. "Photo Realist Davis Cone: Exhibit of Theater Paintings Opens at Georgia Museum." *Banner Herald/Daily News* (Athens, Ga.), Oct. 30, 1983, p. 1D.
Shearer, Lee. "The Art of Davis Cone." *Athens* (Ga.) *Observer*, Oct. 27, 1983, pp. 1B–2B.
"Exhibit Opening at Hunter Depicts Vintage Theatres." *Chattanooga Times*, Jan. 13, 1984.
"Photo Realist Cone at Hunter Museum." *Chattanooga News—Free Press*, Jan. 8, 1984, p. 4L.
Findsen, Owen. "Taft Exhibit 'Night Lights' Illuminative, Highly Seductive." *Cincinnati Enquirer*, May 5, 1985, p. F6.
Hamilton, Kendra. "Show Displays Artists' Sense of 'Place.'" *Greenville* (S.C.) *Piedmont*, Aug. 20, 1985.
"The Last Picture Show: The Paintings of Davis Cone" (book review). *American Film*, July/Aug. 1988, pp. 26–31.
Novak, Ralph. "Picks and Pans" (book review). *People*, Oct. 17, 1988.

CATALOGUES
Armstrong, Tom. *Visions of New York City*. Tokyo Metropolitan Museum of Art, 1981.
Chase, Linda. *Davis Cone: Theater Paintings 1977–1983*. Georgia Museum of Art, University of Georgia, Athens, 1983.

BOOKS
Chase, Linda. *Hollywood on Main Street: The Movie House Paintings of Davis Cone*. Woodstock, N.Y.: The Overlook Press, 1988.

ROBERT COTTINGHAM

Born: 1935, Brooklyn, N.Y.
Education: 1959–63, Pratt Institute, Brooklyn, N.Y.
Teaching: 1969–70, Art Center College of Design, Los Angeles, Calif.

SOLO EXHIBITIONS
1980 Ball State University, Muncie, Ind.
Carlson Gallery, University of Bridgeport, Conn.
Madison Art Center, Wis.
Thomas Segal Gallery, Boston, Mass.
1981 Fendrick Gallery, Washington, D.C.
Mattatuck Museum, Waterbury, Conn.
Swain School of Design, New Bedford, Mass.
1982 Coe Kerr Gallery, New York
1983 "Robert Cottingham: The Complete Prints," Modernism, San Francisco, Calif.
"The Photo-Realist Statement: Recent Paintings by Robert Cottingham," Wichita Art Museum, Kans.
Signet Arts, Saint Louis, Mo.
1984 Fendrick Gallery, Washington, D.C.
Coe Kerr Gallery, New York
Palace Theater—Inaugural Exhibition, New Haven, Conn.
Springfield Art Museum, Mo.
1985 "Robert Cottingham—Photorealist Painter, Printmaker," The Art Guild, Farmington, Conn.
Roger Ramsay Gallery, Chicago, Ill.
Reynolda House Museum of American Art, Winston-Salem, N.C.
Virginia Shore Art Gallery, Abilene Christian University, Tex.
1985–86 "Barrera-Rosa's, Robert Cottingham," traveling exhibition: The Arkansas Arts Center, Little Rock; Fendrick Gallery, Washington, D.C.; Washington University, Saint Louis, Mo.; Art Institute for the Permian Basin, Odessa, Tex.
1986 "Robert Cottingham—Photorealism," The Museum of Art, Science, and Industry, Bridgeport, Conn.
Gallery Karl Oskar, Westwood Hills, Kans.
Signet Arts, Saint Louis, Mo.
1986–91 "Robert Cottingham—A Print Retrospective, 1972–1986," traveling exhibition: Springfield Art Museum, Mo.; Hunter Museum of Art, Chattanooga, Tenn.; Nelson-Atkins Museum of Art, Kansas City, Mo.; Spiva Art Center, Joplin, Mo.; Museum of Art, University of Oklahoma, Norman; Cedar Rapids Museum of Art, Iowa; Bucknell University, Center Gallery, Lewisburg, Pa.; Davidson Art Center, Wesleyan University, Middletown, Conn.; Muscarelle Museum of Art, College of William and Mary, Williamsburg, Va.; Herbert F.

Johnson Museum of Art, Cornell University, Ithaca, N.Y.; Paine Art Center and Arboretum, Oshkosh, Wis.; Rahr-West Art Museum, Manitowoc, Wis.; Lyman Allyn Art Museum, New London, Conn.
1987 Gimpel and Weitzenhoffer, New York
Union Station, Hartford, Conn.; permanent public installation of 12 enamel panels depicting American railroad imagery
1988 Fendrick Gallery, Washington, D.C.
Roger Ramsay Gallery, Chicago, Ill.
1989 Fendrick Gallery, Washington, D.C.
Gimpel and Weitzenhoffer, New York
1990 "Robert Cottingham—Rolling Stock Series," Marisa Del Re Gallery, New York
Roger Ramsay Gallery, Chicago, Ill.
1991 Harcourts Modern and Contemporary Art, San Francisco, Calif.

GROUP EXHIBITIONS
1980 "New York—The Artists' View," Hirshhorn Museum and Sculpture Garden, Washington, D.C.
1981–82 "Realist Drawings, Watercolors, and Paper: Contemporary American Works on Paper," Gross McCleaf Gallery, Philadelphia, Pa.
1982 "Painter as Photographer," British Art Council traveling exhibition: John Hansard Gallery, Southampton; Wolverhampton Art Gallery; Museum of Modern Art, Oxford; Royal Albert Memorial Museum, Exeter; University Art Gallery, Nottingham; Camden Arts Center, London; Windsor Castle; National Museum of Photography, Film, and Television, Bradford
"Photorealism Revisited," Molly Barnes Gallery, Los Angeles, Calif.
"The Herbert W. Plimton Collection of Realist Art," Rose Art Museum, Brandeis University, Waltham, Mass.
1983 "A Heritage Renewed: Representational Drawing Today," University Art Museum, University of California, Santa Barbara; Oklahoma Art Center, Oklahoma City; Elvehjem Museum of Art, Madison, Wis.; Colorado Springs Fine Arts Center, Colo.
1984–85 "American Art since 1970: Painting, Sculpture, and Drawings from the Collection of The Whitney Museum of American Art, New York," traveling exhibition: La Jolla Museum of Contemporary Art, Calif.; Museo Tamayo, Mexico City; North Carolina Museum of Arts, Raleigh; Sheldon Memorial Art Gallery, University of Nebraska, Lincoln; Center for the Fine Arts, Miami, Fla.
1984 "On 42nd Street: Artists' Visions," Whitney Museum of American Art at Philip Morris, New York
1986 "Familiar Reality," The Arkansas Arts Center, Little Rock; traveling exhibition
"Interiors and Exteriors: Contemporary Realist Prints," Yale University Art Gallery, New Haven, Conn.
1987 "Close Focus: Prints, Drawings, and Photographs," National Museum of American Art (Smithsonian Institution), Washington, D.C.
1991 "Double Takes on the Photoreal," Whitney Museum of American Art, Fairfield County, Stamford, Conn.

CATALOGUES
Goodyear, Frank H., Jr. *Robert Cottingham—New Works*. Coe Kerr Gallery, New York, 1982.
On 42nd Street: Artists' Visions. Whitney Museum of American Art at Philip Morris, New York, 1984.
Arthur, John. *Robert Cottingham—A Print Retrospective 1972–1986* (catalogue raisonné). Springfield Art Museum, Mo., 1986.
Zimmer, William. *Robert Cottingham: The Rolling Stock Series*. Marisa del Re Gallery, New York, 1990.
Eliasoph, Philip. *Robert Cottingham: The Rolling Stock Series—Works on Paper, May 1991*. Harcourts Modern and Contemporary Art, San Francisco, Calif., 1991.

RANDY DUDLEY

Born: 1950, Peoria, Ill.
Education: 1973, B.S., Illinois State University, Normal
1976, M.F.A., Virginia Commonwealth University, Richmond

SOLO EXHIBITIONS
1980 O. K. Harris Works of Art, New York
1983 O. K. Harris Works of Art, New York
1985 O. K. Harris Works of Art, New York
1987 O. K. Harris Works of Art, New York
1988 Roger Ramsay Gallery, Chicago, Ill.
1989 O. K. Harris Works of Art, New York
1992 O. K. Harris Works of Art, New York

DON EDDY

Born: 1944, Long Beach, Calif.
Education: 1967, B.F.A., University of Hawaii, Honolulu
1969, M.F.A., University of Hawaii, Honolulu
1969–70, University of California, Santa Barbara

SOLO EXHIBITIONS
1982 University of Hawaii at Manoa, Honolulu
1983 Nancy Hoffman Gallery, New York

1986 Nancy Hoffman Gallery, New York
1990 Nancy Hoffman Gallery, New York

GROUP EXHIBITIONS
1980 "Objects in Contemporary Still-Life," Goddard-Riverside Community Center, New York
"Words and Numbers," Summit Art Center, N.J.
1983 "Toys R Art," Greenville County Museum of Art, S.C.
1984 "A Feast for the Eyes," Museum of Modern Art, New York
"Visions of Childhood: A Contemporary Iconography," The Whitney Museum of American Art, New York
1989–91 "At the Water's Edge: 19th and 20th Century American Beach Scenes," traveling exhibition: Tampa Museum of Art, Fla.; Center for the Arts, Vero Beach, Fla.; Virginia Beach Center for the Arts, Va.; The Arkansas Arts Center, Little Rock

ARTICLES
Bourdon, David. "Art: Reflection of Infinity, Painters Explore the Limits of Vision." *Architectural Digest*, Apr. 1980.
Raynor, Vivien. "Art: A Show That Requires Reading Too." *The New York Times*, Mar. 23, 1980.
Carr, Gerald L. "New Paintings by Don Eddy." *Arts*, Nov. 1983.
Urban, William. "Interview: Don Eddy." *Airbrush Digest*, July/Aug. 1984, pp. 16–23.
Martin, Alvin. "Spaces of the Mind: New Paintings by Don Eddy." *Arts*, Feb. 1987, pp. 22–23.

CATALOGUES
Don Eddy. Nancy Hoffman Gallery, New York, 1986.
Lynes, Russell, William H. Gerdts, and Donald B. Kuspit. *At the Water's Edge: 19th and 20th Century American Beach Scenes.* Tampa Museum of Art, Fla., 1989.

RICHARD ESTES

Born: 1932, Kewanee, Ill.

SOLO EXHIBITIONS
1983 Allan Stone Gallery, New York
1985 Louis K. Meisel Gallery, New York
1990 "Richard Estes: The Complete Prints and the Japan Paintings," Sert Gallery, Carpenter Center for the Visual Arts, Harvard University, Cambridge, Mass.
"Richard Estes 1990," traveling exhibition, Japan: Isetan Museum, Tokyo; The Museum of Art, Kintetsu, Osaka; Hiroshima City Museum of Contemporary Art
1991 "Richard Estes: Urban Landscapes," Portland Museum of Art, Maine

GROUP EXHIBITIONS
1983 "Modern Art in the West," Tokyo Metropolitan Museum of Art
1984 "On 42nd Street: Artists' Visions," Whitney Museum of American Art at Philip Morris, New York
"Andrew Wyeth: A Trojan Horse Modernist," Greenville County Museum of Art, S.C.
1991 "Images in American Art 1960–1990," Southern Alleghenies Museum of Art, Saint Francis College Mall, Loretto, Pa.

ARTICLES
Arthur, John. "Conversations with Richard Estes." *Architectural Digest*, Oct. 1982.
New York, May 13, 1985, ill. p. 40.
Meisel, Louis K. "Richard Estes." *Composición Arquitectónica—Art and Architecture*, Feb. 1990, pp. 5–24.
New York, Nov. 26, 1990, ill. p. 38.
Hurwitz, Laurie S. "Richard Estes: Illusion and Reality." *American Artist*, Dec. 1991, pp. 28–35.

CATALOGUES
Richard Estes: A Decade. Allan Stone Gallery, New York, 1983.
On 42nd Street: Artists' Visions. Whitney Museum of American Art at Philip Morris, New York, 1984.
Arthur, John. Introduction to *Richard Estes.* Traveling exhibition, Japan: Isetan Museum, Tokyo; The Museum of Art, Kintetsu, Osaka; Hiroshima City Museum of Contemporary Art, 1990.

BOOKS
Arthur, John. *Realists at Work: Studio Interviews and Working Methods of 10 Leading Contemporary Painters.* New York: Watson-Guptill, 1983.
Meisel, Louis K., and John Perreault. *Richard Estes: The Complete Paintings 1966–1985.* New York: Harry N. Abrams, Inc., 1986.
Arthur, John. *Spirit of Place: Contemporary Landscape Painting and the American Tradition.* Boston: Bulfinch Press (Little, Brown & Co.), 1989.
Wood, Michael, et al. *Art of the Western World.* New York: Summit Books, 1989.

AUDREY FLACK

Born: 1931, New York
Education: 1951, The Cooper Union, New York
1952, B.F.A., Yale University, New Haven, Conn.

1953, Institute of Fine Arts, New York University
Teaching: 1960–68, Pratt Institute, Brooklyn, N.Y.
1960–68, New York University
1966–67, Riverside Museum Master Institute, New York
1970–74, School of Visual Arts, New York
1975, Albert Dorne Professor, University of Bridgeport, Conn.
1982, Mellon Professor, Cooper Union, New York
1986, Master Workshop, Atlantic Center for the Arts, New Smyrna Beach, Fla.
1987– , National Academy of Design, New York

SOLO EXHIBITIONS
1981 "Audrey Flack: Works on Paper, 1950–1980," Fine Arts Gallery, University of South Florida, Tampa; Art and Cultural Center, Hollywood, Fla.
1982 "Audrey Flack: Drawings and Prints," Gallery Eleven, Tufts University, Medford, Mass.
1983 "Audrey Flack: The Early Years 1953–1968," Armstrong Gallery, New York
Louis K. Meisel Gallery, New York
1984 Hewlett Art Gallery, College of Fine Arts, Carnegie-Mellon University, Schenley Park, Pa.
Tomasulo Gallery, Union College, Cranford, N.J.
1986 "Dye Transfer Photographs and Prints," Atlantic Center for the Arts, New Smyrna Beach, Fla.
1986–88 "Saints and Other Angels: The Religious Paintings of Audrey Flack," traveling exhibition sponsored by The Cooper Union, New York: The Cooper Union, New York; Alexander Brest Museum, Jacksonville University, Fla.; Gallery of Fine Arts, Daytona Beach Community College, Fla.; Philip Johnson Center for the Arts, Muhlenberg College, Allentown, Pa.; The Hoyt L. Sherman Gallery, Ohio State University, Columbus; The College of Wooster Art Museum, Ohio; Charleston Heights Arts Center, Las Vegas, Nev.; Irvine Fine Arts Gallery, University of California; Danforth Museum of Art, Framingham, Mass.
1990 "Civitas," Belk Building, Town Center Mall, Rock Hill, S.C.
1991 "Audrey Flack: Islandia, Goddess of the Healing Waters," The Parrish Art Museum, Southampton, N.Y.
"A Pantheon of Female Deities," Louis K. Meisel Gallery, New York
1992–93 "Breaking the Rules—A Retrospective 1950–1990," traveling exhibition: Wight Art Gallery, University of California, Los Angeles; Butler Institute of American Art, Youngstown, Ohio; National Museum of Women in the Arts, Washington, D.C.; The J. B. Speed Art Museum, Louisville, Ky.

GROUP EXHIBITIONS
1980 "Still Life: A Collection of Contemporary Paintings," Kent State University, Ohio
1980–82 "Art in Our Time," HHK Foundation for Contemporary Art, Inc., Milwaukee, Wis.; traveled to Milwaukee Art Museum, Wis.; Contemporary Arts Center, Cincinnati, Ohio; Columbus Museum of Art, Ohio; Virginia Museum of Fine Arts, Richmond; Krannert Art Museum, University of Illinois, Champaign; High Museum of Art, Atlanta, Ga.; University of Iowa Museum of Art, Iowa City; Brooks Memorial Art Gallery, Memphis, Tenn.; University Art Museum, University of Texas, Austin
1981 "Distinguished Graduates," Yale University, New Haven, Conn.
1981–83 "Deja Vu: Masterpieces Updated," Western Association of Art Museums traveling exhibition: El Paso Museum of Art, Tex.; Cheney Cowles Memorial Museum, Spokane, Wash.; Arapaho Community College, Littleton, Colo.; Roanoke Fine Arts Center, Va.; Colorado State University, Ft. Collins; Dayton Art Institute, Ohio; Pacific Union College Art Gallery, Angwin, Calif.; Art Center, Inc., South Bend, Ind.; Beaumont Art Museum, Tex.; University of Hawaii, Honolulu; Santa Fe Community College Art Gallery, N.Mex.; Bass Museum, Miami Beach, Fla.; The Fine Arts Center, Nashville, Tenn.
1982 "Cranbrook U.S.A., 15 Artists' Painting and Sculpture" (alumni show), Cranbrook Academy of Art Museum, Bloomfield Hills, Mich.
1983–84 "American Still Life: 1945–1983," traveling exhibition: Contemporary Arts Museum, Houston, Tex.; Albright-Knox Art Gallery, Buffalo, N.Y.; Columbus Museum of Art, Ohio; Neuberger Museum, State University of New York, Purchase; Portland Art Museum, Oreg.
1984 "Major Contemporary Women Artists: In Celebration of Simone de Beauvoir," Suzanne Gruss Gallery, Philadelphia, Pa.
1984–85 "Nine Realist Painters Revisited: 1963–1984," Robert Schoelkopf Gallery, New York
1986 "The Figure in 20th Century American Art—Selections from The Metropolitan Museum of Art," Colorado Springs Fine Arts Center, Colo.
"Sacred Images in Secular Art," The Whitney Museum of American Art, New York
1988 "Classical Myth and Imagery in Contemporary Art," The Queens Museum, Flushing, N.Y.
"This Was Pratt: Former Faculty Centennial Exhibition," Pratt Manhattan Gallery, New York; Schafler Gallery, Pratt Institute, Brooklyn, N.Y.
1989 "Making Their Mark: Women Artists Today," traveling exhibition: Cincinnati Art Museum, Ohio; New Orleans Museum of Art, La.; Denver Art Museum, Colo.; Pennsylvania Academy of the Fine Arts, Philadelphia

1990 "Images of Death in Contemporary Art," Haggerty Museum of Art, Marquette University, Milwaukee, Wis.
1991–92 "New Viewpoints: Contemporary American Women Realists," Seville Expo '92, Spain, Consular Residence, Main Salon

ARTICLES
Bourdon, David. "Made in U.S.A." *Portfolio*, Nov.–Dec. 1980, pp. 45–47.
Flack, Audrey. "On Carlo Crivelli." *Arts*, June 1981, pp. 92–95.
"On Audrey Flack." *Arts*, June 1981, pp. 96–97.
Kohen, Helen C. "Shutterbug Superrealism: Flack's Photo Images Strike Familiar Chord." *The Miami Herald*, Mar. 8, 1981.
Kotrozo, Donnell C. "Women and Art." *Arts*, Mar. 1981, p. 11.
Rodriguez, Milani Joanne. "Audrey Flack, Mistress of Manipulation." *The Tampa Tribune*, Jan. 29, 1981.
Bourdon, David. "Contemporary Still Life Painting." *America Illustrated*, Nov. 1982, pp. 20–27, ill. 24–25.
Colby, Joy Hakanson. "The Cranbrook 15 Return in High Style." *The Detroit News*, Feb. 7, 1982, p. 4E.
Delatiner, Barbara. "Art to Read As Well As See." *The New York Times*, July 4, 1982.
Tannenbaum, Barbara. "Audrey Flack on Painting" (book review). *Women's Art Journal*, Spring/Summer 1982.
Tomkins, Calvin. "The Art World: The Truth of Appearances." *The New Yorker*, Sept. 5–11, 1982, pp. 103–8.
"Creative Women in New York." *Cordier Essence*, Fall 1983, pp. 34–35.
Gouma-Peterson, Thalia. "Icons of Healing Energy: The Recent Work of Audrey Flack." *Arts*, Nov. 1983, cover ill., pp. 136–41, ill.
Russell, John. Review. *The New York Times*, Nov. 11, 1983.
Urban, William. "Audrey Flack—An Interview." *Airbrush Digest*, Sept./Oct. 1983, cover ill., pp. 12–17, 49–55, ill.
Bass, Ruth. "Audrey Flack." *ARTnews* 83, no. 1, Jan. 1984, p. 149, ill.
Gibson, Eric. "American Still Life." *The New Criterion* 3, no. 2, Oct. 1984, pp. 70–75.
Henry, Gerrit. "Audrey Flack at Meisel." *Art in America* 72, no. 4, Apr. 1984, p. 186, ill. p. 184.
Miller, Donald. "Flack's Realism Is Intense." *Pittsburgh Post-Gazette*, Feb. 11, 1984, p. 22.
Dalphonse, Sherri. "Artist Audrey Flack Sees Too Much Flack in the Art World Today, and Proposes Taking a Little Bit Out by Having Art Go Unsigned." *Hamptons* (newspaper/magazine), July 25, 1985, p. 10.
Hall, Jacqueline. "Works by Flack Express Her Religious Convictions." *The Columbus* (Ohio) *Dispatch*, Sept. 1987.
Martin, Judy Wells. "Saints and Other Angels—Jacksonville University Exhibits Religious Art of Audrey Flack." *Times-Union/Journal* (Fla.), Jan. 31, 1987, p. 6.
"Angels Take Wing at Danforth." *The Middlesex News* (Boston, Mass.), Apr. 19, 1988.
Day, Meredith Fife. "Up Close and Spiritual—The Accessible Saints of Audrey Flack." *The Middlesex News* (Boston, Mass.), May 13, 1988, pp. 1C, 4C, ill.
Garfield, Ken. "Artist Falls in Love with Rock Hill." *The York Observer* (York County, S.C.), July 24, 1988.
Handal, Chris. "Gateway Plaza with Sculptures to 'Set Tone for City.'" *The Herald* (Rock Hill, S.C.), July 12, 1988, pp. 1A, 7A.
Larson, Kay. "An Artist's Sense and Sensibility." *Architectural Digest*, Mar. 1988.
Polak, Maralyn Lois. "Audrey Flack—A Firm Grip on Her Art" (interview). *The Philadelphia Inquirer Magazine*, July 17, 1988, pp. 9–10.
Stapen, Nancy. "Religious Art Works Mix Humanity and Spirituality." *The Boston Herald*, June 17, 1988, p. 55, ill.
Taylor, Robert. "Audrey Flack Offers Diverse Layers of Meaning." *The Boston Sunday Globe*, June 26, 1988, p. 91, ill.
Burnham, Sophy. "Portrait of the Artist As a Woman." *New Woman*, June 1990, pp. 94, 96, 99, ill.
Handal, Chris. "'Civitas' a Hit at Unveiling." *The Herald* (Rock Hill, S.C.), Oct. 5, 1990, pp. 1A, 10A.
———. "Statue Sculptor Feels Work Will Draw Notice to City." *The Herald* (Rock Hill, S.C.), Oct. 4, 1990, pp. 1A, 11A.
Nel, François Pierre. "Gateway Sculpture Unveiled." *The York Observer* (York County, S.C.), Oct. 4, 1990, p. 1Y.
Plumb, Terry C. "Monument to the City." *The Herald* (Rock Hill, S.C.), Oct. 4, 1990, p. 10A.
Seawright, Sandy. "Audrey Flack Super Realist." *Break* (Charlotte, N.C.), Oct. 17, 1990, pp. 21–22.
Collins, Amy Fine, and Bradley Collins. "Audrey Flack at Louis K. Meisel" (review). *Art in America*, Nov. 1991, p. 152, ill.
Danto, Arthur C. "Books and the Arts: Our Holiday Lists" (review). *The Nation*, Dec. 30, 1991, pp. 850–51.
Goldowsky, Barbara. "A Welcoming Goddess Greets Museum Visitors." *The Southampton Press* (L.I.), June 6, 1991, ill. p. 22, p. 26.
Hurwitz, Laurie S. "A Bevy of Goddesses—Paintings and Sculptures by Audrey Flack." *American Artist*, Sept. 1991, pp. 40–47, 85–86, ill.
———. "Audrey Flack—Louis K. Meisel Gallery, New York" (review). *Sculpture* 10, no. 6, Nov.–Dec. 1991, pp. 55–56, ill.
Maschal, Richard. "Art with a Purpose—Rock Hill's Gateway Plaza Puts Public Space to Work." *The Charlotte* (S.C.) *Observer*, May 24, 1991, pp. 1F, 4F, ill.
Raven, Arlene. "The Virgin Forest." *The Village Voice*, July 2, 1991, p. 90, ill.

CATALOGUES
Perreault, John. *Art in Our Time.* HHK Foundation for Contemporary Art, Milwaukee, Wis., 1980–82.
Dietrich, Linnea S. *Audrey Flack—Works on Paper, 1950–1980.* College of Fine Arts, University of South Florida, Tampa, 1981.
Cranbrook U.S.A. Cranbrook Academy of Art, Bloomfield Hills, Mich., 1982.
Perreault, John. *Audrey Flack—Light and Energy.* Louis K. Meisel Gallery, New York, 1983.
Sacred Images in Secular Art. Whitney Museum of American Art, New York, 1986.
Sims, Lowery S. *Saints and Other Angels: The Religious Paintings of Audrey Flack.* Traveling exhibition organized by Dominique Mazeaud and The Cooper Union, New York: The Cooper Union, New York; Alexander Brest Museum, Jacksonville University, Fla.; Gallery of Fine Arts, Daytona Beach Community College, Fla.; Philip Johnson Center for the Arts, Muhlenberg College, Allentown, Pa.; The Hoyt L. Sherman Gallery, Ohio State University, Columbus; The College of Wooster Art Museum, Ohio; Charleston Heights Arts Center, Las Vegas, Nev.; Irvine Fine Arts Gallery, University of California; Danforth Museum of Art, Framingham, Mass., 1986–88.
Classical Myth and Imagery in Contemporary Art. The Queens Museum, Flushing, N.Y., 1988.
Civitas. Belk Building, Tower Center Mall, Rock Hill, S.C., 1990.
Casteras, Susan p. *Audrey Flack—A Pantheon of Female Deities.* Louis K. Meisel Gallery, New York, 1991.

BOOKS
Flack, Audrey. *Audrey Flack on Painting.* New York: Harry N. Abrams, Inc., 1981.
Australian National Gallery—An Introduction. Canberra: The Australian National Gallery, 1982.
Johnson, Ellen. *American Artists on Art, 1940–1980.* New York: Harper & Row, 1982.
Rubinstein, Charlotte Streifer. *American Women Artists.* Boston: G. K. Hall & Co., 1982.
Lucie-Smith, Edward. *American Art Now.* New York: William Morrow & Co., Inc., 1985.
Russo, Alexander. *Profiles on Women Artists.* Frederick, Md.: University Publications of America, Inc., 1985.
Flack, Audrey. *Art and Soul.* New York: E. p. Dutton, 1986.
Heller, Nancy G. *Women Artists—An Illustrated History.* New York: Abbeville Press, 1987.
National Museum of Women in the Arts. New York: Harry N. Abrams, Inc., 1987.
Flack, Audrey. *Audrey Flack—The Daily Muse.* New York: Harry N. Abrams, Inc., 1989.
Gadon, Elinor W. *The Once and Future Goddess.* San Francisco: Harper & Row Publishers, 1989.
Rosen, Randy, and Catherine C. Brawer. *Making Their Mark: Women Artists Move into the Mainstream, 1970–85.* New York: Abbeville Press Publishers, 1989.
Greenberg, Jan, and Sandra Jordan. *The Painter's Eye—Learning to Look at Contemporary American Art.* New York: Delacorte Press, 1991.
Wheeler, Daniel. *Art since Mid-Century: 1945 to the Present.* New York: The Vendome Press, 1991.
Gouma-Peterson, Thalia. *Breaking the Rules: Audrey Flack, a Retrospective 1950–1990.* New York: Harry N. Abrams, Inc., 1992.

STEPHEN FOX

Born: 1957, Richmond, Va.
Education: 1980, B.F.A., Virginia Commonwealth University, Richmond

SOLO EXHIBITIONS
1983 Cudahy's Gallery, Richmond, Va.
"Three Plus One," Peninsula Fine Arts Center, Newport News, Va.
1987 O. K. Harris Works of Art, New York
1989 O. K. Harris Works of Art, New York
1992 O. K. Harris Works of Art, New York

FRANZ GERTSCH

Born: 1930, Mörigen, Canton of Bern, Switzerland
Residence: Rüschegg-Heubach, Switzerland
Education: 1947–50, Max von Mühlenen's Painting School, Bern, Switzerland

SOLO EXHIBITIONS
1980 "Franz Gertsch," Kunsthaus, Zurich; Kunstmuseum Hannover mit Sammlung Sprengel
1981–82 "Franz Gertsch—Major Works," Louis K. Meisel Gallery, New York
1983 "Franz Gertsch—Arbeiten 1981/1982/1983," Galerie M. Knoedler, Zurich
1986 "Franz Gertsch—Bilder von 1980–1986," Museum moderner Kunst, Vienna; Kunsthalle Basel
"Franz Gertsch—Johanna II," Kunsthalle Bern
1987 "Franz Gertsch," Louis K. Meisel Gallery, New York
"Die Holzschnitte," Galerie Turske & Turske, Zurich
1988–89 "Farbholzschnitte 1986 bis 1988," Galerie Michael Haas, Berlin

1989 "Bois Gravés Monumentaux," Cabinet des estampes du Musée d'art et d'historie, Geneva; Musée Rath (Musée d'art et d'histoire), Geneva
"Die Holzschnitte," Galerie Friedman-Guinness, Frankfurt
1990 "Die Holzschnitte," Galerie Turske & Turske, Zurich
"Large-Scale Woodcuts," traveling exhibition: Museum of Modern Art, New York; Hirshhorn Museum and Sculpture Garden (Smithsonian Institution), Washington, D.C.; San Jose Museum of Art, Calif.
Louis K. Meisel Gallery, New York
1992 "Franz Gertsch: Gravures sur bois 1986–1991," Galerie Patrick Roy, Lausanne, Switzerland

GROUP EXHIBITIONS
1980 "Printed Art. A View of Two Decades," Museum of Modern Art, New York
1982 "Franz Gertsch and selected works by Friedel Dzubas, Herbert Ferber, Adolph Gottlieb, Nancy Graves, Rolf Iseli, Robert Motherwell, Ludwig Sander, Kimber Smith," Knoedler, Zurich
1985 "Miscellanea—Miscellanées," Kunstmuseum Bern
1987 "Works on Paper," Louis K. Meisel Gallery, New York

ARTICLES
Matta, Marianne. "Gespräch with Franz Gertsch." *Du* (Zurich), May 1980, pp. 73–74, ill.
Borch, Agnes von der. "A Newer Objectivity: Franz Gertsch's Photo-Realist Paintings." *Arts,* Dec. 1981, pp. 154–55, ill.
Rogge, Peter G. "Basel als Kunstmesseplatz." *Der Monat in Finanz und Wirtschaft* (Basel), May 1981, pp. 14–17, ill.
Grundbacher, François. "Der Panther im Dschungel." *Du* (Zurich), July 1982, pp. 58–59.
Grütter, Tina. "Frau als Modell-Facetten zum Thema." *Kunst Nachrichten* (Zurich), Jan. 1985, pp. 27–30, ill.
Acatos, Sylvio. "Au-delà du réel." *Construire (Migros),* Aug. 20, 1986, p. 23.
Dittmar, Peter. "Photo-Realismus: Die Basler Kunsthalle zeigt Gemälde von Franz Gertsch—Alle Augen folgen dem Betrachter." *Die Welt* (Zurich), July 24, 1986, p. 14.
Monteil, Annemarie. "Gesteigerte Wirklichkeiten: Bruce Nauman und Franz Gertsch in Basel." *Die Weltwoche* (Zurich), July 17, 1986.
Zimmermann, Marie-Louise. "Ich versuche, dem Augenblick Beständigkeit zu verleihen." *Berner Zeitung,* Aug. 15, 1986, p. 12.

CATALOGUES
Billeter, Erika, Jean-Christophe Ammann, Joachim Büchner, Evelyn Weiss, and Agnes von der Borch. *Franz Gertsch.* Interview by Jürgen Glaesemer. Kunsthaus Zürich, 1980.
Franz Gertsch (translation of Kunsthaus Zürich catalogue, 1980; appendix to catalogue raisonné). Galerie M. Knoedler, Zurich, 1981.
Ronte, Dieter. *Franz Gertsch—Arbeiten 1981/1982/1983* (postscript no. 2 to Kunsthaus Zürich catalogue, 1980; appendix to catalogue raisonné). Galerie M. Knoedler, Zurich, 1983.
Ammann, Jean-Christophe. *Franz Gertsch—Bilder von 1980–1986.* Museum moderner Kunst, Vienna; Kunsthalle, Basel, 1986.
Franz Gertsch. Farbholzschnitte 1986 bis 1988. Galerie Michael Haas, Berlin, 1988–89.
Mason, Rainer Michael. *Bois gravés monumentaux/Grossfromatige Holzschnitte/Large Scale Woodcuts.* Essay by Dieter Ronte. Cabinet des estampes du Musée d'art et d'histoire, Geneva; Turske & Turske, Zurich, 1989.
Mason, Rainer Michael, Dieter Ronte, and Riva Castleman. *Franz Gertsch: Large Scale Woodcuts.* Cabinet des estampes du Musée d'art et d'histoire, Geneva, 1990.

BOOKS
Ronte, Dieter. *Franz Gertsch.* Essay by Jean-Christophe Ammann. Bern: Benteli Verlag, 1986.

ROBERT GNIEWEK

Born: 1951, Detroit, Mich.
Education: 1973, B.F.A., Wayne State University, Detroit, Mich.
1979, M.A., Wayne State University, Detroit, Mich.

SOLO EXHIBITIONS
1981 "Photo Realist Cityscapes," O. K. Harris West, Scottsdale, Ariz.
1982 Semaphore Gallery, New York
1984 "Photo Realist Cityscapes," O. K. Harris West, Scottsdale, Ariz.
1986 Robert Kidd Gallery, Birmingham, Mich.
1987 "Nocturnal Images," Helander Gallery, Palm Beach, Fla.
1989–90 "Nocturnal Landscapes," Helander Gallery, Palm Beach, Fla.
1990 "Nocturnal Urban Landscapes," Helander Gallery, New York

RALPH GOINGS

Born: 1928, Corning, Calif.
Education: 1953, B.F.A., California College of Arts and Crafts, Oakland
1965, M.F.A., Sacramento State College, Calif.

SOLO EXHIBITIONS
1980 O. K. Harris Works of Art, New York
1983 O. K. Harris Works of Art, New York
1985 O. K. Harris Works of Art, New York
1988 O. K. Harris Works of Art, New York
1991 O. K. Harris Works of Art, New York

GROUP EXHIBITIONS
1983–84 "American Still Life: 1945–1983," traveling exhibition: Contemporary Arts Museum, Houston, Tex.; Albright-Knox Art Gallery, Buffalo, N.Y.; Columbus Museum of Art, Ohio; Neuberger Museum, State University of New York, Purchase; Portland Art Museum, Oreg.
1984–85 "Automobile and Culture," Museum of Contemporary Art, Los Angeles, Calif.; Detroit Institue of Arts, Mich.
1985 "Photorealist Watercolors," Acme Art, San Francisco, Calif.
1987–88 "Painters Manipulate Photography: Goings, Hockney, Warhol," Tampa Museum of Art, Fla.

ARTICLES
Cottingham, Jane. "Techniques of Three Photorealists." *American Artist,* Feb. 1980, pp. 61–65, 95–96.
"Ralph Goings at O. K. Harris Works of Art" (review). *The New York Times,* Mar. 14, 1980.
Karmel, Pepe. "Ralph Goings at O. K. Harris" (review). *Art in America* 68, no. 4, May 1980, pp. 151–52.
"A Classic Theme: The Nude and Nearly Nude—The Lonely Look of American Realism." *Life,* Oct. 1980, pp. 74–82.
"Paris: Richard McLean et Ralf Goings." *Beaux Arts* (Paris), June 1984.
Ratcliff, Carter. "A Photorealist's Farmhouse." *Architectural Digest,* June 1988, pp. 134–39.
Atterberry, Gisele. "Quality Is Common Denominator." *Champaign-Urbana* (Ill.) *News-Gazette,* Feb. 16, 1991, p. C–1.
Kalina, Richard. "Freeze Frame." *Art in America* 80, no. 3, Mar. 1992, pp. 106–9, 137, ill.

BOOKS
Chase, Linda. *Ralph Goings.* New York: Harry N. Abrams, Inc., 1988.

GUS HEINZE

Born: 1926, Bremen, Germany
Education: 1950–51, Art Students League, New York
1958–60, School of Visual Arts, New York

SOLO EXHIBITIONS
1972 The Deecey Gallery, Manchester, Vt.
1973 Gallery 3, Greenwich, Conn.
1976 Far Gallery, New York
1981 William Sawyer Gallery, San Francisco, Calif.
M. Shore and Son Gallery, Santa Barbara, Calif.
1985 Ankrum Gallery, Los Angeles, Calif.
William Sawyer Gallery, San Francisco, Calif.
1988 Modernism, San Francisco, Calif.
1989 Modernism, San Francisco, Calif.
1991 Modernism, San Francisco, Calif.

DON JACOT

Born: 1949, Chicago, Ill.
Education: 1968, Augustana College, Rock Island, Ill.
1971, B.A., University of Illinois, Champaign
1977, B.S., Mercy College of Detroit, Mich.
1985, Wayne State University, Detroit, Mich.

SOLO EXHIBITIONS
1985 "Urban Realism," Xochipilli Gallery, Birmingham, Mich.
1988 "Detroit Landscapes," Xochipilli Gallery, Birmingham, Mich.
1990 "Don Jacot—El Structures," Xochipilli Gallery, Birmingham, Mich.
1991 Louis K. Meisel Gallery, New York

JOHN KACERE

Born: 1920, Walker, Iowa
Education: 1949, B.F.A., University of Iowa, Iowa City
1950, M.F.A., University of Iowa, Iowa City
Teaching: 1950–53, University of Manitoba, Winnipeg, Canada
1953–58, University of Florida, Gainesville
1958–64, The Cooper Union, New York
Parsons School of Design, New York
1964–72, University of New Mexico, Albuquerque
1973–77, New York University
1977, School of Visual Arts, New York

SOLO EXHIBITIONS
1980 O. K. Harris Works of Art, New York
1981 Galerie Jean-Pierre Lavignes, Paris
1982 O. K. Harris Works of Art, New York
1983 Galerie Jean-Pierre Lavignes, Paris
1984 O. K. Harris Works of Art, New York
1987 O. K. Harris Works of Art, New York

1989 O. K. Harris Works of Art, New York
 Galerie Lavignes-Bastille, Paris

ARTICLES
"A Classic Theme: The Nude and Nearly Nude—The Lonely Look of American Realism." *Life,* Oct. 1980, pp. 74–82.
Godard, Agathe. "John Kacere: Tout Me Passionne, les Femmes comme les Cathédrales." *Paris Match,* Nov. 1983, pp. 64–65.

CATALOGUES
John Kacere. Galerie Jean-Pierre Lavignes, Paris, 1981.

BOOKS
Brach, Paul. *John Kacere.* Turin, Italy: Lincoln Publishing—Sonodip/Galerie Lavignes-Bastille, 1989.

RON KLEEMANN

Born: 1937, Bay City, Mich.
Education: 1961, B.S., University of Michigan, College of Architecture and Design

SOLO EXHIBITIONS
1983 Louis K. Meisel Gallery, New York
1985 "Realism: Ron Kleemann," Bay City Council on the Arts, Mich.
1992 Louis K. Meisel Gallery, New York

GROUP EXHIBITIONS
1981–82 "Auto Art," Auto Art, Inc., Interlaken Inn, Lakeland, Conn.
 "Champions: Heroes of American Sport," The National Portrait Gallery, Smithsonian Institution, Washington, D.C.; American Museum of Natural History, New York
1983 "Free Wheeling," Squibb Gallery, Princeton, N.J.
1985 "Starved for Art," School of Visual Arts, New York

ARTICLES
McGee, Gay. "Noted N.Y. Artist Brings Work Back Home." *Bay City* (Mich.) *Times,* June 6, 1985.
Stains, Laurence R. "Hot Cars." *The Christian Science Monitor,* Apr. 15, 1985, p. 34.
Gould, John. "Clang! Clang! Clang!" *The Christian Science Monitor,* Feb. 6, 1987, p. 34, ill.
Watkins, Eileen. "Art." *The Star-Ledger* (Newark, N.J.), Oct. 11, 1991, p. 49.

RICHARD McLEAN

Born: 1934, Hoquiam, Wash.
Education: 1958, B.F.A., California College of Arts and Crafts, Oakland
1962, M.F.A., Mills College, Oakland, Calif.

SOLO EXHIBITIONS
1981 O. K. Harris Works of Art, New York
1983 O. K. Harris Works of Art, New York
1986 O. K. Harris Works of Art, New York
1989 O. K. Harris Works of Art, New York

GROUP EXHIBITIONS
1980 "The Figurative Tradition and The Whitney Museum of American Art: Painting and Sculpture from the Permanent Collection," The Whitney Museum of American Art, New York
 "Photo-Realist Painting in California: A Survey," Santa Barbara Museum of Art
1982 "Northern California Art of the Sixties," De Saisset Museum, University of Santa Clara
 "Northern California Realist Painters," Redding Museum
1983 "Directions in Bay Area Painting—A Survey of Three Decades: 1940s–1960s," Richard L. Nelson Gallery, University of California, Davis
 "Drawings by Fifty California Artists," Modernism, San Francisco
1983–85 "West Coast Realism," Laguna Beach Museum of Art, Calif.; traveled to: Museum of Art, Fort Lauderdale, Fla.; Center for Visual Arts, Illinois State University, Normal; Fresno Art Center, Calif.; Louisiana Arts and Science Center, Baton Rouge; Museum of Art, Bowdoin College, Brunswick, Maine; Colorado Springs Fine Arts Center, Colo.; Spiva Art Center, Joplin, Mo.; Beaumont Art Museum, Tex.; Sierra Nevada Museum of Art, Reno, Nev.; Edison Community College, Fort Meyers, Fla.
1984 "San Francisco Bay Area Painting," Sheldon Memorial Art Gallery, Lincoln, Nebr.
1985 "American Realism," William Sawyer Gallery, San Francisco, Calif.
1988 "Spanish Watercolors: Robert Bechtle and Richard McLean," Wiegand Gallery, Belmont, Calif.

ARTICLES
Northwood, Bill. "They Paint What They See, Not What They Dream." *The Museum of California Magazine: Oakland Museum,* May/June 1982, pp. 13–16.
"Paris: Richard McLean et Ralf Goings." *Beaux Arts* (Paris), June 1984.

CATALOGUES
Lagoria, Georgianna M. *Northern California Art of the Sixties.* De Saisset Museum, University of Santa Clara, Calif., 1982.
Baird, Joseph Armstrong, Jr., ed. *Directions in Bay Area Painting—A Survey of Three Decades: 1940s–1960s.* Richard L. Nelson Gallery, University of California, Davis, 1983.
Gamwell, Lynn. *West Coast Realism.* Laguna Beach Museum of Art, Calif., 1983.
Neubert, George W. *San Francisco Bay Area Painting.* Sheldon Memorial Art Gallery, Lincoln, Nebr., 1984.

BOOKS
Broder, Patricia Janis. *The American West: The Modern Vision.* Boston: Little, Brown & Co., 1984.

JACK MENDENHALL

Born: 1937, Ventura, Calif.
Education: 1968, B.F.A., California College of Arts and Crafts, Oakland
1970, M.F.A., California College of Arts and Crafts, Oakland

SOLO EXHIBITIONS
1981 O. K. Harris Works of Art, New York
1983 O. K. Harris Works of Art, New York
1985 O. K. Harris Works of Art, New York
1988 O. K. Harris Works of Art, New York
1991 O. K. Harris Works of Art, New York

GROUP EXHIBITIONS
1980 "Realism," Walnut Creek Civic Arts Gallery, Calif.
1982 "California Realism," Molly Barnes Gallery, Los Angeles
 "Northern California Realist Painters," Redding Museum
1983–85 "West Coast Realism," Laguna Beach Museum of Art, Calif.; traveled to: Museum of Art, Fort Lauderdale, Fla.; Center for Visual Arts, Illinois State University, Normal; Fresno Art Center, Calif.; Louisiana Arts and Science Center, Baton Rouge; Museum of Art, Bowdoin College, Brunswick, Maine; Colorado Springs Fine Arts Center, Colo.; Spiva Art Center, Joplin, Mo.; Beaumont Art Museum, Tex.; Sierra Nevada Museum of Art, Reno, Nev.; Edison Community College, Fort Meyers, Fla.
1985 "The Real Thing," North Miami Museum and Art Center, Fla.
1990 "Contemporary Realism: Perception and Experience," California College of Arts and Crafts, Oakland
 "Oakland's Artists," The Oakland Museum, Calif.

ARTICLES
Northwood, Bill. "They Paint What They See, Not What They Dream." *The Museum of California Magazine: Oakland Museum,* May/June 1982, pp. 13–16.
Stofflet, Mary. "Contemporary American Realism since 1960." *Southwest Art,* 1982.
Lundegaard, Diane. "Jack Mendenhall at O. K. Harris." *Sunstorm,* Oct./Nov. 1988.

CATALOGUES
Gamwell, Lynn. Introduction to *West Coast Realism.* Laguna Beach Museum of Art, Calif., 1983.

REYNARD MILICI

Born: 1942, Brooklyn, N.Y.
Education: 1967, B.F.A., Hartford Art School, Conn.

SOLO EXHIBITIONS
1980 Arts Exclusive, Simsbury, Conn.
1981 Western New England College, Springfield, Mass.
1987 Arts Exclusive, Simsbury, Conn.
1990 Louis K. Meisel Gallery, New York

DAVID PARRISH

Born: 1939, Birmingham, Ala.
Education: 1957–58, Washington and Lee University, Lexington, Va.
1958–61, B.F.A., University of Alabama, Tuscaloosa

SOLO EXHIBITIONS
1981 Nancy Hoffman Gallery, New York
 "David Parrish," traveling exhibition, Alabama: Birmingham Museum of Art; Huntsville Museum of Art; Montgomery Museum of Fine Arts
1987 Greenville County Museum of Art, S.C.
1990–91 Louis K. Meisel Gallery, New York

GROUP EXHIBITIONS
1980 "Contemporary Paintings in Alabama," Huntsville Museum of Art
1983–85 "Painting in the South: 1564–1980," traveling exhibition: Virginia Museum, Richmond; Birmingham Museum of Art, Ala.; National Academy of Design, New York; Mississippi Museum of Art, Jackson; J. B. Speed Art Museum, Louisville, Ky.; New Orleans Museum of Art, La.

1989 "Expressions and Discoveries," Huntsville Museum of Art, Ala.

ARTICLES
Martin, Ann Marie. "The World of David Parrish—Huntsville Artist Transforms Ordinary Items into Vibrant Images." *The Huntsville* (Ala.) *Times,* May 10, 1989.

CATALOGUES
Kahan, Mitchell D. *David Parrish.* Montgomery Museum of Fine Arts, Ala., 1981.
Meisel, Louis K. *David Parrish—Porcelain Still Life.* Louis K. Meisel Gallery, New York, 1991.

JOHN SALT

Born: 1937, Birmingham, England
Education: 1952–58, National Diploma in Design, Birmingham College of Art, England
1958–60, Diploma in Fine Arts, Slade School of Fine Arts, London
1967–68, Post-graduate scholarship, Birmingham College of Art, England
1969, M.F.A., Maryland Institute College of Art, Baltimore

SOLO EXHIBITIONS
1981 O. K. Harris Works of Art, New York
1986 "John Salt: Paintings 1969–86," Wolverhampton Art Gallery and Museum, England; Bolton Museum and Art Gallery, Lancashire, England
1991 O. K. Harris Works of Art, New York

GROUP EXHIBITIONS
1984–85 "Automobile and Culture," Museum of Contemporary Art, Los Angeles, Calif.; Detroit Institute of Arts, Mich.

ARTICLES
The New Republic, Mar. 15, 1980, cover ill.
Eliasoph, Philip. "America on Wheels: Whitney Show Explores Our Paved-over Paradise." *Southern Connecticut News,* Apr. 8, 1984.

CATALOGUES
Karp, Ivan C. Introduction to *John Salt: Painting 1969–1986.* Wolverhampton Art Gallery and Museum, England; Bolton Museum and Art Gallery, Lancashire, England, 1986

BEN SCHONZEIT

Born: 1942, Brooklyn, N.Y.
Education: 1964, B.F.A., Cooper Union, New York

SOLO EXHIBITIONS
1980 Nancy Hoffman Gallery, New York
 Gibbes Art Gallery, Charleston, S.C.
1981 Gallerie DeGestlo, Cologne
 Nancy Hoffman Gallery, New York
1982–83 Nancy Hoffman Gallery, New York
1984 Delaware Art Museum, Wilmington
1988 Galerie Ninety-Nine, Miami, Fla.
 "Comedia Mural," Tomatissimo, Cologne
1989 J. J. Brookings Gallery, San Jose, Calif.
 Modernism, San Francisco, Calif.

GROUP EXHIBITIONS
1982 "Rebounding Surface," Edith C. Blum Art Institute, Bard College, Annandale-on-Hudson, N.Y.
1983 "Contemporary Images, Watercolors: 1983," Allen Priebe Art Gallery, University of Wisconsin, Oshkosh
 "New Art From New York City: Contemporary Artists' Paintings," Delaware Museum of Art, Wilmington
 "Realism: The Thirties and the Eighties," Summit Art Center, N.J.
1985 "Dispersal: A Decade of American Realism 1975–1985," Wichita Art Museum, Kans.
1989 "American Icon," The Phyllis Rothman Gallery, Fairleigh Dickinson University, Madison, N.J.
1989–91 "At the Water's Edge: 19th and 20th Century American Beach Scenes," traveling exhibition: Tampa Museum of Art, Fla.; Center for the Arts, Vero Beach, Fla.; Virginia Beach Center for the Arts, Va.; Arkansas Arts Center, Little Rock
1991 "Get Real," North Miami Center of Contemporary Art, Fla.
 "Inheritance and Transformation," The Irish Museum of Modern Art, Dublin
 "Sammlung Lafrenz," Neues Museum Weserburg Bremen, Germany
 "Twentieth Century Flower Paintings," Museum of Art, Fort Lauderdale, Fla.

CATALOGUES
Lynes, Russell, William H. Gerdts, and Donald B. Kuspit. *At the Water's Edge: 19th and 20th Century American Beach Scenes.* Tampa Museum of Art, Fla., 1989.
Hentschel, Martin. *Sammlung Lafrenz.* Neues Museum Weserburg Bremen, Germany, 1991.
McGonagle, Declan, and John Hutchinson. *Inheritance and Transformation.* The Irish Museum of Modern Art, Dublin, 1991.

ACKNOWLEDGMENTS

I acknowledge and thank the following people for their support and contributions:

Aaron J. Miller for assembling all the photography and documentation of the artworks.

Diane Sena for years of research developing the bibliography and exhibition records.

The staffs of O. K. Harris Works of Art, The Pace Gallery, Nancy Hoffman Gallery, and Allan Stone Gallery.

Margaret Donovan, my editor and coordinator of this entire project, which covered four books and about 2,700 pictures on more than 1,300 pages, over a period of fourteen years.

Dirk Luykx for his consistent and outstanding design of all four books.

PHOTOGRAPH CREDITS

The photographs of the works of art were provided by the following individuals and organizations, whose contributions are gratefully acknowledged: John Beck; Ken Cohen; Bevan Davies; D. James Dee; O. K. Harris Works of Art; Bill Jacobson; Keith Jones; Steve Lopez; Dennis McWaters; Aaron J. Miller; Modernism, San Francisco; Al Mozell; William Nettles; Edward Owen; The Pace Gallery; Pollitzer, Strong & Meyer; Ellen Page Wilson; Alan Zindman.

Also acknowledged are those who took the photographs of the individual artists: Martin Brett Axon (Flack); Kate Cameron (Jacot); © Jane Corbett 1984 (Eddy); Liz Kessler (Salt); Gunnar Kleemann (Kleemann); © Robert Mapplethorpe (Estes); Louis K. Meisel (Gertsch); Kim Wolfman Mendenhall (Mendenhall); David Plakke (Close); Nancy Rica Schiff (Baeder); © Harvey Stein, 1990 (Cottingham); Matthew Wysocki (Blackwell).